COAT FRONT

B

TURNING

Dressed

DRESSED

THE SECRET LIFE OF CLOTHES

SHAHIDHA BARI

JONATHAN CAPE
LONDON

1 3 5 7 9 10 8 6 4 2

Jonathan Cape, an imprint of Vintage,
20 Vauxhall Bridge Road,
London SW1V 2SA

Jonathan Cape is part of the Penguin Random House group
of companies whose addresses can be found at
global.penguinrandomhouse.com.

Copyright © Shahidha Bari 2019

Shahidha Bari has asserted her right to be identified
as the author of this Work in accordance with the
Copyright, Designs and Patents Act 1988

First published by Jonathan Cape in 2019

penguin.co.uk/vintage

A CIP catalogue record for this book is available
from the British Library

ISBN 9781787331495

Printed and bound in India by Replika Press Pvt. Ltd

Penguin Random House is committed to a sustainable future for our
business, our readers and our planet. This book is made from Forest
Stewardship Council® certified paper.

TO ALMARA

CONTENTS

Prologue 1

Introduction 8

1. Dresses 26

2. Suits, Coats and Jackets 80

3. Shoes 134

4. Furs, Feathers and Skins 196

5. Pockets, Purses and Suitcases 240

Epilogue 282

Sources 287

List of Illustrations 299

Acknowledgements 302

Index 303

PROLOGUE

THE CHINESE DRESS

She wears a different cheongsam in every scene – stiffened silk, capped sleeves, high collars – and is, somehow, impossibly lovelier each time. All quiet grace and lissom limbs, she is a sylph, silently slipping through narrow corridors and darkened stairwells, her tiny wrist brushing against his sleeve, their bodies only momentarily turned to each other on their star-crossed paths.

After the revolution of 1949, the Communists had curtailed the wearing of the cheongsam in Shanghai, but émigrés carried them with them to Hong Kong as a marker of a defiant elegance. In Wong Kar-wai's film, *In the Mood for Love* (2000), Maggie Cheung's cheongsams are perfectly fitted to her slight frame, the upright collars reaching to the neck, always meticulously matched to studded ears. The dresses are structured and traditional, skimming close against the ribs and over the waist, holding her in place, holding her back, holding off the tumult inside. She never lets go.

He, by contrast, is young and warm, capable of passion. Tony Leung plays him with a rueful, smiling carelessness: a slim hand habitually running through glossy hair, rolled sleeves and slackened collar. He is plain-shirted, but stylish-smart, quick to laugh, neat in a narrow tie and tiepin.

When, partway through the film, she realises that they can never act on their desire, the camera catches her gazing wistfully from a gilt-edged window, its golden frame picking up the yellow jonquil printed on her dress, the flower's own mute beauty, in

turn, mocked by the landlady's loudly chintzed lounge stretching behind her. The green tendrils of some climbing plant creeps into the edge of the shot. In its original Cantonese, the film was titled 'The Age of Blossoms'. Maggie Cheung's still-girlish character, in the spring of her life, mourns the loss of a flowering that never comes. She sips absently from a glass of water; her slender arm is pressed against her waist, holding in everything she might once have felt, might ever feel again, under the blooming yellow jonquil printed on her bluish-grey dress and across her heart.

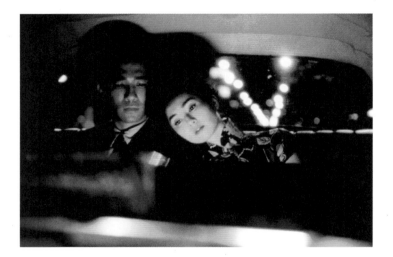

In the Mood for Love (2000)

THE BOOTS

When the American heiress Claribel Cone purchased an oil painting depicting a pair of discarded boots, she grimly conceded to her sister, Etta, that she was 'not so pleased' with her newest acquisition. You picture her writing from the satin-slippered serenity of her salon with a disappointed, grudging respect: 'the pair of shoes will not grace my living room with beauty – however – it is a Van Gogh – almost certainly – Mr V. [Vallotton] says *sans doute* ... ' The painting is unmistakably Van Gogh's, a variation on one of his particularly obstinate themes. The boots were his too, bought in a Parisian flea market in 1886. The feverish series of paintings that followed indicate how they possessed him in that wildly productive year, repeatedly commanding his painter's eye and demanding the touch of his brush.

The 1886 canvas in the Van Gogh Museum in Amsterdam is also, unmistakably, his, profoundly marked by that peculiarly heavy hand and rendered in the dulled browns of his Dutch Nuenen palette. The paint is thickly knifed, the pigment-clogged brush visibly scrubbed across the canvas next to vigorously cross-hatched textures. The brushwork is graceless, brutish, honest. So are the boots. They sit exhausted, reluctantly ordered like chided children, right and left in place, the battered leather robust and defiant, and the long-worn uppers curled from use. The laces are tightly threaded but left strewn, resting in the gleaming eyelets they have pierced. The lolling tongues dip into each boot's dark internal recess. And yet they have the grace of the sunlit earth on which they rest. *They rest*. These boots have walked, have worked, and though they come to rest here on this sunlit earth, they are only momentarily stilled, as though they might labour yet with ragged breath.

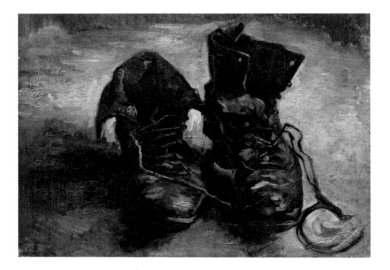

VINCENT VAN GOGH *Shoes* (1886)

The German philosopher Martin Heidegger, seeing the painted boots in an exhibition, wrote of them in an essay of 1950. He feared and romanticised them, projecting onto them the 'toilsome tread of the worker' and 'the menace of death'. The shoes, he claimed exultantly, contained a world, full of ripening grain and fallow wintry fields. 'On the leather,' he wrote, 'lie the dampness and richness of the soil. Under the soles slides the loneliness of the field-path as evening falls. In the shoes vibrates the silent call of the earth ...' But perhaps the world they contained was less even than this and more profound. The boots are simple and entreating, piercing us with their visible fatigue. They ask us to imagine the life of feet, conjured, as they are, by Van Gogh's hand. But walking and painting were always bound together for him.

As a child, he had roamed the fields and woodlands of Brabant, feeling the colours of sky, marsh, heath and sand resonate with unspoken tone and atmosphere. When in 1890 he

suffered a breakdown, he sought solace and tranquillity in the grounds around Auvers-sur-Oise, painting landscapes palpably freighted with an emotional charge. 'Sometimes I long so much to do landscape,' he wrote, 'just as one would for a long walk to refresh oneself, and in all of nature, in trees for instance, I see expression and a soul, as it were.' In July 1890, he walked out into the wheat fields around Auvers for the last time and shot himself in the chest.

THE DENIM JACKET

'Take me to the centre of everything,' is what she demanded, apparently, when she first arrived to New York City in 1978, clambering into a taxi. The driver deposited her in Times Square. She found a job in Dunkin' Donuts before being fired for squirting jam into a customer's face. It's an apocryphal story, but you believe it, and have a sense of how well she would retell it, laughing wickedly. She is fearlessly, unstoppably fun and almost feline in her daring, confident that she'll land on her feet and right herself whatever risks she takes.

Madonna lived in the Lower East Side of Manhattan and in Corona, a neighbourhood in Queens, during the early 1980s. By the time of 'Borderline', the fifth single from her first album, titled *Madonna*, she had dated the artist Jean-Michel Basquiat, was kicking around with Andy Warhol and the Beastie Boys, hanging out at Studio 54, Danceteria and the Pyramid Club. Her style in those first years was boho-punk, both feminine and tomboyish, cool, carelessly sexy, fingerless gloves and string vests, a jumble of jewellery, jackets you could leave behind on the subway, on a dance floor, in a Brooklyn apartment at four in the morning.

'Borderline' was released in 1983. In the video to the track, she is a messy blonde, her hair a peroxide tangle with visible

roots, topped by an orange-red headband tied in an impudent bow. She pairs a tangerine vest with baggy black cargo pants, dressed up with fluorescent socks and an armful of bangles. She finishes the look with a sleeveless denim jacket, oversized, as though she's borrowed it (and has no intention of returning it). The whole ensemble has the haphazardness of a spree around a thrift shop – and a certain poise, too.

The video begins with her dancing under a bridge, bopping with her cute Latino boyfriend, against a backdrop of corrugated iron and dilapidated warehouses. A handsome photographer in a slim-cut tan-coloured suit turns up. He carries her off in his smart car and gives her an expensive leather jacket, but she's street-smart and unseduced by his debonair ways. When she tires of his studio, the classical busts and faux Roman colonnades, she takes a canister to his marble walls and spray-paints a wonky heart so rudimentary that Basquiat would have been ashamed of her. No matter. Boys don't matter. She can take their jackets or throw them off at will.

The opening notes of the song, if you know it, are high and clear – a penetrating sweetness to them – the synthesised melody uncomplicated, given momentum by the drums that roll in, blithe and relentless. 'Something in the way you love me won't let me be,' she sings in that high, still-childlike register, 'I don't want to be your prisoner, so baby, won't you set me free?' But it's not a request. Nothing will curtail her ambition and she'll meet every question with a level and challenging gaze.

Over the years, there will be other jackets – the short, glittering, greenish-bronze cropped jacket with zebra-patterned lapels and a pyramid embroidered on its back that Rosanna Arquette returns to her in the 1985 film *Desperately Seeking Susan*; the lurid purple leather bomber jacket, paired with an eye-wateringly high-leg leotard and a Farrah Fawcett flick for the disco themed *Confessions on a Dance Floor* album; the snug-fit, one-buttoned denim jacket, worn with nothing underneath

it, her honey-coloured beach-waved hair flying against the wind, as she leans into the hurtling high-speed flashes of the 'Ray of Light' video.

But back then, singing 'Borderline' with all her heart, dancing under the bridge in that sleeveless denim jacket, you sense in her the longing of youth and the vulnerability that comes with it. The lyrics of the song are reflective, knowing how alert young people are to their own dreams, how determined they can be in their right to pursue them undiscouraged. They are buoyed by an innocence that hasn't yet met experience. She skips and trips in that opening sequence, moving guileless and free, filled with the kind of elation that you are only ever capable of at that age. 'Take me to the centre of everything,' she said.

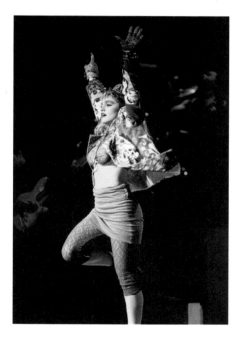

Madonna in concert (1985)

INTRODUCTION

THE THOUGHT OF OUR CLOTHES

A girl in a jade silk skirt dashes past on the escalator. She is like the glimpse of an unguessed possibility, a dauntless flash of brilliance against the ambient blue wash of an ordinary day. A man in neon-striped running shoes steadily circuits the park. He is racing the earth as it rotates beneath him, striving to peel back the years with each stride. What am I to them, in grey woollen coat and red suede gloves, this wintry morning? Only another person, walking through the world, thoughts carried in a fragile body, dressed like any other.

But when I listen closely in a crowd, I am conscious of the synthetic rustle of a jacket's lining as it grazes against an acrylic jumper, the crackle and quick hum of a zip as it zooms up to a neck, the pleasing clatter of an assortment of heels. I know precisely the smart smack of a leather sole against a solid floor. When the noise of voices, traffic and TV subsides, you'll hear it too – a cloud of inchoate sounds, the murmur of tangled fibres as they brush against surfaces of all kinds. When a sweater snags on a door handle or a button dangles from a dangerously loosened thread, our clothes pointedly remind us that they are there. They are *always* there, these wordless witnesses to our lives.

If, like me, you are haunted by clothes (garments you have worn, discarded or dreamed), and your memory is replete with the form and feel of dress (belonging to people you have loved, known or lost), then you will understand something of the mystery and

allure that this book sets out to investigate. If you are compelled by that irresistible impulse to read dress, then you know that to do so is to peer into a world that is continually reconfigured round every new corner. I could not say how far an alertness to dress is as particular a facility as an ear for music or an aptitude for numbers, but I can easily believe in the deep and equal logic of our clothes, the subtle and complex ways they work in our lives.

I confess, from the start, that the thoughts gathered here come from my own irrepressible interest in matters of appearance and self-presentation. My eye is easily caught by a stranger's coat in a train carriage, my hand prone to drifting absently through any array of textures, my brain too readily disengaged from the task at hand and inclined instead to wonder about the sympathies and sensibilities made visible in the things worn by any passing body at any given moment. Yet I know, too, that the understanding won by this mode of wondering is not always wasted and that this form of engagement with the world can be humane, responsive and thoughtful. To care about clothes is to care about the people who make and wear them too. Each time we feel ourselves distracted by the colour of someone's cardigan or we straighten a friend's crooked tie, our clothes compel us to concede how susceptible we are to each other.

Some people love clothes: they collect them, clamour over them, take pains to present themselves correctly and consider their purchases with great care. For some of us, the making and wearing of clothes is an art form indicative of our discernment and the means by which we assert our distinction. For others, clothes fulfil a function, or provide a uniform, rarely meriting a thought beyond the requisite specifications of decency, the regulation of temperature and the unremarkable meeting of social mores. I write here for readers from both these houses (or wardrobes), since dress is, at its heart, really about memory, meaning and intimacy: the ties, if you like, that bind.

In clothes, we are connected to other people and other places in complicated and unyielding ways.

The pleasure of dress comes easily: in the unexpected thickness of velvet into which our fingertips sink or a skinny knitted tie the exact colour of moss. Clothes can work upon us quickly – the suit that commands our attention with the authority it emanates, the fluorescent vest that warns us of the hazard from which we must swerve, the gown whose golden lustre summons our eye like a sunbeam in a darkened room. But the ubiquity of clothes means that we can be careless of them too. We rarely think to take the things we wear and hold them up to the light, inspecting them as objects of intellectual enquiry.

What do we talk about when we talk about clothes? Mostly, I think we are liable to lapse into truisms. Our 'identities are expressed' by them, we say vaguely, as though the boy in the Ramones T-shirt was the sum of what he wore and as though selfhood were a thing that could be articulated so effortlessly. Fashion historians, more usefully, trace the genealogy of corsets and conscientiously chronicle the Victorian dress reform movement. Ethno-sociologists identify the sartorial markers of subcultures in leather jackets and feathered headdresses. Formidably stylish bloggers swoon over the sumptuous details of designer wear. None of this explains what it feels like to pull on a padded coat on the first cold day of September. Why do some of us carry rucksacks and handbags spilling with stuff we *think* we need and can never find what we *do*? What is the peculiar peace that overcomes us when we peel off our shoes at the close of day? These are the questions that interest me.

It is true that, in times of crisis, what we wear can feel like the most trivial of concerns. But isn't it curious that so many of our most heated cultural disputes should circle around the right to wear particular clothes in particular circumstances? Think only of the dresses claimed by trans women, the near constant state of anxiety over the visibility of the Islamic veil in Europe, or

the length of skirts regularly rebuked in cases of sexual assault. In our clothes we see our larger social crises play out. If I elect not to address these specific issues in this book, it is because you'll find the arguments around them rehearsed at length in innumerable other places. What strikes me, though, is how the undeniable politics of dress illuminates a paradox: we dismiss dress as the most superficial of subjects but we return to it too, again and again, in the critical debates of our time.

What I mean to say here is that life happens in clothes. In the chapters that follow, I focus on selected aspects of dress – gowns, suits, boots, animal skins, pockets and bags – identifying in each the articulation of a particular idea or dilemma. The depredations of violence and ageing, the longing for freedom, our illusions of civility and the erosion of privacy are the themes of this book. Underlying every chapter is a concern for the body – invested with authority as it is for men and subject to surveillance as it is for women. I write to both male and female readers here, and also to anybody for whom the conventions of gender can make the act of dressing an especially alienating or emancipatory practice. In the end, we are all of us returned to the fragility of our human form for which our clothes provide only the thinnest protection.

We are dressed. In all parts of culture – literature, music, film and art – we find the representation of clothes. They can be ordinary and unremarkable or glamorous and arresting, but they are *there.* I gather some of those representations together here in an effort to truly see our clothes, hoping to better understand how they function and what they might mean to us. In many ways, this is less a book about dresses and dinner jackets than about desire and denial, the fever and fret with which we love and are loved in clothes. Our deepest internal life is found in them. The garments we wear bear our secrets and betray us at every turn. I want to encourage us to put aside the distracting questions of what constitutes 'fashion', and move beyond the

conventional discussions of identity, subcultures and social history. What I have in mind is something more expansive and open than that: a kind of philosophy of dress. I want to suggest that in dress we might find a way of apprehending the world, understanding it as it is expressed in an idiom that is found everywhere, if only we care to read it.

We are, everywhere, surrounded by ideas. For the most part, we unthinkingly suppose that they are found in the form of books and poems, visualised in buildings and paintings, exposited in philosophical propositions and mathematical deductions. Some ideas are born of dogged intellectual enquiry or diligent scientific discovery; they are taught in classrooms, a form of knowledge expressed in the mode of language, number and diagram. But what if clothes could be understood as ideas too, as fully formed and eloquent as any poem, painting or equation? What if in clothes the world could open up to us with the tug of a thread, its mysteries unravelling like the frayed edge of a sleeve? What if clothes were not simply reflective of personality, indicative of our banal preferences for grey over green, but more deeply imprinted with the ways human beings have lived, a material record of our experiences and an expression of our ambition? Could it be possible to understand the world in firmer, *felt* truths, in the perfect geometry of a notched lapel, the orderly measures of a pleated skirt, the stilled, skin-warmed perfection of a circlet of pearls?

For all the abstracted and elevated formulations of selfhood and the soul, interior life is so often *clothed*. Our memories tenaciously retain the texture and forms of dress. My own childhood replays itself as a jumble of sense impressions, often in the colour and shape of clothes – most unforgettably, an emerald green winter coat, fur-lined, hooded and belted, worn to the circus one afternoon, its silhouette so perfect that every coat after is a vain attempt at recovering it, caught at like a dream. I remember that coat and I see myself in it as I was then: a childish body, unbruised and uncurbed. We outgrow clothes,

of course, and yet they stay with us, as though their fibres were imperceptibly threaded into our memory, winding through our experience. But our clothes do more even than this, sometimes more than we can know.

If through them we seek to declare our place in the world, our confidence and belonging, we do so under the veil of a deception. We select clothes painstakingly as though they didn't ruthlessly appoint us, indifferent to our intentions and contrary to our will. Old, favoured clothes can be loyal like lovers to our cause, when newer ones dazzle and deceive us. There is a naivety in the perilous ways that we trust in clothes because dress never promises to indemnify us, neither from external assault nor internal anguish. Skin turned to sunlight, some of us exult in exposure, as though unclothed we could be closer to truer, freer, more naked realities. E. M. Forster, misquoting Henry Thoreau, wryly cautions us to 'Mistrust all enterprises that require new clothes'. He has the slogan scrawled on a wardrobe belonging to the soulful George Emerson in *A Room with a View* (although there is another kind of closetedness we might read into Forster's own Edwardian elegance too). Our clothes can also provide refuge, acting as a canopy under which we shelter our most secret agonies. When despair echoes deep inside, dress can help us pacify and dull pain; a blazer and slacks somehow allay our vulnerability. Yet to trust that our clothes will keep our secrets is a seduction in itself.

Clothes can be the disguise in which we dissolve, the camouflage that allows us to keep something of ourselves in reserve, as though the only thing we are and own is that which we refuse to articulate in our outerwear. Or else they enable us to acknowledge our responsiveness to life, and we demonstrate it in the deft and quirky ways that we fix a belt, hang a tie, roll a sleeve. The clothes we love are like friends, they bear the softness of wear, skimming the various planes of our bodies, recalling the proportions that they seem almost to have learned by memory

and habit. There are certain clothes that we long for and into which our limbs pour as soon as we find a private moment: the jumper in which you, at last, exhale at the close of day, the T-shirt that is the only thing pressed between you and your lover through the long hours of the night. We need not be the sort that wears our hearts on our sleeves for our clothes to already know everything we might say and many things for which we could never find words.

Writers sometimes find the words. In Edith Wharton's 1905 novel, *The House of Mirth*, Lily Bart concedes to herself the powerful truth of her passion for Laurence Selden:

> She was very near hating him now; yet the sound of his voice, the way the light fell on his thin, dark hair, the way he sat and moved and wore his clothes – she was conscious that even these trivial things were inwoven with her deepest life.

When we speak of things being 'woven together', we mean affinity, association, inseparability, but Wharton's 'inwoven' suggests yet more than this, something like an intimacy so close that it is constitutive. Her insight is more complex than the crass idea of clothing as an expression of character, more profound than the paradox of a surface that could speak of the inner self. Lily is bound to Laurence, not simply by some romantic pledge of affection but in the particularities of his being, as though the tightest seam ran back and forth between her slow-gathered sense impressions (his voice, his hair, his *clothes*) and the interior life to which they seem to reach. As Lily is to Laurence, we too are inwoven, bound up with things and the people to whom they belong or refer. To engage thoughtfully with clothes is to acknowledge the nature of objects and our utter entanglements with them. Isn't it possible that what we *are* could in some way be dispersed through the stuff of the world? Objects are imbued

with the lives of those they serve, nicked, as they are, by incident, worn by habit and warmed by touch. Our clothes are closest of all.

For Karl Marx, clothes perfectly epitomised the mystification of objects that he saw as symptomatic of modern culture. When he described the world in the language of labour and economy in *Capital*, his treatise of 1867, it was a coat that exemplified the distorted nature of all commodities in a capitalist society. This, he understood first hand. Down on his luck one summer, he deposited his overcoat with a pawnbroker and found himself barred entry to the reading rooms of the British Museum without the appropriate attire. What was it about objects like coats, that they could so magically open doors and bestow permissions? Not even a coat belonging to Marx could evade the ineluctable mechanisms of capitalist exchange.

All commodities, including coats, it seemed to him, were mysterious things, loaded with significance, drawing their value not from the labour invested in their production but instead from the abstract, often ugly and always competitive social relations of capitalism. Commodities, as Marx understood it, were alienated from the workers who made them. He observed how the mundane and repetitive making of such objects exhausted their will and drained their vivacity, and he noted too the perversity with which a commodity could, in turn, appropriate and imitate the qualities of a human being, as though they possessed a diabolical life of their own.

Clothes present that awful mimicry with a particular acuity. Think of the swaggering braggadocio of the newest trainers with their insouciantly swishing insignias, the dress that seems in possession of its own flirtatious personality as it swings on a store hanger, or the dangerously vertiginous heels that speak of a leisurely life without exertion, worlds away from that of the worker who made them. Garments enter the market seemingly untouched, the prints of the working hands through which they have passed wiped clean. Marx's criticism here is

not so much directed at the garment itself but the values with which it is imbued. When he condemned the all-consuming 'commodity fetishism' of modern culture, he derived the term from the Portuguese *feitiço*, meaning charm or sorcery, referring specifically to the West African practice of object worship witnessed by fifteenth-century sailors. To the fetish, worshippers could attribute the kinds of magical properties that such objects did not possess in reality. In the same way, modern capitalism, it seemed to Marx, traded on the supernatural life of objects.

Clothes are not exempt from eliciting false idolatry. We sing the praises of shoes, dresses, jackets and bags as though they were in possession of an inherent power, a spirit or a soul. We attribute to them stories and character, and blot out their real origins, the hardships of mass production and the working conditions from which they come. The things that we wear bear the touch of the people who construct them. Marx theorised this in the nineteenth century, but the truth of it is as pressing for us now as it was for him then. As the rapid production cycles of 'fast fashion' render our garments increasingly disposable, it seems more important than ever to pause and to reflect on our clothes. If our clothes mean something to us, so too must the people who make them. And if we are to reshape the fashion and textiles industry for a sustainable future, then we must believe that there is more to our clothes than it first appears.

'Appearance' is itself an elusive term. In philosophy, it belongs to epistemology and tiresomely technical discussions about the limits of knowledge and the nature of perception. It is almost always disconnected from matters of dress. Plato, puzzling over how to distinguish between appearance and reality in the 'allegory of the cave', reveres the disclosure of truth and deplores the dissimulations that keep us from it. His mistrustful assessment that appearances can be deceptive lastingly shapes the tradition of thought that follows. For Immanuel Kant too, in the eighteenth century, the question of appearance is strictly

philosophical, concerned with the thorny relationship between the reality of things 'as they really are' (*noumena*) and the limited ways in which we perceive them (*phenomena*). When Friedrich Nietzsche returns to the question of appearance in nineteenth-century philosophy, though, it is with wild enthusiasm for Dionysian disguises. Truth, as he figures it, *appears* as variable surfaces and masquerades, and he exhorts us to relish in its transformative possibilities. 'Truth is a mobile army of metaphors,' he explains, subject to 'translation and decoration'. It is not a disembodied abstraction, and the question of who we are is fused with the matter of how we appear.

This idea that 'being' and 'appearing' might be entangled, rather than opposed, is an alluring and persuasive one. How could we think that our experiences of selfhood were not shaped by many things, including clothes? When we disregard dress, relegating it as a superficial concern, we obstruct a mode of understanding ourselves and others. As the critic Susan Sontag demurs, contra Plato, maybe there is 'no opposition between a style one assumes and one's true being ... In almost every case our manner of appearing *is* our manner of being.' We think that the truth is naked, but perhaps, instead, it is dressed up, changing day to day, eluding any easy grasp. We *are* in clothes. Perhaps we are *most* ourselves in the things we wear.

And yet, when we overthink our appearance, we hazard accusations of narcissism, as though self-concern were an impropriety. In the ancient Greek story, Narcissus is the prettiest youth with glossy hair and an ivory neck. Driven to distraction by the beauty reflected back to him in a woodland pool, he turns inward and away from life. His error is partly vanity, but mainly stupidity. He is the unthinking idiot, unable to recognise how the water only presents his own image back to him. He lends his unhappy name to a pathological self-centredness, but isn't narcissism only a naive version of the self-consciousness to which philosophy has directed us for centuries?

Freud discerns in the phenomenon of narcissism an instinct for self-preservation, 'a measure of which', he argues, 'may justifiably be attributed to every living creature'. This narcissism, he claims, forms part of our necessary infantile development since it describes the promiscuous ways in which we see ourselves in all things, our toys, our trinkets and our mothers alike. The entire world returns to us an inflated sense of ourselves, but this also tethers us to it in turn. This is a narcissism predicated on a fundamental sense of relatedness that means we cannot retreat from the world as Narcissus does. We are, instead, inextricably caught up in it for it is in the world that we find ourselves and in which we see ourselves.

And *seeing* ourselves, both literally and metaphorically, somehow finding a way to hold us up to our own inspection, is a profound task. The narcissist need not be stupidly self-absorbed. They can possess a vigilant and critical form of self-consciousness; they can be wry and ironic. When we fashion ourselves artfully and attentively, we are open to accusations of vanity and pretension, but the ability to imagine ourselves outside of ourselves is an important philosophical strategy. To reflect on the ways in which we are seen is also to pose questions about authenticity. How far are we able to present our inward selves with outward accuracy? Are there ever any moments that we make ourselves 'real' or 'true' to others?

Seeing ourselves can be a burden too, of course. This is made manifest in the dutiful ways we self-regulate, assessing our appearance against exacting ideals of beauty, propriety and age. Our clothes can be cruel, forcing us to confront our everyday attrition and our ineluctable mortality. When we dress, we see our bodies as mutable things, not always within the limits of our control. This is painful perhaps, but it is a vulnerability we all share, and as soon as we extend our imagination to the possibility of others, we form the basis of ethical relationships. When we disconsolately lament our fluctuating weight, our

washed-out skin and our tired clothes, the kindness we deny ourselves we might extend more sympathetically to others with the understanding of our own imperfections.

Are these kinds of self-reflections always wasteful? We are accustomed to the idea of a contract-based culture of rights and responsibilities in which we abide by laws and fulfil obligations, but we might also think about the ways in which civic society is predicated on ideas of self-cultivation, not far removed from narcissism. We can 'care for the self' as the ancient Greeks once advised. This is what the French philosopher Michel Foucault contemplated towards the end of his life, his body pitilessly ravaged by Aids-related illness. To take care of oneself is to attend with great concern to every aspect of one's being, 'taking pains with one's holdings and one's health' alike, he explained. Self-care can take the form of writing, reading, eating and exercising, he lists, and in these activities we cultivate in ourselves a dignity that we might attribute to all human beings. Rather than bending inward like Narcissus, we can be selves that turn out to the world, open to the enquiry and engagement of others. This is self-care, not in the vein of Ayn Rand's rational egoism, but a mode of well-being based on a collective vision of society and our obligations to it.

'Caring for myself is not self-indulgence, it is self-preservation,' declares the black feminist poet and activist Audre Lorde, in the epilogue to her book *A Burst of Light* (1988), 'and that is an act of political warfare.' Here, self-care is not an excess of vanity but a way to insist on your own value in an oppressive culture disinclined to prize your particular body and being. Our acts of self-care are most powerful of all in a society that insists that we are not worthy of it. Working with a group of South African activists in the struggle against apartheid, Lorde recalls with tender detail how the women 'are sewing, sweeping the dirt ground of the yard, hanging out clothes in the sunlight at the edge of the enclosure, washing, combing each other's hair'.

Later, in her own struggle with cancer, she asserts her sense of 'responsibility for attending my own health. I cannot simply hand over that responsibility to anybody else,' she explains, since acts of self-care are 'crucial strategies in my battle for living. They also provide me with important prototypes for doing battle in all other arenas of my life.' We care for ourselves, because if not us, then who? The dignity that we grant ourselves, we realise, can extend to all others equally. And the most profound parts of our lives – the intellectual enquiries that preoccupy and the moral questions that trouble – none of that can be abstracted from the bodily forms we inhabit and the social conditions in which we suffer hardship.

But what we come to know by caring for ourselves is the hardest truth of all. Our bodies are not unchanging and they will not last forever. We take pleasure in clothes perhaps because they seem to deny death, offering up endless possibilities for transformation and alteration. We can accomplish this in clumsy ways – the glasses that you hope might lend you gravity, the padded bra that fills out a flat chest – but in innumerably subtle ways too – the heel that imperceptibly cants the body and contracts your stride, the tie that stiffens your neck and straightens your spine. We can experiment with our image, as though renewal were always available to us. In the end though, seams tear and fabrics fray. Our clothes will fall apart. So will we.

There are some garments that we feel *closely*, which make apparent the difference of their textures to that of the surface of our skin, reminding us that we and they are not one. They can cause us discomfort, palpably constricting, itching and chafing – the shoes that are a half-size too small and which make your toe throb the whole day long, the buttoned collar that closes uncomfortably around your neck. These clothes alert us to the fact of our bodies in a way that can feel at odds with the rest of the world that glides past, apparently undisturbed. They sit in contrast to other garments that we wear almost imperceptibly,

that are so light or diaphanous that they are hardly seen or felt, as though we were sheathed in air. Clothing continually places us in a relationship to a body that we can forget or deny but in which we always are.

The transformations that our clothes can enable are exciting, but they can also dislodge our self-assurance. How, for instance, can it be that we so easily emulate others in what we wear? When we adopt each other's style, we reveal how interchangeable and indistinct we really are. We make light of costumes, but their very possibility contests what we regard as our as unique personhood. If I can glibly dress as someone else, how, then, are any of us ourselves at all? Anxieties about authenticity linger under the surface of all forms of dress. We seek clothes that we think 'are us', and there is an implicit insolence in the ready-to-wear, off-the-rail garments we rifle through, something unsettling in the idea that our precise measurements could be, instead, revealed as generic or average.

At other times, though, there can be immense tenderness, close to tragedy, in the different ways that our clothes tell the stories of a self that is subject to all kinds of alteration: the bitter-sweetness of growing into a coat inherited from a long-gone parent, remembering a forgotten life in the work shirt worn for a job you have left behind, throwing out the trainers for the runner that you no longer are, or folding away the maternity dress you will never have cause to wear again. Sometimes, there is, in dress, only anguish: the garments that bring to you the memory of someone you once loved and will never see again, the bloodstain on a T-shirt from that most terrible of days.

Death – and love – is never very far from dress. The French philosopher Roland Barthes, in his 1980 study of photography, *Camera Lucida*, pores over one particular image of his mother. The photograph captures her as a tiny child, decked in a stiff white dress from under which peep the smallest boots. Over the course of the book, he delineates an idea of the 'punctum',

the detail in any given picture that penetrates, and by which we establish a relationship with the object or person represented to us. The punctum is the pinprick that startles, the part of an image that opens it up, suddenly permitting us to see more deeply and to understand differently. Searching the grey and grainy photograph of his mother, Barthes finds the punctum in her unbearably small hands, observing how she 'hold[s] one finger in the other hand, as children often do, in an awkward gesture'. But there is something in the fullness of the dress and the scuffed shoes too: a certain innocence that wounds.

Barthes's mother had died a year prior to the writing of *Camera Lucida*, and the book weighs with his grief. He would write of her death in his diary with piercing insight:

> One doesn't forget, but something *atonal* installs itself in you ... Grief ... is a sort of deposit, of rust, of mud ... a bitterness of the heart. I say to myself ... how barbaric it is not to believe in souls – in the immortality of souls. What a stupid form of truth materialism is.

Barthes didn't believe in souls, and it made his grief intolerable. When we talk of the truth of materialism, we mean how fortunate and clever we are to no longer believe in God or in the truth of insubstantial souls, and how enlightened to believe instead in the truth of real things: of stuff. Perhaps stuff compared to souls is prosaic, boxy, ungraceful in some way, but stuff is also a solace to us, since it allows for there to be truth in things. Materials tell us truth; materials *are* a kind of truth.

What Barthes knows is that we are the bodies our parents give and the beings they make us, that our whole lives are continuous, faltering attempts to reshape the fates they consign us to. Our relationship with our parents is gravely weighted with desire – to know them, be like them, live up to them, have them love and forgive us, never to lose and always to run from them. We can

inherit their things – an antique sari, a battered pair of rain boots, a set of twisted cufflinks – but those things only suggest their inscrutability even more, crushing us with the sense that the people we love best, are, in curious ways, those we know least. The clothes that our parents once wore and leave behind alert us to their interior life, the unseen, ever-present companion to all their experiences, of which we can have no part.

In Barthes's earlier work, *A Lover's Discourse* (1977), he writes of a ribbon belonging to Goethe's Young Werther, that having been 'touched by the loved being's body [it] becomes part of that body'. Werther kisses the knot of ribbon Charlotte has given him, the letter she has written, the pistols she has touched, because, Barthes notes, 'From the loved being emanates a power nothing can stop.' Each consecrated object becomes like 'the stone of Bologna', which by night radiates with the light it has accumulated during the day. Love is a terrible form of idolatry, but the consecration of *things*, the ways in which matter absorbs meaning, calls upon a kind of magic, a foolish superstition to which we stupidly subscribe nonetheless. If we believed that we could impress some mote of our being on all that we touched, somehow we might keep death at bay, because in things, in stuff, in matter, the people we love too would be and remain. In their things we might find them again and so not be abandoned, just as we would not abandon them. The clothes that we inherit from the dead are tainted by this longing; they carry this broken promise.

It is unfailingly moving to me how clothes mark our mutability, paralleling the vicissitudes of our lives in their own subtle shifts of colour, sheen and quality over time. The insight that follows from this is pressing and plain and all the more true for it: our clothes age and we age in them too. Moment by moment, we erode and attenuate, our claim to life loosening like a seam that can no longer hold. In new clothes, we disguise our mortality, but even the best of them wear. In the thinning of threads, the gradual blanching of a former brilliance, our clothes

speak truth to the deception that we could ever have thought that we might stay as we once were forever.

Do clothes speak? They 'express' us, of course, indicating affiliations and identities, and the word 'text' itself retains the memory of a lost materiality, connected to 'textile' and deriving from the Latin *texere*, 'to weave'. We read our lives into the things we wear, but they, too, can seem in possession of their own life. How could we not believe there to be some animating principle at work in the crisp, stiffened transparency of organza, whose bridal layering accomplishes a strength that belies its fineness, or the cobweb softness of gossamer whose name ridiculously conjoins the Middle English for 'goose' and 'summer'? Isn't there a hint of coquettish nonchalance in chiffon, romance in voile?

When we choose to 'read' our clothes, our task is to find their precise and equitable translation in language. This is a challenge because dress, in its fullest range, intimates something of the diversity and delicacy of the lived experience, to which words only falteringly reach. In dress, we impart some mysterious thought, quality, mood or aspect, only inadequately conveyed by any other means. And yet, at times, our clothes seem also to solicit language. Think only of the T-shirt in that precise and rare shade that brings unbidden to your mouth the shape of the word 'turquoise', the belt on the beige, buttoned mid-length jacket that makes it exactly a 'trench coat' and nothing else, or the soft, smooth warmth against our skin that is 'brushed cotton'. The things we wear can elude our words, bringing language up close to its limits, but at other times, they seem almost to be *awaiting* our articulation, the exact arrangement of words by which something particular, somehow *known* and *felt*, might finally make itself understood.

This is why if you love language, you might find that you love clothes too. Both possess the capacity for exactitude and evasion, revealing us as we are and protecting us from too penetrating a gaze. For this reason, what I write here is given as an act of

undeniable disclosure. How could I tell you of the life of clothes if I were not also to tell you of the life of the wearer? And if I cannot take you to my barest heart, if I keep you at arm's length, then remember that in clothes we hide too, cloaking the most naked truths. This book comes only from the conviction that there may be in clothes that which language cannot contain, and something else in language too that might realise the life of clothes that is otherwise left unspoken.

We think we dress for decency's sake, but what our clothes conceal is an indecent truth, difficult to bear and harder to confront with every passing moment: that we are embodied and yet fragile, unknowable to others just as they are to us. Our clothes, in all their joy, range and colour, brightly ward off death. We wear them valiantly, presenting an image of how we might wish to be remembered – *dressed* – in place of the bare bones we must ultimately become. Clothes tell our stories, some that we would rather not tell, others that we hardly know ourselves. The clothes of those we love tell us how little we have known them, how failed we all are by the brute fact of our mortality and how insufficiently love shields us from this. And yet, how little we think of it in the things we ourselves wear. Our garments are unequal to the ways in which we are loved, but all that language cannot articulate – the life of the mind, the vagaries of the body – is there, ready to be read, waiting to be worn.

When she raises her eyelids it is as if she were taking off all her clothes.

SIDONIE-GABRIELLE COLETTE
Claudine and Annie (1903)

1.

Dresses

YOU ARE CLAMBERING OVER THE RAILINGS, shoes tucked under one arm, fingers closing around the base of the spike as you determinedly haul yourself up, triumphant, irrepressible, joyous as you leap. Nothing can restrain you, not even the black lace evening dress with its heart-shaped bodice and the train that catches and rips, dramatically twisting as it tears diagonally from hem to hip. Someone tells you that I can sew and so, some days later, you are at my door, smiling and rueful, clutching a billowing mass of black taffeta, net and rent lace.

We have always liked each other, nodding in agreement in classes, admiring from a distance, gradually edging together in a crowd over the course of an evening, drawn by mutual interests in books and buildings – and something else, some vaguely intuited sense of shared experience, a dimly felt understanding of a certain kind of pain, an unhappy undercurrent of vulnerability that manifests itself in me as watchful reticence and in you as reckless daring. And so when you arrive at my door that day and we speak for the first time alone, there is no distance, no awkwardness, only the beginning of a friendship that we have both seen coming, life-changing and lifelong.

You are sunnily undeterred when I explain that I cannot run the fabric through the machine, that, at best, I can piece the jagged lace together with small, slow stitches, reworking the pattern by hand until it is almost imperceptible. You sit close, watching intently as I work at it over the next few hours under the anglepoise. When it is done, we hold up the gown together, inspecting it against the sunlight. It is like a scar, I say, this seam that holds this gown together: it will never have the natural give and yield of the original fabric. It will always have this weakness, I explain, as I pull it taut, and you run your finger along the snaking

river of thin black thread. Only you will know it, I say reassuringly. But you have always known your own frailty, known how to tear yourself asunder.

You wear your body lightly, unabashedly, turned out to the gaze of others without shame or self-consciousness. Your tastes are unrefined, not elegant, not expensive: you choose what to wear impulsively, driven by the desire of a moment, uncurbed by conventions. You are never derailed by trends, unhampered by the body consciousness and the distrustful indecision that plagues me. You pluck unloved things from charity shops, rifle through your many friends' closets; you are lent designer samples and collect cardigans discarded in parks with the same equanimity. Everything you wear has the carelessness of a happy accident or a joke, but you know the seriousness of life too. You collect stories and culture, listening intently, full of unasking curiosity. One afternoon, I tell you about the gowns of hummingbird down worn by the women of El Dorado that Voltaire describes in Candide. You dig it up and read it out loud, persuading me to swathe you in a cloud of net, chicken wire and a tangle of flashing Christmas lights. A passing stranger throws you a pound mistaking you for a street performer. Life is better for you in it.

But you hurl yourself into this life too, casting yourself headlong into destructive things. And then I fear for you, knowing that the wild things you wear are a costume, a whirling disguise for your brittle frame thinned by self-punishing starvation, a bloodstream loaded with substances that dull your agony and weaken your heart. You act jubilantly and recklessly, as though there were nothing anyone could do to you worse than you do to yourself, that your life was your own to throw into an abyss, as though you were not compelled by unspeakable experiences, unbearable pain.

That last summer, we had been in touch so little that I felt a heated flash of shame when you called to say you had found that black lace dress again, the heart-shaped bodice crushed in the bottom of a storage box, the seam still holding fast. You had been

ill – your heart was the problem, a hole like a small tear – but you would be well again. It can be repaired, you said.

Hearts are strange, I say to you, telling you about a book I am reading. At the heart of things, we like to say, as though it were the same heart for all things, a shared heart for everyone. A heart that does not beat, that has nothing to do with death at the heart of things. When you are gone, this is what I remember. How you were always at the heart of life itself, how easily you reached into the heart of important things, you, the unstoppable friend of my heart.

WHAT WOMEN WEAR

There is a charge

For the eyeing of my scars, there is a charge
For the hearing of my heart –
It really goes.

And there is a charge, a very large charge
For a word or a touch
Or a bit of blood

Or a piece of my hair or my clothes

SYLVIA PLATH, 'Lady Lazarus'

Sylvia Plath is pastels, colours that are soft and clean. She is neatly pearl-studded ears and a headband, a thin knit sweater gracefully slung around slender shoulders and loosely knotted at the neck, a mid-length circle skirt swinging as easily as she is startled, a Peter Pan-collared, cap-sleeved blouse, baring bone-thin arms and wrists so beautiful that a supervisor at Cambridge would remember them decades after her death. She is tall and neatly groomed. Virginia Woolf is greens and browns, a mannish

tweed overcoat, strings of long beads, a fur stole, floppy brimmed hat and galoshes, suede gloves under which are long ink-stained fingers: vaguely clumsy, raffish, haphazardly assembled. Joan Didion is black and grey, a fine, loosely fitted and silk-soft cashmere sweater, small, narrow ballet flats on feet and cigarette in hand: thin, brittle, but not breakable.

Some writers come to us distinctively dressed. They spring to life in their language and sentiments, of course, but sometimes they are more even than this, their spectral forms hovering at the edges of our vision as we read. Clothes mattered to Woolf. They 'change our view of the world and the world's view of us', she asserted. In *To the Lighthouse*, she notes how the faded skirts and lonely coats languishing in a forgotten wardrobe retain the memory of the human shape that once inhabited them, their emptiness a reminder of 'how once they were filled and animated'. In *Blue Nights*, Didion too reflects on the death of her husband and her daughter, remembering the familiarity of their clothes, which would 'blow in the wind on the clotheslines outside my office window'. What I mean to illustrate by these examples is how powerfully dress can figure in the lives of women, and how thoughtfully writers can conjure them. Garments of all sorts surface in prose, miraculously emerging in the shape of words.

Nothing rational explains the particular connection that often exists between women and the things they wear. It is a conjecture, illogical and yet insistent. We stridently rebuke how routinely women and all their accomplishments are reduced to matters of physical attractiveness, but there is a latitude and variety in womenswear that also makes it exceptionally expressive. Women's dress is full of promise even as it is the object of prejudice. If there is a reason for it, then it may be that it comes as a consequence of the status of women's bodies in life more generally: the numerous ways in which they are observed and assessed, subject to a surveillance that

is differently experienced by men. These are the conventions by which women are customarily evaluated for their anatomy and appearance, often against their will. Yet when so much of your existence is front-loaded, your value discerned from what can be viewed externally, there can also be a kind of knowing, a conscious consideration even, of the surfaces by which you will be understood.

Plath had some idea of this possibility. 'Why can't I try on different lives, like dresses to see which fits best and is more becoming?' she had written in her diary as a young woman, puzzling over the choices available to her. In post-war America, you could experiment with the dazzling colours and cuts of womenswear, as though each ensemble were only a temporary flirtation, but the life that Plath sensed stretching before her, with its competing claims of career, motherhood, marriage and poetic ambition, seemed to demand a narrower commitment, irreversible and exclusive. When Plath took up an internship in New York in 1953, at *Mademoiselle*, a fashion magazine with literary pretensions aimed at 'the smart young woman', womenswear had never looked more different and would become still more various over the course of her lifetime: voluminous Dior-ish New Looks relishing in the largesse and leisure of economic recovery; the impish, surrealist-influenced trompe l'oeil trickery of Schiaparelli that could find mischief and play in optical illusions festooned across women's bodies; the ultra-lux insolent femininity of Chanel, challenged and rephrased by Saint-Laurent's astonishingly modern palette of mustards and pinks and then reconfigured entirely in his gracefully queered tuxedos.

Unsurprising, then, that Plath should so often record the details of dress with unmistakable pleasure and curiosity, alert to how a certain ensemble might be sympathetic to the certain person you imagined yourself to be.

I wore a black shantung sheath that cost me forty dollars ...
This dress was cut so queerly I couldn't wear any sort of a
bra under it, but that didn't matter much as I was skinny as
a boy and barely rippled, and I liked feeling almost naked
on the hot summer nights.

The sheath she describes here, in *The Bell Jar* (1963), is an
experiment with adulthood. The coolly detached drawl conceals
her apprehensions. Clothes, she recognised, can expose us.
They can be the sign of a life veering off the track – like the suit
donned for the first day of an internship spoilt beyond repair
after a sudden nosebleed, or a dress torn during a sexual assault.
This last incident Plath calmly retells in *The Bell Jar* through
her thinly veiled alter ego, Esther Greenwood. Soon after that
encounter, Esther impulsively casts her clothes from the roof
of her hotel.

Piece by piece, I fed my wardrobe to the night wind, and
flutteringly, like a loved one's ashes, the grey scraps were
ferried off, to settle here, there, exactly where I would
never know, in the dark heart of New York.

An act of self-sabotage, exuberantly visible and mockingly
funereal, it brings her neither satisfaction nor relief. It serves,
instead, as a desperately issued distress signal, an external
realisation of her inward dereliction. Afterwards, she is forced
to borrow from a neighbour a peasant blouse and green dirndl,
a comically kitsch outfit, donned almost jeeringly, and which
she wears every day, sinking further into mental breakdown.
Garments give up Esther's psychic crisis but behind that dramatic
impulse to disown one's clothes, there is also something quieter
and more familiar to many women, perhaps, for whom dress, for
all its joyous possibilities, can feel like a trap, a shorthand for a
set of exhausting responsibilities or impossible expectations, all

of which, one might, on a jaded day, long to cast into a night sky. Esther senses in clothes a larger infringement of her freedom and she finds it intolerable.

The collective history of womenswear records that experience on a broader scale; panniers, crinolines and stays are a litany of cruelty, revealing the ways in which women's bodies have been constrained over the centuries. Dresses (and all their variations, from the Roman *stola* to the South Asian sari) track the changing contours of an idealised female form, and from that we might deduce the opportunities that have been curtailed in them too. Fashion historians patiently recount this story, how freedom begins with the liberation from corsets in the nineteenth century and the raising of skirts in the mid-twentieth. They argue how femininity is apparently emancipated by the turn to trousers in contemporary culture. Could it be so easy? Why is it, then, that the dress still survives? And what are the particular conditions of femininity that it seems to paraphrase?

Esther regards her dresses with dismay, hurling them into the darkened city sky. It's a gesture that may seem alien to many of us who revel in clothes and contrive to dress with verve and imagination, seizing it as an expression of the liberty we possess. It's entirely possible to insist that there is independence and dignity in what women chose to wear. *There is.* But the romance of the billowing ball gown and the beguilement of the 'little black dress' are seductions too. What is it that we think we are free *of* when we dress freely? What is really at stake in womenswear that it should be the subject of constant commentary and moral vigilance? A woman can be failed by a gown. Or else she can fit it perfectly. In a dress, she can be the object of mystery, fantasy and violence. How, then, do we begin to think more deeply about the experience of dresses, their folds and cuts, the gaze they draw and the surface that a woman presents to the world when she wears one?

Ariadne stands on the shores of Naxos at the edge of the Aegean Sea in Titian's voluptuous painting of 1520–23. She is pitifully reaching for the lover who has abandoned her, and half turning to the god who leaps from his chariot to claim her in his place. Theseus's insolent ship is a distant, white, wind-swept smudge at the edge of Titian's frame, and Bacchus is a tornado of limbs and swirling rose-coloured robes ready to seize her, the force of his personality almost crushing her into the far left-hand space of the canvas. Ariadne herself has little time to register her feelings, so rapid is her transit from the possession of one lover to the other. But her costume says what she has no time to utter. Her gown falls off the shoulder in an almost post-coital disarray. Theseus's desertion is sudden and she is still striving to catch up with men whose treacherous desires fluctuate so unpredictably that they leave her breathless and barely dressed. The voluminous blue robes, gathered in her hand and catching under her feet, have become twisted in her haste and impede her pursuit. The red spiral of the scarf wound around her feet, arms and neck burns brightly like a bloodied snare. Titian has her turning from the horizon, her expression not easily read, but her body, even from behind is sexed, the stretch of her bared back and shoulder suggesting the disrobing that will come soon enough.

Although her passage from Theseus to Bacchus is inexorable in Titian's concise image, it is not clear what crosses Ariadne's mind in the fleeting instant. Perhaps it is a commingled despair and fear. Even if there were relief at the rescue that Bacchus provides, isn't there also at the back of her mind a bitter uncertainty, misgivings as to the constancy of men and the dependence of women – a resolve to be steeled for the next abandonment and the next? Bacchus is arriving in this picture: near-naked, he leaps towards the object of his desire with

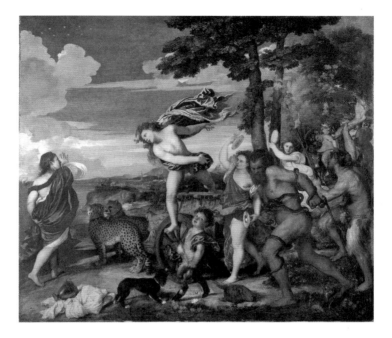

TITIAN *Bacchus and Ariadne* (1520–23)

unmistakable intent. His bizarre entourage of nymphs, satyrs, cheetahs and goats are an undisguised, uproarious frenzy of flesh and appetite. Ariadne's only defence against the onslaught to come are the robes of which she will soon be stripped, and in the moment of Titian's painting, it is as if all the betrayal she must feel, the distress and misery, are carried in their folds, sunk into their hidden depth and darkness.

Folds and drapes are characteristic of classical women's dress: the *chiton* and *peplos*, the pinned and stitched tunics of the Greeks, and the *stola*, the neatly pleated dresses of the Romans. With their architectural tucks and furrows, they are heavy with mystery in the way of all things that fold (or are arranged to fall in folds), since a fold conceals and makes visible at the same time. The fold is the contraction that contains something bigger than itself, the

concertina that opens up unseen possibilities. It is a fold that forms the throat from which come words, and also the womb from which come children. The fold is a secret depth, the existence of which is indicated only by the hint of an opening. And it is everywhere in womenswear – in pleated saris and gathered skirts, cowl necks and ruched waists, the darts and gathers by which fabric is coaxed to take the complex form of a woman.

The French philosopher Gilles Deleuze understood something of the mystique of the fold, fashioning from it an entire philosophical concept. The fold is 'an inside to life, labour and language, in which man is embedded', he wrote, opaque and dreamy. It is an image of the endlessly bifurcating paths, routes and ripples of experience. For Deleuze, there is no smooth surface, no undisturbed stretch of fabric, only an infinite series of pleats and furrows, twists and turns. There is a certain allure to this notion of the fold and the dynamically labyrinthine world it suggests. And yet for all of this, isn't the fold, which Deleuze takes as emblematic of all the world, especially meaningful for *women* – women who are capable of complexities and contain multitudes? Who else?

In a hushed and dim corner of the Victoria and Albert Museum, the three Fates are depicted in a sixteenth-century Dutch tapestry. Their modest robes and veils are like a shroud that seemingly dulls the terrible power they possess. Charged with the 'thread of life', the three women, Clotho, Lachesis and Atropos, are usually depicted as remorseless and unfeeling crones. They are the original 'spinsters', a jibe that discloses the anxiety around unmarried women and which is itself an effort to check the self-sufficiency of which they are suspected. But here, in wool and silk dyed brilliantly red, blue and gold, they are dignified and undiminished by centuries of inspection. Most striking of all are their skirts, plush and dense. Clotho clutches at the heavy brocaded fabric, considerably lifting it up above Lachesis's tripping feet. Against a bucolic backdrop of bluebells and lilies of the valley, bounding

hares and partridges, the three women are awkward and enigmatic, unperturbed by the body of another woman (Chastity), trampled under their disregarding feet.

Enfolded in their extravagant gowns, the Fates are figures of opacity, the keepers of their own counsel. Their unbending reserve is the mark of their formidability. Is this what the fold of a gown conceals? A hidden complexity, the possibility of something more than might be immediately apparent on a surface? The dart, essential to women's dress, seems a more sympathetic form of fold. It is deployed strategically and thoughtfully so as to clothe a body whose complex curves and planes are not easily mapped. These tucks and pleats are the attempts to make a dress equal to women's forms. But what we wear could never be equal to who we are.

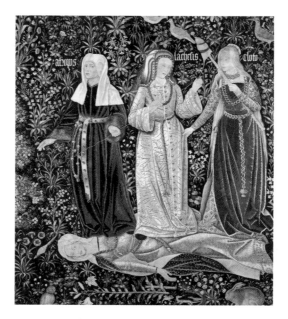

The Three Fates or The Triumph of Death (early 16th century)

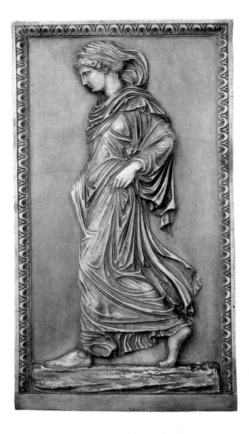

Gradiva or 'The Woman Who Walks' (1st century BC)

This is what Freud never quite understands in the case of Gradiva, the Roman girl in a draped dress. He spots her ancient bas-relief image while wandering through the Vatican Museum in September 1907 and writes home to his wife, Martha, of her 'dear familiar face'. Freud recognised Gradiva instantly because he had read of her in Wilhelm Jensen's novella of 1903, *Gradiva: A Pompeiian Fantasy,* publishing his own essay in response to it in 1906. The original story is strange and circular. It begins with a fictional archaeologist named Norbert Hanold who grows

fixated with an antique engraving of a woman dressed in an elaborate *stola* and sandals. The lovesick Hanold grandly names her 'Gradiva', after Mars Gradivus, the Roman god who walks into war (walking is important and we'll return to Gradiva's sandals later), but the image, which sparked his fantasy and which Freud identified in the Vatican, is deceptively simple. It comprises the figure of a woman, captured in profile as she strides forward, her impressively full-skirted gown rippling in folds around her.

When Hanold spots a woman who resembles Gradiva walking through the ruins of modern Pompeii one day, his affections immediately shift from the bas-relief to reality. Hanold, who began by dreaming about an imaginary Gradiva in a Roman gown, comes instead to mull over the mystery of a flesh-and-blood woman, fully dressed and no longer fanciful. It is this, perhaps, that accounts for Freud's interest in the story since Gradiva is that rare thing: a fantasy that is realised in reality. Predictably enough, Freud reads the novella as an unconscious expression of Jensen's own repressed sexual neurosis, analysing the fictional Hanold accordingly and retracing the story to a childhood experience. But Gradiva is, to all three men – Freud, Jensen and Hanold – a puzzle awaiting decipherment. She is the key that opens the psyche – only never her own. They devote their attentions to her, and yet what they recover from deep in the folds of Gradiva's gown is not Gradiva's secret self but the story of male desire.

Into the twentieth century, Gradiva would become shorthand for a particular brand of psychoanalytical practice. Copies of her image were passed among fashionable young analysts, keen to exhibit their Freudian affinities. Leafing through Edmund Engelman's photographs of Freud's Viennese consulting rooms, you'll find Freud's own Gradiva easily enough, the bas-relief visible amid the clutter. She hangs adjacent to and just above the couch, as though she marked the end of the analytic process.

Later, travelling with Freud to England, she would hang on the wall of his London rooms at 20 Maresfield Gardens, the girl in *stola* and sandals a constant companion to his thinking. She remains there to this day. Up close, you notice that, fixed in stone, Gradiva's flowing gown is heavy and lined, impossibly cumbersome with its innumerable folds and furrows.

There is something in this translation of cloth into marble that mirrors Freud's own distorted reading of female selfhood as male sexuality. Why would you *not* identify the fold with femininity, suggestive as it is of women's sexual organs? But Gradiva presents the opposite of the phallus, and Freud overlooks it, determinedly seeing in her instead only Jensen's 'delusions and dreams'. For Freud, she is only ever the object of a man's fantasy and a pathway into their pathology. What he never thinks to ask is the question of her own unexplored desire. In the psychoanalytical setting, the girl in the gown is a silent witness to the unburdening of confessions. Of herself, she has nothing to say.

Not all girls in Greek dresses are doomed to be passive witnesses to the world. Some retool their gowns as weapons. The poisoned robe that Medea gives Glauce, daughter of King Creon of Corinth, and new wife to Jason, is a bitter and black inversion of the Cinderella story. It sets her rival alight, the 'flesh melting from her bones, like resin from a pine tree'. Dress, like infanticide, provides Medea with the means by which to retaliate at the husband who abandons her and the king who refuses her refuge. Medea's story is a myth, but the apocryphal story of the women of Athens is recalled by Herodotus as history. Their menfolk massacred in a disastrous military campaign, the devastated wives apparently turned on a hapless messenger – the sole survivor – tasked to return to them with the terrible news. Taking the pinned brooches from their gowns, they stabbed him to death.

The grisly story contains a warning note: beware women

– and their dresses. There is no charm to womenswear here, only danger. Their frenzied attack is a manifestation of their uncontrollable grief and the terrible expression of the contingency of women whose condition in life is dictated by men who seek out wars and die. The anguished women of Athens are those who are left behind, but rather than suffer the consequences of violence, they shockingly re-express it using the weapons nearest to hand: the brooches that fasten their dresses. Remarkably, Herodotus reads this sensational story as a kind of social history, citing the episode as the reason for the transition from the pinned Doric *chiton* (sleeveless tunics secured at the shoulders with those fatal brooches, *fibulae*) to the pleated Ionic gown (sleeved tunics, variously sewn, buttoned and girdled). He understands it as a deliberate, cautionary action taken for the disarmament of dangerous women. If there is an absurdity to the idea that the Ionic gown could circumvent the threat of female violence, it also reveals some implicit intuition of the unpredictability of women, the mysterious impulses by which they might be moved and the unconstrained ways that they might act – in short, the powerful, complex and variegated internal life that is theirs and so often concealed. It is a hidden depth – like a fold – hardly visible at all.

In these myths, women are, at worst, dangerous, at best, only duplicitous and composed of competing impulses. They are condemned to dependence and yet capable, led by their own desires and yet desired against their will too. When contemporary fashion reproduces the lines and drapes of antique style, as it so often does, it invokes the grace and measure of a classical civilisation as though this were not a fiction. The fold falls so effortlessly that it seems authorless, artless and true, as though the woman wearing such a thing were impassive and acquiescent, uncomplicated and unquestioning. But there are always questions to be asked about why and how women are dressed, whether they are in *stolas* or saris, Victorian ball gowns or couture concoctions.

How can we look at a dress and not ask what lies beneath the image of femininity and the shapes it is forced to take? Where we pin, tuck and pleat, gather and fold, what is it that we contract and conceal about female experience altogether?

THE LOOK

In Book 14 of *The Iliad*, the goddess Hera, with ambrosia-soaked skin and glossy plaits, snares Zeus and so secures peace between him and her father, Cronus, with only a gown and a belt. Her toilette begins like a campaign, a battle to be decisively won. She puts on a lavishly embroidered and 'fragrant robe of delicate material' fashioned by Athena and fastened with golden clasps. Aphrodite gives her a hundred-tasselled 'zone', a girdle unimaginably ornate with 'curious stitches', and instructs her to keep it close. 'All my power resides in this, and I have no fear that you will come back from your mission unsuccessful,' she explains in sisterly confidence, the ultimate girlfriend loaning a dress, buoying Hera with hope. The ensemble is so effective, Homer writes, that 'at the first look, Zeus's heart was captured by desire'.

Hera's is the dress women dream of: the kind that is capable of beguilement. We long for the dress that could transfix all who look upon it. This is the very definition of 'glamour', a word that derives from the Old Scots *gramyre*, and refers to something akin to sorcery, a charm or deception cast over the eyes. In 'glamour', the object of a dress is never simply the loveliness of the garment itself but the gaze it can summon. Yet, in glamour there is also something of the deep, indelicate truth, the desperation, sometimes, out of which we buy or borrow clothes. We hope they may possess a power that we do not, that they could secure transactions, or lure affections, bending to our will any contrary inclination.

Hera's dress is enchanted, but there is a form of magical thinking in our own clothes too, in the hopes that we harbour in them. We entrust to them the task of concealing our imperfections and showcasing our assets, presenting us from the outside as we will ourselves to be from the inside. The clothes in which we attain our hearts' desire feel as though they'll always retain that aura of enchantment: a creamy silk sheath dress with a narrow black ribbon at the waist, purchased in passing one spring, and then reached for, almost instinctively, for interviews and excursions, dinners and dates, that one year in which the entire world seemed to yield to your every whim. You wear it until it splits at the seams, as though it could no longer contain all the ambition and triumph you sought in it. We each of us know these dresses – the wedding, sun or cocktail dress that hangs in thick, textured darkness, closeted against everyday shirts and sweaters. Against our dull and forgettable things, they ought to pulse with memory.

We are foolish to think these dresses possess supernatural power and perhaps more foolish still to think that their powers won't ever fade. Dresses age and fall out of fashion. Even the most loved gowns will languish in a closet one day. If we imagine that the faintest brush with their faded sheens will recall some residue of that old promise, returning to them brings with it the realisation of loss too. The wedding dress that will never fit us again is like a stab of pain in the heart. The potency of a pastel sundress wilts in the chill of a discontented winter. What remains is the desire for the glory these garments once brought. This lingers. This is what we remember each time. The gowns of our glory days prick us like a forgotten pin found beneath our searching fingers.

We are, though, ever alert to the possibility of the next dress like this – the dress that will win us all we could ever wish for and that we are committed to purchasing even when it bankrupts us. The cost of a dress is always a wager. The modestly priced

gown licenses us to hazard a risk since we have so little to lose, just as the expensive gown compels us to calculate an equation, figuring out the rates of deployment and durability over a projected period of use. A dress is an investment with hopes of a handsome return, and so when it fails, we are confronted not only with a financial loss, but also the full measure of our folly, the utter naivety by which we might have dared to purchase in a gown what we have no right to claim in life.

Sometimes a dress fails to accomplish the feats we aspired for it, but it can also expose our vulnerabilities, to others and to ourselves, reaching at something deeper, reopening a wound that never heals. Sometimes we catch a glimpse of ourselves and all pretence slips away as we are compelled to acknowledge our failure to realise from without that mercurial, vital and exceptional something we believe of ourselves from within. Quick on the heels of the magic dress, there is the awful realisation of its lie, most sharply felt in those jarring moments in which we see ourselves, darkly, in a glass, as we cannot bear to believe we are. This disjuncture is felt as a jolt, the discomforting recognition of an alienation perhaps never to be overcome, no matter how we dress it up.

If there is a gulf between how we feel and how we look, then it can be broadened or bridged by the clothes we wear. The German Romantic writer Novalis once described philosophy as a feeling of constant 'home-sickness, a wish to be at home, everywhere'. The world can seem strange and distant. In philosophy, we longingly reach for understanding and find it continually eludes us. In clothes, too, we can sense ourselves gone astray or lost at sea. Womanhood, as it is articulated in womenswear, can leave us feeling grievously self-estranged. Wearing dresses can generate an unease never quite dispelled. Some of us prefer, instead, to reach more routinely for our jeans, a uniform, something unisex or unsexed altogether, in order to feel less at odds with the bodies we have and the world in which

we are compelled to be. So often the experience of womanhood seems constituted by the feeling of having failed to be a woman – being never quite feminine, fertile, thin or beautiful enough to be equal to that title. Sometimes we barely feel at home in our own skin, let alone the shirts on our backs.

Yet, for trans women, the wearing of a dress can be a coming home. In Alain Berliner's gorgeously surreal domestic drama of 1997, *Ma Vie en Rose*, seven-year-old Ludovic perplexes his neighbours when he saunters into a suburban garden party wearing his sister's princess dress. Clip-on turquoise teardrops dangle delicately from his small ears. In the course of Ludovic's pained investigations as to his sex, he learns that it is not enough to feel like a girl and only privately acknowledge it to oneself; rather, it must be made visible, be *seen*, in fact, in the eyes of others. The right to dress like a girl seems crucial to being one, and although his parents, peers and teachers variously censure or shrug off his feminine dress as play, there is a seriousness there he cannot allow to be cast aside. Anxiety, grief, joy and bafflement cross his small, elvish face because gender *is* a puzzle not easily solved, and in the course of the film, we recognise the unsteadiness of our claims to it. What Ludovic senses is how miraculous it is to be known as a girl. Buried in his sister's closet, he lovingly presses the dresses to his face, as though there were something *in* them that could confer his sex like a benediction. The voluptuous fairy princess of his favourite television programme becomes the object of his adoration, but if he recognises in her the marvel of *being* a girl, over the duration of the film, he also teaches his family and neighbours that his femininity is *made* real by their acknowledging gaze.

In the telling of fairy tales we enshrine and imbibe the magical thinking behind dresses. We are encouraged to trust in them. Cinderella, a version of whose story exists in almost every culture, is the girl whose fate turns on a gown (and a slipper, of course – to which we'll return). In the kindest readings of

the story, though, it is not the dress per se that makes the char-smudged girl beautiful; instead, the enchanted gown only makes apparent what is already there. To read the dress any other way would be to advance the terrible hypothesis that a woman is made desirable by her outward apparel, rather than inherent gifts. A truly magical dress would neither conceal nor disguise, but the discomforting truth of the Cinderella story is that beauty is only a conjuring trick and princes are easily beguiled by a girl in the right gown.

In Cinderella's case, we tell ourselves that this dress of dresses simply shows her as she really *is* – as we all really are – beneath the rags. In the end, each of us will be seen and understood: this is the pledge implicitly made to us in the story. The promise of that is overshadowed by the precariousness of Cinderella's fate. Even in her glorious gown, she is plagued by the possibility of exposure. The ever-approaching chimes of midnight hang over the heroine's fairy-tale future, threatening the calamity of an illusion dispelled. Happiness is, for her, not a hard-won prize but a stroke of luck – and it is as fragile as an easily broken charm. Cinderella's life rests on the phantasmagoria of an enchanted ball gown, but all gowns are weighed down by the delusion that we could obtain in them all that we desperately hope for. The final revelation of a girl who can be loved even in her rags proffers an improbable domestic reassurance, as though a reality of contentment (implicitly, marriage, wealth and the settling of injustices) could be available to all women, even those who live outside the purviews of fabulous dresses and magical godmothers.

Cinderella *does* have a godmother though, and she presents a cheery model of benign female influence, offering maternal magic in the absence of a real mother. The fairy fantasy of the Cinderella story always sits unconvincingly next to its more acute account of blended families and their tangled realities. The stepsisters and stepmother provide a truer portrait of female

rivalry, a model of womanhood that can be cruel and competitive. Beneath the surface and behind the charmed dress is something real and saddening: a young woman, unsure of her place in the world and her own capacity to secure a safe future. The dress, for all its delicacy, armours her, only temporarily, at exactly the moment she takes her first steps into adulthood. And without the magic, there is nothing to protect her from the world.

JOHN TENNIEL *The Haunted Lady, Or
'The Ghost' in the Looking-Glass* (1863)

The challenge of the Cinderella story is to see beyond the ballgown, because despite her happily-ever-after triumph, the figure of the belle of the ball is haunted by a girl in rags. John Tenniel's print for the periodical *Punch*, *The Haunted Lady, Or 'The Ghost' in the Looking-Glass* of 1863 recalls Cinderella's moment of glory and casts a long shadow over it. A preening young woman in a voluminous crinoline and ruched ballgown

delightedly admires her reflection, but overlooks in the corner of the mirror the image of a starving woman, slumped against the wall behind her.

The source for this image was likely Mary Ann Walkley, a 20-year-old seamstress who had died of overwork after sewing for almost 27 hours without relief. Tenniel took up her cause célèbre in his grimly sardonic cartoon, but Marx too, more soberly, cited the details of her appalling case in *Capital*. Seamstresses like Walkley were the spectres stalking capitalism, he argued. Then, as now, young women made up the majority proportion of the textile working poor. Their fingers ulcerated from handling arsenic based dyes and their lungs clogged with cotton dust, they were the victims of the experimental industrial chemistry and mechanical mass production that characterised the nineteenth century. This is what we are never permitted to see at the end of a fairytale. The ballgown that brings life to Cinderella is the dress that brings death to Walkley. They are the two inseparable strands of one thread.

Beautiful dresses dazzle us, but if we were able to see our clothes clearly, we might be compelled to recognise the unhappiness in them, the idea that there could be in them something inimical to the well-being of women themselves. The dress reform movement of the late nineteenth century was motivated by a similar suspicion. Committed to women's suffrage, it repudiated the tyranny of corsets, crinolines and bustles. The Victorian writer, Charlotte Perkins Gilman, instinctively despised how fashion conspired to constrain women, scathingly denouncing the 'mincing twittering gait' of hobbled skirts. We reel off the names of those offending garments as though pain were a relic of the past. But why would we believe that modern womenswear wouldn't continue to collude in that discomfort? Don't we find that what we wear is antagonistic, sometimes, to even our simplest objectives?

Most women have some small sense of this: the bra strap

that digs, the string of a sari drawn so tightly that it cuts into the waist, the skirt that contracts the stride, the bandage dress that is so unforgiving of your form that you don't dare to eat, the sleeve that is cut to catch and chafe under your arm, the sharp edges of a sequin trim that scratches where it meets your skin, and so on. We can shrug most of this off with a rueful acknowledgement of the trials of femininity, or we can robustly refuse to tolerate it. The more serious injuries – the ways a bodice might compress your ribcage, or how the weight of a pannier could cut and scar a set of hips – we think of as consigned to a cruel and stupid past. But the ways in which women are injured by dress extends beyond what is visibly done to a body. It includes too the possibilities that are foreclosed, all the running, reaching, climbing, building, fighting and thriving, the fullest extensions of the limbs, that are disqualified by the conventional lines of women's dress. Womenswear is not always fit for purpose – but perhaps its purpose has not always been the enablement of the body.

THE GAZE

Orpheus cannot resist the sight of Eurydice in the old story. When he turns to look at her, he breaks the terms of the deal he cuts with death. The moment that their lines of sight are fatally crossed, he sends her hurtling back to Hades. It is not that he doubts Eurydice's presence; rather, he absolutely believes in the truth of his own gaze. He turns not because he knows that she is not there (why would you turn to see nothing if you knew it to be nothing?), but because, implicitly, he knows that she *must* be there, and that she only exists, in any meaningful way, by the virtue of being seen by his own eyes. His gaze verifies her.

In 1972, the art critic John Berger pithily dismantled the dominant social conventions by which 'Men look at women. Women watch themselves being looked at.' It's an assessment so

succinct that it has the ring of an epigrammatic truth, as difficult to disprove as it is infuriating. In a culture saturated with images of the objectified female body, it feels impossible to dispute the case that men see and women are seen. It *is* true. Even so, the sentiment still agitates because it poses the more implicit question 'Who do women dress for at all?', and the answer to that threatens to unravel the pretences with which we wake and clothe ourselves every day. If we scored out the different vectors of sight, the criss-crossed lines of gaze in the various permutations of seeing and being seen, we might dismiss the notion that women only dress for men as reductive, overlooking the autonomy and resistance of which they are capable. We might protest that women dress to please themselves, the surface of their bodies their own to fashion, beyond the consuming gaze of the opposite sex. We might even contend that gay women dress for each other, outside the strictures of hetero-normative sexuality, reading each other differently, with a knowing sympathy and sensitivity.

And yet, if we do dress for others, isn't it for the acknowledgement that they are able to grant and which confirms to us that we exist? I think here of that flicker of recognition, admiration or understanding that crosses between women, the unspoken exchange on the escalator, the glance across the corridor. These are the wordless conversations conducted in transit, inferred with a lightning quickness, in the crossed paths of daily life. We mentally log the ensembles, the looks, the entire lives we covet in place of our own. There is an irrefutable authenticity to those encounters, a keenly felt gratification, as though the truest approbation were that read in the eyes of a stranger, sometimes even felt in their passing touch. A small girl reaches from her seat on the bus, lured unthinkingly by the filmy edge of a grey chiffon camisole so pale and thin it gives the wearer the air of a ghost. Afterwards, the garment bears the lightness of her passing attention. An older woman in a post-

office queue one winter, absent-mindedly strokes someone's coat sleeve, as though the oxblood-red wool had triggered a memory and conjured a world apart. It absorbs her admiration like a warmth that it will impart forever.

But there are other moments of being seen when the confidence of our clothes can crumble. The catcall that plucks you from your reveries and leaves you powerless, the fragment of an explicit remark overheard that somehow strips you of your excellent education, your cultured manners, all the armour of your intelligence and accomplishment made nothing in the face of your instant objectification. There is something decisive and disillusioning in that moment when you most fully realise how little you might command or deter the gaze that falls in your direction. Every part of our culture – literature, film and art – provides proof of how the right to see and the indignity of being seen is so unequally distributed between men and women.

In Søren Kierkegaard's chilling philosophical psychodrama of 1843, 'The Seducer's Diary', his alter ego, Johannes Climacus, manipulates the affections of a young woman named Cordelia, narrating their dreadful love affair, including her part in it, exclusively from his own position. He confides in the reader, privately mocking what he takes to be her affectations, rendering her every gesture, her very appearance, inauthentic, a performance staged only for his consumption: 'That's right, throw the silk shawl back over your shoulder: walk quite slowly, that should make your cheek a little paler and the eye's lustre more subdued.' There is a cruelty in the access to her inner world that he commands. Her gown and shawl offer little protection from his gaze, which penetrates so completely that he seems almost to have invaded her, be *inside* her, ventriloquising her interior experience and thinking on her behalf. 'She does not see that I am looking at her, she feels it, feels it through her whole body,' he writes evocatively, with an underlying menace, thick and seductive, 'her eyes close and it is night, but inside it is broad

daylight.' Under his inspection, her exposure is absolute. She has no defences, not even closed eyes. The right, both to see her and to see through her, he seizes victoriously.

The unfair power of the male gaze is what the critic Laura Mulvey investigates in her account of the dynamics of film. Films, Mulvey astutely observes, seem to reproduce the inequality of seeing, privileging the perceptual position of male characters or viewers and prizing their pleasures above all else. Here the cinematic lens only repeats onscreen the wider social relegation of women, as scrutinised, rather than seeing, subjects. This matters since seeing is a form of knowing, and in seizing the right to inspect women, men claim the right to know them too. The questions, then, that devolve from the idea of a dominant cultural gaze are serious. Who, for instance, falls out of the line of sight and who qualifies as worthy of being seen? Is it possible for a woman to evade the gaze altogether? Is it possible for a woman to remain unknown?

'It hurts to be alive and obsolete,' Zoe Moss confesses in the title of her vigorous feminist tract for the 'ageing woman'. The ageing woman is supposed to 'fulfil [her] small function and vanish'. The invisibility of older women in social life and cultural representation is a coercive form of pacification. She presents neither promise nor threat, so she is a void. The muted palette of the clothes conventionally designed for her, implicitly collude in this erasure. She cannot snag or jar our vision as we survey the world before us. She may escape our notice, but, Moss persists, 'don't pretend for a minute as you look at me that I am not as alive as you are'. By contrast, young women and adolescent girls, Simone de Beauvoir observes in *The Second Sex*, are 'torn between the wish and the refusal to display'. It is no small dilemma. How *do* we dress to the gaze of others? We can internalise that gaze or we can defy it. We can dress to the dominant mores of heterosexual masculinity or we can resist its demands, finding ways to inflect it differently.

If resistance is possible, it lies in the second part of that formula: 'Men look at women. *Women watch themselves being looked at.*' The woman who *sees* herself as the object of another's gaze is reflexive. She suffers from the whiplash of a sudden turn. This woman is capable of astral projection, the out-of-body experience by which she is able to see herself as though she were external to herself. All clothes, to some degree, encourage wearers to imagine themselves from the outside, to be at angles to one's own body enough so as to inspect how well one might inhabit the form of a garment. But dresses particularly, whether on mannequins or hangers, project the shape of a body, suggesting the parameters of the silhouette promised to each wearer. Hangers have a comically plaintive quality for that reason; their meagre lines can only approximate the shape of an entire body. When we eye up a garment, we assess its limp shape against our private mental vision of the fuller bodies we live in. This body is so much more than is signified by a cursory 'Size 16', a 'Tall' or an 'XS'. But it can also change without warning, and without you even noticing. You hold the hanging garment up against you, confident of its fit, but then you glance in the mirror and find your judgement disconcertingly awry. In any case, we *see* ourselves *outside* of ourselves.

'Off the peg' gowns dangle indolently from department store rails. Their labels are a form of shorthand. Standard sizes paraphrase our complex bodies, as though they could be glibly decanted into a universal average measurement. If we are lucky, we are skilled enough to know precisely the nature of our shape, have accurately internalised the ways we are seen so that we are unerring in our judgement. We can instantly discern how elegantly or awkwardly something will fit and we work with that knowledge pragmatically. Otherwise, we guess more blindly – the jersey dress bought in a hurry is like a jab in the dark – and we buy things nonetheless, even though they cannot and may never meet our particular proportions with any grace or ease.

We buy aspirationally, dreaming of bodies that are taller, smaller, fuller or thinner than those we possess. Those spectral visions of ourselves haunt these garments like all things that are romanticised and never realised. We cherish them because they momentarily enable us to see ourselves as we imagine we are, if only in our mind's eye. And we despise them because they remind us of our foolishness too. Have you ever bought a dress that you know you will never wear? There are garments in which we intuit mysterious things – not the possibility of our own beauty but something else that they contain precisely *without* us, as though our flawed forms would only spoil them. We long for them nonetheless. If you have ever been seduced by such a thing, stored it away shamefacedly in some hidden recess, it is because you know that it realises in its own perfection something that we desire deep within and which it alone seems able to present. This dress – not a poem, not a painting, but a dress – is something, maybe even all things, that we are not.

Yes, women watch themselves being looked at, but they *see* themselves too. This capacity for out-of-body inspection is a gift and a burden. At its worst, it takes the form of an unflinching internal supervision, a self-policing self-awareness. We imagine how we might be watched and we keep ourselves in check. Women see themselves being seen and they dress to solicit approbation, desire and respect, and also to keep criticism, rejection and assault at bay. Behind the question of what women wear is anxiety, a restless vigilance that is recognisable in those moments when a woman catches herself and thinks twice at the mirror by the front door, tugs at the high hem of a skirt or pulls up a low-cut blouse, silently slips off a formal jacket at a party or smooths down a T-shirt in a meeting. Women watch themselves being watched, uncertain if they might ever possess the peace of mind of men who need only see.

To be seen always is to be refused the right to reserve our privacy, no matter what we wear. We watch ourselves

being watched and feel how helpless we are in the face of the evaluative glance of others. To walk in the world as a woman is to be made available for assessment. We are visible, legible, *known* even, against our will. Fashion, with its discomforting culture of spectacle and its impulse to display women, mimics the compulsively fascinating ways women are watched, by men, by each other, by every authority that declares itself fit to adjudicate on their health, beauty and well-being. There are subtle, surreptitious ways in which we assess the life of women, their bodies and souls, as though such things could be understood from the outside. We notice the constancy of their weight, the contours of their silhouette, the condition of their skin, their ability to select a dress appropriate to age and occasion, the attention they pay to cosmetics and hair.

What I mean to say here is that the visibility of the female body is a negotiation, not always mutually agreed. In Jean-Honoré Fragonard's rococo portrait, *The Swing* (1767), a girl in an exuberantly frothing peach dress knowingly kicks up a leg as the swing on which she sits soars, revealing stockings and all else beneath to the lover adoringly gazing up from below. The mutual titillation is staged as a wordless pact. In *Lolita* (1955) though, Humbert Humbert espies in the underage object of his affections the 'frank soft shape of her small breasts ... brought out rather than blurred by the limpness of her thin shirt'. This 'frankness irritated me', he notes, as though the sexual candour were of her conscious design rather than the projection of his desire. Another 'perfect little beauty in a tartan frock', who clatters next to him on a park bench righting the strap of her roller skate, forms the object, he acknowledges more truthfully, of a 'one-sided diminutive romance'. There is an uneasiness in the asymmetry of desire here, in how freely Humbert extracts (sexual) pleasure from a young girl who intends none.

Isserley, by contrast, the extraterrestrial protagonist of Michel Faber's *Under the Skin* (2000), dresses her sexualised

female form deliberately, luring into her vehicle a stream of doomed hitchhikers diligently collected each night and delivered for death to an alien abattoir. The vast, self-buoying breasts surgically affixed to her body for that purpose are to her bewildering and alienating. Alone, she gazes only blankly at the row of 'identical low cut tops' hanging in her desolate wardrobe, oddly depressing and menacing at once. Isserley's alien consciousness is a metaphor for the alienation of women from their own bodies, sexualised and made strange in the eyes of others – a parallel as unsubtle as the low-drifting sightlines of the hapless men she coaxes into her car. And yet there is something more alien still in the blankness with which Isserley goes home and confronts her lifeless wardrobe, so literally empty in contents, but devoid too of any trace of memory, association, impulse or imagination.

Dresses may not hold any special allure for all of us, but what tumbles out of the sundry cupboards and drawers in which we store our clothes is more than those clothes themselves. In our wardrobes, there is texture, colour, shape and the residues of the life we live. We stumble upon the crumpled tissue in a pocket, a sticker peeling off a sweater, the faintest trace of smoke rising from the deep grain of a dress, the drifting, diluted scents of our lovers, children and homes, all awakened by the slightest disturbance. In this rounded and full life, we dress for power and professionalism, utility and beauty, as an expression of our confidence or flair, our iconoclasm or obedience, our seriousness and our flippancy, by turns. These are the choices to which women rise and dress every day, some of us unthinkingly, some of us with a pained consciousness: all of us negotiating the question of how to solicit and how to deter gaze, seeking out in colour and cut, texture and tone the ways to be seen that might serve our will rather than subject it.

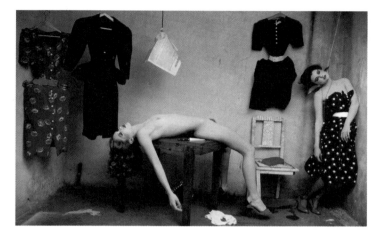

GUY BOURDIN *Untitled*

A model lies sprawled across a table in a squalid room, naked except for a pair of red shoes. An upturned butcher's knife gleams dangerously under the arch of her back. In the corner of the room, another girl in a strapless polka-dot dress hangs quietly from the rope around her neck, slightly askew in the way that dresses sometimes droop from hangers. Here, though, designer dresses, disturbingly cheerful, dangle instead from ceiling hooks like cuts of cured meat. In the image, taken by the French fashion photographer Guy Bourdin, everything is calmly upended: a woman is refigured as a corpse and a fashion shoot becomes a crime scene. Bourdin both heightens and lampoons the contortions of the female form in his work, deploying the recognisable tropes of fashion photography and providing its pointed critique in the same image. His work amplifies the sadism it finds inherent in women's fashion. The images are wickedly self-aware, excoriating in their satire and luxuriating in

their spectacle. They revel in beauty, but know, too, the violence that subtends it.

We are accustomed to the fragmented forms of women's bodies: the cinematic close-up that lingers on the girl's reddened lips, the bra advertisement that decapitates the model and slices her at the torso. Models and actresses are distilled into outstanding particularities: an oversized mouth, a boyish frame, a pearlescent cheek. We are expert at decrying the objectification of women as dehumanising and depersonalising, but the fragmented ways that we customarily depict and so understand the female body could not even claim the integrity of an object. To be a woman is to be cut, carved and hewn. From the outside, this broken female body can never be allotted the autonomy of a complete human being, not its flesh and form, not the unruly life of an independent mind and all the psychic storms and emotional torrents that come with it. It is only its disjointed parts.

Even when we dress ourselves as the whole people we imagine ourselves to be, the garments we wear are constantly dismantling that integrity, portioning and partitioning the parts of our bodies that might be seized for someone else's pleasure. This is an effect that seems particular to women's bodies since womenswear is designed to isolate and exaggerate parts of their anatomy. Corsets used to compress the waist and spill the breasts, but modern dress too is complicit in this division of the body. Necklines can scoop or plunge into the chest. A sari conceals everything but gathers at the exposed navel. Pencil skirts narrow to accentuate the width of a hip. Womenswear is capable of this easy manipulation, telescoping the viewer's gaze so that the body emerges not as a whole, but as fragments, revealing an anatomy that is detachable for scrutiny.

The reveal can be strategic too, deliberately designating different sites of the body as desirable. 'Is not the most erotic portion of a body where the garment gapes?' wrote Barthes

provocatively in 1973. There are no erogenous zones, he declared, only 'the intermittence of skin which is erotic', alert to the suggestiveness of that flash of flesh between 'two articles of clothing'. It's an insight that makes particular sense in the context of Barthes's life and the fugitive culture of homosexuality in twentieth-century France. The fleeting appearance and disappearance of skin might be read as a sign where more candid expressions of sexuality were not possible. In womenswear, though, a flirtatious dress can either be cut low for the chest or worn short on the legs according to the arbitrary 'rules' that dictate how the exposure of one feature is acceptable, but both too much. And yet, when we reflect on it, there are so many other areas of the body that can be framed and shaped in dress. The body can be made visible, not only for the purposes of stoking desire, but for the sake of interest, intrigue or mystery. Think of that awkward joint of a wrist, for instance, exposed by a three-quarter-length sleeve, the strangely graceful, jutting wing of a shoulder blade revealed by a racer-back vest, or the sharp, horizontal, weight-bearing line of a collarbone that runs between the bands of a halter-neck strap.

In John Singer Sargent's painting *Portrait of Madame X* (1883–84), Parisian socialite Amélie Gautreau stands in a black satin and velvet dress, dramatically cinched at the waist, the hint of a bustle behind her and a train pooling at her feet. Her face, inclined away from us, is difficult to read, and so everything is expressed instead in the taut length of her tilted throat, the line of her collarbone, the pale bared arms, and the expanse of alabaster skin that sinks into the sweetheart neckline of her dress. Two gold chains form the straps of that dress. In an earlier version of the portrait, exhibited at the Paris Salon of 1884, Sargent had scandalised viewers by leaving the strap carelessly slung off the right shoulder. 'One more struggle,' wrote an excitable critic in *Le Figaro*, 'and the lady will be free.' In reality, the straps were ornamental and Gautreau perfectly

secured in a rigid bodice comprising a metal-and-whalebone frame. The furore, though, was enough to mortify the sitter who compelled a reluctant Sargent to return to the painting to realign the strap. The exposure that had been read as an outré marker of sexual freedom meant in reality, for Gautreau, social ostracism instead. The story lends the portrait a frisson, but for all the disapprobation there remains in it an enduring dignity, a sense of balance and measure in its composition: a strength borne across the length of her bare rounded shoulders, a stretch as steady as a horizon.

In sports jargon, athletes talk of core training, the strengthening of abdominal muscles, that stabilises and centres the body, but in womenswear it is that isosceles running along the clavicle to the ends of the shoulders, inclining up to the neck and meeting at the base of the head, that provides the most basic structure of suspension for dress. That triangle forms a powerful zone of the body, and most clothes are designed to swing from hangers that replicate this structure. It is, almost magically, both fragile and foundational. In Robert Browning's gruesome dramatic monologue of 1836, 'Porphyria's Lover', a man confesses to murdering his beloved with her own hair, which:

> In one long yellow string I wound
> Three times her little throat around
> And strangled her.

The strangulation arrives in the poem almost as abruptly to the reader as to Porphyria, although, retrospectively, the details of her dress – an inexplicably 'dripping cloak and shawl' and 'soiled gloves' – darkly suggest things amiss. Even the 'little throat', in its very littleness, reveals Porphyria's lover's intention. The 'little throat' is delicate, lovable, infinitely breakable. She trustingly places his cheek on her 'smooth white shoulder bare', before the grotesque reversal when he props her lifeless head up against his own.

JOHN SINGER SARGENT

Portrait of Madame X (1883–84)

Browning constructs the entire poem around the image of a woman's garrotted neck because the neck is a fulcrum, a site of precariously balanced beauty and frailty. Its visibility is a general principle of modern women's dress design, so customary that we rarely regard it at all. The varied names that we have for the range of necklines reads like an incantation, revering that most sacred expanse of the body: the sweetheart, the surplice, the scoop, the square, the boat, the plunge, the cowl, the crew, the V. The bared V-neck, with its unsubtle arrow pointing to all below, is the most obviously sexualised framing of the upper body, but it is also only a tentative invitation, an openness that can be vulnerable too. Womenswear habitually toys with exposure – dipped necklines, transparent panels, cut-outs and reveals – in the pursuit of a particular trend or the expression of a confident sexuality, but it also concedes the body's violability. Women dress to face the world, but there is no guarantee that the world won't injure them.

'I like to think of myself as a plastic surgeon with a knife,' wrote British designer Alexander McQueen with a gruesome relish. Film footage of McQueen at work in his studio records him swooping back and forth between models, scissors in hand, incisions made by apparently reckless impulse. McQueen had trained as an apprentice on Savile Row and was supremely confident of his skill. None of that, though, alleviates the sense of something more disturbing at work when we watch a garment that mimics the female form being slit and pierced. Is what we do to a garment really only what we imagine doing to a body? The dressed female form is the object of fantasy, with every permutation of imagined violation available to it. Dressmakers know how, in the stretch of fabric before a blade is taken to it, there is the fullness of unspoilt possibility: something unblemished and unscored. They know too that with every incision something is lost, an opportunity foreclosed or a freedom circumscribed, as though in the making of dresses one might prefigure the lives of women, so often curbed and

constrained. The cut is not just a cut: it is a decision, an act by which life is enhanced or denied.

McQueen understood the drama of a cut – the dress pattern that could dangerously narrow to a nipped waist or a hobbled skirt, the jagged pieces of a sharply tailored jacket or a fitted blouse that are precisely pieced together. He fitted his garments to models viewed side-on, attending to the contours of human anatomy and its dynamic form, rather than the flat pattern templates that reduced the body to the fused surfaces of front and rear. Slicing and stabbing at material, he refused to revere the fabric itself, no matter how antique or expensive. Instead, his work seemed determined to realise a vision, not of a dress, but of the woman encased in it. This woman was formidable:

> I design clothes because I don't want women to look all innocent and naïve ... I want woman to look stronger ... I don't like women to be taken advantage of ... I don't like men whistling at women in the street. I think they deserve more respect. I like men to keep their distance from women, I like men to be stunned by an entrance. I've seen a woman get nearly beaten to death by her husband. I know what misogyny is ... I want people to be afraid of the women I dress.

The candour of this statement comes of lived experience. McQueen, who had witnessed the years of domestic abuse to which his older sister Janet had been subject, sought in his work to articulate that fantasy of an unassailable female power. That he himself had been the victim of abuse at the same hands, might have amplified this vision with the power his own vulnerable identification. And yet, what this fantasy cannot elude is its terrible predicate: the reality of a body that is violable in the first place. This surfaces relentlessly in his work, as black parody, a perverse and taunting ambiguity.

A green leather shift dress from the controversial *Highland Rape* collection of Autumn/Winter 1995 is cut simply, with a pewter-studded collar, sharply rebarbative, and a tear across the right breast. The woman who wears it is cast as belligerent and beleaguered at once. The provocative title of the collection, McQueen insisted, had been widely misunderstood, referring not to the rape of women but the plundering of the Scottish Highlands by English colonisers in the eighteenth and nineteenth centuries. That history resonated with him, urgently, the twentieth-century genocides of Rwanda and Bosnia pressing upon his conscience. He roundly rebuked the criticism that the collection aestheticised sexual violence, but his alignment of rape to colonisation suggests something more distressing than that still. The contested and exploited terrain of a woman's body could not only parallel a turbulent national history, it could *carry* it, understanding it, providing its most plangent articulation. To represent this relationship, even as a metaphor, is to acknowledge a resemblance, deep and awful.

An early graduate collection was inspired, McQueen acknowledged, by Jack the Ripper's Whitechapel victims of 1888. In his work, a woman's form could take the most terrible abuses to which it had been subject, and articulate it differently, even indifferently. There is a curious ambivalence to a meticulously tailored woman's dress coat cut from an iridescent shot pink silk. A delicate black thorn print runs through the garment like the shadow of barbed wire. Contradictions characterised both McQueen's work and the complex idea of womanhood he was capable of perceiving: a woman who could be injured and injuring, scored by violence but sharpened by it too. A girl in a torn dress could be self-possessed and defiant, as if there were nothing anybody could do to her that could be worse than that which she might choose to do to herself. In the following decade, he would send down the catwalk a stream of near-naked models tightly bandaged in cling film or sheathed in latex, a zipped

cellophane dress with dripping rust-coloured paint congealed like blood, girls in smartly cut blazers gaping open to reveal tyre marks across bare chests.

'There's blood beneath every layer of skin,' he commented blankly, the banality of the fact making it no less disquieting when realised on a catwalk. Slashed sylphs and bloodied bodices challenged the conventions of classical and romantic femininity, dispelling their fantasies with a dogged realism. A Grecian dress in draped beige crêpe, tails off, bedraggled, as though it had been ravaged by moths or just caught at the edge of a consuming flame. Femininity cast this way reveals its vulnerability, trembling on a precipice, always about to be engulfed at any moment. A model in a green-and-bronze lace dress who sways nonchalantly down a catwalk, the deliberate lines of her gown attenuating from the hip into scraps, rags and tatters, the cobweb-thin fabric brusquely torn, looks the sashaying epitome of couture and a staggering victim of assault. The line between sexual evocation and assault is drawn dangerously thin, not as a provocation but as an acknowledgement of a darker truth of women's bodies and the claims made upon them without their consent.

McQueen's work would recklessly oscillate in its strident expressions of feminine beauty and sexual power, arch, lilting and self-possessed on the one side, and then angry and indignant at its vulnerability on the other. In his clothes, a woman might reclaim her image, taunting and reconfiguring male power. Lithe models swaying under the weight of American football pads could lampoon the grandeurs of masculinity. A collection inspired by the work of Bosch and Botticelli could redeploy the language of old masters so that they might speak differently from a woman's body; the images digitally printed onto silk bodices and wound around the models, embellished with expertly embroidered jacquards and vintage brocades, bullet pleats and stiffened drapes drawing out shoulders and hips, an exaggerated femininity now armoured for war.

ALEXANDER MCQUEEN Green and bronze torn dress
(Autumn/Winter 1995–96)

'When you see a woman wearing McQueen,' he said, 'there's a certain hardness to the clothes that makes her look powerful. It kind of fends people off.' It's a sentiment that seems contrary to the conventions of womenswear, which, with its traditionally silkier sheens and softer fibres, often encourages contact. This, though, is also the scandal of womenswear. It invites touch so much more than any other categories of dress, as if the female body were itself intended to be made available to the grasp of

others and its clothing only ever a solicitation of the hand that will reach for it. But the world can come too close and we might well wish for a mode of dress that would keep others at arm's length. McQueen understood the agitation and the anxiety underlying womenswear. His work prompts us to confront difficult questions. When women dress, what is it that they are seeking to keep at bay? What is it that women should fear? Is it the physical exposures of our environment – the forces of nature, the elements, the cold, the hot, the sharp and the rough? Is it men – their gaze, their judgement and disapprobation? Is it the touch that can turn to violence without invitation? And against any of those things, what confidence can we have that the garments we wear will protect us, providing a barrier that could be in any way sufficient to the task of holding off the world?

We think that we dress *for* something (an occasion, an event, a task), but we know that we dress *against* too. In a contemporary culture where what women wear is routinely discussed in heated debates about rape blame and street harassment, even the most strident of us might easily succumb to those tacit ordinances that specify what is appropriate, seemly and safe. The unsettling truth is that sometimes women dress to deter advances and avoid censure: they dress to keep the world at a distance, compelled by fear. Clothes cannot 'invite' assault or signal sexual availability without consent. The clothed body is not divorced from the consciousness it contains, and gaze has no automatic right to become grasp. But in those most awful circumstances in which it makes no difference what we say or do, we realise what little protection our clothes could ever have afforded us anyway.

And yet, in the moments of greatest duress, sometimes all we have are the clothes we stand in – the ruggedness of the stranger's coat in which you are wrapped for warmth as the ambulance arrives, the unyieldingly rod-straight shoulders of the blazer worn when you swear on oath in a court of law, the cardigan that blares brightly, despite your dejection, signalling

your commitment to the life that goes on without the lover who leaves you. At those moments, when everything is brutish and bruising, the fabrics against our skin are the only things we can bear, and clothed in them we might ask how we ever consent to be touched at all.

We dress to deflect others, and we dress for ourselves too, quietly reserving something private and inalienable, unavailable for public display. If we shroud our bodies, is it because we believe those bodies make us vulnerable, or because our bodies are also the site of something more precious than our bodies alone? Our clothes can outwardly exhibit that something or keep it out of sight, preserving it within. Sometimes women dress to steel themselves for confrontation, masking the thin skin beneath. They dress to issue a challenge, to present the facade that fortifies them against failure or indemnifies them against defeat, confirming to the world their self-esteem even when they may not feel it so themselves.

Women dress fearlessly too, of course, inspiring our admiration. They can dress with exuberance or confidence, as a statement of their worldliness and composure, or their lightness and humour, their possession of freedom and their capacities for irony, advertising their sex and their strength at once. We dress, often, from choice, with will and knowledge, skill and certainty. Some women dress to state out loud that there is nothing in the world that could hurt them, others dress as though they are in possession of a secret, always about to be revealed yet never quite said. None of those qualities and intentions could be inherent to a garment itself, but, for many of us, those possibilities are ours, available in the blue bodycon sheath, the white cotton shirtdress, the summer maxi and the woollen winter shift. There is a power to be claimed in dresses. Our clothes can illustrate our interior life and they can also present the privacy of such a thing. They are the surface that masks all that is withheld beneath. And then, the question to ask is not what do you say in the clothes that you wear, but what is it that you refuse to lay bare?

'Surface', wrote Nietzsche, is a 'woman's soul, a mobile stormy film on shallow water'. It is a typically oblique assessment, partly pejorative but envious too. He relegates women to the shallows, denying them depth, but he knows that the surface has its own qualities. It is fluid and responsive, always visible and easily altered. The surface is a plane of possibility – why would a woman not seize it and set out her sense of self? When in Henry James's 1881 novel, *The Portrait of a Lady*, Isabel Archer dismisses surface appearances, her companion, the older, wiser, more jaded Madame Merle, challenges her:

> we're each of us made up of a cluster of appurtenances. What do you call one's self? Where does it begin? Where does it end? It overflows into everything that belongs to us – and then it flows back again. I know that a large part of myself is in the dresses I choose to wear. I have a great respect for *things*! One's self – for other people – is one's expression of one's self; and one's house, one's clothes, the book one reads, the company one keeps – these things are all expressive.

Over the course of the novel, it becomes clear that the cultured European life Madame Merle presents acts as a screen, veiling the moral corruption beneath, and yet there is in her understanding something which Isabel cannot follow, a metaphysics of sorts, the recognition of a life that takes place through *things* and a self that exists as a visible surface.

It is easy to dismiss as crude the analogue of self with stuff, as though the substance of the soul could only be short-changed by the material things with which we might articulate it. But Madame Merle's interjection is reflective, not flippant,

reconciled to the inconstancy of this surface by which a self might be expressed. The care with which she assembles her 'cluster of appurtenances' indicates her skill and power. She is trained in the art of appearances, armed, even, with the knowledge of all the possibilities available to her. In eliding the distinction between 'one's self' and 'one's expression of one's self', Madame Merle lives in her world of 'things' and finds nothing wanting, no unsettled remainder or unexpressed excess. Isabel, though, fumbles, trying to formulate a rejoinder, certain only of her dissatisfaction with such a state of affairs. She refuses to commit to a selfhood that could be invested in 'things', when no thing seems to her equal to that task.

The alternative is to come up against a limit:

> I don't know whether I succeed in expressing myself, but I know that nothing else expresses me. Nothing that belongs to me is any measure of me; on the contrary, it's a limit, a barrier, and a perfectly arbitrary one. Certainly, the clothes which, as you say, I choose to wear, don't express me; and heaven forbid they should!

Madame Merle insolently points out how well Isabel dresses as though it were a hypocrisy, but Isabel dismisses her clothes as an expression of her dressmaker, an imposition of her society. Isabel *does* dress well. What disturbs her nonetheless is a tacit sense of the dislocation of the dress from the woman who wears it, a vague and sobering idea that if our clothes are all that we are, the one thing we are not in them is free. Nothing expresses Isabel, and this is, first of all in the novel, a challenge she determines to contend with, then a fate that is agony and to which she finally concedes defeat. There is a cruelty in the idea that the things we keep closest to us, nearest our skin, that immediate medium through which we are almost always seen in the world, may not be commensurate to all that we are. There is a kind of calamity

in the clothes that are not the sum of the man, but particularly not the sum of the woman, for whom selfhood is so profoundly pressed upon from the outside, discerned almost by sight alone. In James's novel, the surface is not always enough for a soul.

Isabel is from the first 'a tall girl in a black dress' lingering in a doorway, 'slim and charming', but what distinguishes her is the wilful defiance with which she purposefully sidesteps the sharply demarcated life before her. In her cousin Ralph's provocative phrase, she is 'a certain young woman affronting her destiny'. Isabel's tragedy is that the decisions she makes in the name of freedom prove to be betrayals of that very thing – marrying for love, she finds appearances are not what they seem, that they are, in fact, only ever appearances. At the beginning of the novel, when Ralph teasingly enquires to his mother as to 'what you intend to do with her', she reproves him: 'Do with her? You talk as if she were a yard of calico.' The retort is throwaway and yet astute. Isabel struggles to be understood, not *in* things, nor *as* a thing. She is not a fabric to be fashioned, so much more than the surface to which she is condemned. She is unexpressed by all those things and so suffocated too by the wealth and glamour she is forced to illustrate.

When Ralph encounters Isabel again, following her unhappy marriage, he notes how the 'amplitude and a brilliancy in her personal arrangements ... gave a touch of insolence to her beauty'. Her new finery finally does express her, literally weighing her down with the heavy burden of her marriage:

> Her light step drew a mass of drapery behind it; her intelligent head sustained a majesty of ornament. The free, keen girl had become quite another person; what he saw was the fine lady who was supposed to represent something. What did Isabel represent? Ralph asked himself; and he could only answer by saying that she represented Gilbert Osmond.

In representing her abusive husband, Isabel's self-estrangement is absolute. She succumbs to a world of appearances and her transformation amounts to more than a relinquishment of her freedom: she becomes an object to herself as she is to others. She is absent, a void behind the impressive gowns. Ralph senses this grievous loss. But Isabel is also secured by these clothes in a different way. They are never capable of expressing her and so their inadequacy preserves something sacred and interior that is hers alone and never allowed to surface. Perhaps the dress that one longs for most of all, the one in which we might be most free, is the one that never yields our secrets.

James is always alert to the significance of dress, conscious of its capacity for illusion and disillusion both. In his earlier short story, 'The Romance of Certain Old Clothes', two sisters, Rosalind and Perdita, fall out vying for the same suitor. The plot is less concerned with the lover than a primal sibling rivalry, expressed by transference in the sisters' furious contestation over the possession of a particular dress. This second dispute is every bit as powerful as the first, their growing rancour manifesting in a gown that seems almost invested with supernatural power: Perdita's wedding dress. James describes its 'white silk, brocaded with heavenly blue and silver', detailing its intricacy like an incantation. Rosalind, who is humiliatingly obliged to help prepare her sister's gown for the wedding, reaches for the 'great shining fabric', as though under a spell:

> ... she took it up in her hands and felt it – lovingly, as Perdita could see – and turned about toward the mirror with it. She let it roll down to her feet, and flung the other end over her shoulder, gathering it in about her waist with her white arm, which was bare to the elbow. She threw back her head, and looked at her image, and a hanging tress of her auburn hair fell upon the gorgeous surface of the silk. It made a dazzling picture. The women standing about uttered a little

'Look, look!' of admiration. 'Yes, indeed,' said Rosalind, quietly, 'blue is my colour.'

James unfurls the scene almost in parallel to Rosalind's unfurling of the gown. There is a dazzling, lethargic triumph in the way the passage moves, as though James were getting at the real-time experience of actually putting on a gown – the kind of gown that is not simply thrown on but which curiously unfolds and expands with it a world of possibilities for the wearer. This dress is the sort that gleams differently with every new glance of light. The fabric itself seems possessed, divining its rightful owner, as though the attunement of gown and girl were a marker of destiny.

In it, Rosalind, the slighted sister, finds that her feelings rise to the surface, irrepressible, as she stands enveloped in yards of silk. Later, Perdita catches her illicitly donning the discarded dress immediately after the ceremony, watching Rosalind secretly as she stands 'before the mirror, plunging a long look into its depths and reading heaven knows what audacious visions'. In that moment of perfect confluence between dress and wearer and perfect enmity between the two sisters, the women finally confront each other with an undisguised contempt, the dress releasing their otherwise unarticulated hostility. The curtain between them that once veiled their private resentments is rent, and they are revealed to each other in the fullness of their fury.

Years later when Perdita falls ill, she gathers together an array of gowns, sealing them in a chest for her young daughter to inherit. Dresses again become loaded with significance, freighted with an uncanny force. Filling the chest, she imagines the dresses lying there 'quietly waiting till she grows into them – wrapped in camphor and rose-leaves, and keeping their colours in the sweet-scented darkness. She shall have black hair, she shall wear my carnation satin.' The mother imagines through them the life she is unable to witness, and the dresses 'lie in wait'

to realise this oddly tyrannous maternal vision. When Rosalind, having finally married her sister's widow and turned mother to her sister's daughter, finds that she cannot resist the allure of the gowns, Perdita enacts her revenge from the grave. Rosalind's body is found crumpled and lifeless at the opened chest, her face mysteriously lacerated as if by clawing fingernails.

James uses the malevolent spirits of supernatural fiction to make manifest the simmering unhappiness of the sisters, the crackling tensions and cross-currents of feeling that splinters their relationship. The supernatural becomes a mode of figuring the disturbances of psychic and emotional life. But dresses can do that too, since they possess their own diabolical magic, exposing the deepest life of the wearer even when they seek to hide it. We think of dresses as the image of contented femininity, the costumes of matrimony and motherhood, but James reminds us how they can also be invested with secret passion, even a sinister autonomy, becoming sites of anxiety and profound ambivalence. His weird ghost story attests to the ways in which they carry the tumult of our closest relationships and how some feelings cannot linger under the surface forever. The things we wear seem to move indiscernibly between material and metaphorical registers. That may seem strange, but isn't it stranger still to imagine that our clothes should only ever be an impassive accessory in our lives, as though they would bear no trace of us at all?

The idea that our internal being might be externally realised in a dress is what possesses Mabel, in Virginia Woolf's short story 'The New Dress'. She confidently commissions a new gown for a party and eagerly imagines the impression she could make, only to find herself shrinking with doubt, ultimately unequal to the dress she has selected. Woolf recounts the tale wryly, mocking and sympathetic at once, recognising the debilitating self-hatred that makes itself felt in the 'wrong' clothes. She captures the giddiness of Mabel's ambitions – her intrepid dream of a dress

that would distinguish her, imbuing her with an air and lending her allure. And so we feel all the more keenly the crushing blow of disappointment when the dress on which Mabel had pinned her hopes seems to have failed her. As she enters the room, she is seized by the terror of having overstepped some unspoken sartorial rule. Woolf never indicates if she really has. It doesn't matter. The dress only consolidates an array of other insecurities, the anxieties that might well torment a woman without personal fortune and who is neither beautiful nor young.

Woolf depicts the scene from the position of Mabel's unrelenting wretchedness:

> ... she dared not look in the glass. She could not face the whole horror – the pale yellow, idiotically old-fashioned silk dress with its long skirt and its high sleeves and its waist and all the things that looked so charming in the fashion book, but not on her, not among all these ordinary people.

She turns from a mirror, refusing to face her own face, as though it were the site of the most intimate betrayal. Mabel's sense of abjection is immense. She shuffles through the party filled with silent reproach and self-loathing. Her realisation is instantaneous and she announces it to herself with an unwavering doom: 'No. It was not *right*.' But what is it to wear something *right*? What is at stake in accomplishing that tremendous feat whereby who you are, what you wear and where you wear it are magically sympathetic?

We are muffled much of the time in the clothes we pull on unreflectively and in the lives we live unthinkingly, but the wrong outfit can jar, sounding a loud and discordant note. There are so many ways to get it wrong. The brave and bold dress, for instance, that you dare to pull on in a fleeting moment of courage and in which you realise how little capable you are of either braveness or boldness; the sober-coloured, stoutly cut work skirt that hangs listlessly from your hips, which you would never

have elected to wear and in which you find yourself etiolated and invisible; or the unforgiving sheath that vaunts your femininity and alienates you even as it clings to you as close as could be. Dressing is so hard, it is astonishing that we ever find the courage to keep trying as we do every day.

What is it that compels us, if not the dream of the 'right dress'? The idea that in the 'right dress' there might be some congruence between inside and outside, that our clothes could grant us the self-assurance that we are not just dressed right in the right place and the right time, but are altogether just *right* in ourselves, seems such an unthinkably facile formulation. But perhaps it is because we can be at odds with ourselves and the societies in which we move that we also seek the clothes that will confirm our timeliness, our seemliness, our adequacy. Perhaps we think the right dress will finally distinguish us as the discrete and entire human beings we are, altogether ourselves in a world of many others.

The dressmaker that can fabricate the gown that is right, that fits us just so, is, then, like some divine being, the master or mistress of a mystical craft. The French philosopher Hélène Cixous writes of designer Sonia Rykiel with seriousness, intuiting what it is that the 'right dress' can do. She articulates the unshakeable sense of confidence that comes of being comfortable, not just in your skin but in your dress too, and perhaps even in your dress when not in your skin. 'The dress that comes to me,' she observes, 'agrees with me, and me with it, and we resemble one another ... The dress dresses a woman I have never known and who is also me.' This dress is a dream, newly illuminating the wearer but also affirming an account of themselves that they recognise and gladly snatch up for display. In this dress, she is free from the anxieties of her body, her beauty, her age and sex, as though the sense of perfection, contentment or completion it imparts were divine.

Yet there is no divinity in dress. It is instead the site of real things, the blunt fact of unequal power, the projections of sex

and violence. If there is any deep truth to the dresses that women wear, it is only that of their variable surface and the ways in which we trace across them the struggles of womanhood, its fraught psychic, emotional and bodily life. In the rare moments when a dress is right, we might find ourselves seamlessly continuous with the garment itself in a kind of alliance or an accord:

> I enter the garment. It is as if I were going into the water. I enter the dress as I enter the water which envelops me and, without effacing me, hides me transparently. And here I am, dressed at the closest point to myself. Almost in myself.

In the Rykiel dress, Cixous finds there is no rupture, no discontinuity, only fabric that feels like the body itself, transmitting the truth of the self through it as though there were no estrangement or impediment. This dress of all dresses aspires to a kind of transparency, so that we might be seen on the surface as we really are deep inside: at our very best, in a light that is unrefracted, perfectly truthful, kind and just.

Some of us own such a dress, an exceptional thing, lovingly preserved and only carefully exposed to the light of day; others of us reach for its possibility and find in every new purchase a pretender, sensing it forever slipping from our grasp or gaze, like the faces of the dead that come to us only in dreams. Perhaps the power of the right dress must, of necessity, come only rarely, like a hard-won self-knowledge, the shining truth of which cannot stand too much scrutiny, its brilliance too blinding, too perfect to bear up. Such dresses are not perfect forever, dating or wearing away over the years, but while they last and while they fit, we feel in them as though we could tilt the world.

My own dress – a filmy, grey silk, knee-length with luminous yellow piping all over, slanted pockets low at each hip, a neckline sinking across the chest – hangs in darkness, obediently awaiting a new awakening. The merest, accidental touch of it triggers a

cascade of associations: summer birthdays and a bicycle, the city I live in on a sunnier day, the glossy hair and the smaller, slighter body I found myself slowly recovering into after a debilitating illness, a body that I won't have forever but which I have now and which lives in a particular way only in that particular dress. After everything, the violence of the gaze, the fragmentation of the body, the history of injury and constraint, there is this.

'If the body,' wrote de Beauvoir, 'is not a thing, it is a situation; it is our grasp on the world and the outline for our projects.' How women dress their bodies is the project of possibility. Women's clothes can be elusive and evocative, serious, parodic or playful. Dresses solicit the gaze and subject us, but they are the surface too for the soul of a woman. In these surfaces, women reflect on what they understand of themselves and how they wish to be understood by others. Perhaps there is no garment equal to who we are, no fold, no cut, no gaze, no look that could have the measure of this. But the challenge of dress is only to seek out the truths of the body, its variegated surfaces and sensations, the brute fact of biology and the infinitely different ways we experience it – this body which we cannot escape and which we clothe to meet the world.

Give me my robe, put on my crown; I have
Immortal longings in me

WILLIAM SHAKESPEARE
Antony and Cleopatra (Act 5, Scene 2)

2.

Suits, Coats and Jackets

WHEN THEY CUT ME OUT OF THE CAR, prising the mangled door from the crumpled frame, it is your jacket that someone retrieves from the back of the seat, placing it kindly around my shoulders, the cashmere to be ruined by rain and matted with blood as dusk turns darker. This coat becomes a shroud as uniformed strangers cluster closely, speaking quietly, compressing wounds and securing broken limbs. Above them, a canopy of interlocked branches quiver, the trees too supplying a kind of shelter, their skeletal silhouette disappearing into an increasingly tenebrous sky. What I know in that moment is that this impulse to cloak is not only an act of care, but of desperation, as though thread and fibre could form a structure solid enough to encase a person and keep them safe, as though they would not collapse at the slightest contact, folding, it turns out, as easily as a car into a tree.

In that moment, I have the surest sense of my body, its infirmity, the impact it cannot absorb, the bones that can shatter, the ribs that can splinter, teeth that crack and lips that tear. A welt, rich and dark, surfaces across my shoulder and along my chest, marking where the seat belt strained to hold me in place. A bruise deepens under my eye from some dull-edged object flown up against my face, and a sharp, hot ache pulses from tendons deep inside my neck, abruptly flung forward one instant and then snapped back by the blunt force of collision. Amid all this, as pain sounds within me, a ceaseless, keening pitch, I am conscious of your jacket with its broad, square shoulders, its smooth silk lining and neatly notched lapels. In these circumstances, its crisp, cultured civility feels like a terrible joke, insolent and unkind next to the paramedic in wipe-clean green who carefully counts my broken ribs or the fireman in a high-vis vest who surveys the mechanical wreckage sprawled before him.

Your suit is a uniform of sorts too. You deal in brazen ambition, determinedly racing ahead, in pursuit of the self-advancement that comes at any cost. These are the jackets that are knowingly slung on the back of office chairs to signal devotion to a job that demands every waking hour, that destroys every human relationship. These are jackets with platinum cards tucked in inside pockets and secret sachets of cocaine stashed in sleeves. Suddenly, here and now, in the incontrovertible agony of injury, I have the measure of my own foolishness. I see clearly the wretched illusion of authority you claimed in your smartly fastened suit. I see the pitiless self-regard and reckless desire it dignified with its implicit expense and outward elegance. Only searing pain stifles the words that gather in my throat.

The sirens quieten and the whirling lights still, but the irony is that what I need to be saved from in this moment is not the cold or the rain, not the injury or the shock – only you, and the havoc you wreak every time you exercise your will. You and your obdurate, infinite sense of entitlement, how undeterred you are when you leap into this car to take control, when your eyes dilate from the influence of some intoxicant and your foot fixes itself on an accelerator with every belief in your unassailability, your absolute, unstoppable inheritance of the earth. And so, when you stumble toward me now, dazed and uncertain, silent and unscathed – cufflinks gleaming in the dark, one sleeve blood-stained from the panicked moment you reached to release me from my seat – I know what to do. I flex – with an agonising effort that costs me everything – and let your jacket fall from my shoulders into the pooling rain.

Cary Grant strides out of an overfull elevator in the opening sequence of *North by Northwest* (1959). He cuts a lean, lithe and blithe figure, distinguishable from the surging crowd tripping behind him by the bemused expression on his face and the harried secretary on his arm. Lounging next to her in the back of a New York taxi as she hurriedly takes dictation, he pauses mid-flow:

> 'Say, do I look heavyish to you?'
> 'No.'
> 'I feel heavyish. Put a note on my desk "Think Thin".'

It's a wry observation, since Grant's character is in this film insistently wiry, agile and tenacious, not remotely 'heavyish' when ducking beneath low-descending corn-dusters and clinging from Mount Rushmore by his fingertips. There is even a sharpness to his character's very name – Thornhill – suggesting the kind of whip thinness that might hold you in good stead if you were to be pursued by surly heavies along a winding Long Island road. 'Roger', too, has a roguish air, a disarming breeziness, a flickering, gleaming, wicked humour, all of which Grant seems to impart with a subtlety faintly at odds with the garish Technicolor of Hitchcock's film.

The film came fairly late in Grant's career, and he had been reluctant to accept the role since, at fifty-five, he was considerably older than the part of an insouciant young ad man capriciously collared for a caper. But it was age, perhaps the settled self-assurance of middle age in particular, that allowed Grant to bring to the part a certain urbanity and a knowing, jaded exasperation, leavening the film's more dangerous moments. Apart from a brief disguise, Grant wears a single, simple grey suit throughout. When Martin Landau's younger, menacing

henchman assesses him early on, he notes, 'He's a well-tailored one.' It's a private joke since all of Landau's suits for the film had been cut by Grant's own tailor. In the scene, Grant's Thornhill is bewildered but unfazed, retaining his composure until Landau's heavy hand descends on his shoulder, crumpling the clean lines of his immaculate jacket. Then, his face hardens and the film shifts gear.

North by Northwest (1959)

What is it about the suit that it should be taken as the sign of our civilisation? It suggests control and calm, moderation and regulation, as though it could safeguard us from external assault. How is it that it should be the generally agreed uniform of bank managers and estate agents, businessmen and bridegrooms, as though it were unimpeachably respectable? Appearances are deceptive in *North by Northwest*. When Eva Marie Saint's double agent saunters onto the scene, her duplicity is demurely buttoned up in a blazer, and James Mason's villain, trim in a

three-piece, reveals how easily the suit wearer summons power and masks malevolence. This is a determinedly stylish film and not in any superficial sense. Nobody is who they seem and the question of appearance is crucial to the mistaken identity plot from which the story spins. 'I told you, I'm not George Kaplan. Whoever *he* is,' Grant's Thornhill protests to his captors to no avail. He proves this to us, if not to them, when he dons Kaplan's suit and finds its sleeve several inches too short. A man's suit does not lie: it is a second skin, as dependable as a friend and as unfaltering too.

Grant's own suit in the film fitted him perfectly, having been cut by his London tailor, Kilgour, French & Stanbury of Savile Row. It was replicated eight times over by Hollywood tailors, Quintino of Beverly Hills, to allow for the wear and tear of filming over a period of five months. You can detect the label when Thornhill briefly disrobes early on in a hotel room, the glimpse of it like a momentary breaking of a fourth wall. The writer Todd McEwen pronounced it a 'gorgeous New York suit' in his 2006 essay 'Cary Grant's Suit', which recounts the film's plot from the suit's inanimate viewpoint. In the same year, a panel of stylists and fashion writers for *GQ* declared that 'the grey suit worn by Cary Grant was the best in film history, and the most influential on men's style', a distinguished predecessor of the standard-issue, slim grey suit donned by the full array of modern Hollywood's leading men. *GQ*'s accolade was, like Grant's suit, fitting, since Grant himself had penned a piece on the principles of good dress, printed in the Winter 1967/68 edition of the magazine. His advice was simple, precise, and so disarmingly modest and light as to be almost offhand:

> ... if you wear cuff links, as I do, don't, I beg you, wear those huge examples of badly designed, cheap modern jewelry. They, too, are not only ostentatious, but heavy and a menace to the enamel on your car and your girl friend's eye.

One imagines the man who could issue this kind of advice, the low-slung car he would buff on alternate Sundays, the elegantly bemused girlfriend around whom he could sling an arm, the slow transatlantic drawl with which he speaks, the confidence that comes of possessing all the time in the world and the smartest cut suits too. The right suit can suggest composure, just as the badly fitted one can expose an ineptitude beyond merely clothes. (Think of Keanu Reeves, indubitably slick-suited in the *John Wick* films, even when splattered in blood and sprinkled with gunshots, next to the schlubby polyester of Ricky Gervais's David Brent in *The Office*, and then tell me I am wrong.) A suit can speak volumes. Grant knows this. Despite the disclaimer of not considering himself 'especially well dressed', his *GQ* column discloses a dogged and detailed thoughtfulness as to the habits of men's dress. A blustering nonchalance undercuts any hint of vanity and keeps things light, but the particularities of what one wore and how seemed to matter to Grant, more perhaps than he might have been able to say.

Curiously, the grey suit revered by *GQ*, McEwen remembers as 'a real beauty, a perfectly tailored, gracefully falling lightweight dusty blue'. On close inspection, Grant's suit is neither exactly grey nor blue, but partly both. It is a lightweight worsted woollen two-piece in a fine Glen plaid pattern, the jacket ventless with jetted pockets and notched lapels, the trousers high-waisted and straight-legged with unusually feminine forward pleats. Altogether, Grant's look is bespoke and slim-fitted. On-screen, in certain lights, the check pattern dissolves into a flatter, gunmetal grey, pairing with the skinny tie, one shade darker, and the ribbed socks, one shade lighter, bringing out both the metal tones of his iron hair and the steely resolve he demonstrates in the film. The jacket is three-buttoned, but Grant fastens only the middle; the look is slightly raffish, still sharp, although not restrictive, and convenient for those having to bolt through trains and leap from motorcars at short notice.

What strikes me now about this suit is how it frames a lean, not athletic, body. In *North by Northwest*, Grant is thin. The suit he wears belongs to a different vision of masculinity with which modern audiences are less familiar: not shirt-bulging machismo, but something more laconic, an effortless, almost lazy self-assurance capable of turning swiftly into quick-wittedness and skill. This is a suit that shakes its head politely at creases, gently turns down rumples, refuses to tear, wear or break out in a sweat racing through a thriller. And this is the thing. It's not just what the suit is, but the way that Grant *fits* the suit and it him that makes the whole look so remarkable. It is as though they were boyish friends conspiring with each other, as if their entire lives were a smart cocktail party where you would only ever be vaguely drunk and confident that your every utterance would be a wry epithet, as if the world were always to you slightly aslant, mocking, dangerous and ironic. There is something companionable about the way they live together – the man and his suit. And there is something darker there too, Hitchcockian even. The suit is the colour of a glistening, trembling knife-edge.

Cary Grant was born Archibald Alexander Leach in Bristol, 1904. His father, who would jettison him early on in life for a second family, had been a tailor's cutter. This was the father that had institutionalised his mother when Grant was a child and had led him to believe that she had died – a stunning deception uncovered when, aged thirty-one, he found her alive in a secure unit for the 'mentally defective'. This was the stock from which he came. Cary Grant with the cufflinks and imperturbably good manners was also Archibald Leach, the abandoned son of a suit-maker. In every suit that he wears, in every part – the reams of handsome, ambling gentlemen he would play time and again – Grant bears up that secret knowledge.

We all come from somewhere. Sometimes, that somewhere is more painful than we could ever allow ourselves to reveal outwardly. A suit rises to the occasion in these circumstances;

it is capable of dignified deception, precisely because it seems, on the surface, to signal the surest safety, asserting polite blandishments, keeping unruly feelings at bay. Its uniform blankness wards off inspection and keeps private things in reserve. Even as it provides the most basic building block of smart dress for men, the suit can always makes room for secrets – internal pockets, concealed fastenings, hidden linings. The greatest secret of all, though, is its own vulnerability. We speak readily of dressing for the job, of the desirability of a man in his Sunday best, of a modern courtliness attendant on tops and tails, blazers, boating jackets and black tie. When the suit possesses a sexuality, it is one of cool reserve, carefully concealed yet effortlessly unstripped. Across the world, men conventionally marry in different versions of the suit, as though despite the variations of length, fabric, tailoring, colour and style, the garment reserves for itself some guarantee of uprightness and rectitude – a commitment that can be committed to.

But the history of men's suits doesn't simply shore up the assurance of masculinity – it interrogates it too. What Roger Thornhill's suit reveals is that a suit is never just a suit. Each time Grant's long, tanned fingers are forced to brush down and straighten up his jacket, it is a fantasy of self-possession that they are struggling to regain. We wear cuffs, collars and ties in a world that is beyond our control. We button up our bodies as though we could do the same with memories and feelings, the excitations and agitations that plague us. Sometimes it works. The trouble is that we can only keep the world at bay for so long. The suit has a secret life. We might mistake it for a uniform, worn with mute obedience, but it possesses its own power. Understanding how it works might mean questioning the authority it exerts and facing up to the awful parts of life that a suit can legitimate. The suit's seriousness can, of course, be unbuttoned. Isn't it capable of lightness too, the carelessness of a loosened tie and a jacket slung off a shoulder on a summer's day?

There is only the finest thread between tragedy and comedy. The figure in the suit belongs to both.

THE HEAVINESS OF COATS AND THE LIGHTNESS OF JACKETS

Trousers, more often than jackets, seem to lend themselves to comic causes. They can be merry and mortifying, liable to fall down to the knees or tear at the buttocks. They are nearly always disastrous in Charlie Chaplin films: a blundering tailor's assistant singes his master's trousers in *The Count* (1916), a bumbling bum drops an ice cream down a trouser leg, through the slats of a balcony and onto the neck of the elderly lady seated below in *The Adventurer* (1917), and a drunkard husband sets out for the day without his trousers, forced to lurk in telephone boxes, skulk behind newspapers, and dive into a stranger's bed to save his dignity in *The Idle Class* (1921). Most glorious of all are the incorrigibly loose-waisted trousers that tirelessly tumble down in *The Gold Rush* (1925) when Chaplin's luckless prospector unexpectedly finds himself waltzing with a beautiful woman. Improvising, he hooks the crook of his walking stick into the belt loop and hoists them back up, determinedly still whirling, stick held aloft. Later, he snatches a piece of string from a nearby table and hastily knots it into a belt, only to drag along with him the bewildered dog that turns out to be attached to its other end. Despite all this, or perhaps because, Chaplin's bungler triumphs: he gets the girl, deservedly it seems to the viewer, almost as a reward for his enterprise, the film providing a fantasy of the underdog who could, finally, come first.

Chaplin gleefully mines the comedy of clothes with endless invention, and under his deft touch, even the simplest clownery opens up into something more serious. Trousers are, to him, especially absurd, but the suit, in general, serves as the uniform

of a civil society which he finds authoritarian and exclusive. Clothes easily abbreviated the social inequalities he sought to criticise. You could attack the suit, repeatedly singeing and scuffing it, as though dismantling the respect it seems to demand. Or you could level these inequalities in a lovable character like the prospector who, ragged in his jacket, is noble in the eyes of his dancing partner and the audience. For Chaplin, authority is for questioning because power isn't granted to each of us equally.

The impoverished 'Little Tramp', the most recognisable figure of Chaplin's repertoire, is a hapless yet kind-hearted vagrant. He is always dressed like a down-at-heel gent, dignified even in destitution. Chaplin (himself born into poverty to a mother who sometimes took work as a seamstress) assembled his 'tramp suit' deliberately, explaining in a 1933 interview:

> I went to the wardrobe and got a pair of baggy pants, a tight coat, a small derby hat and a large pair of shoes. I wanted the clothes to be a mass of contradictions, knowing pictorially the figure would be vividly outlined on the screen ... The clothes seemed to imbue me with the spirit of the character. He actually became a man with a soul – a point of view ... He wears an air of romantic hunger, forever seeking romance, but his feet won't let him.

The precariously parked hat and the dishevelled collar suggest a creature who fits his clothes as poorly as he fits his society. He has a meandering sensibility at odds with the relentlessly driven engine of modern industrialised capitalism, but his shabbiness could also elicit sympathy. The Little Tramp offers silent acknowledgement: he demonstrates solidarity with the drudgery of labour, lampoons the compulsions of consumer desire, and intimates the loneliness of the immigrant. Over the years, 'the little fellow,' as Chaplin fondly called him, would reflect back to

viewers a mocking image of the Great Depression, symbolising the moral and economic bankruptcy of the twentieth century, and rebuking the authoritarian politics that had taken hold across Europe.

Always teetering on the brink of disaster, the tramp can be piercingly vulnerable. He has an easy gift for turning catastrophe into comedy, but there are bleaker realities beneath the horseplay. Chaplin satirises the privilege of the affluent suit wearer – bank managers and factory bosses, gentlemen and politicians – exposing the fragility of their authority and offering up its critique. The tramp, by contrast, is resourceful in adversity and rebellious against tyranny, often managing to cock a snook at the aristocrats who ignore or exploit him. Even so, he is, ultimately, destitute. His impoverishment is made heart-achingly visible in the battered suit, its sadly missing buttons and poorly patched elbows. He never possesses the indemnity of the smart suit wearer whose dignity could deflect any query.

When we are compelled to wear smart suits ourselves, it is often because we too must claim that indemnity, acquiescing to ordinary life and the formal ways that this is organised by bankers, civil servants, policemen, doctors, lawyers and statesmen, even the lowliest clerk. Akaky Akakievich is a clerk in Nikolai Gogol's droll but enigmatic short story of 1842, 'The Overcoat'. His entire life is as unvarying as his work as a copyist in a central Russian bureaucracy. He undertakes this work with unquestioning contentment, until one day he feels a chill on his neck and finds his long-worn winter coat deteriorated beyond repair. Obliged to commission a new overcoat that he can ill afford from Petrovitch, his temperamental one-eyed tailor (prone, Gogol, notes, both to drink and to cursing at needles he cannot thread), Akakievich begins to save with a ludicrously scrupulous discipline, skipping meals and cutting back on candles, even taking to treading lightly on the soles of his shoes so as to longer preserve the heel. All the while,

a vision of the new overcoat flickers like a flame newly ignited, kindled until blazing in his imagination.

Akakievich counts down the days, and after nine months of saving and dreaming, when the garment is finally presented to him – a queer cat-skin-collared cloak, quilted and stitched with small silk seams – Akakievich dons it and sees his entire life through new eyes. The streets of his city and the pleasures of the people it contained are to him suddenly brighter, louder, fuller. The day that Petrovitch delivers the coat is, Gogol notes, with a benign mockery, the most 'perfect day' of Akakievich's modest life. Overcome by the bemused congratulations of his otherwise uninterested colleagues, he uncharacteristically heads out to celebrate his new purchase with them, but almost as soon as it is won, the garment is lost, snatched from his shoulders by thugs in a night-fallen St Petersburg.

The following day, grief-stricken and returned to the indignity of his old garb, Akakievich timidly approaches a 'certain prominent personage' at his workplace, hoping for assistance in recovering the stolen coat. Instead, he finds himself furiously dismissed for impertinence. Gogol, merciless to the last, has him catch a cold on his mortified route home from work, which swiftly turns into a fatal fever and a whimperingly inglorious death. In an impish twist, the ever-unfortunate Akakievich returns as a disgruntled spectre, prowling around the scene of the crime, habitually snatching at passers-by, until one day he seizes the coat of the 'certain prominent personage' himself and vengefully makes off with it into the ether, finally satisfied.

More than 170 years later, the strangeness of Gogol's mischievous and melancholic short story continues to baffle and delight readers. For some, it is a dark satire on the powerlessness of lowly citizens and the tyranny of their unbending masters, and a parody of clunky Russian bureaucracy. For others, it is a fantastical, proto-Dadaist fable of devils with the meting of a ludic justice, or even a modern drama of manners, elbowing at

officious administrators. There is certainly a retributive justice to the story's close when the phantom Akakievich contemptuously cries at the overbearing official: 'Ah, here you are at last! I have you – by the collar! I'll take your cloak; you took no trouble about mine, but reprimanded me; so now give up your own.'

However one chooses to understand the tale, Gogol's brief story about a man who loses a coat belies its littleness, expanding to reveal a hidden capaciousness. Fyodor Dostoevsky (or possibly Ivan Turgenev, nobody seems to know for sure) apparently declared that 'We all came out of Gogol's "Overcoat"', as though the modern Russian literary tradition, even Russia itself, were somehow better understood in the small details of a foolish man fretting over his overcoat than in the sprawling grandeur of a *War and Peace*. The dogged modesty of the story, though, is crucial. Gogol observes how Akakievich is so banal and so familiar a creature to his fellow workers that they hardly regard him at all. At best, they are oblivious to his existence, and at worst, they taunt him for his witless obedience. Gogol, too, is precise and unsparing, cruelly detailing how strands of straw and thread seem always to stick to Akakievich's trousers, noting with mild astonishment his peculiar talent for always 'arriving beneath a window just as all sorts of rubbish were being flung out of it'. And yet there is *more* to Akakievich, and to Gogol's simple story, which shifts and tilts, lurching from a companionable drollery to something sharper.

Akakievich is singularly absorbed in his work as a copier, an undemanding activity that requires no critical engagement. He possesses few things, is burdened by neither vice nor virtue. Until the prospect of a new overcoat arises, he is utterly untroubled by anything like curiosity. In this respect, he is the perfect employee of a bureaucratic machine that demands an unreflective adherence to rules and deference to superiors. He is the copyist who devotedly works with letters but cannot string together a coherent sentence when required, who lives not with language

but only in its endless and senseless imitation. He lives to work, and work blots out every aspect of life – and so he carelessly swallows flies with his soup and never brushes his hat. All this changes with the dream of the new coat. Suddenly, Akakievich feels the paltriness of his life more deeply. When a colleague teases him with especial tenacity, he snaps uncharacteristically, exclaiming, 'Leave me alone! Why do you insult me?' and this reproach echoes unsettlingly in the memory of the offending official, 'long afterwards, even in his gayest moments'.

This episode prefigures the eerie way in which the story itself reverberates, way beyond its compact parameters, sitting with the reader, long after reading, with a disconcerting determination. Reading 'The Overcoat', you have the sensation of plunging a hand into a pocket you believed to be small and find to be endless. Akakievich, for all his absurdity, is a man who has silently tolerated death by a thousand paper cuts, enduring small persecutions every day. Gogol's contemporaries interpreted the seizure of the pompously 'important personage's overcoat' as a fantasy of the retribution awaiting the unrepentant Russian ruling classes. And yet it is not the theft of the coat but the longing for it in which Gogol articulates his most profound critique.

What is it that a coat can contain? *A world.* A lifetime of suppressed longing and pleasure denied. The coat, once Akakievich dares to imagine it, becomes a repository of all that life has refused him. It becomes an object of fantasy, into which he can direct the desire that has otherwise been extinguished by the monotony of work. The dream of a new coat, something unspoilt and entirely his own, awakens that desire, inspiring it *in extremis*. The coat, as he imagines it with 'thick wadding and a strong lining incapable of wearing out', occupies his every thought, bringing to his etiolated life a new brilliance, filling it like 'some pleasant friend who had consented to travel along life's path with him'.

The pleasure Akakievich takes in the coat emanates into the wider society for which he finds a newly stirred interest. He *notices* the varied life of his city, handsomely dressed women and peasant waggoners, drivers in red velvet caps and lacquered sledges, playful advertisements in shop windows, a poster of a woman's foot that stops him in his tracks and inspires him to laugh out loud. He laughs, Gogol observes with suggestive mystery, 'because he had met with a thing utterly unknown, but for which every one cherishes, nevertheless, some sort of feeling ...' Precisely what that 'thing' could be is left unspoken, perhaps because the pleasure of it is so alien to Akakievich that he hardly knows how to recognise it, can barely finish even the sentence by which such a sentiment might be expressed. The surge of desire stimulated by the coat is so puzzling, that at one dizzyingly glorious moment, 'he even started to run, without knowing why, after some lady, who flew past like a flash of lightning. But he stopped short, and went on very quietly as before, wondering why he had quickened his pace.'

This is what a coat can contain. Akakievich's coat inspires in him a desire for desire itself. Dreaming of it, the stuttering and shambling bureaucrat imagines all other kinds of possibility too, as though he could find round the next corner an exhaustless life of sensory and emotional plenitude, a world flooded with colour and promise. In essence, between the remarkably ordinary Akakievich and his glorious coat, Gogol fashions a powerful love story, as brief as the encounter of garment and wearer, and filled with the plangent irony of a man who means so little to others and to whom a little thing comes to mean so much.

That the garment capable of inspiring the clerk should be an *overcoat*, pleases Gogol, who relishes in its utterly banal nature. He's conscious of its metaphorical suggestiveness – this coat that is designed to hold off the piercing Russian chill, but which, instead, warms the dormant blood in Akakievich's veins, enlivening his senses, thawing the icy distance he keeps from the

congenial society that surrounds him. The overcoat designed to close around him encourages him to open up instead. There is an equilibrium to all this. The insignificance to which Akakievich is socially relegated is countered by the significance with which he loads his coat. Its heavy form lightens his step, and Gogol maintains a tonal joke between the levity with which he describes the coat, and the gravity of his protagonist's suffering.

Perhaps this is what coats do. They set a tone. They try to level a difference, proposing how we and the outside world should relate. They come in different weights for different weathers – those Afghans, anoraks, parkas, pea coats, blazers, boleros, waterproofs and windbreakers – and their variety is an attempt to enable us to contend with the various conditions with which we can be confronted. I don't mean to suggest that our emotions are regulated by coats – we can certainly feel at odds to the weather and what we have to wear in it – but there is something prescriptive in the nature of these garments. They are designed precisely to warm us up or cajole us into lightness. A coat can coax us into a mood.

Summer jackets are blithe, easily cast aside or dangled off an arm, worn to impart only the impression of sartorial completeness. Their carelessness feels deliberate. They are *meant* to be forgotten in a restaurant or discarded at a picnic. They invite us to be breezy and untroubled. Meanwhile, the transitional coats that carry us through spring and autumn are a wager, seldom guessed at right, huddled in on a brisk day and jubilantly peeled off on bright ones. Think of the cropped denim jackets worn by truculent teenagers on the walk to school every morning for as long as they can hold out against the cold, their jarring unseasonability a marker of juvenility.

Winter coats are different. They bear the burden of insulating the body, their weight distributed evenly across shoulders whose breadth is, in turn, sometimes augmented or bulked with pads to be equal to that task. Coats like this often feel as

heavy as the responsibility with which they are tasked, keeping us warm and bearing out those bitter months, year on year. Fittingly, Akakievich's preposterously overwrought overcoat acknowledges the solemnity of its task and the commitment to life made in it. Like Akakievich, we purchase our winter coats with care; we intend them for repeated wear and so assess them seriously as investments, calculating how far they will see us through the seasons and carry us through the years. Gogol seems to notice the plangency of this, the ways that coats are predicated on a claim to the continuance of life itself and how such a thing is never guaranteed.

Death, for Gogol, is always undercut by a keen sense of ludicrousness. In 'The Overcoat', he shifts between lightness and seriousness then back to lightness, like the coats changed from and returned to for different weathers. We think that life is more turbulent than the regularity of the seasons, but even they make no promise of when they will come. We slip and lurch from one to the other, longing for the spring that becomes summer, cossetted in autumn as it slinks into winter. We pull on each coat and try to anticipate the next season but we can never be entirely sure of their arrival. They are a hope and a hazard too, a future that, at some point, for each of us, will never come again.

It is the charming past though, not any storm-clouded future, to which the always hopeful Jeeves and Wooster stories tend. They offer up a comedy of manners, as light as a summer blazer at a boating party. The worst that could happen is that Bertie Wooster's white cropped mess jacket could be 'accidentally' singed by the imperious Jeeves. Wooster eyes Jeeves suspiciously at this lamentable tragedy near the end of P. G. Wodehouse's novel of 1934, *Right Ho, Jeeves*. Cut in the Continental style, the jacket is worn by Wooster with no inconsiderable nonchalance in the casinos of Cannes ('not only *tout ce qu'il y a de chic*, but absolutely *de rigueur*'), much to the distaste of Jeeves. Smuggling it home, Wooster

sheepishly concedes to worrying over how his valet might take it since 'in the matter of evening costume, you see, Jeeves is hidebound and reactionary. I had had trouble with him before about soft-bosomed shirts ...' The encounter unfolds into a typically polite but taut tug of war, as Bertie narrates:

'Yes, Jeeves?' I said. 'Something on your mind, Jeeves?'
'I fear that you inadvertently left Cannes in the possession of a coat belonging to some other gentleman, sir.'
I switched on the steely a bit more.
'No, Jeeves,' I said, in a level tone, 'the object under advisement is mine. I bought it out there.'
'You wore it, sir?'
'Every night.'
'But surely you are not proposing to wear it in England, sir?'
I saw that we had arrived at the nub.
'Yes, Jeeves.'
'But, sir——'
'You were saying, Jeeves?'
'It is quite unsuitable, sir.'
'I do not agree with you, Jeeves. I anticipate a great popular success for this jacket. It is my intention to spring it on the public tomorrow at Pongo Twistleton's birthday party, which I confidently expect it to be one long scream from start to finish. No argument, Jeeves. No discussion. Whatever fantastic objection you may have taken to it, I wear this jacket.'
'Very good, sir.'

In the series of stories and novels, Jeeves is always pointedly a valet, not a butler, particularly attendant (notwithstanding the anomaly of Pongo Twistleton's birthday party) to his master's toilette, their relationship founded on the concern of one for the other's appearance. But Jeeves is much more than this, too,

in Wodehouse's gaily satirical social portrait. He is a protector and all-purpose problem solver, discreetly devising all manner of plans by which his master might escape the invariable mess in which he finds himself. Although the formal nature of the master and servant arrangement structures the stories, it is a relationship of mutual and profound affection. Jeeves cares for Wooster's clothes and, by proxy, Wooster too, just as Wooster commands and yet depends on his servant's sagacity. Jeeves's unfailing judiciousness in matters of dress is a mark of his more general wisdom, and Wodehouse takes pleasure in having Jeeves find ways of strategically marshalling (and often disposing of) the sartorial whims by which Wooster is so regularly taken. Monogrammed handkerchiefs, straw boaters, an alpine hat, a scarlet cummerbund, Eton-coloured spats and purple socks form the stuff of their domestic disputes, always peaceably resolved in the end like the tiffs easily fixed between familiar lovers.

While foppish Wooster is so often the butt of the author's joke, the seriousness with which Jeeves considers clothes is also a source of ridicule. Wodehouse archly notes how Jeeves's résumé includes a resignation from the service of Lord Worplesdon, apparently submitted in exasperation at Worplesdon's predilection for eccentric eveningwear. Clothes maketh the gentleman in the upper- middle and aristocratic classes of Wodehouse's fiction, but master–servant relationships are levelled in some way in the advisory negotiations over what is proper for a gentleman to wear. Jeeves is right to be unpersuaded by the white mess jacket Wooster brings home from Cannes, which in real life also possessed its own ridiculous history. The mess jacket, a formal garment which could be double-breasted and unfastened, or single-breasted and fastened, with either shawl or peak lapels, offered an alternative to black tie in tropical climates, and formed part of the uniform of first-year Etonians. Its popularity, though, is absurdly owed to George, the 2nd Earl Spencer, who was thought to have singed the tails of his tailcoat

while sleeping beside a fire (or else caught them on brambles while hunting), thereby unwittingly (or witlessly) initiating the trend.

In the Jeeves and Wooster stories, Wodehouse takes a level potshot at the landed gentry, their indolence and idiocy epitomised by Wooster ('a typical specimen of a useless and decaying aristocracy' in Aunt Isabel's pithy phrase), while managing to present Jeeves as a silent, impassive and yet not entirely unjudgemental witness to their absurdity. Sometimes, he is even complicit in its amplification. In *Right Ho, Jeeves*, he kindly (but mischievously) advises the faint-hearted and feeble-willed Gussie Fink-Nottle to dress up as Mephistopheles for a costume party, imagining that a diabolical disguise might better stir him into livelier spirits when addressing the icy object of his affection, Madeline Bassett. When the hapless Gussie manages to forget his wallet en route to the party and tries to abscond, the cab driver gives chase and snatches off his coat, unveiling, to his astonishment, a devil speeding furiously into the night. Later, an irritated Wooster, oblivious to the irony, chastises Jeeves for having dissuaded his friend from his usual costume: Pierrot the clown.

The devil in a coat and a singed white jacket are the source of mirth for Wodehouse, over which sincere and affectionate friendships are forged between men. And for Jeeves, as much as for Wooster, the general good maintenance of appearances provides a gentle means of securing the social order of things – the right dress coats are in the wardrobe and all's right with the world. It makes for a quiet kind of conservatism, and Wodehouse indicates that this is a congenial order that neither master nor servant have any interest in upsetting. In 'The Aunt and the Sluggard', when Wooster's friend Rocky, characterised efficiently as a sluggish creature fond of lounging in pyjamas and watching worms, complains of having to socialise ('Good Lord! I suppose I should have to dress for dinner in the evenings. What a ghastly notion!'), a speechless Wooster is 'shocked, absolutely shocked' by his slovenliness:

'My dear chap!' I said reproachfully.

'Do you dress for dinner every night, Bertie?'

'Jeeves,' I said coldly. The man was still standing like a statue by the door. 'How many suits of evening clothes have I?'

'We have three suits full of evening dress, sir; two dinner jackets—'

'Three.'

'For practical purposes two only, sir. If you remember we cannot wear the third. We have also seven white waistcoats.'

'And shirts?'

'Four dozen, sir.'

'And white ties?'

'The first two shallow shelves in the chest of drawers are completely filled with our white ties, sir.'

I turned to Rocky.

'You see?'

The chappie writhed like an electric fan.

'I won't do it! I can't do it! I'll be hanged if I'll do it! How on earth can I dress up like that? Do you realize that most days I don't get out of my pyjamas till five in the afternoon, and then I just put on an old sweater?'

I saw Jeeves wince, poor chap! This sort of revelation shocked his finest feelings.

Wooster is right to be concerned for Jeeves's delicate sensibility. He is refined and benign, a model of domestic security in the stories and novels. Placing an unerring hand on the tweed-jacketed elbow of gentlemen who are otherwise tyrannised by wives, fiancés and great-aunts, he kindly steers them through a series of elaborate, evasive manoeuvres. He is the model of a disarming, uneroticised homosociality that manages to rout or else roundly ignore pushy womanhood altogether, with a

chummy chap-ish superiority. He is, in this way, essential in shoring up Wooster's freedom and his cheerful resistance to feminine wiles. A man's valet loyally stands between him and any potential wife in the war against matrimony.

At one moment, it does occur to Wooster, with vague horror, that 'there must be quite a lot of fellows who have to press their own clothes themselves ...' He *is* fortunate in having Jeeves. Ousted to a hotel room after yet another chaotic case of mistaken identity, a despondent Wooster turns to his valet with his woes and finds the consoling Jeeves ready for him: 'The situation is certainly one that has never before come under my notice, sir,' he concedes gravely, before proceeding seamlessly: 'I have brought the heather-mixture suit, as the climatic conditions are congenial. To-morrow, if not prevented, I will endeavour to add the brown lounge with the faint green twill.' Under Jeeves's watchful eye, no storm is unnavigable, and there is every reassurance of the restoration of order. With him by his side, Wooster finds that all things in life can be fixed as easily as a crooked tie righted.

This simplicity is both the charm and the puzzle of Wodehouse's work. The Jeeves and Wooster world is never overcast by the wars that spanned their period of writing between 1915 and 1974 – apart, perhaps, from one detail. Wodehouse named his Jeeves after a real-life Percy Jeeves, a Warwickshire cricketer, whom he had happened to come across at a cricket match against Gloucestershire in his native Cheltenham in 1913. The *Wisden Cricketers' Almanack* records Percy Jeeves with fully realised detail: 'a right-handed bowler on the quick side of medium pace, and with an easy action that came off the ground with plenty of spin'. The real Jeeves was talented enough to impress the great England cricketer Sir Pelham Francis Warner, who earmarked him as a prospective bowler for his country. But within months, war was declared in Europe, and Percy Jeeves's brilliant future was tragically

curtailed. Volunteering for service, Private 611 Jeeves of the 2nd Birmingham Pals was posted to the Western Front with the 15th Battalion of the Royal Warwickshire Regiment. In July 1916, aged just twenty-eight, he was killed in action at High Wood, during the Battle of the Somme, his remains never recovered.

In one of the surviving images of Percy Jeeves, a grainy black-and-white equivalent of a player's headshot, he is posed in his professional kit, a snug Warwickshire team cap firmly tugged down on his head, beneath which a pair of faintly protruding ears can be seen. There is a schoolboyish quality to the face, offset only by the neatly bowed necktie and the lines of sloping shoulders just visible under a cricket blazer. The rounded collars are familiarly upturned in such a way as to suggest a certain sporting carelessness. He is youthful and handsome, Grecian-nosed with the hint of a smile about to break. In a military photograph, likely taken only a year or so later, the friendly cricket cap is replaced with a rigid peaked martial one: the same parted lips are discernible, still opening as if to laugh or smile, but the slight figure is drowned now in an oversized felt overcoat, the shoulders no longer sloping, but stiffened, extending beyond the parameters of the portrait.

There is a sorrow to the coat that does not yet fit its wearer, the shoulders that are compelled to carry the burden of war. The military overcoat asserts a sturdy manliness and demands that boyish things, cricket balls and village greens, be left behind. There seems little consolation to be drawn from the idea that Percy Jeeves, who would not be permitted the chance to play for his country, could be asked to die for it. In Percy Jeeves, the fate of young men in their cricketing whites wheeling across the Arcadian village greens of England are fused with those in the muddied trenches of France. Wodehouse's Jeeves extends to him a curious afterlife, a pastoral fantasy, in which an English idyll continues, untroubled by tragedy and unperturbed by politics. And yet, even as he was writing, Wodehouse's innocuous brand

of thornless comedy was already nostalgic, already redolent of a lost England barely in possession of its innocence.

THE POWER OF THE SUIT

A missing tie is the first sign of trouble in *Rhinoceros*, Eugène Ionesco's absurdist drama of 1959. The inhabitants of a provincial French town transform into the animals over the course of three acts, horns bursting from their heads and their skin turning to hide. The only human left standing (on two feet, not four) is a man called Bérenger, who begins the play notably dishevelled, being chastised by his disciplinarian friend, Jean, for his slovenly ways. When Bérenger admits to having misplaced his tie, Jean fishes one out of his pocket and knots it, reproving him: 'Your clothes are all crumpled, they're a disgrace! Your shirt is downright filthy, and your shoes ... [Bérenger tries to hide his feet under the table] ... What a mess you're in! And look at your shoulders ... Turn around! Come on, turn around! You've been leaning against some wall!'

Jean brushes Bérenger down and tries to straighten him out, figuratively as well as literally. This makes sense since the play's rhinoceroses are intended to be figurative too – they stand in for brutish impulses and a herd mentality. The idea that Bérenger has 'been leaning against some wall' horrifies Jean. It smacks of delinquency, of slouching James Deans and mooching Marlon Brandos, and Jean takes Bérenger's posture as demonstrative of a wider disregard for order and authority. It is the opposite of his own uprightness. Bérenger seems, instead, more inclined to, well, incline. He *leans*. He might even push, eager to test all forms of apparent rigidity. And so the dusty jacket discloses his autonomy in a terrifyingly conformist society.

The play, often read as critique of totalitarian ideologies (the various upsurges of Communism, Fascism and Nazism in

the twentieth century), depicts dissent as something that can be visibly identified and visibly repressed, as though obedient citizenship could really be told by the way one knots a tie. Clothes, here, work as a form of allegory, just like Ionesco's rhinoceroses stampeding across the stage. The animals suggest the forceful homogeneity of a conformist society and how impossible it would be for a dissenting voice to be heard among their ranks. Bérenger is firstly bemused by them, then rightly terrified, as the play's tone swings wildly from the lightly comic to the darkly sublime. The world it conjures seems to be teetering on an edge.

Writing between the wars, Freud also worries about the emergence of an increasingly conformist culture in his 1930 work, *Civilization and its Discontents*. If the submission of individual will to communal rules constitutes 'the decisive step towards civilization', civilised man, he observes, trades aggression and will for beauty and obedience. Such a civilisation, though, he notes anxiously, cannot be taken as an unambiguous good, since repression is unconducive to well-being. When Jean remonstrates with Bérenger over the dusty blazer, the scuffed shoes and the askew tie, he acts in the service of a collective civilisation and its ideals. The suit is the sign of a civilised restraint: what it houses is an unruly body whose desires and impulses are tamped down. But as Freud knows, the suited man is a tinderbox whose compulsions cannot be contained forever.

Foucault described the obedient citizen as a 'docile body' in his 1975 study *Discipline and Punish*. This docile body, he asserted, is the product of a society which marshals and trains human beings in the institutional forms of schools, hospitals, the military and the workplace, so that those bodies might then be 'subjected, used, transformed and improved' for a capitalist economy and the state it serves. The docile body obeys laws, heeds edicts, never deviates. The suit, and the formal uniforms of schools, the state and its workers, is one way in which this

disciplinary society makes itself manifest. It seizes the smallest quirk of individuality as a flashing warning, a signal of defiance to be squashed.

But Foucault's disciplinary society also works by subterfuge, unobtrusively acting upon each and every subject, cultivating in them a watchful self-regulation. This society needs no real threat of penalty when it can rely instead on an internalised discipline. We self-regulate in fear of retribution and reproof, Foucault explains, following the rules and tying our shoelaces as we are taught. How we dress can reveal that watchful, inward vigilance. Certainly in the workplace, many of us dress cautiously, fearful of digressions from specified regulations and accusations of unprofessionalism. The question at the heart of the disciplined society is *what* is it that we self-regulate? What do we fear in and for ourselves?

The suit emanates the power of the state, channelled through teachers, doctors, managers, bankers, policemen and politicians, outwardly imparting their authority. Its power can be self-effacing, so ordinary as to be invisible. In this way, men's suits are expressive of our peculiar modernity. In saying nothing, the suit says everything about us. You sense the eerie blankness of the ordinary in René Magritte's surreal series of suited men, their expressionless faces hanging in mid-air or obscured by an apple. They are uniform in their single-breasted suits, collared shirts, ties and bowler hats. They are the visual definition of nondescript, spookily vacant, like the void of the zombie dead. They could be anybody, and so nobody, all at once, banal and terrible in the same brushstroke.

Curiously, Magritte's surreal images emerged in parallel with more ordinary developments in the mass production of tailored suits during the early part of the twentieth century. The paradox of the ready-to-wear range was that there could be suits for everyone and that everyone could follow suit in wearing them. In one respect, the development of ready-to-wear, off-

the-rack suits is a form of democratisation, allowing all men access to the same silhouette. Its status as the default uniform of masculinity is owed to twentieth-century techniques of generalised pattern cutting, the machinery of mass production, even the development of standardised tape measures. But the anonymity afforded by the suit is a form of deletion as well as a democratisation.

The artist Joseph Beuys puzzles over this in his iterative *Felt Suit* series of 1970, an enigmatic meditation on the infinitely anonymous suit. The Beuys suit at Tate Liverpool is number 87 of one hundred identical suits produced in the same year in Düsseldorf. Its mottled brown felt is austere, purely functional, although never permitted to function. A simple two-piece, the jacket has broad notched lapels, graceless flap pockets at the hip and one at the breast, with no lining, no buttons and only a label stamped with the edition number of the work. It dangles, slightly slovenly, from a wooden coat hanger. When asked how he would like the work to be displayed, Beuys shrugged: 'I don't give a damn. You can nail the suit to the wall. You can also hang it on a hanger, *ad libitum*! But you can also wear it or throw it into a chest.' If there is an irritation in that apparently throwaway remark, perhaps it is because Beuys registers the reproducible suit as an insult too. It is a dehumanising object, deserving no special care.

Except that Beuys's installation *does* demand the particular care permitted an artwork. The felt suit on display is, in the gallery, demarcated by its aesthetic status, ring-fenced so as not to be touched, even as it is resolutely, almost impishly, ordinary. The curiosity of his suit is how determinedly unlovely a thing it is – blocky, brown and basic – so unvaried as to be almost uninspiring, the opposite of an artwork *made* into an artwork. It waits for a body that never comes, and so remains unspoilt, but it is also utterly unfulfilled. By being neither an ordinary suit nor an extraordinary artwork, it directs us to reflect on the arbitrary

JOSEPH BEUYS *Felt Suit* (1970)

distinctions between aesthetic objects and everyday apparel. Beuys's mischief exposes how the status of the suit is always a question. It can be anonymous and authoritative, freighted with a silent power, but it is never innocent.

This is what the political philosopher Hannah Arendt discovers when she reports on the proceedings of the Nazi war crime trial of Adolf Eichmann for the *New Yorker* in 1961. Eichmann confounds her – he is the 'banality of evil', a middle-aged man in a badly fitting suit and small, round spectacles, capable of sanctioning genocide. Eichmann was, it seemed to Arendt, the disconcerting picture of a greying bureaucrat, sober and imperturbable, as inoffensive as 'a bank clerk'. Watching him, she registered how the formality of the courtroom setting seemed to yield to Eichmann a certain respectability. The challenge, she realised, was to recognise respectability itself as a facade. Fascism could be an unthinkable monstrosity, and yet it could present in banal things – intractable bureaucracy, due process, obedient administrators. To understand evil in this way was not to downgrade atrocity, but rather to be alarmed by its ubiquity, the possibility for inhumanity in the most anonymous of creatures: a man in a suit, relentlessly following the most awful instruction.

What's so remarkable about Eichmann is how unremarkable he is. Even at his own trial, he is eclipsed by others. The Israeli writer and Auschwitz survivor Yehiel De-Nur takes to the stand in session 68. From the film footage, you can distinguish his white suit, so brilliant on camera that it is almost theatrical in comparison to Eichmann's drab and blocky form at the margins. When the prosecutor presents to De-Nur 'a suit of striped clothes' as evidence of the uniform worn by inmates of the camp, it is an astonishing moment for modern audiences, too, for whom the Holocaust can seem the distant subject of historical memory. Here it is made material and real. For De-Nur, the uniform renders the past undeniably present and that

realisation falls upon him like a blow. He sways unsteadily and absently hands the folded garments back to the court attendant, visibly dazed, before rambling incoherently and collapsing on the stand.

Throughout the proceedings, Eichmann is blank and unresponsive, as though he were an impartial witness to his own trial. He is as unbending as the suit in which he stands. At certain moments, he can seem wretched, the faintest expression of a bewildering vulnerability crossing his face. When the camera closes in, we note the receding temples, a stray wisp of hair, the nervous itch of the nose. He gives so little away that we seek out the clues, most particularly when he twitches or shifts, when his suited square form ripples. We catch a glimpse of the lines of a body shrunken by age, swamped by a blazer perhaps two sizes too big, the rumples in the shirt, his tie the smallest degree askew. In the film, the testimonies against him accumulate, but so too does the overwhelming sense of his alienation. How strange and puzzling is the watchful man in the suit who listens from the sidelines as each survivor recalls the horror unleashed at his behest?

Courts of law operate with codes of conduct and suit wearing forms part of the theatre of justice. To the impartial eyes of a judge or jury, a criminal in a shirt and tie can present themselves as a figure of moral uprightness. The suit loans them this, as though dignity, respectability, even innocence were qualities inherent to the garment itself, acting not even as a disguise but almost as a shield, deflecting any accusation. In a suit, one might secure absolution from even the worst crimes, and yet what both Eichmann and De-Nur reveal in the courtroom is the secret life of the suit wearer, the deceptions of which clothes are capable and the tumult they cannot always contain within.

The irony is that the purpose of the suit is to conceal weakness and withstand outward scrutiny. Formality is a mode of resistance to unwanted intrusion. The modern suit

has a certain totality and robustness, an 'irritating perfection', as dress historian Anne Hollander once wrote, noticing in it a completeness at odds with the jagged edges of life. The solidity of the suit sits awkwardly, she observes, when 'current millennial impulses tend towards disintegration'. When all around is fragmented and deconstructed, the suit remains, largely, the same. Its dominance in the history of menswear is itself a perfect expression of its power. In part, this resilience, the intention to survive any manner of indignity or infringement, is the purpose of the suit. It allows its wearers to emerge from any encounter unscathed. At its most exaggerated, the Bond hero gracefully dusts off his innumerable brushes with death, confirming the suit's ludicrous hardiness. On a Bond, the suit possesses a supersexed machismo. It is immunised with immortality.

The suit-wearing man heads fearlessly into danger, but there is a danger in the authority conferred by the suit. At times, this authority seems to derive from nothing but the fact of the suit itself, as if it generated it of its own accord. One of the peculiarities of men's formal wear is that it is so freighted with ideas of power and control, latent images of force figured in buttons, braces, zips, cuffs and ties. The suit retains this tacit possibility for repression. Even in its verbal noun forms – the 'collaring' and 'buttonholing', for instance, that mean to entrap or corner – the language of the suit suppresses and restrains. Power is a part of the suit like no other item of dress, audible in its language and visible in its form.

Hitchcock relishes in this in his 1972 thriller, *Frenzy*, in which genial fruit merchant and dapper dresser Robert Rusk turns serial killer, sexually assaulting women before strangling them with his own neckties. At the height of the drama, Rusk jostles with a corpse that he has dumped amid sacks of potatoes in the back of a lorry, desperate to recover incriminating evidence seized by the victim during the attack. It is a grim and entirely undignified scene. He snaps her rigor-mortis-stiffened fingers, triumphantly

releasing a distinctive jewelled tiepin in the shape of his initial, 'R'. Rusk, though, is finally 'collared' by the nicely arch police inspector, Oxford. Returning to the scene of his crime with a suitcase, ready to dispose of his latest victim, he finds the inspector awaiting him. The film ends with a brilliantly black and witty observation from Oxford: 'Mr Rusk, you're not wearing your tie.' There is a late-Hitchcockian silliness to the film that translates badly to modern audiences. It possesses none of the sultry heat of *Rear Window*, or the sordid Bates Motel menace of *Psycho*. It has instead a strange, prurient sensationalism, an unapologetically crude and sadistic impulse running through it. Hitchcock delights in the bizarre sexual fetish that can turn a smart tie and a tiepin into vicious murder weapons, but *Frenzy* also exploits the more real and alarming possibility of sexual violence that can lie under a smartly suited masculinity: this ruthless, reckless desire, tamped down, but lingering, not very far beneath the surface.

The suspicion that something more sinister might simmer beneath the facade of the suit's respectability recurs in more recent culture. Patrick Bateman, the eponymous American psycho of Bret Easton Ellis's novel, is its poster boy. Early in the novel, Ellis has him irritably remonstrating with the Chinese dry-cleaner to whom he delivers, with alarming regularity, a stream of blood-splattered ensembles. Women can be casually slaughtered, but each suit – by Armani, Hugo Boss, Brooks Brothers, Garrick Anderson, Soprani and Kilgour, French & Stanbury – is attended to with supreme care. Ellis's *American Psycho* viciously skewers the veneer of modern appearances, the 'yuppies' of the eighties and their preoccupation with luxury brands. But he also understands with his own sardonic and incisive intelligence that the suits in the novel do not simply mask violence, they are contiguous with it, even an absolute expression of it.

American Psycho (2000)

Bateman invites an ex-girlfriend to dinner, lures her home and then tortures her. Having nail-gunned her hands to the floor, he furiously corrects an error she had made earlier in the evening. 'And another thing,' he yells, 'It's not Garrick Anderson either. The suit is by *Armani*! *Giorgio* Armani,' before spitting at her, spraying her with Mace and forcing his penis into her mouth. The scene makes graphic the force of a powerful man and the incapacitation of the woman who faces him. Bateman's rage is maniacally absurd. What's more absurd, perhaps, is how in Ellis's prose, acts of sexual assault, torture, even decapitation are matched in their painstaking detail by meticulous accounts of dress. Murder and matters of dress are made part of a continuum of equal aesthetic and moral value. If Ellis never allows us to be sure of whether Bateman's assaults are vicious fantasy or gruesome fact, we are never in doubt of his monstrous vanity. It is *because* Bateman's narcissism knows no bounds and his delusions are so comprehensive, that we cannot trust his capacity to present an accurate account of himself. What we do know is never to trust in the facade of his fine clothes. In *American Psycho* the sharp suit and the knife-sharpening man are imbricated. The fantasy of violence is a manifestation of the rage and ruthlessness that is already there in the hedge fund manager.

Despite the emphasis on appearances, no one in Bateman's world places any stock in the respectability of the suit, least of all the suit wearers themselves who revel in their undisguised racism, misogyny and rampant addictions. Bateman only *acts* upon the same psychopathy that his peers recognise in themselves. At the beginning of the novel, Bateman and his friend Price visit the Manhattan home of a girlfriend. Bateman smiles as he catches his own reflection on the glassy surface of the table when he sets down a platter, while the preening Price immediately asks for a 'lint brush', wondering how well white socks pair with white trousers. All the characters in the novel agonise over the details of dress, at the expense of all other modes

of human engagement. They assess matters of appearance as though weighing up the meaning of life itself. When another friend, Craig, consults Bateman as to whether it is 'proper to wear tasseled loafers with a business suit', the question is posed as though it were a philosophical problem for the ages. 'Don't look at me like I'm insane,' he adds. Bateman *is* insane, of course, but so too is the society he keeps.

The luxurious consumption in which they indulge is frenzied and perverse – the same approach that Bateman takes to murder. Ellis implies that this world is distorted by the suit wearer and the serial killer alike. Neither of them is capable of basic moral judgement. What Bateman begins as meticulous scene setting spirals out of control into a kind of deranged monomania. He lists a linen suit by Canali Milano, a cotton shirt by Ike Behar, a silk tie by Bill Blass, cap-toed leather lace-ups from Brooks Brothers, threatening to go on ad infinitum, mimicking in his sentence structure the relentless accumulation of suits, stuff, money. Clothes signal status here. They are never a costume to conceal darker sentiments, since Bateman and his friends have no need for pretence, making apparent their contempt for women, prostitutes, tramps, taxi drivers, dry-cleaners, even dogs. The ludicrously expensive suit is the perfect *expression* of, not a disguise for, moral turpitude. And Ellis need not grant his characters qualities beyond their clothes, because they have none. They can identify the brands they wear but they can scarcely remember each other's name. Their self-inspection can only be skin-deep.

Stepping into the lift at work, Bateman observes his reflection, mentally itemising without pause his 'mini-houndstooth-check wool suit with pleated trousers by Hugo Boss, a silk tie, also by Hugo Boss, a cotton broadcloth shirt by Joseph Abboud and shoes from Brooks Brothers'. He briefly notes the coppery taste of blood at the back of his throat from having over-flossed his teeth. Immune to the gratuitous bloodshed of his crimes, Bateman *is*

alert to his own blood. But this is all the self-awareness of which he is capable. The details of his dress, obsessively catalogued to exasperate the reader, stand in for a soliloquy, the spiralling sentences piling up like the designer goods so feverishly accrued by all the characters in the novel. Despite this plenitude, the one sensation of which Bateman is sure is his own emptiness.

The terrible truth of the suit is that if it confers dignity and authority, it can also be erosive, offering up a dangerous kind of impersonality. In the novel, Bateman slips easily into alter egos and allows himself to be mistaken for others. He can do this because he is only pretending at being a person at all. During a muddled discussion of the merits of Bruce Boyer, the real-life fashion editor of *Town and Country* and author of the 1985 *Elegance: A Guide to Quality in Menswear*, Bateman has to interject to correct a misunderstanding, 'And no, Craig, he wasn't a serial killer in his spare time,' before proceeding to explain, 'It's an excellent book. His theory remains we shouldn't feel restricted from wearing a sweater vest with a suit...' In Bateman's world, fashion editors can be mistaken for serial killers – but so too can fathers for sons. Ellis stated that Bateman bore some resemblance to his own father, who had been a property developer and abusive alcoholic. In later years he would admit that 'Patrick Bateman was about me at the time ...' and that this misdirection was a way to deflect 'all the rage and feelings' that were his.

The admission is crucial. There is something disconcerting to the idea that the murderous man in the suit might be any of us, and that beneath its veneer we might conceal our most base instincts. The suit allows us to disavow those aspects we most despise of ourselves. It indicates the meeting of social mores, the polite restraint of anger and the disciplining of desire. Civilised social life hangs on the sturdiness of suited masculinity. Young men grow into the adult responsibility of its broad shoulders. Nations wait on the measured response of two-buttoned and straight-tied statesmen in times of crises. The beauty of the suit

is its even lines, its solid form, the assurance it so effortlessly imparts. We can modify suits, lend them colours, a jaunty tie, a stylish cut, but its object is almost always to mask the body, to suggest a formality, rigid and unbending. It can flatten the quirks of our dissenting personalities and it can override our errors of judgement with the authority it impresses nonetheless. The suit can dignify our most awful actions and impulses. And sometimes, wearing it, we mistake that dignity as our own.

HANGING ONTO COAT-TAILS

A necktie preoccupies T. S. Eliot, the former bank clerk turned poet, in 'The Love Song of J. Alfred Prufrock'. Prufrock despairs over the indignity of age and so he dresses with self-loathing and a resigned precision: 'My morning coat, my collar mounting firmly to the chin / My necktie rich and modest, but asserted by a simple pin'. He takes painstaking care to look entirely ordinary, even to disappear, but invisibility is its own kind of agony for Prufrock who finds the monotony of middle age punctured only by stabs of thwarted desire, the passing glimpses of girls bathing on beaches to whom he hardly registers. Prufrock longs and yearns but he also plods with resignation into a midlife so ordinary that it is absurd:

> I grow old ... I grow old ...
> I shall wear the bottoms of my trousers rolled.
>
> Shall I part my hair behind? Do I dare to eat a peach?
> I shall wear white flannel trousers, and walk upon the beach.

Suits can lend us the gravitas of age. It is the mode of dress most intended to indicate maturity. But Prufrock's rolled trousers

T. S. Eliot (1955)

reveal a man shrunken by the passing years. This – and the 'white flannel' uniform of the infirm on their daily constitutionals, the harrowing uncertainty as to the security of one's own teeth when consuming soft fruit – forms the interior monologue, merciless and mortifying, of a man confronting his own terrible senescence.

'Prufrock' was written in 1915 when Eliot was just twenty-six, but it is an older Eliot that better accompanies the poem. Percy Wyndham Lewis painted him in 1938, reclining in an armchair, his three-piece grey suit slightly rumpled, a white pocket square visible at the breast, signet-ringed hands neatly folded in lap, hair parted precisely and a shrewd look in the eyes. The younger Eliot had, at their first meeting in 1915, made a strong impression, Lewis recalling him as a 'sleek, tall, attractive transatlantic

apparition'. In the portrait, he has an angularity that owes to Lewis's cubist-influenced Vorticism, although it suggests, too, something of Eliot's thin patience, a steely inflexibility. There is no softened or diffused edge to the portrait; instead a faintly discernible vertical line runs along the plane of the nose, through the join of the waistcoat and through the seam of the trouser fly, as though the portrait could be split asunder, exactly in half. Curiously, the entire portrait, with Eliot's low-seated position and resting hands, draws the gaze down to his crotch. This doesn't seem intended as a crudely asserted sexuality. It is, instead, an expression of quiet self-control.

This makes sense. In the poem, the prospects of incontinence and impotence horrify Prufrock. The old age in which you are no longer capable of controlling your basic genital function is a fate worse than death. Eliot's Prufrock is plagued by a sense of the brittleness of masculinity, the indignity of the bodily and libidinal desuetude against which clothes provide such little indemnity. The suit houses the body, as though it could be encased in straight, upright, dignified lines, but this body is not always trustworthy. It is a body that cannot always master its functions, can scarcely contain its desires.

The idea of a masterful masculinity is what the suit holds up, but who is to say that this itself should be prized? 'I have always disliked being a man,' writes Paul Theroux in an essay titled 'The Male Myth' for the *New York Times* in 1983, bitterly lamenting how modern American masculinity seemed so unfairly to entail the loss of female friendship, relinquished in unsatisfactory exchange for a loutish sports culture. Masculinity, he complains, 'feels a little like having to wear an ill-fitting coat for one's entire life', while being a man means 'Be stupid, be unfeeling, be obedient and soldierly, and stop thinking ... It is a hideous and crippling lie.'

The ill-fitting coat is a metaphor for a broader discomfort, affective and intellectual, although Theroux specifically lists among the failings of manliness the 'sinister silliness of men's

fashions', and 'the so-called "Dress Code" of the Ritz-Carlton Hotel in Boston'. What he senses, lingering behind these strict edicts, is the closed culture of masculinity, the uniformity pressed upon the suit wearer and the challenge of living up to its dominant image. Theroux rebukes the demands made in the name of this masculinity and dreams of a different way of being a man. But, in 1983, his essay would have predated the panicked Aids scare of the later part of the decade. He invokes a crisis of masculinity, never imagining the storm still to come.

The anxiety around HIV infection, made manifest in the ostracisation of gay men, would undo the old securities of masculinity, perforating it and revealing its vulnerability. It also drew to the surface once more the old antipathy between sturdy manliness and an apparently pernicious homosexuality. This antipathy, still palpable today, is so bone-deep that it seems almost constitutive, as though homophobia were the axiom of masculinity, as though same-sex desire could dilute something quintessential to it. In designer Tom Ford's 2009 film, *A Single Man*, based on Christopher Isherwood's tender novel of 1964, Colin Firth's closeted gay college professor evaluates his life after the sudden death of his lover. As his life falls apart inwardly, he maintains an outward composure, his grief neatly contained within the confident lines of Ford's tailoring. When a neighbouring child innocently asks about his shoes, having overheard Firth's character euphemistically described as 'light in his loafers', Firth smiles wanly and deflects the enquiry. His perfectly pressed suits screen him from the world he cannot bear but in which he is forced to continue.

The culture of fashion is so often ambiguous in its understanding of sexuality. High fashion, in particular, can be temperamental in its vision, orthodox in its presentation of the extreme femininity of womenswear and the machismo of menswear in one season, then dismantling its tropes and radically queering gender in another. The suit has a crucial part to play in this, for women as well as

men. Yves Saint-Laurent's 'Le Smoking', a trouser suit designed for his experimental womenswear collection of 1966, recurs in his subsequent work. Redolent of the old Hollywood androgyny of Marlene Dietrich, it was in tune, too, with modernity and what seemed to be the increasingly unfixed lines of sexual difference. In Helmut Newton's photograph for *Vogue Paris* in 1975, a woman, cool and slender, stands in a night-lit street, her cropped hair slicked back and a cigarette in hand. She wears a Saint-Laurent tuxedo and is her own man.

When women adopt the trouser suit, it makes for a strident look, but it is also different each time. She can be Diane Keaton's scruffy devil-may-care Annie Hall, all oversized layering, boxy jackets, billowing trousers and ties, or a nineties supermodel in a low-buttoned blazer that plunges from sternum to navel. The suited woman is confident in her right to possess all the command ordinarily claimed by men. She can rephrase and query this masculinity too. 'It's like I'm powerful with a little bit of tender / An emotional, sexual bender,' sings Janelle Monáe in her synth-pop bisexual anthem of 2018, 'Make Me Feel'. Her vocals swing from breathless seduction to swaggering authority, surging with the refrain each time. She wears a patchwork suit in the music video, broadened with shoulders pads and nipped at the waist, as she moves freely between her male and female romantic interests. Tuxedos are Monáe's costume of choice, made glossy in satin, jazzed up with embellished lapels, bow ties and customised cuffs, exhilaratingly different and imparting a coolly urbane beauty.

A woman in a suit can be the most brilliant simulation, more manly than a man, a masquerading pretender to the crown, gamely seizing for herself the privilege that is not her birth right, without a flicker of doubt. If she is subject to derision, her power parodied and demeaned, it's because she poses a challenge, eluding any easy understanding of sexual identity and upturning the received modes of femininity. Masculinity, too, does not

escape this encounter unscathed. The woman in the suit, as Saint-Laurent understood it so clearly, is a question posed. She reframes manliness, performing it askew or even rupturing it so that it can be exposed as a fiction. What is it that women want from the suit? Not necessarily to be a man, entitled to all his authorities, immunities and dispensations. Perhaps they want to be *more* than a man. To prove just how flimsy his power, how carelessly appropriated and easily discarded it can be.

Janelle Monáe (2012)

The greatest illusion of the suit is its ability to signal strength even where there is none. At our most testing times, at weddings and funerals, job interviews and court hearings, we wear the suit as though it might imbue us with something we seem not to possess without it. It is one of those habitable structures – like homes and schools, offices and temples – in which life takes place. Structures are always predicated, though, on the possibility of collapse. Everything – sexuality, strength and civilisation – seems to hang from the suit. The thinness of this lie is, in part, also what makes the suit. The moments when the facade of the suit's impenetrability falls away can be powerfully illuminating: the reams of shamefaced traders exiting a disgraced investment bank clutching their possessions in a cardboard box, a stricken office worker thickly coated in dust being assisted from the site of an explosion, an American president crumpled like a marionette in the back of an open-topped Lincoln limousine.

Even the most powerful man in the world, suited and striding across a double-bulletproof glass-encased stage before a crowd of hundreds of thousands of people and a global audience of millions, the night after an American election, is vulnerable, violable. In an interview with *Vanity Fair*, Barack Obama affably explained his proclivity for a uniform range of grey or blue suits. 'I'm trying to pare down decisions,' he said, 'I don't want to make decisions about what I'm eating or wearing. Because I have too many other decisions to make.' The Obama dress code combats what is commonly known in popular psychology as 'decision fatigue', the phenomena by which one's ability to adjudicate steadily erodes over the course of a day. The sentiment has a certain carelessness, a confidence that matters of dress could only ever be a distraction, which is itself the privilege of a man with unquestioned power.

There *is* strength in steadfastness though. You recognise it and are reassured by it – the dependably unswerving

commitment made by the man in the suit who pledges to be always there, the rod-straight lines of a silhouette, unbending even under the greatest duress. The term 'investiture' is taken from Latin (*vestire*, 'dress', and *vestis*, 'robe'), and it refers both to the formal installation of an incumbent, a head of state, and the formal dress or adornment by which that status can be conferred. A man in a formal suit can claim the greatest power – an investiture by which they are granted the right to decree, making decisions to go to war, holding fire, declaring states of emergency, denouncing enemies, offering solidarity and sentencing death. How, though, could we ever be sure that we are equal to the commitments we make in the suit, whether they are wedding vows, funeral orations or presidential pledges? The suit channels power. It can mask doubt and deny disaster – but it is an illusion, both easily cast and uneasily unmasked.

The film-maker Wim Wenders describes his own dawning realisation about menswear in his meditative documentary of 1989, *Notebooks on Cities and Clothes*, which follows the work of the Japanese master tailor Yohji Yamamoto. He acknowledges, with surprise, the startling experience of first wearing Yamamoto's pieces. 'I bought a shirt and a jacket,' he intones gravely early in the film, as the camera pans across a studio following a young Yamamoto diligently bent at his work. 'From the beginning, they were new and old at the same time,' Wenders observes with quiet astonishment. It is an elliptical statement, the half-mystical thought that one might expect to find drifting through a languid Wenders feature film. It is true, too, in the sense that the best new clothes can feel as though we have worn them forever, managing to be fresh and familiar at once. Wenders means more than simply this though. Wearing a Yamamoto suit, he both remembers long forgotten things and feels his youth renewed. He understands, in short, the remarkable conjuring trick of clothes.

'In the mirror I saw me,' he explains, 'only *better. More* me than before.' He wears this suit in a way unknown to him in any

previous act of clothes wearing, and in that instant, he seems to magically realise the potential of the garment that was always there, awaiting the right possessor. We can fulfil a garment, as well as fit it. This garment 'suits' us, we say, meaning that its particular beauty, size or proportion is sympathetic to our form, but Wenders imagines a more magnificent collocation: the life of the suit and the life of the wearer somehow illuminating each other with a rare, mirrored glory. The suit *suits* him, like nothing else ever before.

Yohji Yamamoto (2018)

The Yamamoto suit seems to open up to Wenders what Freud would call the unconscious: thoughts that are barely admitted, hardly spoken out loud. When he dons his Yamamoto suit, what comes most powerfully of all is not only some sense of *himself* but the memory of someone else. This suit that suits him so perfectly is more than a mirror, allowing him to perceive a resemblance never before acknowledged: he sees in his own clothed body, the forgotten form of a lost father. Later in the film, Yamamoto, with immense difficulty, discloses the memory of his own father's death, and falteringly articulates an enduring sense of obligation, a responsibility to a lost generation of Japanese war dead, a burden, he concedes, borne in his work. What is most staggering here is the notion that an inanimate garment could contain such a thing.

How is it that a profound experience could be provoked by something as ordinary as a shirt and jacket? Wenders's scepticism yields under the force of an experience so extraordinary that he is tempted to accuse Yamamoto of supernatural powers: 'The label said Yohji Yamamoto. Who was he? What secret had he discovered, this Yamamoto? A shape, a cut, a fabric? None of these explained what I felt. It came from further away, from deeper.' Yamamoto possesses a secret, every secret that anyone might ever have, tailored into a garment, woven into the cloth. And it is this, finally, that Wenders succumbs to – the idea that an item of dress could carry our most deeply privatised confidences, the most unspoken things.

Nothing is more private than death. Not just the sacred memories of the death of those we have loved, but also the experience of our own, which is always coming, never quite here. The German philosopher Martin Heidegger describes death, exultantly, as our 'ownmost, utmost possibility', as though nothing could be closer to us, always at the edges of our being, carried in our selves. It is borne in our clothed bodies too. The promise of death is a burden like the heaviest coat – only we can

bear it for ourselves. At the end of the first volume of Karl Ove Knausgård's unstintingly attentive series of autobiographical novels, *My Struggle*, the author recalls the death of his father. 'Death was everywhere,' he writes. 'Death was in the jacket in the hall.'

Dreaming of his father's corpse, he awakens to such tremendous fear, he rummages through the wardrobe to reassure himself that there *is* nothing there – he heads there instinctively as though spectres and spirits would naturally congregate in closets, as though it were obvious that the dead leave their clothes last of all. He revisits the body in the morgue, and, at last, it is in the blunt reality of objects, not abstract formulations of the soul, nor romantic notions of nature, that death makes itself understood to him:

> Now I saw his lifeless state. And that there was no longer any difference between what once had been my father and the table he was lying on, or the floor on which the table stood, or the wall socket beneath the window, or the cable running to the lamp beside him. For humans are merely one form among many, which the world produces over and over again, not only in everything that lives but also in everything that does not live, drawn in sand, stone and water. And death, which I have always regarded as the greatest dimension of life, dark, compelling, was no more than a pipe that springs a leak, a branch that cracks in the wind, a jacket that slips off a clothes hanger and falls to the floor.

That death should return human beings to the ordinariness of inanimate things, is not for Knausgård some final insult or awful revelation, but the barest assertion of fact, pitilessly unsentimental and quietening. Death is the jacket slipping from a hanger. For Eliot, it is the coat being held out:

I have seen the moment of my greatness flicker,
And I have seen the eternal Footman hold my coat,
and snicker,
And in short, I was afraid.

Prufrock despairs at old age, but he also plucks from it a bleak sense of absurdity, mustering a defiance to be mobilised in the face of coming death. None of this keeps fear at bay. The concession that life's opportunities for greatness might long be snuffed out like a flame is painful. The eternal footman that assists you with your coat does not wish you well on your journey, only contemptuously marks you for your last departure. Death is not dignified or transcendent, not even melancholic and mournful, only inglorious, faintly foolish, and utterly ordinary again. Departures, whether everyday or absolute, are signalled in the taking of coats and the leaving behind of jackets. And so these garments seem so often to retain a certain phantasmal quality, a spookiness, not just in their suggestion of the dead that leave them behind, but also in the way that they take the shape of the bodies of the living who wear them. Coats without their owners have a cavernousness, seem often to be waiting in attendance, expecting the body that could fill them.

The dead leave their coats behind, but the young grow into grown-up suits. In the 1984 film of the Talking Heads concert *Stop Making Sense*, David Byrne happily bounces along to the band in a ludicrously oversized grey two-piece suit that ripples like water with every flex of his gawky frame. The absurdly proportioned blazer that lampoons the ostentations of yuppies, and the monstrous egotism of artists, is allusive, learnedly redolent of stylised Japanese Noh theatre, even mocking Beuys's repetitive brown felts. What tells most of all, though, is Byrne's youth, the loose limbs and even looser imagination. The suit for all its attempts at disciplining the body, denuding the idiosyncrasies of character and blanketing the quirks of

personality, cannot contain the young life within it, irrepressibly responsive, moving, living, growing. Byrne's beanpole body mocks the serious adulthood signalled by the suit: the sobering idea that the job of life is to grow into responsibility, authority, masculinity, not resist it, ridicule it, cast it aside altogether.

This is the kind of resistance of which only youth are capable. It happens in the lightness of song or the speed of a film. Young men tear off the sobriety of the suit and throw off coats, laughing at them, leaving them far behind, sailing off unburdened. In Leonard Cohen's 'Famous Blue Raincoat', the coat of the song is 'torn at the shoulder', and that smallest detail seems to suggest the weight of the world: the melancholy of a love affair as it falls apart, the carelessness of the betrayal that instigates the end, the slow, creeping drizzle of the city in which one might be left behind, unloved, and in which a raincoat offers small protection. The raincoat had been made by Burberry and bought in London when Cohen was just twenty-five. 'It hung more heroically when I took out the lining,' he said, 'and achieved glory when the frayed sleeves were repaired with a little leather. Things were clear. I knew how to dress in those days.'

Coats aren't meant to last. We mend them, lose them, replace them. At some point, we're supposed to grow out of youthful jackets and into grown-up suits. For some of us, that adulthood never comes. In *Rebel Without a Cause*, James Dean wears a blazing-red blouson jacket, as though he could wear it forever. It is a trim, light scarlet flash of a thing and it exemplifies the film's spirit of youth, eternally reckless, rash and desirous. It is the coveted red jacket, ineffably sexy, smart and cool, that Jim trades for Plato's gun and in which Plato is fatally shot. But in life, as in film, the jacket could only ever belong to James Dean. It is vivid, truer than the black-and-white shots of his battered biker jackets. The red jacket signals life, even beyond the fact of death. We are accustomed to the idea that we take our leave by taking our coats, and there is an undeniable melancholy in the disappearing silhouette of our loved ones after they've said their goodbyes,

Poster for *Rebel Without a Cause* (1955)

but coats are for peeling off, for swinging off shoulders and tying around waists too. The discarded coat hanging from the back of a chair tells us that someone is here, that they have brought with them laughter or adventure, life itself.

And we can hold fast on to the coat-tails of others. 'Don't let go the coat,' croons Roger Daltrey in the 1981 The Who song of the same name. There is a self-righting resilience to the melody, impossible to describe, but which offsets the boyish disregard of the opening lines where he insists that he 'can't be held responsible for blown behaviour'. In Pete Townshend's version of the song, he admits to a charming dissipation, a recklessness audible even in his rhymes (the roguish Tuesday 'mor-ning' that stretches so nonchalantly into 'yaw-ning'). But Townshend had written the song in the throes of addiction and religious salvation, the latter most particularly in the form of the teachings of Indian guru Meher Baba, to whom the song is dedicated. This tumultuous background accounts for the song's curiously dovetailed religious and rock-and-roll register, and its oddly commingled seriousness and exhilaration.

In the music video, as Daltrey cheerily bops along in an oversize white blazer and insouciantly shoulder-thrown silk scarf, Townshend supports from the side with guitar, leaning in meaningfully for the chorus, repeated blindly like a mantra. In Townshend's own vocals, there is something more aching, a pleading insistence, almost helpless, hardly even hopeful:

> Please don't lock me out because I missed a phone up
> I can't bear to live forever like a loner
>
> Don't let go the coat
> Don't let go the coat
> Don't let go the coat
> Don't let go the coat

The headiness of youth, love and intoxication is steadied by a chorus that is less a chorus, and more an incantation, as adamant as it is simple. *Don't let go the coat.*

The tradition of the touching of hems derives from the Bible, specifically Matthew 9:20, which recounts the parable of the woman who reaches for the hem of Christ's robe and finds herself cured of disease. In its more idiomatic usage, touching hems signifies respect or reverence for someone, a gesture of fealty or fidelity by which we might draw the strength or comfort from another that we otherwise lack alone. When we need in this way, we are abased, but we are compelled to supplicate because our experience of dereliction is so extreme that it demands repair. When we touch a hem or catch at the sleeve of another, we admit what little faith we have in our own ability for restoration. We hang on to the coat-tails of those in whom we have confidence and this is predicated by our own self-doubt. And yet to *keep* hold also requires courage or commitment, something like faith. To hang on to someone else's coat-tails can be literally hard: our grasp must hold fast with their every unpredictable turn or whim. It requires strength to abdicate one's own will to that of another, something like love. But when Townshend recites again and again that rolling refrain – 'Don't let go the coat' – it is an invocation of himself, a gathering of his own resolve even as it is a statement of devotion to another. It is the most perfect expression of that faulty, utterly human sort of impulse, the ruinous one of youth, that drives itself into disaster, falters and finds its feet again and again:

> So I live my life tearing down the runway
> Sure to get the hang of hanging in there someday

Grown-ups know to be resigned to this – we cannot stop the heady tearaway who speeds off, regardless of risk, in the pursuit of adventure. But there is an understanding here too.

How difficult it must be to get the hang of hanging in there, not just learning to hang on for dear life but learning to live at all, coping with the lapses and recoveries, the triumphs and the disappointments, and the commitment to continue to seek absolution. The song has a quiet determination, that strange, characteristic, inexplicable touch of Who-ish melancholy, a youthful doggedness, a hope for salvation, because if not that, then what?

Adolescence is always edged with this yearning. I think of the boys I've watched grow up, their jackets snagging on fences and their coats soaked in the rain, and later, the men that I loved, leaning against bars and leaving their blazers behind, how impossible it felt to contain them, to keep up with them. The suit images adult masculinity, the conformity and convention of sober, responsible life. It is underpinned both by the violence of authority and the comedy of manners, but what it wants to resist finally, perhaps, is something unstoppable and ebullient: the spirit of youth, rolled-up sleeves and loosened ties, coat-tails flying in the wind.

'There are moments, Jeeves, when one asks oneself "Do trousers matter?"'

'The mood will pass, sir.'

P. G. WODEHOUSE *The Code of the Woosters* (1938)

3.

Shoes

HOW TO STOP TIME IS THE QUESTION. How to push up and out from your curled toes and bent knee when the gun goes, as though you were the bullet it expelled, generating from within the force to propel an entire body forward. How to test gravity, springing clean away from the ground and across the earth, each reaching stride purposefully lifting off from the track beneath. How to get yourself from the hard edge of one white line to cross another, only by means of your feet. I run instinctively barefoot at first, fluent and childishly unencumbered. Small and slight, I can summon an unexpected power from some unseen depth. I leave older, bigger, brasher kids behind, and when I glance back I am surprised to see them struggling in my wake, falling off the race resigned, because I can run forever. I know the kind of speed that is so unreasonable and so wildly uncurbed that it feels like delirium.

Freedom is the feeling of the crushed grass that stains the balls of my arched feet. A watchful teacher collars me after school, puts away the hurdles, clearing the track on a warm day, holding out to me those gleaming new, light-as-air three-striped spikes that change everything. I don't know where that first surge of strength comes from, how my limbs and lungs give up to me the speed I call for, but with those shoes on my feet, I feel myself running up as close as I can against a limit I never knew I possessed. From then on, I run compulsively, against the wind, against myself, against the clock, straining to beat time itself. Even now, in the slowed decades afterwards, the memory of that speed comes flooding back to me easily, unbidden, remembered in the rush of air in my ears, the passing cadence of a runner's yearning stride. Eventually, I give up track, turning to court shoes, blocky wedges and towering platforms, relishing in the sharpness of a narrow vamp, a flash of rude colour, the variegated textures of leather, suede and snakeskin,

the perfect declining gradient of a heel. I run only for trains and out of the rain. I am constantly hurrying somewhere late and braking to a sudden stop, pulled along by the speed of life.

When my meniscus tears the summer I turn thirty-seven, I watch silently as uninjured athletes stream steadily beneath my window, their ears plugged in, their feet unfaltering onwards. The days are long and balmy, and I sense how the sun-softened tarmac yields to the pressure of their heels, how the mild air warms their muscles. My recovery is slow, the consultant explains, pointing to the shadow on the MRI, because blood supply to the menisci is poor. They are the crescent of the moon, the curved C-shaped cartilages at the articulating joint of the knee, connecting femur to tibia. They are firm and flexible – but they wear with age and impact, suffering a daily attrition. What the misery of injury opens up to me most of all is the unseen mechanics of my frame, the precise and delicate architecture of joint, muscle and bone that allow for the perfect articulation of our limbs. How could I ever have assumed that my small, sole-worn Nikes would be sufficient to the task of absorbing the force of the earth against my feet? How could I have ever supposed that this fragile joint would hold firm, that this easy, painless running motion would be mine forever?

The thing is, deep down, I still think that I will be able to run for all eternity, that it is some strange genetic gift, a birth right of speed that I can summon like a superpower, a sense of balance and response that is uniquely mine. I know how to propel myself through air and against gravity. Age will not strip me of this, I think, disbelieving. So I look everywhere for light-as-air, three-striped spikes, determined to stop time again.

The German poet Johann Wolfgang von Goethe once wrote beseechingly to a girlfriend, requesting a pair of her shoes. 'So that I can have something of yours,' he entreated, 'to press against my heart.' Fortunately for that lovelorn youth, stiletto heels had yet to be invented, thus averting literary disaster. But as Goethe's impulse indicates, there is something undeniably intimate, romantic even, to the humble shoe. In shoes we trudge, often along lowly paths, through detritus and debris, and yet they can solicit the highest praise. They are capable of elevating us in every sense.

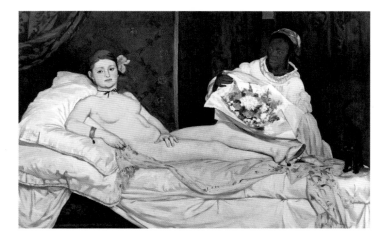

ÉDOUARD MANET *Olympia* (1863)

Even Manet's Olympia knows to keep hold of hers when all else is stripped off. She reclines in the painting, her gaze cool and her creamy body tapering (for those whose attention is not derailed by the nudity) into a pretty pair of clogs: blue-trimmed

and stout-heeled, oddly innocent, quaintly redolent of ice cream and hair ribbons. These shoes reward attention. We notice that they are small, too small, in fact, for her feet. One shoe has been kicked off and nestles in the tellingly tousled bedsheets, the other perches pertly on a foot evidently unconcerned by details like size or fit. This is footwear that cares not one whit for functionality. Practicality matters so little to Manet's *demi-mondaine*, who will never need to stand, is destined always to be supine, supremely sexed.

A century earlier, the French writer Nicolas-Edme Rétif had described the delicious allure of the *venez-y-voir* or 'come hither' shoe, giving his name to 'retifism', or footwear fetishism. The protagonist of his pornographic novel *L'Anti-Justine*, a 1798 riposte to the Marquis de Sade, swoons over *'un joli soulier rose à talons verts, élevés minces'* (a pretty pink slipper with green-coloured heels, high and slender), conceding *'J'avais surtout un faible pour les jolis pieds et les jolies chaussures'*. ('I had an especial weakness for pretty feet and pretty shoes'). The association of shoes with sex is long-standing. Sexologist Alfred Kinsey soberly documented how 'curled toes have, for at least eight centuries, been one of the stylized symbols of erotic response'. At the most basic level, some shoes simulate a sexual stance; a heel elongates the leg, amplifies the arch of the foot, raises the buttocks, cants the entire axis of the body, tilting the torso forward. And who dares deny that the pliant foot mimics the penis when it enters that dark, contracted space of the shoe, prising it open, or else easily finding entry into a form that tightly holds it close?

But this is an absurd idea too! How tiresome is the notion that a woman's shoes could be shorthand for her sexual availability. How uneasy are the fantasies figured in the foot and the contortions it is forced to take. Some shoes break us – the stilettos that squeeze our toes senseless, the court shoes that cast us headlong down a flight of stairs – but then there are the spikes in which we run so fast that it can feel like flight, skates in which

we whirl and win medals, sturdy wedges in which we navigate whole cities as a stranger, buoyed with a confidence expressed in our unfaltering stride. The life we live in shoes is capricious. Our shoes try to match this life, like for like, as though they could be as sharp and rebarbative or flirtatious and alluring as we are. They can be structured, supple, aggressively engineered, primitively simple or dazzlingly futuristic. They can hobble us and they can enable us. In them, we can prove our agility, but they are often quietly expressive of other things too. We can be fleet-footed and quick-thinking at the same time, because the life of the mind is not so far from the life of our legs.

What I mean by all this is that in their shod state, human beings find their footing, figuratively, as well as literally. They make sense of the world, reckoning with its physical conditions and testing their ability to master it. Our shoes allow us to realise that potential. In them, we traverse all manner of terrain at unexpected speeds and to unimaginable ends. It is strange, then, that we so rarely grant them any great dignity. At best, we are absent-minded, and at worst, we are contemptuous, splashing in puddles, stepping in shit, levering them off by squashing the back heel of one with the toe of the other, abandoning them, scuffed and unsorted, in miscellaneous hallways and porches. When we do take care of our shoes, it is with the fervour of idolatrous worship, in senseless devotion to a favoured brand or in the breathless longing for luxury goods: the pristine Adidas hi-tops you've collected since you were thirteen, the pearl-studded Jimmy Choos, still boxed and pressed in paper from your wedding day.

What, though, would we discover if we paused for thought? If we peeled the shoes off our feet and held them up for inspection, would we dismiss them as the uninteresting artefacts of our hopelessly mundane lives? Or could it be possible to recognise in them a particular aspect of our humanness? They house our feet, of course, and we are accustomed to treating our feet as objects

of absurdity. Feet are certainly functional and often unlovely, but they are also the starting place for so much of what we do and who we are. Our feet make us travellers, workers, dancers, clowns and athletes. They make us free, or at least they express our longing to be free, and so our shoes, then, are the instruments of that freedom. And yet, if they enable our accomplishments – whether ordinary or exceptional – they always come up against a limit. Each time we bend to tighten a lace or right a strap, we confront the problem of the bipedal creatures we are and the enormous ambitions we contain.

When Ted Hughes wrote of the caged jaguar, he recognised how, even in his captivity, 'His stride is wildernesses of freedom: / The world rolls under the long thrust of his heel. / Over the cage floor the horizons come.' Humans are not wild cats, but the world spinning under the soles of our feet compels from us the same impulse and is met with the same frustration. We move and yet can never move enough. If we're lucky, we'll see the world, but there's always more to see. Our existence is determinedly earthbound, even when our aspirations are elevated. Heidegger loftily complained of the 'groundedness' of ordinary life, lamenting the everyday conventions and familiarities into which we lull, when we might instead be thunderously awakened by the existential realisation of 'being' itself. But one of the ways in which we exist, *in situ*, in life, is on our feet. It makes sense to think that the shoes we choose to wear might shape the nature of that existence. If first we begin barefoot, then come bootees, the plimsolls in which we play, the whole heap of jumbled Ls and Rs. Their names are an incantation: those brogues and clogs, decks and Doc Martens, espadrilles, flip-flops, galoshes, gumboots, kitten heels, lace-ups, loafers, moccasins, mules, sturdy oxfords, studs, trainers, waders and walking boots. Each offers a way of navigating the world. We can flounder, trip or trek. We walk the earth in so many ways, with such determination and desire, that sometimes it feels as though we might even step clear off it and away.

When toddlers are first coaxed to walk, their unblemished feet steadied against a flat surface, we cheer and coo appreciatively at this developmental marker, this rite of literal passage. How quickly, though, we forget the struggle of taking a step forward. For most of us, ambulation is a thoughtless aspect of our lives, but there are powerful truths about us that are understood in the work of our feet. So much begins and ends there – religions and races, civilisations and their apocalypses. Our feet come first in the story of being human. 'Put off thy shoes from off thy feet,' commands God to Moses with a beautiful evenness in Exodus 3:5 of the Old Testament, 'for the place whereon thou standest is holy ground.' When God manifests in the burning bush on Mount Sinai, he instructs Moses to come no closer, demarcating an unbreachable line between the human and the divine. He demands instead that Moses remove his shoes, so that he may feel this holy ground, as though Moses could never be close enough to Him, as though only skin to skin, or sole to soil, one might finally come close to God in life.

Curiously, the science behind the story makes sense of it since the human foot possesses more nerve endings per square inch than anywhere else in the body. These nerves continuously evaluate the characteristics of the surface underfoot, assessing its viability for walking, bearing our weight and maintaining our balance. Moses's story, though, suggests more even than this. Going barefoot is sacred. You'll know this if you have ever stridden through sun-warmed sand, stepped out on the first fine film of snow or propped up a toddling baby on a tickling lawn. Our relegation to everyday shoe wearing can feel like an implicit insult, a reminder of our own ungodliness, the heavy, human fact of our lumbering footfall that contrasts with the ethereal lightness of the divine.

Is this why we remove our shoes to enter some places of worship? Ancient Egyptian priests at the threshold of their temples knew not to sully sacred spaces with a stray sandal. It is a practice that continues in modern Islamic, Judaic and other religious traditions, where the removal of shoes seems both to preserve the cleanliness of a site of prayer and signals a symbolic submission to holy will too. It is an act of intimacy and deference. In the case of Moses, the baring of feet is especially meaningful in the context of the eventual exodus of the Israelites from Egypt. They walk through the wilderness to their promised land. This idea of walking as an act of worship is a feature of the Islamic tradition, too, in the journey of hajj and the circumambulation of Mecca. *How* you walk, in particular, is a spiritual question. In 'The Criterion', Chapter 25 (63) of the Quran, God advises the faithful to walk in 'humility and sedateness', to 'tread the earth gently, and when approached with ignorance respond only in peace'. It is a quietly expressed sentiment about expressing religious sentiment itself quietly, strikingly at odds with the hostile parts of contemporary culture that configures Muslims as extremists readying to blow up the innocent passer-by. Here, instead, the edict is to walk (يَمْشُونَ, *yamshūna*) on the earth with gentleness (اَنْوَه, *hawnan*).

This idea that God might be found in our feet seems counterintuitive to the familiar notions of worship where prayers, once uttered, drift up, ascending to heaven. But if the treading of feet, like the meeting of hands, is a gesture freighted with religious feeling, it means that shoes, too, bear a spiritual significance. In the Christian tradition, Christ washes the feet of the disciples at the Last Supper. When John recalls this in the Book of John (1:27), it is with a profound sense of his own unworthiness. He metaphorises these feelings specifically in the image of a shoe. Christ is he who comes for John, but 'whose shoe's latchet I am unworthy to unloose', he confesses. At the heart of John's consternation is the truth of a relationship – tender and

reciprocally compassionate even if he does not feel equal to it – unexpectedly forged in this image of feet. John gives his feet to Christ and Christ sacrifices his earthly body for John. We know that to drop to our knees or to kiss another's foot is a form of supplication, an acquiescence to a greater authority, but do we ever truly register the contract implicit in it, the relationship affirmed by it? When we fall at another's feet, often at their shoes, we entrust ourselves to their care.

In the Book of Ruth (4:8), Boaz buys the hand of Naomi with a shoe and this humble gift to his neighbour serves as the surest commitment. The contractual nature of their marriage is made manifest in this object. It seems too easy to suggest that relationships are expressed in and through our shoes when relationships can be so inconstant and unpredictable, but our shoes seem capable of figuring that complexity as well. We can run to those we love and kiss the feet of those whose mercy we plead. We throw shoes as a mark of our contempt and kick at those we despise. Suetonius, the Roman historian, records the Emperor Nero kicking his pregnant wife, Poppaea, to death, after she complained at his coming home late from the races. Our shoes are a complicated marker of our social bond – and the means by which we break it too.

When two mismatched shoes forlornly wash up on the shore of Robinson Crusoe's desert island, the dejected castaway laments his comrades, drowned in the shipwreck that only he has survived. They deepen his sense of abandonment. He responds almost entirely differently though, later, when he stumbles upon a stranger's footprint on the sand, thunderstruck by the idea of an alien presence. 'How it came thither I knew not,' he puzzles, 'nor could in the least imagine.' It never occurs to Crusoe that this footprint could be attributable to a friend, could promise companionship or rescue. He understands it instinctively, reading it instead as a threat, the cipher of a monstrous, phantasmal intruder, the mere possibility of

which sends him scurrying back to a sleepless night in his shack. His paranoia exposes the logic of the coloniser who cannot countenance the idea of their own strangeness. How could anyone else have a prior claim to a land in which you are newly arrived? Despite the humanness of the footprint, in Crusoe's imagination, the native islander is a devil, a race apart, and so his response is to master and bend Friday to his will. The sodden shoes were the sign of lost friends, but the footprint instigates enslavement – a devastatingly different mode of relationship entirely.

Perhaps Crusoe is right to fear the footprint. Footprints can be ghostly things, the barest impression of a body that was here in this place where we are too. They are evidence, conventionally betraying burglars and murderers. They tell us we are not alone. Yet the footprint can be alluring too. It is that fading trace of an ephemeral presence, the faintest sense of something fuller that might still be yet to come. In Rainer Maria Rilke's late poem, 'You Who Never Arrived', he imagines an elusive lover, always a few steps ahead, the 'Streets that I chanced upon, – / you had just walked down them and vanished'. The footprint is like a fragile and tantalising promise. It attests to our ability to come and to go, the mobility *and* the mutability that makes us human, like the marks that melt in snow or the shapes washed away from a shore.

Sometimes, though, miraculously, footprints are captured in stone, deep and old. These ancient footprints are a sign of the longevity of life, a synecdochic part that figures the whole, a representation not just of a man, but potentially all men. When we see it in geological museums or archaeological sites, this footprint awakens a primordial memory of a distant past that is carried within us still. It is at once small and enormous. The earliest bipedal hominoid footprints were discovered in Laetoli, Tanzania, in 1976 by archaeologist Mary Leakey. What the analysis of the Laetoli footprints reveals is the obligate bipedal locomotion that characterised the evolutionary shift towards a

recognisably upright human form. Some 3.7 million years ago, this earliest human strode through volcanic ash, so that we might retrace their footsteps and understand our own origin. The analysis of the print reveals a pronounced heel strike with a lateral transmission of force to the base of the metatarsal, a well-developed medial longitudinal arch and an adducted big toe with a deep impression suggesting lift. In short, the Laetoli footprint reveals the bone-deep knowledge we already possess of how to walk.

On any given day, we will pull on our boots and stroll over to the supermarket, the post office, to work, to lunch, to play. Will we think that what we do with our feet could reveal to us anything even remotely important about our nature? The philosopher Georges Bataille noted how the foot differentiated humans from anthropoid apes, how it marked our earthboundedness, in contrast to our tree-dwelling ancestors. 'Man moves on the earth without clinging to branches,' he wrote, 'raising himself straight up in the air like a tree, and all the more beautiful for the correctness of his erection.' The idea of the vertical axis of human life is persuasive, if we think of how stoutly we privilege our uprightness, locating our intellect in the head rather than the feet. And yet, in electrical theory, we talk of 'earthing', safely discharging currents from our contact with the solid land beneath us, just as in common speech we prize the 'down to earth' and the 'well grounded'.

Human life, Bataille mused, is only erroneously understood as an elevation. With our feet in the mud and our heads in the light, we move back and forth, enraged by our lowliness and longing for the height of the skies. Our feet are as far as it is possible to be from the brain. It seems such an obvious observation, but this distance is indicative of a more general disdain for the bodily life that is emblematised by our feet. Bataille observed the 'imbecilic way' in which our feet are fated for corns, calluses and bunions, the ugliest manifestations of our faulty and easily disfigured

form. Despite this, it is our ungainly feet that hold us firm and walk us home.

Oedipus owes his grim fate to his feet. He is unfazed by the Sphinx's riddle: 'What is that which in the morning goeth upon four feet; upon two feet in the afternoon; and in the evening upon three?' The Sphinx guards the entrance to the Greek city of Thebes, perplexing all travellers seeking passage – except for Oedipus who answers easily with a uniquely personal, first-hand, first-*foot* even, knowledge. Walking (or, at least, the various stages of our ability to master it as babies, as adults and in old age with the aid of crutch) is the key to the conundrum. *Man* walks. The answer comes to Oedipus readily since walking is not an unthinking activity for him. Disabled, almost from birth, he owes his limp to the injury inflicted upon his feet by his fearful father. His very name – *oida* (I know), *pous* (foot) – attests to how integral an activity walking is to his identity.

Sophocles describes Thebes, the city to which Oedipus seeks entrance, as 'a desert blasted by the wrath of heaven', but this is also the city of his birth to which he has unwittingly tracked home. Footprints are especially important to desert people – each track is idiosyncratic, marking a distinct pathway out of the endless stretches of sand. When Laius orders the disposal of his baby son, Oedipus, he specifies that the cursed child be abandoned on a 'trackless mountainside', so that he might never be able to find a route home again. But Oedipus, who *knows* by his *feet*, does exactly that. And it is his injured feet that finally verify his awful identity to his horrified mother/lover, Jocasta.

Perhaps Jocasta, too, is guilty of covering her tracks. Does her attraction to Oedipus bear the unsettling trace of a latent memory? Isn't it the residue of a deeply imprinted genetic footprint, forgotten for so long and fated now to surface, despite the catastrophic consequences? We jest about the blind leading the blind (and blindness will be Oedipus's fate too), but from the beginning of the story, Oedipus's limping feet lead him back to

Thebes with an almost automatic knowledge, like the muscle memory you cultivate when you have walked a route home, time and again. His feet already know everything he has yet to learn.

The point is that we need not be Oedipus to find at our feet the truth about ourselves. All of us walk in the footsteps of our ancestors. Even when we seek to innovate or when we falter and err, whether we consciously strive to defy those time-honoured traditions or take a wrong turn by accident, we find ourselves, so often, returning to a familiar path, a deeply worn rut, a groove. We fall back into the behaviours and impulses that we inherit, the habits of our mothers and the faults of our fathers. Sophocles calls this fate. We might call it genes. Whichever it is, we cannot run from it.

Oedipus is unlucky. His life goes astray from the moment of his birth. Most of us find a more straightforward route into adulthood. Somebody props us up, puts the shoes on our feet and teaches us to step forward, until we are able to carry ourselves into life independently. We need help because learning to walk is no small feat. It is children and clowns, not lofty gods and Greek kings, who know the difficulty of this best of all. Falling over is a frequent part of the repertory of both, and that accounts, perhaps, for their affinity. As any child can tell you, a clown's boots are always oversized and their laces likely to be tangled. Their shoes will get stuck in mud and molasses, leaving telltale prints across circus stages. The feet within are easily sprained and toe-stubbed, stumbling over sundry dogs, balls and banana skins. Chaplin noted wryly of his clownish Little Tramp that a funny walk comes naturally when you put on size 14 shoes.

The thing about clowns is that they understand the sheer ludicrousness of being bipedal, the absolute hokum and miraculous jiggery-pokery by which human beings ever manage to stand upright at all. Grown-ups stupidly forget that we ever had to learn to walk but clowns only play dumb. They know the mystery of walking – and also its counterpart, the tragedy of the

pratfall. Shakespeare's clown Launce makes a joke of left and right shoes in Act 2, Scene 3 of *The Two Gentlemen of Verona*, distinguishing one as his mother and the other as his father, since one 'hath the worser sole'. But in Act 4, Scene 6 of *King Lear*, walking is no joke. Edgar turns carer to his blind father, pulling him to his feet, in a heartbreaking reversal, with the patience of a parent with a child: 'Give me your arm. Up, so. How is't? Feel you your legs? You stand.' We say with such lightness that a person never forgets how to ride a bike, as though a motor skill, once learned, is never forgotten, but when we find our feet in walking, there is no promise that this knowledge will not leave us. The loss of this knowledge is catastrophic because it is connected to so much else. When consciousness begins to go, when the world slips away, it is our legs that fold first, the sign of something terribly wrong. When we recover, we strive to be 'back on our feet', made steady again.

In the moments of crises, there is no guarantee that any of us will be ready to run. When the storm breaks and we are compelled to flee, there may be no time to find the right shoes for our feet. 'Remember, when there is war, the first thing is shoes, and second is eating,' Primo Levi writes in *The Truce* (1963), the record of his experience of Auschwitz. 'Because if you have shoes, then you can run and steal. But you must have shoes,' he insists, repeating the advice given to him by his fellow captive, Mordo Nahum. 'Yes, I told him, well, you are right, but there is not war any more. And he told me, "Guerra es siempre." There is always war.' This is what we forget. We forget that we must always be on our toes, prepared to run when the danger comes, because it can come so suddenly, without warning and without end. The wearing of shoes can ready us for this, that moment, whether we stumble or sprint, when everything will be trampled underfoot because nothing matters any more except out lives.

The barefooted who flee the burning house or stagger from the earthquake display a vulnerability to which we might

all be subject to different degrees. In his 1947 memoir *If This is a Man*, Levi describes a state of dereliction, where having 'reached the bottom', it is not possible to sink any lower. 'Nothing belongs to us any more,' he explains, 'they have taken away our clothes, our shoes ...' Nazi storehouses, like the one discovered at the Majdanek camp in German-occupied Poland, with its mountain of 800,000 shoes, are a harrowing monument to the abandonment of European Jewry during the Second World War.

Some shoes are forcibly taken away; others are unknowingly left behind. At the end of Virginia Woolf's *Jacob's Room*, Jacob's mother asks bewildered: '"What am I to do with these, Mr Bonamy?" She held out a pair of Jacob's old shoes.' The sadly abandoned shoes break her heart, but the tragedy can be in the walking too, in small feet that are asked to make unthinkable journeys, trekking from war-torn homes in shoes designed for children still young enough to be carried. For most of us, the longest journeys are undertaken by air, the kind where we readily complain about cramped seats and queues. We kick off our boots and pull out our tray tables, occasionally registering the expanse of the earth that rolls away beneath our resting feet. On-board screens track our flight paths as a dotted line. But 'flight' also means to flee. For some of us, the routes we take are not always those we might have chosen for ourselves.

The refugee runs, swims, sails the winding route, seeking the place where their feet might finally be permitted to be still. What they leave behind is more than only a home (as if a home could ever be *only* such a thing), it is also the generational footprint that situates us in the places our families have lived and died for centuries. These are the places with paths that have been forged by the feet of our ancestors, whose footsteps no one will ever follow in again. A Syrian boy washed up on a Turkish beach, drowned in a desperate attempt to traverse an enormous sea, wears shoes for the land he will never live to walk upon. In the 2015 photograph of Aylan Kurdi, his sodden corpse has

been collected by a Turkish coastguard and he is carried in the familiar way of sleeping children by their parents, feet dangling and shoes still strapped on, only one Velcro band loosened by the water – as though a thousand possibilities for adventure and investigation were still available to him should he only awaken and fasten his shoe.

Wearing shoes imparts a basic sense of dignity, and for those who survive disaster, those who are pulled from rubble or saved from the fire, the loss of shoes is also a mark of absolute dispossession. In Samuel Beckett's *Waiting for Godot*, Estragon miraculously manages to keep hold of his boots in the play's post-apocalyptic wasteland, but these boots are, in turn, a taunting reminder of his abject condition. What does it matter that we have boots if there is nowhere for us to walk? They acquire a grandiloquence, mockingly meaningless. When Estragon decides to pull off his boot, it is a struggle that seems eternal, a task of cosmic magnitude to which he applies himself with monumental effort and in whose accomplishment he only finds infinite disappointment:

(ESTRAGON *with a supreme effort succeeds in pulling off his boot. He peers inside it, feels about inside it, turns it upside down, shakes it, looks on the ground to see if anything has fallen out, finds nothing, feels inside it again, staring sightlessly before him.*)

VLADIMIR: Well?

ESTRAGON: Nothing.

VLADIMIR: Show me.

ESTRAGON: There's nothing to show.

VLADIMIR: Try and put it on again.

ESTRAGON: (*examining his foot*) I'll air it for a bit.

VLADIMIR: There's man all over for you, blaming on his boots the faults of his feet.

There is a disjuncture here between the confidence with which Estragon believes he will find something and the indifference with which he receives his disappointment. Beckett pillories the idea that our greatest revelations should be sought anywhere at all by having Estragon seek them inside a boot. There is no divine meaning to discern in the play's wasteland (in which, notoriously, 'nothing happens, twice'), and our search for it is as insignificant as emptying a boot. Instead, there is a subtle, tauntingly circular pun in the boots themselves: the *godillot*, or French clodhoppers, whose very name rings of the Godot whom the two characters await, and their own affectionate diminutives – Didi and Gogo.

Godot is as readily found in humble boots, perhaps even in ourselves, as he is in divinity or sophisticated philosophical enquiry. When the two protagonists discover that Estragon's boots have been swapped in the second act, they discuss this insignificant detail with great seriousness. 'Mine were black,' Estragon explains. 'These are brown.' Vladimir questions him thoughtfully: 'You're sure yours were black?' Estragon replies doubtfully: 'Well they were a kind of gray.' Beckett taunts us with the utter banality of their exchange. The colour of the boots means so little; they are engaged only in what Freud once described as the narcissism of minor differences. These distinctions matter nothing because existence is futile and the world is empty, like the dark interior of a pair of boots, and when Estragon eventually discards them in frustration – 'That's enough about these boots' – he means more than the boots alone. He means that's enough of God, of civilisation, of love even.

Estragon's struggle with his boots is existential, but there are other more mundane kinds of struggle too, like the everyday troubles of the worker who grapples with their daily toil. Estragon's hobnailed boots are also those of the labourer. They resemble those that Van Gogh famously painted, and in which peasants till fields and farmlands. The shoes that we pull on for

work, without pleasure, are tainted by futility, the pointlessness of having to work in order to live and only being able to live by working. Exploited French millworkers in the eighteenth century cast their wooden clogs, *sabots*, into their machines as an act of defiance. From those clogs, we derive the word 'sabotage', and so there is both abjection and resistance in the shoe.

In the opening scene of Shakespeare's civic drama *Coriolanus*, the Roman Senator Menenius Agrippa singles out one of the gathered citizens as 'the great toe of this assembly', to which epithet the bewildered citizen takes umbrage:

> FIRST CITIZEN: I the great toe? Why the great toe?
> MENENIUS: For that, being one o' the lowest,
> basest, poorest,
> Of this most wise rebellion, thou go'st foremost.
> Thou rascal, that art worst in blood to run,
> Lead'st first to win some vantage.

Hobbes, later in the century, would describe the nation as a body, the king at its head. Menenius has something similar in mind when he describes with withering condescension the 'greatness' of the toes, those lowliest citizens, sent out first into battle and among whose ranks the most blood is shed. The 'First Citizen' is deliberately nameless, only one of so many in a faceless crowd, but this crowd also votes with their feet. They move en masse, their allegiances shifting to and from Coriolanus in the course of the play, their collective will as fickle as fate, transforming the city around them. The citizens remind Coriolanus of how power is felled by the body politic and how the 'great toes' can pull the rug out from under those who claim to rule, as readily as they give them footing. They are this multitude, relegated to the margins and they might at any moment rise to their feet. They are only the footnote to a history that is conventionally told through kings and colonels, but which is meaningless without them.

Workers might be the footnote to history but they possess revolutionary power, as Marx understood with such clarity. The margins can be an exciting place to be. You can derail the order of things when you are made to stand at the sidelines. *Actual* footnotes do this too, in some small way. When we read heavily annotated works, a niggling irritation tugs our reading down and away. Nicholson Baker plays with the relationship between a shoe, a foot and a footnote in his comically digressive novel *The Mezzanine*. 'My left shoelace had snapped before lunch,' explains the narrator, deadpan, providing the story's only plot point before extending into excruciatingly painful detail. His narrative meanders, always eventually returning to the blank fact of the broken lace. Is it an event of no consequence or every consequence? It's hard to tell. The protagonist cannot decide either. Indecision is, for him, a crisis of almost existential proportions.

Baker's narrator suffers from an extreme version of what is, in reality, the everyday dilemma of judgement which all of us wrestle with all the time: the difficulty of discerning the substantial from the superficial. How do we ever work out what to attend to at any given moment? We sift the data from the digression or detach the body of text from the foot of a page. We examine the face instead of staring at the shoe. But the things that we dismiss as inessential prove themselves, so often, to be indispensable too. Both footnotes and feet share a curious banality, an ordinariness that is ultimately revealed to be integral. Baker's own footnotes to the novel grow increasingly rambling, as his protagonist's story spirals out of control. He even offers up a footnote on footnotes, advising against digressions, although it is advice he doesn't heed himself. His prose strays wildly, is not at all plot-driven, always prizing the detail over drama. And by parrying with the conventions of writing, he opens up questions about how stories work altogether. Aren't the truest parts of a story the auxiliaries,

the background colour to the big action – the scuffed boots, we might say, rather than the bravado?

The small things are what enchant Vladimir Nabokov when he reflects in a 1944 lecture on the brilliance of Gogol's 1842 novel, *Dead Souls*. He observes how Gogol gives life to peripheral characters by illustrating some striking detail. In *Dead Souls*, it is the new boots belonging to a lieutenant, recently arrived from Ryazan.

> Every now and again he would go up to his bed as though he intended to take them off and lie down; but he simply could not; in truth those boots were well made; and for a long while still he kept revolving his foot and inspecting the dashing cut of an admirably finished heel.

Gogol's scene with the lieutenant testing his immortal jackboots lingers like the embers of a fire in Nabokov's own imagination, his fascination with the passage mimicking that of the man with his footwear. The detail possesses him, carries his own writing away:

> the leather glistens, and the candle burns straight and bright in the only lighted window of a dead town in the depth of a star-dusted night. I know of no more lyrical description of nocturnal quiet than this Rhapsody of the Boots.

The boots seduce Nabokov as they do the lieutenant. Rereading Gogol, he finds that the devil is in the detail, that attending to the minutiae rewards us. From the small things – a man's new boots – we might derive an entire world.

And isn't this the point? Isn't this the secret beneath the footprint on the shore that alerts us to those who were here before us, the telltale limp of a king that will unravel his entire

life, the rebellious 'great toe' upon which the body politic stands, the footnote at the bottom of the page that explains it all? All kinds of knowledge, everything, lies at our feet. We need not be seeking the answers in the stars. We might pause to glance down instead. We pull on our boots and thoughtlessly stride through the detritus of a day. But our feet, callused and limping, our shoes, lace-torn and lost, remind us that we can understand the world in more modest terms, that the truth is not found in transcendent but earthbound things, expressed not at length but only quietly footnoted.

WHERE WOMEN WALK

When Hamlet gladly greets his troupe of travelling players in Act 2, Scene 2 of Shakespeare's play, he ribs the adolescent boy assigned the female parts, noting his apparent growth spurt: 'Your ladyship is nearer to heaven than when I saw you last, by the altitude of a chopine.' Chopines were the staggeringly high platform shoes of sixteenth-century Venetian noblewomen. They could be made of wood or cork, covered in brocade or velvet, but always tall, the sole of some reaching a thickness of twenty inches. Surprisingly practical, they hoisted the foot above muddied early-modern streets and waterways. Their Eastern equivalent was the *qabâqiib*, a vertiginous wooden clog, worn to keep feet dry in the hammam, or baths. The most exquisite, extant versions are inlaid with mother-of-pearl in that instantly recognisable style of Ottoman furniture.

The height of the chopine and the *qabâqiib* signalled high rank: a symbolism as heavy as the step of the woman wearing them. But they were shoes that prompted more subtle moral questions, too, about the elevation of earthly women over heavenly gods. It wasn't unusual for men to wear heels in the early-modern period but, as so often, there seemed to be

something more serious at stake in the matter of what women wore on their feet. We can make ribald jokes about what the size of a man's shoe reveals, but women's shoes solicit more sober inspection. They are objects of imaginative and often sexual speculation in art and in wider culture. How women walk matters.

In Shakespeare's joke, the chopine serves as a scale of measurement. He calculates the boy's height by his *actual* foot as well as in feet. That feet happen to be the conventional unit of poetic metre as well makes for a quirk that always delights Shakespeare. Here, as elsewhere, he riffs on it in the way of a deliciously reflexive joke. In Sonnet 130, he famously teases his lover for her black hair that is like 'wires', the breasts that 'are dun' and the breath that 'reeks', before the pay-off that comes at the closing couplet: the reassurance that this faulty mistress elicits a love that is more real and true than disingenuous flattery could suggest:

> I grant I never saw a goddess go;
> My mistress, when she walks, treads on the ground:
>> And yet, by heaven, I think my love as rare
>> As any she belied with false compare.

Everything turns on the couplet, which swoops in to allay an angry mistress. The twelfth line, though, supplies a crucial detail. This mistress 'walks, treads', not glides nor floats. She is earthbound, not ethereal. She is, perhaps, even rather plodding, especially heavy-footed, both *walking* and *treading* at once. The doubled motion sub-vocally suggests two feet but it also, mischievously, serves to supply an extra beat to meet the metrical footage required by iambic pentameter. It levels the ground for the punchline to come in the closing couplet, metaphorically anchoring the mistress on earth and metapoetically drawing our attention to the writer's own unerring sense of metre. Shakespeare can toy as easily with poetic feet as he toys with his

mistress's vanity in this sonnet. And he cannot place a foot wrong because, in this sonnet, those feet that tread on the ground know that they are loved beyond measure.

By contrast, when Juvenal ridicules love in an attempt to dissuade his friend Postumus from marrying in *The Satires*, he sneers, 'What's more insufferable than your well-heeled female?' The contempt is not for the shoes per se but for the self-possession they seem to signal, the calculated threat to carefree male bonhomie that marriageable women seem to pose. The correlation of women's shoes to matters of love and marriage is the stuff of folklore, visible in so many folk customs: the tying of old boots to the cars of newly-wed couples, the superstitions by which a loosened shoelace signals how you linger in your lover's thoughts, or the shoe on which a piece of clover catches and augurs marriage to the next single man who crosses your path.

It is the stuff of fairy tale too, with variations of the Cinderella story extant in almost every culture. Among them you will find an ancient version that dates back to the first century BC, in which a Greek slave girl, Rhodopis, has her sandal snatched by an eagle, retrieves it and marries a king of Egypt; a ninth-century Chinese version in which the hard-working Ye Xian befriends a fish (the reincarnation of her dead mother), loses a slipper and is rescued from her tormenting stepfamily by a king; and an early Native American tale in which a young girl suffers burns to her face, escapes her cruel sisters by borrowing her father's moccasins and stumbles into the home of a great chief capable of recognising her inner beauty. The name 'Cinderella' derives from Giambattista Basile's 1634 Italian version of the story, where a girl called Cenerentola loses an expensive platform shoe, a *pianelle*, that raises her 'a span and a half'. Charles Perrault translates a version of the story in 1697 as 'Cendrillon', for his *Histoires ou contes du temps passé avec des moralités*, and it forms the basis of the subsequent Brothers Grimm version and other modern English translations.

Curiously, somewhere along the story's circuitous line of transmission, a confusion emerges. The French novelist Honoré de Balzac seems to have been responsible. Noting how the French word for glass (*verre*) resembles a different, archaic word for fur (*vair*), Balzac conjectured that Perrault, having misheard one for the other, had perpetuated an error in the story – fabricating a glass slipper in place of a fur one. Balzac's theory seems unlikely (*vair* had long fallen out of use, and Perrault seems to have been working from a text, not oral sources), but whatever the truth, the idea of the glass slipper troubled him. Perhaps it should trouble us too. What's so striking about glass is how it lends its particular qualities – fragility, transparency, a sharp edge – to Perrault's telling of the story.

We might imagine that Cinderella's slipper is bespoke and impossibly precious, but the shoe itself is not fragile, proved by the prince who systematically tests it on every woman in the land. Much more brittle is Cinderella's fate. It's this fragility that glass suggests, the precariousness of a future decided by the fitting of one foot to one shoe. Glass can intimate violence too. In Perrault's version, the wicked stepsisters are threatened with the hacking off of toes in an attempt to secure the slipper, but this is only a caricature of the implicit brutality that permeates the story itself. Cinderella's servitude is sentimental in the innocent schoolroom telling of it, but hers is also a form of subjection secured by an implicit abuse. The treatment she receives at the hands of uncaring siblings tacitly threatens to tip into violence at any moment. This is the jagged edge of glass. The redemption of glass, though, is its transparency. And Cinderella's glass slipper also promises revelation, the making visible of the truth: that the girl in rags will ultimately be seen for the woman she is.

The difficulty of the Cinderella story is that it should all end so neatly. It was Cinderella's story that yielded that old adage which begins 'If the shoe fits ... ', and which we often neglect to complete, so self-evident is its apparent truth: 'wear it'.

In Cinderella's case, if the life offered up to you is attractive, then seize it. In Beeban Kidron's quirky feature-length film of the fairy tale from 2000, with Kathleen Turner as a foghorn-voiced stepmother and Jane Birkin as a gap-toothed mermaid godmother, Marcella Plunkett makes for a troubled, lip-bitingly unsure Cinderella. When the shoe fits, something else niggles and she refuses to wear it, turning on her prince, demanding what he will do for the peasants he's never met, the tradesmen he's never heard of, the kingdom that is his and for which he has displayed so little interest so far. This Cinderella seizes the right to demand more from this charming prince than is offered up to her, more from the complete life now stretching before her. This uncertainty, this refusal to accept at face value some facile promise of a fairy-tale ending, comes, perhaps, from bitter experiences of servitude – and of something else. There is in the fairy tale a detail worth attending to: the shoe that fits Cinderella also once fell from her foot when forced to run for her life. When the storm comes, when the chimes hit twelve, we might find that we are alone. We have only our own resilience to rely upon – not even the shoes on our feet will stay with us through the cold, dark journey home.

For those of us who wear heels, if not quite glass slippers, the vexation of the shoe that is faithless to our foot is a familiar feeling. We know the small irritation of a leather upper loosened by daily wear, the pump that parts from the arch of our foot at every step and trips us up. Shoes demand a particular kind of muscle memory from feet. We are most alert to it when we change shoes, shifting from favoured winter boots to forgotten summer sandals. We remember the friction-incurred calluses that are softened in the winter and harden once more in the summer when we return to slip-ons, sandals, loafers and flip-flops. We find ways to ease the transition: pop socks and plasters, blister pads and bunion shields. But the truest relief comes like an unburdening when we are freed from footwear altogether,

when we can pull off our boots and rest our working/walking feet. Our shoes don't always fit us easily, but perhaps nothing in life does. Even in Cinderella's case, how can we be sure that married life will promise happiness forever after? The shoe that apparently fits seems to consign us to a certain kind of life, but we can kick back. We need not toe the line.

In Hans Christian Andersen's 'The Red Shoes', Karen cannot be kept in check. She covets red shoes, her material longings usurping her spiritual commitments. In dreaming of red shoes, she neglects her daily work and heavenly devotions alike, and so the story presents a thinly allegorical battle for Karen's soul/sole. The bewitched shoes she receives doom her to dance forever. They are the realisation of her deepest desire and its reproof too. Her compulsive dancing is presented in the story as an act of retribution for her impiety. It is also an expression of her irrepressible will. When she beseeches the woodcutter to finally amputate her feet in order to detach the cursed red shoes, the grim gesture is offered up as a bloody penance paid to her censorious community. It is also a violent act of self-suppression. To win back the confidence of her church, Karen is compelled to cripple herself. Afterwards, the ghoulish shoes eerily traipse off into the woods, while the maimed Karen hobbles to her pew.

The reward for Karen's renunciation is glorious entry into the kingdom of heaven. At the last, she joyfully trades in her humble earthly life for holy ascension. Andersen describes the bright sunshine that streams into the church in which Karen sits, how it fills her with peace and joy until her very soul 'flew on the sunbeams to Heaven, and no one was there who asked after the Red Shoes'. Unlike the crippled Karen, Andersen moves easily here, shifting in register from fairy tale to religious fable, but the story's abrupt conclusion poses a problem, physical, as well as theological. How *does* one reach God? How do mortal, faulty, desirous human beings transition from earth to heaven? Andersen has Karen magically float away on a ray of light, as

though heaven were no abstraction but a material destination, an actual journey easily undertaken in a fairy tale. But if Andersen means Karen's floating soul as a clumsy allegory of Christian redemption, the fantasy of her flight reminds us of the fact of our real feet. We are decidedly earthbound and, at least, unharmed, even if our souls are unsaved.

The problem of how we might travel from a state of sin to one of salvation – and how a woman, in particular, might move through the world – takes a different, aesthetic turn in Michael Powell and Emeric Pressburger's experimental film adaption of 1948. Marius Goring's ardent composer Julian Craster promises a kind of transport, both actual and figurative, to Moira Shearer's dreamy, aspirant dancer Vicky. 'When you're lifted up into the air,' he assures her, 'my music will transform you.' 'Into what?' she replies sceptically. With its suggestion of wind-tossed flowers and soaring birds, Craster declares that his music and her inspired dancing will reach, literally, new heights. But Vicky knowingly retorts: 'It's hard enough to get off the ground anyway without being a bird or flower.'

The mechanics of how you move from reality to imagination is posed again as a technical problem later in the film, when during the ballet performance the shoemaker leaves the fabled red shoes positioned upright, *en pointe*, onstage, and Shearer's dancer, with fantastic athleticism, leaps directly into them, the ribbons magically fastening up her ankle without human assistance. When the sequence is slowed, the frames betray a telltale flicker, the splicing together of two discontinuous shots. The illusion of Shearer's tied shoes are realised by a sleight of technical hand. The answer to the question 'How do women move through the world?', is, then, in reality, easy and facile: by special effects.

The leap in the film, though, is presented as a kind of magic, and like Karen's ascension to the heavens in the fairy tale, it exposes the fantasy of a woman's effortless movement. Vicky is

cynical of Craster's vision because she knows, by her practised, cruelly callused and contorted feet, the hard work required to realise it. She knows too how difficult it is for a woman to fulfil her ambitions, to move through the world without restriction. No dancing shoes are equal to the desire that drives her. When Anton Walbrook's brooding and temperamental maestro Lermontov interrogates her at the beginning of the film as to why she dances at all, she responds passionately: 'Why do you want to live?' There is a theatricality to the exchange, something florid, almost embarrassing in the undisguised precocity, but Vicky is articulating an overwhelming desire of which dance is only an expression.

This desire is more than simply sexual. It is libidinal in Freud's encompassing sense of the term, referring to that feverish psychic drive behind our mental, as well as bodily, processes. It is the insatiable compulsion to think, feel, sense and see, an inchoate but insistent hunger. Tellingly, after her marriage, a fitful and secretive Vicky wakes in the night and rifles agitatedly through a drawer of ballet shoes, as though the shoes might provide what married life has failed to: the satisfaction of some unarticulated longing. When at the very end of the film Vicky abruptly leaps in front of a passing train, the melodrama of the moment disguises the more pressing question: *why?* Vicky leaps *to* her death, but we also leap *from* things – from pain and pressure, guilt and struggle. Powell and Pressburger's film retains some of the fantastical qualities of the Andersen fable, but it is something *real* and unspoken that Vicky, ultimately, cannot bear. Freud once famously conceded his inability to illuminate the answer to the question 'What does woman want?' In *The Red Shoes*, female desire doesn't reveal its object, only that it is an ungovernable and self-immolating force – obliquely articulated, here, in a woman's feet.

The relationship between feet and desire is fraught. The descent into a bended knee is a gesture of supplication – a lover

conventionally lowers himself to his beloved's feet when asking for her hand. In Anaïs Nin's *A Spy in the House of Love*, Sabina's young lover, Donald, kneels to re-lace a loosened sandal and he feels 'a unity resembling the first unity of the world, unity with nature, unity with the mother, early memories of an existence within the silk, warmth and effortlessness of a vast love'. Sabina's foot operates as a conduit, providing a communion between 'the heart of her and the core of himself'. For Donald, the taboo of the foot fetish is not the thing itself but the latent sexuality it awakens, associated with the memory of a maternal intimacy.

It is a taboo sexuality of a different order that Humbert notoriously succumbs to in *Lolita* when he deploys the apparent innocence of foot fondling as a decoy for masturbation. Lolita's sunburnt legs sprawl across his lap in the infamous scene as Humbert's feverish desire escalates, but the novel is littered throughout with 'loosened slippers', 'sloppy anklets', 'sandaled feet' that brilliantly illustrate both Lolita's juvenility and the absurdity of Humbert's ardour. Nabokov is wickedly alert to this. When he has Humbert describe how in kissing 'the yellowish soles of her long-toed feet, I immolated myself', it is to lampoon the self-deceptions of which he is capable. Later, he imagines 'falling at her dear feet', but the professions of abjection are transparently insincere, a simulation of submission in a fantasy scenario where only his desire is absolute and uncurbed. Significantly, in both Nin's and Nabokov's descriptions, the female foot is immobilised. Stilled, the older woman and the younger girl disclose a vulnerability that is eagerly seized. We like to say that we 'fall' in love, casually, as though it were only a stumble, an accident of circumstance or even spontaneous. But the question of what happens at and to women's feet, in the fantasies of men, is complicated.

Women's feet are easy to worship, or at least this is what Pushkin enthuses at considerable length in his 1833 narrative poem *Eugene Onegin*. Onegin exuberantly declares his beloved's

foot greater than Diana's bosom and Flora's dimple. He reverently, but promiscuously, envisages it everywhere:

> at long hemmed tables, half-concealed,
> in spring, upon a velvet field,
> in winter, at a grated fire,
> in ballrooms, on a glossy floor,
> on the bleak boulder of a shore.

> I see the surf, the storm-rack flying ...
> Oh, how I wanted to compete
> With the tumultuous breakers dying
> In adoration at her feet!
> Together with those waves – how much
> I wished to kiss what they could touch!

Like Donald kneeling at Sabina's sandal and Humbert's 'immolation' at Lolita's long toes, this kissing of the ground beneath a woman's feet is imagined as an act of surrender. It is also an aggressive act of adoration since those worshipped feet are disenabled. There can be no resistance to this apparent act of submission. The adored woman cannot run since Onegin only adoringly follows in her footsteps, tracking her movements. The poem reveals here the impulse for surveillance beneath the supplication, because to worship a woman is to demand to know her whereabouts, where she has come from and where she will go next.

Where *do* women walk? And can they ever go alone? These are Hanold's questions, you'll remember, in Jensen's *Gradiva* (see the chapter 'Dresses'). The bas-relief that Freud spots in the Vatican is browned with age, and the young woman in it is poised mid-stride, head bent forward as she hurries, pacing everlastingly onward. Marching into battle, the gown that falls in folds around her swirls too, suggesting the speed and vigour of

her movement. The skirts that are drawn up to clear the ankles expose her faintly sandalled feet: one pressed flat, the other arched in motion, toes pushing off from the ground beneath her.

Gradiva is the object of Hanold's fullest fantasy. He happily attributes to her an elegant gait, miraculously deducing it from her stilled image alone. When he launches into an account of her 'maidenly grace', it is with an unimpeded imaginative licence, detailing the 'sandaled feet', the ankle, the left foot that advances, the right foot about to follow, the sole, the heel, the tips of toes. She possesses, he enthuses, 'exceptional agility', a poise and peculiar dignity. But '*Where had she walked thus and whither was she going?*' he wonders.

How is it, we might ask, that a man could fall in love with a woman's walk? Freud offers a typically Freudian answer when he explains a fetish as 'an effect of some sexual impression, received as a rule in childhood', and describes how 'the foot represents a woman's penis, the absence of which is deeply felt'. Jensen certainly cannot resist the sexualised fantasies formed at a woman's feet, but isn't Gradiva the walker of her own path, placing one foot after another, dauntless and unerring? The questions Jensen asks – *Where had she walked thus and whither was she going?* – disclose something less obvious and more disquieting at the heart of the story. This woman possesses her own secrets.

The mystery here is not just Freud's old question – what does woman want? – but *where* do women go? Where is it that a woman comes from and where can she go to next? Where might a woman walk and a man not follow? What does it mean for a woman to take her own path? That women might travel beyond the purview of the men who desire them riles and infuriates. It even inspires the kind of writing in which that freedom is imagined curbed. Yet Humbert cannot prevent Lolita from straying from the tightly circumscribed limits of his fantasy, and in Gradiva's sandals there is another story (about female desire,

volition, interiority) the depths of which not even Freud can begin to plumb.

That women's footwear should be underpinned by an impulse to immobilise is most apparent in the aristocratic traditions of Chinese foot binding which began in the eleventh century, but it remains, undeniably, discernible in the nonchalantly unreasonable culture of modern heels. We might adore the glamour of a sharp vamp or the curved finesse of an instep, but there is no innocence or accident to the fact that free movement is not a prerequisite of women's shoe design. This is disclosed in the sharpness of the stiletto heel and the stupidly distributed weight of a wedge that throws you forward, the lumbering thickness of a platform trainer in which you could never run.

If the formulation of freedom as a literal right to come and go as you please might seem simple, it is also acute, since mobility is central to the language of woman's emancipation – the glass ceilings through which we break, the kitchens in which we are no longer expected to stay, the children we leave behind at home, the career ladders we struggle to climb. How women move in shoes matters. Mobility is a feminist question and a metaphor too that reveals an anxiety about the waywardness of female desire. Freud asks what does woman want, but he might also ask where might a woman go, who might she love and what might she choose to leave behind?

These are Elena Ferrante's concerns in her sprawling modern Neapolitan novels. They begin with the two protagonists, Lila Cerullo and Elena (Lenù) Greco, as children venturing into the basement of the local neighbourhood ogre, Don Achille, in search of their lost dolls. The opening vignette poses the questions the entire series explores, of where women are permitted to go and what they might dare to do there. As their paths fork, Ferrante examines the choices available to women and the lives that entraps them nonetheless. Lila, the daughter of the shoemaker (like a fairy tale gone wrong), finds that her life

stalls as her friend, Lenù, ascends social heights with a glittering, metropolitan and cultured world opening before her.

Lila is forced to find a different route out of the violent, historic familial fractions of her small community. She imagines opening a shoe factory:

> 'A shoe factory?'
> 'Yes.'
> She spoke with great conviction, as she knew how to do, with sentences, in Italian, that depicted before my eyes the factory sign, Cerullo; the brand name stamped on the uppers, Cerullo; and then the Cerullo shoes, all splendid, all elegant, as in her drawings, shoes that once you put them on, she said, are so beautiful and so comfortable that at night you go to sleep without taking them off.

As Lenù takes up Latin, Lila's fingers grow yellow and callused, stitching, gluing and labouring over the perfect prototype shoe with which to launch her business. Making shoes is not only a business; it is a means of reinvention here. The shoes that Lila designs promise to generate revenue and so elevate her from poverty. They feed her hungered imagination too, fuelling her with the dream of the freedom that might come of social mobility. Lila imagines the shoes that could lift her from her straitened, circumscribed existence, taking her places other than home, forging pathways into a new world and new life.

When she reveals her drawings to her friend, Lenù is taken aback by the boldness and ingenuity of the designs, but also the dauntless desire from which they come:

> They were beautiful designs, drawn on graph paper, rich in precisely colored details, as if she had had a chance to examine shoes like that close up in some world parallel to ours and then had fixed them on paper.

What Lenù discerns from these drawings are Lila's utterly original dreams. She is frightened by the ambition she sees in them. The shoes outwardly intimate an inner life carefully concealed and yet so rich and brilliant that Lenù is cowed by it. But Lila's opportunities are repeatedly curtailed, and in the last novel, she is struck a bitter blow when her young daughter is mysteriously lost. In the final few pages, Lila too goes astray.

When Lenù returns home to search for her, she walks through their familiar haunts alone and consoles herself with an idea that Lila had 'broken her confines, and finally travelled the world'. The lost dolls of their childhood are mysteriously returned to her, as though to suggest the completeness of a full circle, but they also answer, in miniature, that larger question of where women go and how far they are ever able to leave. What Ferrante understands is that the question is not only one of where women go and what prevents them, but also how far they are permitted to tell their inward journeys at all. Her writing is a response to that in one respect. She attentively documents the lives of the two women, has us follow them, tracking the complex circling and path-crossing by which their tightly woven bond is forged, intimating how friendship is in the meeting and parting of ways, a constant recalibration of one to the other.

When Lila disappears, Ferrante allows her a privacy that even she cannot penetrate. And her own insistent authorial pseudonymity, like Lila's untrackable disappearance, is also an act of resistance. Male desire is so eagerly invested in women's shoes – figured with such abandon in an Andersen fairy tale, a Powell and Pressburger film, a Pushkin poem, in a novel by Nabokov, an analysis by Freud – that there is a kind of justice to the idea that a woman's freedom might finally be proved in the assertion of her right to walk away, to be left unpursued, to leave, at last, without a trace.

Our shoes are tasked with taking us to the close of day, safely bearing us up and bringing us home, but all of us know shoes that have, at one time or other, left us wretched, caught against a paving slab or stuck between a rail, the heel that snaps, the sole that erodes. We are made conscious of the basic function of footwear when it fails us. In those moments, what matters is not what our shoes look like, nor the sexuality they frame, but what they permit us to do, the support, speed, balance and elevation they lend, opening up to us the fullest possibilities of our bodies as they move across the earth. We dance, play and run to prove the height of our skills and the diversity of our species.

When Fred Astaire thunderously taps and skits across the room above Ginger Rogers's in the opening number of *Top Hat*, he initiates their romance, and reminds us, too, of what the most skilled feet in shoes can do. They exuberantly flaunt our freedom as though it were easily won and effortlessly owned. 'I'm fancy free and free to fancy,' Astaire declares, moving seamlessly from lounging to dancing. He is pouring a drink and then leaping into a heel kick, chatting affably and then flying across parquet, in the blink of an eye. In the sequence, Astaire moves from a ballet jump into a solo tap, increasing in intensity, developing from shuffles *sur place* into travelling patterns, swift staccato heel jabs and then a rolling tour of the room, knocking over a statue, cheerfully catching and parrying with it in a *pas de deux* before Ginger Rogers's frosty Dale Trentor raps smartly at his door with a complaint.

In the course of the film, Astaire's mischievous Jerry Travers attempts to woo the uncertain Dale, who labours under a misunderstanding, having mistaken Jerry for his married friend, Horace. This classic screwball blundering is itself only mended by clever footwork. Horace himself acknowledges to his puzzled butler, Bates, that there's 'a crisis afoot', enlisting his help with the muddle:

HORACE: Mr Travers is in trouble. He's practically put his foot right into a hornets' nest.
BATES: But, hornets' nests grow on trees, sir.
HORACE: Never mind that. We have got to do something.
BATES: What about rubbing it with butter, sir?
HORACE: You blasted fool, you can't rub a girl with butter!
BATES: My sister got into a hornets' nest ...

Theirs is the kind of tangled exchange that exacerbates the muddle *and* the merriment of the film. But isn't it true that falling in love *is* like kicking up a hornets' nest? It can be a rebellious gesture or a reckless accident, clumsily stumbled upon, its consequences unavoidable. We think love happens in the heart, but Astaire and Rogers demonstrate in their feet the hectic pursuit, the intertwined pathways, the utter waywardness of romance and, ultimately – nearly *always* – the sure-footed routes that lovers find, leading them back to each other's arms.

In the film's most beautiful sequence, Jerry and Dale dance 'Cheek to Cheek', and their routine emerges once again with that same effortless fluency, Jerry's mid-sentence seguing into the song, his walk strolling irresistibly into a waltz. He leads the hesitant Rogers onto a crowded floor. If Astaire's feet are light, careless of gravity, Rogers's are more careful, not quite reluctant but her movements marred by the misgivings of which Astaire is happily oblivious. He is only mildly mystified as to her anxieties, and this never weighs him down. He is, instead, always aerated, his feet, like his ardour, pushing forward, lifting them both up, taking them across a bridge to a deserted ballroom nearby.

The pair spin and lean, darting back and across from each other before moving into a standard ballroom position. The sequence incorporates a series of backbends, Rogers yielding and then righting herself again. When Astaire sends her into a spin, he is dependably there to collect her upstage, manoeuvring her into a linked-arm stroll, leading her forward, spinning and

Top Hat (1935)

encircling her all the time; their feet, in their own idiom, tracking the dynamics of their feelings. At the climax, they rush towards the camera, then away in a flurry of steps with a series of ballroom lifts and deep backbends, as though this boldness were itself the promise of their partnership, a life of risk and pleasure. There are other parts of the routine that are more muted and

tender, when they are hardly dancing at all, their feet shifting only, as they sway cheek to cheek.

At the joyful close of the film, we are reassured that all muddles can be disentangled in dance, and that the various ways our feet move, sometimes strong, sometimes subtle, are as expressive of our desires as any language. And yet more than this, the film asserts something else: an idea of how self-righting and resilient we can be, the way that our bodies are compelled by the momentum generated by our feet, sweeping away all doubts. We speak fondly of falling head over heels, but in dance the heels lead the way and they do so incorrigibly, insistently optimistic that all will effortlessly come right.

In the 1937 follow-up *Shall We Dance*, Astaire candidly spells out how tap could be a tonic for the blues, singing cheerily:

Shall we dance or keep on mopin'?
Shall we dance and walk on air?
Shall we give in to despair?
Or shall we dance with never a care?

Our dancing shoes are capable of acting against our internal anguish, as though they lead by example, lifting our state of mind. Standing still is no option for those languishing in despair. We are urged instead to leap out of bed and into the daily melee, however reluctantly, as though the very act of putting on our shoes could propel us into perpetual motion, swinging us back into life, even against our will. In *Shall We Dance*, Astaire and Rogers are mired in another of their familiar misunderstandings, but their whirlwind romance allows no time to rest and think. The drama is set on a cruise ship and the eternal 'You say tom-AY-to, I say tom-AH-to' number takes place on roller skates. They are always in motion. The skating sequence combines elements of ballroom and ballet as well as tap, and the couple's increasing fluency, the pratfalls that become pirouettes,

reflects their developing sympathy. They tell us that romance is irresistible, utterly unstoppable, and that lovers are always in pursuit, speeding, spinning and gliding off their feet. If we are inclined to believe them, it is because, dancing together, they defy the rules of gravity and suspend time itself.

Astaire and Rogers beat out time as though they might at any minute manage to stop it altogether. They coast and rally at will, slowing to a stilled pose, spinning and breaking to a stop, hanging mid-air and hurtling full speed at any given moment. They retard the laws of time, delaying, decelerating, checking pace and picking it back up again, lingering in a moment, finding a way to trill back and forth, drumming out with their shoes a staccato rhythm or a blithe torrent. This is the power harnessed in their feet. They propel us into and through their world, even if, beyond the frame, we know that life cannot always feel as compelling and joyous as they make it seem. The light-footedness of the ballroom dancer is an optimistic illusion. When we are low, we know that it is a lie, sensing it in our own heavy-heartedness and the slow passing of a depressed day. But if these films temporarily trick us, it is because there is in dance something so basic and compulsive that we cannot resist it. The tap shoe with its unrelenting rat-a-tat insists that life can be ebullient and uplifting, that it will move onward and take us with it. The best dancers allow us to understand how eloquent our own bodies could be, somehow more fluent and forgiving than the graceless spoken language in which we grapple with each other every day.

When Don and Cosmo leap onto the table during their elocution class in the 1952 *Singin' in the Rain*, pulling faces and mocking the teacher's practised tongue-twisters, it is to drown out speech and allow their feet to do the talking, their spats furiously tapping away. In the beloved rain scene, none of the apocryphal stories – about the milk poured into water to render the rain visible, the miraculous one continuous shot in which

Singin' in the Rain (1952)

the sequence was apparently filmed, or Gene Kelly's 103-degree fever – matter. The real miracle of the sequence is Kelly's momentum, unfaltering and irrepressible. With Kathy's kiss still lingering on his lips, Kelly's Don waves away his chauffeur because, visibly walking on air, he has his own transport, his heels lifting off the doorstep as he trips elatedly down the stairs. Even for seasoned viewers, when the song starts, with its

pitter-patter notes and Kelly ambling down the rainy street, the nimbleness with which he clambers up onto the street lamp is as startling as the first time it is seen: the lightness of his feet, the weightlessness of his body as he hops off the kerb and up onto the cornerstone of the lamp post is nothing short of astonishing.

Kelly's slim, small brown brogues are modest, contrary to the force that comes from them. He rises just as the strings do too in the orchestral accompaniment, as though the entire world had suddenly surged with him. When he spirals across the street, barrelling umbrella around with wild abandon, he is unable to curtail his velocity. Each unabashedly battering foot tap in the puddle sequence is felt like a jolt through the ankles and up the leg. The brogues enable him to channel a winning combination of sprung lightness and a vigorous rhythm, issuing an energetic retort to the idea that tap could be corny, kitsch or anything, in fact, other than relentlessly, electrifyingly, alive.

Dance begins from the ground up, with the solid and hard work of our feet, all the force and stretch of the adjacent tendons, the sinews and muscle which the shoe contains and discharges, straining to lever, pivot and lift the body entirely. The delicate satin and ribbons image of ballet shoes contrasts to the reality of the shellac-stiffened shank and the hidden pointe block. In Darren Aronofsky's 2010 *Black Swan*, Natalie Portman's frail and unhinged dancer prepares a new pair of pointe shoes, audibly cracking the heel, forcefully bending it forward and bashing it back to break its rigid form. She takes scissors to the insole, levering it out, tearing at the fibres; she pierces the binding with needles, reinforcing the ribbon with stitches, scoring the outer sole with a knife to give greater purchase and spraying the surface with glue to prevent tears, such a brilliantly commingled strengthening and softening all at once. Portman plays the harrowed dancer committed to her art with an anguished face, but it is the ballet shoes that tell the secret life of those who dance: the feet they contain so painfully arched, the toes welded

together with tape to give them strength, the metatarsal joints swollen and jutting from overuse.

Degas's smudged pastel dancers don't always manage to articulate this. The paintings suffer too much from a twee late-nineteenth-century aestheticism, often softening the girlish forms and suffusing them in romance. More precise are the canvases prosaically titled 'Dancer adjusting her slipper', 'Dancer fastening her pump' and other such variations, where innumerable young women squat low in that familiar second position, attending to that simple and sacred act: the fastening of shoes. In the ballet slipper, there is tremendous paradox. If ballet is an ephemeral form, extended shapes and pliant arms, all this attenuates into that hardened pointe, strong like steel. Romantic ballet is sylphs and Giselles, figures that float, suspend, fade and flutter – but the pointe is unyielding.

The critic Susan Leigh Foster describes the pointe as a phallus, a quivering responsiveness, aspiring to rigidity, ever erect. The female dancer, upright in her block shoes, is not the object of male desire, she argues, but that desire itself, figured in feet. Trembling and erect, she is a 'divining rod' with 'no tangible or enduring identity' of her own. But the female dancer is not only the expression of her partner's sexuality. Her focus can be singular. So often, her sole goal is the maintenance and manipulation of the perfect line. This line runs along the leg and includes the slippered foot as though the shoe were only an extension of musculature, a continuous length sheathed in nude-coloured nylon, seamless from curve of hip down to the pointe. With the line, the ballet dancer strives for an absolute geometry, a Euclidean beauty. Ballet demands the precise articulation of these legs and feet, and so the pointe shoe is a place of determination, from which the dancer assesses the purchase they have on the ground, calculates how to rise and revolve. Mobility, fluency and grace are the goals of ballet, of course, but it is an art form that is also constituted by its precariousness,

a balance that is hard fought for and could at any moment be stumbled from and lost.

The pointe shoe is strange. It works against the logic of other footwear – it looks to leave the ground behind, to maintain minimal surface contact, to lift and land only lightly. This is what makes Vicky's leap in *The Red Shoes,* from the balustrade onto the railway line, so chilling and so inexplicable. She is the dancer who chooses to crash down to earth rather than leap for the sky. Powell and Pressburger script that leap as though it were automatic, executed without volition, a moment of wild, uncontrollable impulse. It is a leap of faithlessness, bleak and yet inexorable. And at that moment, the film finally gives full expression to what it had only so far managed to imply: the hard truth of dance, its testing of the body and brain to breaking point, the cruel, contorting tyranny of its physical and emotional regimes, the sharpness it masks beneath softness and to which women are subject.

McQueen parodied the pointe shoe in the unearthly 'Armadillo' range produced for his last collection, *Plato's Atlantis,* for Spring/Summer 2010: leather pumps with a hidden wooden platform, enormous in proportion and curved grotesquely so as to position the wearer permanently *en pointe,* propped up by the thinnest sliver of a stiletto. It is an unapologetically malevolent shoe, gorgeous and cruel, but it also makes explicit the mercilessness of the pointe shoe – that rigid, unyielding toe on which the ballet dancer executes the smallest, most rapid steps (the *bourrée*) and steadies the most delicately balanced poses (the *attitude*).

It is Odile, the dark, black heart of ballet, who epitomises this power best in her breathless, show-stopping thirty-two *fouettés* in *Swan Lake*: a feat of mechanics with the leg that whips round in barely one-second intervals, generating the momentum for the entire body to pivot on the one centre of gravity. And for those few moments that she revolves, the entire world narrows to a pointe.

ALEXANDER MCQUEEN 'Armadillo' shoes (Spring/Summer 2010)

CAROLINE GROVES 'Turquoise Parakeet' shoes (2015)

We think of ballet as an art, not an architectural form, but the body is a structure, in dance as in daily life. It is held upright, given varying degrees of balance and pliancy by the shoe. These shoes are assembled by the skilled and stained fingers that lever in nails, manipulate shanks, handle specialist blades, sloughing off the excess of a heel. The uncut leathers, jars of eyelets and jumbled lasts are the materials provided and shoe fitting is the technical puzzle posed to the cobbler. What shape does the perfect heel take? How does a shoe square mobility without loss of balance? In shoemaking, the mechanics of beauty and the beauty of mechanics are entwined. Sometimes, the most beautiful shoes mock us, presenting the image of fleet-footedness with the fact of immobility. See Caroline Groves's sensational bird-wing heels (blue French silk pleats with billowing plumes, and a gold claw perched like a goddess on the end of a Rolls-Royce) and 'Tail Light' (Miuccia Prada's mischievously contoured chassis, with flashing lights and exhaust flames): shoes in which you can only stumble, not fly, totter, never zoom. We strap on our shoes and hope to move, like a bird or a car, anything to escape the hobbled reality of having only two feet and a whole world to traverse.

Like the most skilled forms of engineering, at its best the shoe obscures its inner workings, appears almost effortless. Think of the hidden inch in a platform heel, the insulated toe of a safety boot or the air cushion tucked under the instep of a running shoe. These shoes call upon the technical principles of design. No wonder, then, that when the architect Zaha Hadid turned her hand to shoemaking, she imagined a futurist boot, creating a cantilevered metallic-rubber structure, invisibly supported on a 16cm heel and rotation moulded so as to be seamless. The ultimate objective of the engineered boot, though, is the absolute fulfilment of a particular function. We are accustomed to swooning over visions of vertiginous spike heels and gorgeous wedges, we might covet branded vintage sneakers or celebrity endorsed trainers, but the miracle of our footwear is what it enables us to achieve.

ZAHA HADID Cantilevered shoes (Spring/Summer 2014)

When Nike's 'Magista' football boots were launched for the 2014 FIFA World Cup, worn by Cristiano Ronaldo, the brand confidently boasted 'total ball control', alluringly promising 'creative playmaking' and a 'revolutionary 3-D texture, a lockdown fit and a 360° rotational traction pattern'. For all the jargon, their premise was simple and all the more profound for it: boots designed to simulate a barefoot touch, permitting the kind of control and responsive sensitivity of skin to ball surface. With their thinly textured 'NikeSkin', the 'Magista' boots were unearthly, animal-like, as if something vaguely reptilian lingered beneath the pocked surface. Their luminous Flyknit technology glowed, suggesting a harnessed electric power. The real magic

NIKE 'Magista 2' shoes (2016)

of the boot, though, was its one-piece upper with an integrated sock-liner, designed to feel lighter than air so that the foot inside it could become the ball it reached for, almost without barrier, reactive to the slightest touch.

The 'Magista' is hardly a shoe, and more like the dream of one. What it seems to strive for is a line of continuity between ball and foot, shoe and sock, or, beyond even this, reaching from thought to foot, a body and brain plugged into the pitch itself for the most perfect kind of play. In *A Thousand Plateaus*, Deleuze calls this alignment of heterogeneous elements a 'rhizome', emblematised in the figure of the wasp and the orchid on which it feeds. This is, he writes, not simply a case of each being the things that they are but

> a veritable becoming, a becoming-wasp of the orchid and a becoming-orchid of the wasp ... the two becomings interlink and form relays in a circulation of intensities ... There is neither imitation nor resemblance, only an exploding of two heterogeneous series on the line of flight.

This line of flight is not some mystical evocation. It is that which can always be activated, a possibility that lies inherent to the studded boots and the wearer, each realising the potential of the other in the moment of climax. The shoe designer engineers the right material and the right forms for the right conditions and the right player, and at their best they reach the apex of performance.

It is this kind of performance that Philippe Parreno and Douglas Gordon try to document in their 2006 film, *Zidane: A 21st Century Portrait*. The film records in real time the French footballer Zinedine Zidane, playing during the Spanish Liga Real Madrid game against Villarreal CF at the Santiago Bernabéu Stadium on 23 April 2005. Seventeen synchronised cameras faithfully track the tall, broad-framed, balding no. 5. There are no close-ups or replays, no slow motion, only a dogged diligence near to devotion, as the cameras trained on him capture the player from every imaginable angle, every dart, every rest, every swift feign and reposition. They note the grimaces and furrowed brows, the constant watchfulness legible in the face, but the feet are most telling of all. They are small and swift, shifting direction rapidly, poised to accelerate and decelerate, coming to rest, pacing with anxiety, knowingly retreating or pulling away at any instant. Sometimes they drag across the grass with fatigue, at others they jab at the turf with restless energy. We read Zidane's feet intently, as though we might find in them some code that could unlock the mystery of his gifts, or even the miracle of the game itself.

Partway through the film, the footage is briefly overlaid with the audio from an earlier interview in which Zidane himself assents to a strangely supernatural feeling, a kind of rhizomatic connection between his boots, the field and the goal to which all invariably head. 'Something amazing happened,' he recounts slowly, as though still dazed even by the memory of it. 'Someone passed the ball and before even touching it I

knew exactly what was going to happen. I knew I was going to score. It was the first and last time it ever happened.' The idea of the player's unaccountable intuition is thrilling, but it is also contrary to something else to which the film patiently attests. This is not magic but instead the conscientious and repetitive work of acquiring a skill, developing the stamina, the muscle memory and the learned attunement of brain, body and ball.

In football, the ball is a disobedient object, straying and slipping beyond a player's strict control; the feet are the site of discipline. And so there is a certain irony when at the end of the film, Zidane himself loses control, suddenly enraged, entangled in a brawl that sees him dismissed from the pitch in disgrace. In that moment, the volatility of the player's temperament is finally revealed as a betrayal of his skilled feet. This volatility is important and illuminating in a quiet film that registers the larger paradoxes of this particular player: a son of France born to ethnic Algerian parents, selected to play for his country and whose early career was stalked by racial abuse and marred by the flares of temper it could inspire. In Zidane's towering, sometimes terrible, figure there is this complex interplay of obedience and disobedience to the nation state, a relationship at once of fealty and defiance.

Perhaps there is something of this in all sports, the contradictions of control and abandon, training and impulse that are visible in every player. But what the film ultimately dispels is the illusion of the innocence of sports. It reveals our foolishness in thinking it could ever be free from things like the history of empire and migration, race and religion. It exposes the fiction that sport is only ever sport, a game, not life, and that the world – with all its brutal, bruising collisions of identity and will, the impulses of desire and violence – that all this, finally, will not also make itself felt through our feet.

When German shoemaker and amateur athlete Adi Dassler set himself the task of constructing performance shoes designed specifically for runners at the early part of the last century, he

was already working within the straitened conditions of textile shortages in the aftermath of World War I. Attaching three small vertical strips to the uppers with the intention of strengthening the leather, he also, inadvertently, created the insignia of the brand that would take his name: Adidas. At the 1936 Berlin Games, Jesse Owens won his 100 metres race in a blistering 10.3 seconds, running in a pair of plain white Dassler shoes, made of glove leather, reinforced in the heel and the toe, the sole studded with six metal spikes. Sporting history conventionally casts his athletic brilliance as an eloquent riposte to the rising spectre of Nazism, although Owens's feet had travelled their own fraught path to the Olympics: a childhood of cotton picking in Alabama and then displacement, his family, following in the footsteps of 1.5 million other African Americans in the Great Migration from the segregated South to Ohio in the early 1920s.

Owens won the men's long jump that year too. The winners' photograph records him with the lean, blond German, Luz Long, in second place behind him. Luz's arm is raised in Nazi salute, a swastika emblazoned across his chest. Repeatedly overstepping the board in the first round, Owens claimed to have taken Long's friendly counsel during the competition, adjusting his stride and setting off from his jump foot earlier in order to land a qualifying length. Their paths forked dramatically after the Games – Long, a lawyer who had studied at the University of Leipzig, was killed fighting for Germany at the Battle of San Pietro in December 1943. Owens would remember him kindly in the decades after. Dassler, the performance shoemaker, meanwhile, would fall out with his brother, Rudi, in a rancorous dispute, splitting the fate of their family business into two rival shoe empires: Adidas and Puma, their opposing factories on either side of their home town of Herzogenaurach.

The stories behind Owens, Luz and the Dasslers place the twentieth-century history of sports shoes in a vivid social and political context. The technology of the trainer is part of a

broader picture still, facilitating the performance and redefining the competences and capacities of the human body itself. Specialist shoe designers deploy every advance in engineering and technical experimentation available to them for the enhancement and amplification of all bodily possibility. In 1954, Adi Dassler's boots for the German football team incorporated screw-in studs to reduce slippage, taking the national team to their first World Cup win, and when Muhammad Ali and Joe Frazier famously took to the ring in 1971, it was in Adidas boxing boots, flat-heeled, hi-topped, tightly laced. Without the performance running shoe, there is no Carl Lewis, lithe, limber, the cadence of his legs rapid, no Michael Johnson, stiffly upright, chin thrust high, a short, choppy stride indefatigable and unbeatable, no Jessica Ennis, compact and unstoppably efficient, no Usain Bolt, tall and strong, indubitably out-striding all others with joyful ease.

Performance shoes are part of a technical apparatus. Their job is to disappear, to meld miraculously into our natural instep with lightness and pliancy, or else provide ballast, redistributing weight, securing our footing, permitting rapid changes of direction. When we lace up our hockey boots and tug at the tongue of our trainers, at the start of a game, we might feel this possibility, harnessed in our feet. The technology of the trainer is never artless, nor unconsidered. 'Just do it', the incautious and ubiquitous Nike slogan of recent years, suggests everything is possible, made *easy* in our Nikes, as though in them we too can be champions, sprinting on spikes, walking on air. That is why we seize them up, determined they should assist us in perfecting our poor human forms.

The diversification of the Nike brand into Nike Air was born of the invention of Frank Rudy, a former aerospace engineer who patented an idea for gas-filled membranes in 1979. Refining the concept, Nike injected compressed air into tough yet flexible sacs, placing each unit under the instep, variously beneath the

heel and forefoot, so as to absorb impact and give rise. These Air Soles were responsive to every step – and a metaphor for the seemingly airborne athlete who could represent them: the smiling American basketball hero, Michael Jordan. Five-time National Basketball Association (NBA) Most Valuable Player (MVP), six-time NBA champion, ten-time All-NBA First Team member and fourteen-time NBA All Star, Jordan could leap, seemingly, into space.

His distinctive splayed-jump pose was captured in a dramatic photo shoot for *LIFE* magazine in the run-up to the 1984 Summer Olympics in Los Angeles. Both the US men and women's teams won the gold medals that year. Nike seized upon Jordan's remarkable physique, gave him a silhouette, turned it into a graphic and gave it a name: 'Jumpman'. Strikingly, the pose combined a balletic grand *jeté* with a slam-dunk, not true to Jordan's habitual jumping style on a court, but visually arresting: legs spread in flight, the hi-top trainers unmistakable, their laces visibly lifted by his enormous elevation, his torso taut, an arm outstretched to its farthest reach, a hand seamlessly conjoined to a ball upheld like a sun. It is an enlivened, kinetic animation of Leonardo's Vitruvian man, perfectly proportioned, everlastingly striving. It is what we long to be, even when we are small, sluggish and imperfect. It is the promise of the human form realised.

The insouciant swoosh of the Nike logo was dreamed up by a design student called Carolyn Davidson at Portland State University in 1971, its female origins nicely fitting for the mythical Nike, the Greek *goddess* of victory. A divine charioteer, tasked with decking winners with laurel wreaths, Nike is triumph personified. It was golden Nike who stood erect on the original Jules Rimet FIFA World Cup trophy, her body forming its stem, the outstretched wings framing the bowl. Yet in 2013, it was Adidas, not Nike, who issued a range of winged hi-top trainers, designed by Jeremy Scott. The women's range includes a variant with a wedged heel. They are the kind of sports shoe that is not

JEREMY SCOTT FOR ADIDAS 'Wings 3.0' shoes (2015)

meant for running, decorative rather than athletic, paradoxically popular in the wake of the preceding year's London Olympics. They illustrate the absorption of sportswear into high and mid-range fashion for precisely non-sporting purposes.

There is an irony to the idea that the modern descendants of Nike should be those innumerable girls in winged shoes, slouched in crowded trains and buses, thumbing their iPhones in strip-lit carriages, hurtling through tunnels and snatching at passing Wi-Fi signals. The electronic transmission of their data can travel at speeds faster even than that at which they themselves travel to their destinations. Speed is not the attribute of our feet any more, not simply because we have long been outrun by motors and engines, but because our modern lives

are contingent on a different kind of rapidity: the interminable circulation of global capital and the instantaneous delivery of data. They leave us standing in their wake.

We are accustomed to lamenting how athleticism has been requisitioned in an age of automation and digitisation. We routinely complain how dexterity decreases and obesity rises as our activities diminish to the swiping of fingers across glassy screens and the pressing of plastic buttons. And yet, while the levels of our physical engagement might have dwindled, the sportswear industry seems to have thrived nonetheless. Despite efforts to regulate its industrial operations in Indonesia and Bangladesh particularly, investigations into sweatshop labour continue to record unionised suppliers sidelined in favour of subcontractors with less creditable labour rights records, low levels of basic pay and rudimentary health and safety provision. Like so many of us, the girl on the bus in her winged trainers hurries to work oblivious. What sense do we have of where our shoes originated, the journey they have taken before they land at our feet?

Even though our feet plant us firmly on the ground, in the here and now, our shoes are inextricable from the contexts of global capital and mass production, the colonial history of exploited workers and materials. What we do with our shoes, at our very best – in tap and ballet, in athletics, football and basketball – is made to look effortless, masking the experimental technology from which they come and the nexus of global labour on which they depend. Our shoes challenge us to aspire to a supreme physical condition, enhancing and enabling faster, stronger, higher and longer ways to move through the earth, suspending time and resisting gravity. Isn't this the moment to stop short and ask at what cost?

The novelist Haruki Murakami describes running not as a movement through space, and more as a kind of vacating of space altogether, even a kind of emptying: 'I just run. I run into a void. Or maybe I should put it the other way: I run in order to *acquire* a void,' he writes. Sometimes we lace up our running shoes not to get to some place but to get nowhere, to be no one, to run ourselves out of place and body and then finally be done. We are running to run away, from everyday things, emails, admin and existential questions alike. Running can be a powerfully freighted activity, so much more than the simple locomotive business of placing one foot ahead of the other. We run on desire that takes so many forms: the desire to make up for things we've lost, to escape the lives we might have led so far, to fulfil our utmost potential and to deny our detractors, to prove to ourselves, and to others, that our feet can take us anywhere. Who is to say what it is that compels the runner when they propel themselves across the earth and through the air to cross a ribbon? In some athletes, we catch a glimpse of the pit of cheeks, rising, falling, flushing deeply, the smallest sign of struggle, in others that unmistakable, anguished grimace of exertion. What is it to search for and find that final surge, drawn from the depths, the rapidity that comes from nowhere and in which we hurl ourselves through time and space across a finish line? We can only know for ourselves what it is that drives a runner to the end.

In Alan Sillitoe's potent short story of 1959, 'The Loneliness of the Long Distance Runner', the young delinquent Smith learns why he runs as he runs, narrating with each pace. He turns to running while incarcerated in a juvenile detention centre. His talent draws the attention of his captors, who permit him to train for an inter-borstal competition, keenly anticipating

his victory. Training each morning, his discontent settles into a firmer resistance, a resolve. He recognises the hypocrisy of his disciplinarian masters, the obedience they demand, even as they permit him to run freely, and so racing becomes an act of defiance. He sees the demarcated route of the race with a lucid perspicacity and it becomes a symbol of other circumscriptions: his incarceration, the circuit of petty crime, his birth right of poverty and foreclosed opportunities. 'You should think about nobody and go your own way, not on a course marked out for you,' he observes to himself, his rebellion fomenting.

On the day of the fateful race, he dramatically pulls up short of the finish line, demonstrably defying the prison warden and accepting the inevitable reprisals. In that moment, it is not the race that matters, but the experience of running itself, because in running, his powers of reflection are set free, even as he is not. With each stride, Smith finds new pathways are forged in his thinking:

> I tell myself I'm the first man ever to be dropped into the world, and as soon as I take that first flying leap out onto the frosty grass of an early morning when even birds haven't the heart to whistle, I get to thinking, and that's what I like. I go my rounds in a dream, turning at lane or footpath corners without knowing they're there.

Running enables Smith to enter into an authorless, impassive mode of reflection. The thought of it keeps him awake at night, like a rush of serotonin lighting up the neural pathways of the brain. We run in our bodies and through a landscape as though those two things meet and understand each other uniquely in that particular activity, but we also run *into* ourselves, our feet pacing out our thoughts. Sillitoe writes Smith's interiority in the stride, rather than stream, of consciousness, with the controlled shallow-breathed cadence of the runner, because our thinking

runs with us when we run a route, as though it could pursue a path or take a detour as we do.

Running is a basic impulse. It comes to most of us naturally, even though we must, at some time, have learned it, worked out how to move rapidly, mastered the peculiar mechanics by which our limbs, variously rising off the ground and landing again, generate that mysterious forward propulsion. Once, we had to think how to run. Now, we run to think. At other times, we run to empty ourselves of thought altogether with feet that relentlessly beat out the fact of the body instead. Whichever the case, there is already between the brain and our feet a continuously recalibrating understanding, a rapid relay of nervous information, the rallying back and forth of data that registers our position in space, balance, temperature, our relative physical comfort or discomfort. In our running shoes, we need to be able to feel for pressure, adjust for impact so that it is dispersed safely through our limbs, readying in an instant to handle jolts and assess possible derailments. If there is a consoling repetition to running, the certain, constant processes that don't allow for variation – one foot steadily in front of another – there are also a thousand tiny adjustments being made all the time, our shoes finding the flattest plane, repositioning our weight as we climb and incline, shifting our balance on a sharp curve. If you run, then you will know how unconsciously this works and yet how unearthly it can feel, this almost out-of-body experience that being in our bodies can be.

Our physical agility doesn't only bear a likeness to mental rapidity: it enables it. We praise those who can 'think on their feet', and the phrase suggests a situational responsiveness. Yet isn't there something to this idea that a certain kind of thinking happens only in/on our feet? It can take a fall from our feet to recognise it, a realisation that comes in those microseconds in which our sense of time seems to stretch. In an instant, we anticipate the crash to come, the impossibility of righting ourselves

and preventing it, a microsecond when it feels like our flight is forever. Our proprioceptive senses recalibrate the position of our heels in relation to our head, we have some wild, hurried, passing measure of a shift in air, pressure and force, a fleeting sense of bewilderment and a rapid readjustment all at once. Even when we are unready, the brain seems somehow to have processed the coming disaster, is quick to compensate. When we know that our feet have failed us, we reach out our hands and they take the burden, absorbing the impact, paying the price.

Jean-Jacques Rousseau describes a catastrophic fall in the Second Promenade of his *Reveries of a Solitary Walker* of 1782. Confronted by a runaway Great Dane 'rushing on' him, he finds himself comically cast into the air, landing head before feet on a jagged rock. But this fall is also a formative experience, and when he regains consciousness, he finds himself 'returning at this instant to life ... it seemed to me I filled, with my frail existence, every object I perceived'. In falling off his feet, Rousseau finds his world tipped upside down and newly arranged. He understands better the miracle of balance, the sheer disaster of losing it, and the way in which everything around him might similarly be subject to miracle and disaster. His newly found frailty infuses his entire existence. Standing in our own shoes, we might remember how lucky we are to be standing at all.

We think on our feet but thinking carries us off our feet too. We can 'run with' an idea, and some ideas seem only to come to us when we are in continuous motion. When we run to escape from thought, seeking respite from our cerebral lives, it is as if we believed that thinking really were located in the brain. Our language dispels this lie though. When we are distressed, we pace with worry; when we waste no time, we hit the ground running. Babies know the interrelation of feet and thought, since toddling, crawling, walking, even stumbling, are to them deep ways of knowing the world. We acquaint ourselves with places by forging well-trodden routes, and we tread new places along

ancient paths, trusting blindly that we walk in the footsteps of those before us. So, how could we ever deny how powerful an experience it is to be shod? How could we not care for the shoes on our feet?

At the end of his reflections on running, Murakami ruefully admits to being religiously faithful to his Mizuno running shoes, trying to reasonably account for this precise predilection:

> I tried on all kinds of models, but ended up buying the same Mizunos I've been practicing in. They're light, and the cushioning of the soles is a little hard ... Once when I had a chance to talk with a sales rep from Mizuno, he admitted, 'Our shoes are kind of plain and don't stand out. We stand by our quality, but they aren't that attractive.'

Our shoes don't have to be beautiful. Experienced runners are alert to the small details that set one shoe off from another, the developments in technology that make you fractionally faster, lighter, fitter, stronger. But all of us seek out the shoes that might realise a dream of how we might move through the world, the shoes that could grant us an effortless elevation or would master the toughest terrain, steadying our soles on a mountainside or safely transporting us from A to B.

Some of us pace because there is no peace, and the routes by which we seek refuge, leaving home so far behind, track terrible histories of displacement and disaster. The experience of being on our feet grounds our existence, but our shoes present us with diverse ways of testing that too. At the close of day, when we prise off our boots and rest our tired legs, when we are filled with the recriminations and regrets of things not yet done, we might dream about how else to navigate such a difficult world, the ways we might move through it differently. Life outruns us and we are constantly trying to catch up. At those moments, I imagine the shoes in which I might run from everything, how they would feel

almost as though they were not there, a spectre of the very first spikes strapped on my feet, and in which I suddenly ran faster than I had ever run in my life, felt a weightlessness, an ethereal lightness, a grip sharp enough to secure me to the earth and spring me into the sky at every step. And I cling to this feeling, miraculous and true, that this is how I should move through the world, that this is what freedom feels like, that this is my utmost potential realised, even if I might never capture it again.

'How beautiful are thy feet with shoes!'

Song of Solomon (7:1)

4.

Furs,

Feathers

and Skins

THIS GREEN SNAKESKIN DRESS DOES NOT WANT ME,
can scarcely contain its contempt for me. In the store, it slips
off the hanger and slides off the counter. The sharp edge of its
tag maliciously slices the side of my hand. But I am determined
that it should belong to me, that the disdain it emanates could
be mastered. It gleams so strangely that, wearing it, I am almost
afraid to step into the sunlight. It is iridescent, metallic, inhuman.
In it, I am a serpent in jewel colours: shimmering gold, inflections
of bronze and emerald that startle.

At home, I run it through the sewing machine, narrowing the
curved seam at each side, inserting tiny shard-like darts at the
waist. It fits me but I want it to fit closer still, pressed against the
hip, the thigh and the knee. And even then, I'll wear it cinched tight,
a thin black belt circling the base of my ribs. I am skin and bone
that autumn, surviving almost solely off an unspoken anger. This
dress cannot be close enough. I want its skin to become my skin, as
though I could absorb its insolence and assurance. I want to live
as though I do not care for life, as though I couldn't care less, as
though I were a cold-blooded creature, unflushed by nerves and
untouched by anxiety. Because all of this is what I am not.

The thing about this dress is that it deceives you. If you dared to
touch it, you would find it smooth and synthetic. This is an animal
skin without the animal. I think that maybe I am a human being
without humanness too at this moment. I know that something
inside me has dimmed, is dying, and at night, powerless, I dream
of cruelty, the relief of a random act of violence. I cannot say why I
buy this dress exactly since it is unlike anything else I own. I know
only that I desire it like I desire to climb out of my own awkward
skin and into that of another creature entirely: someone or thing,
sharper, surer, more predatory than I could ever be. I am tired of

my passivity and faltering courage, and so this snakeskin signals the self-possession I lack, the stilled menace of something strong.

I imagine the people who will see me in this dress, how they will sense in me a cool dispassion. This dress is gaudily brilliant, not beautiful, but I am done with beauty. What this dress does is intimate something more shocking, something that I have learned about myself or, at least, never allowed myself to own before: my capacity for cruelty, the smallest insinuation of savagery that is in me. What I know is that the snake is not the friend of a woman. It is the asp that kills Cleopatra, the serpent hissing in the Garden, the severed head of Medusa that Perseus triumphantly parades. Broken in this punishing city, skittish and afraid, longing to signal a sophistication I do not yet possess, I buy that snakeskin dress because I aspire to a sinuous indifference, as though I could ward off the life that wounds me at every turn.

CREATURES AND CLOTHES

'It's in the trees! It's coming!'

When I was a child
Running in the night
Afraid of what might be
Hiding in the dark
Hiding in the street
And of what was following me

KATE BUSH 'Hounds of Love'

A cascade of drums, a thunderous, tumbling tumult begins Kate Bush's 1985 'Hounds of Love', setting the pace for the song and the listener's pounding heart. Although the opening lines are sampled from the 1957 British horror film *Night of the Demon*, in

the song it is not satanism or demonic possession we should fear: only love. The sentiment – that falling in love is as hazardous as the life of a fox pursued by hounds – seems simple enough, but our relationship to animals is more than mere metaphor. Bush knows this. It is everywhere in her work. Later in the song, it is a fox 'caught by dogs', taken in her hands, its heart beating wildly, that compels her to confront her fear and summon her courage. There is something in her voice, the way it trips and catches so peculiarly, like a partly strangulated yelp, that persuades you that she registers this creature's pain, not only as an analogy for her own, but, quietly, in its own terms.

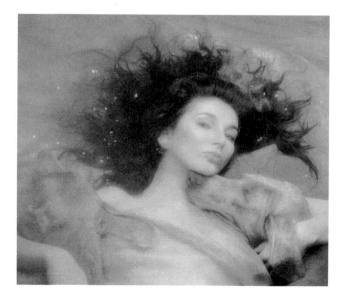

KATE BUSH *Hounds of Love* album cover (1985)

For the cover of the 1985 *Hounds of Love* album, she lies against a gorgeous cosmic wash of purple, a velvety dog tucked under each arm, their noses nestling against her shoulders.

For her 2011 *50 Words for Snow* album, one of the promotional photographs captures her claustrophobically close up, snow streaked, partly masked, shrouded from evidently inclement weather, chin-deep in swathes of thick grey chinchilla. A silky band of silver fox fur forms a slanted crown, the pelt a wintry aureole around her head. Afterwards, Bush, a committed vegetarian for many years, took pains to clarify that the furs were synthetic. Animal skins, though, rely on a certain duplicity, the possibility that an imitation fibre could be the real thing, that a person, even, could be mistaken for the animal they wear. There is a quick glance – a double take, perhaps – a moment of doubt before the illusion is dispelled. We use skins in so many ways, disguising their origins often enough, but what they reveal best of all is the truth of our own nature.

The modern aversion to the commercial use of fur seems so commonplace that we almost forget that this understanding was once hard won not so long ago, that centuries of trapping and skinning were challenged by the diligent campaigns of anti-cruelty and animal conservation groups. But animal life could never be so easily disentangled from the business of constructing clothes, since animals and humans are connected in complicated ways. We pet them and prey upon them, consume them, even as we seek to preserve them – and in dress this relationship is more complex still. Some fabrics only imitate animal forms: 'houndstooth' that is patterned with jagged checks, originating in the Scottish Lowlands and named whimsically for the canines of canines; and 'herringbone', whose distinctive iteration of V-shapes resembles a broken zigzag, named for the skeleton of the fish. Here, animals are made playful, flattering, elegantly civilised so that they are hardly recognisable as animal at all.

Even the most beautiful things can have beastly origins. Muslin, a fabric so ethereal that the thirteenth-century Sufi Indian mystic Amir Khusrow once described it as the 'skin of the moon', comes from raw cotton wool traditionally carded from

cotton plants using the jawbone of the *boalee* – a type of catfish with comb-like teeth – with the separated fibres then stretched and smoothed in the soft skin of the *cuchia*, a Gangetic mud eel. Some fabrics conceal the creatures that make them, like the silk that is cut from the worm. Other fabrics, of course, *are* animal – snakeskins, leathers, suedes and furs – variously treated and repurposed for human use. We try to disguise the animal life of the things we wear and often enough that life is so denatured by human hands that we rarely give it a thought: the alligator-skin Hermès bag whose rippled surface connotes wealth and social status so far removed from its origins in swampy wilderness that it almost seems laughable; the lining of a padded ski suit whose warmth derives from the feathery down of a goose; or the leather motorcycling jacket whose glossy veneer suggests the speed of an engine instead of the skin of an animal.

Over the centuries, we have grown skilled in fashioning synthetic substitutes, adapting prints and embellishing designs, finessing our simulation of other creatures. We mimic with perfect ease leopard spots, tiger stripes, the scales of a fish, the feathers of a bird. Or, alternatively, we have taken pains to verify the authentic animal origins of our clothes – '*genuine* leather' reads the tag, '*real* fox fur' we say – as though it were, paradoxically, proof of our self-possession that we could so easily arrogate the body of another creature for the adornment of our own. This idea that animal skins are worn as the mark of our privilege and poise vividly contrasts to the more atavistic habits of the primitive man we imagine first wearing fur. But is the fur-coat-clad countess in a novel by Tolstoy really so far removed from the image of the caveman crudely draped in hide? Doesn't the same impulse linger beneath the surface of both? The simple fact is that human beings dress in the skins of other animals. We command the life of other creatures in order to make sense of our own. Our relationship with them is unspoken, but *there*, undeniable, in the garments we wear.

We are born naked. We are also born too soon. To a greater degree and for a longer duration than any other creature, we begin life abjectly unfit for it, our senses underdeveloped, our motor mechanisms lethargic, unprepared for the assaults and abrasions, the heat and the cold, the varying experiences of contact, force and pressure that constitute our physical exposure to the world. From the earliest ages of human life, we have reached for the animals around us as a resource. We have sought out their skin because our own is unequal to the task of facing the world, burning easily in midday sun, bruising with the slightest impact.

If we wear skins still (in ways that are now so subtle and sophisticated that they are scarcely recognisable), it remains an acknowledgement of that original experience of dereliction and the fact that we continue to be forced to fend for ourselves in an inhospitable climate. Yet the wearing of animal skins is also an assertion of our mastery as well as a compensation for our weakness. In them, we make a silent claim to our physical superiority, greater intelligence and more urgent need. If we once honed our skills in the functional business of making weapons, tracking animals and avoiding attack, now we craft and style the skins we have won in infinitely imaginative ways. When we kill a creature, it may be in the name of our well-being, but always by the implicit law with which we claim our priority in the world.

Beneath the mastery, when the skin of a once living thing is pressed against our own, there is an uneasy affinity too – a recognition of the animal that we are within. Walter Benjamin, examining a pair of leather gloves, quietly observed how animal skins provoked a 'horror that stirs deep in man ... an obscure awareness that in him something lives so akin to the animal that it might be recognized'. We claim our sovereignty over the

animals we slaughter, but by that very act we also disclose our similarity to them too. For Benjamin, a German Jew, forced to flee France during the Second World War, the brute animality of human beings lay just beneath the veneer of civilisation. Struggling to secure entry at the French–Spanish border in 1940, and anticipating transportation to the camps, Benjamin took a fatal overdose of morphine. He died unaware of the safe passage he would have been granted to Lisbon only one day later.

No matter how refined and cultured we take ourselves to be, there are not so many ways in which human life is distinguishable from that of other animals. Our capacity for despair is one. We can wish to end our own lives and find the means to do so. All our other exclusive qualities, including the propensity to be clothed, seem meaningless next to that awful truth. Still, we *are* creatures that dress to face the world even when that world seems utterly unbearable to us. We dress even though we know, deep down, the stupidity of taking this as a sign of our civilisation, polite and humane. The history of nations tells us that civilisation is hardly even a hope; it is desperately clung to and easily crushed.

We are mistaken too, though, in believing that our animal nature could be disguised or denied. In our unthinking habits of dress, we are recalibrating our relationship to animals, every day, all the time. Our garments open up a different kind of understanding between them and us, and if we dared to think about it we might be stripped of our illusions. It is strange how often we aspire to the appearance of animals even when we deny our deep resemblance. We mimic, mine and steal from them and still declare ourselves originals. We fashion ourselves in their image while turning nature into artifice. And we do so, knowing, all along, that under the skin, we are birds of a feather.

'Animals fascinate me,' McQueen explained once, 'because you can find a force, an energy, a fear that also exists in sex.' His Spring/Summer collection of 2005 included, among other items, a lilac leather dress, pressure-moulded for a stiff fit, flared

at the hip like a pannier, and then fringed with a thick mane of strawberry-blonde horsehair falling to the knees. The dress reaches up the neck, the leather seamlessly encasing the entire skull, like a closely fitted riding helmet, exposing only the face. A small metal horse bit runs along the mouth and a thick ream of hair sprouts from an opening at the top of the head. The ensemble is a gleeful visual pun on ponytails, swinging ebulliently from the heads of schoolgirls and the rears of neatly groomed horses alike. Puns, of course, play with likeness, but there is something more sober at work in McQueen's identification of women with horses, made visible in the leather that contains the body so rigidly and the gleaming metal that constrains the mouth. Riding ponies is the innocent pastime of well-bred girls, but this is an ensemble for a woman whose body imperceptibly becomes the beast she rides, as though she too might be ridden or whipped, harnessed and made obedient to the will of another.

The relationship of humans to horses is mythologised in centaurs and satyrs, ridiculed even in pantomime costumes. But for the philosopher Martin Buber, the recollection of a childhood encounter with a horse provides a starting place for thought in his 1947 work, *Between Man and Man*. He describes stealing into a stable as a boy to stroke the neck of a dapple-grey, deriving from their contact a powerful experience of the animal's 'immense otherness':

> When I stroked the mighty mane, sometimes marvellously smooth-combed, at other times just as astonishingly wild, and felt the life beneath my hand, it was as though the element of vitality itself bordered on my skin, something that was not I, was certainly not akin to me, palpably the other, not just another, really the Other itself; and yet it let me approach, confided itself to me, placed itself elementally in the relation of Thou and Thou with me.

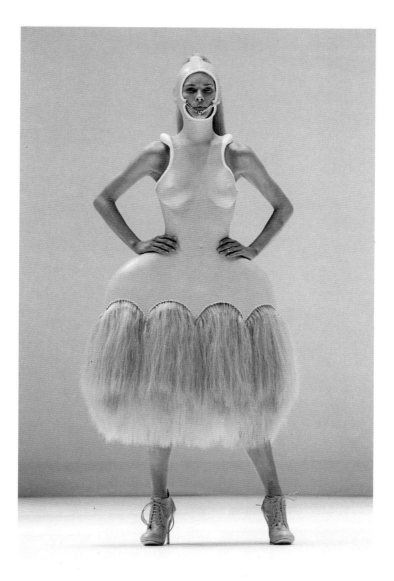

ALEXANDER MCQUEEN *Lilac horsehair dress* (Spring/Summer 2005)

Buber's philosophy is premised on this idea of existence as an encounter, and the horse's hair against his hand awakens him to an understanding both of their absolute alterity and the possibility of their communion. Our relationship with animals is one of commingled strangeness and intimacy. It's an experience that we can sense acutely when we wear animal skins and feel at home in them even as they alert us to their difference. We huddle in the sheepskin coat and find ourselves impossibly warmed. Our fingers pleasurably brush against the angora of an expensive cardigan and discover a texture that is softer than any we could find on our own bodies. In our clothes, we feel alienated from and at one with other creatures. We are not the animal whose leather encases us and yet nothing could be closer to us than this creature's skin against our own.

What I mean to suggest here is something simple and true. We are like and unlike animals. The question of how much or how little is one of philosophy's most enduring preoccupations. Certain thinkers make the case for the exceptional consciousness of human beings, while others remind us of our animal nature to rebuke any claim to greater civilisation. The Italian theorist Giorgio Agamben understands the relationship as a dilemma, stipulating that 'man exists historically only in this *tension*'. Man, he argues, 'can be human only to the degree that he transcends and transforms the anthropomorphous animal which supports him, and only because ... he is capable of mastering and, eventually, destroying his own animality'. For Agamben, the purpose of animals is to overcome them. They might provide analogies to our own condition, but the challenge of being truly human is to learn how to suppress the base part of our nature that most resembles theirs. Our *inability* to do so, the ways that we oscillate between prevailing over and succumbing to our animal instincts, is what makes us human.

But how could we ever deny that we are entangled in animals – not least because we are dressed in them? Being dressed is such

an essentially human experience even as we know that we enter this life naked. The philosopher Jacques Derrida laughingly describes undressing before his cat, catching its impassive eye and being overwhelmed by an embarrassing sense of their parity, his own nakedness juxtaposed to that of his naked pet. The anecdote recalls the essayist Montaigne's famous philosophical cat conundrum, posed in the wry question: 'How can I tell if I am playing with my cat or my cat plays with me?' (Who knows the answer to *that*? Certainly no self-respecting cat owner.) What comes of Derrida's encounter, though, is a dawning realisation that dressing is not only proper to, but a *property of* being human. With the exception of man, no animal has ever thought to dress itself, he observes. Dressing is like the utterance of speech or the exercise of reason, like laughing, mourning, history telling and gift giving. It distinguishes us among the kingdom of animals.

Clothing *makes* us human. Unlike other creatures, we learn to be ashamed of our nakedness, and so in the decision to dress we are the most human of all animals and the most in denial of our animality. And yet what this philosophical deduction overlooks is how the daily act of dressing constantly places us in a relationship to other animals. In our furs, feathers and skins, we implicitly acknowledge, every day, this thing that we are at such pains to deny. The distinction between animals and humans is fine, sometimes, even barely discernible. It is like a woman dressed in the image of a horse become a woman once again. The allure of the animal is, for McQueen, what it knows of itself and which rings true of us too – its possession of 'a force, an energy, a fear'. In the figure of the horse, he, like Buber, recognises an alliance, an affinity, something intangible yet felt, a quality uncommunicated by the horse and yet apparent nonetheless to the humans who handle them. When fashion adopts animal forms, the effect can be arresting, alarming, amusing even, because we are so unused to understanding ourselves as animals too.

Yet fashion returns to the animal, in so many different forms, again and again, as though it were a reflection from which we cannot turn away for too long: a Jean-Paul Gaultier 'leopard'-styled ball gown, the faux print rendered in meticulous beadwork, complete with the creature's face strategically positioned to peer up at the model from the peaked bodice; a cinched emerald-green John Galliano evening dress, nipped into a fishtail but confusingly appliquéd in the design of a peacock, the feathers fanning out at the model's feet; a tweed jacket and mini-crinoline ensemble by the Dutch designer Walter Van Beirendonck, the skirt slashed at the pelvis to reveal an elephant's trunk protruding like an oversized phallus. These outfits are astonishing, outlandish even, but so too are animals. Fur coats, tiger stripes and snakeskins can seem loud, audacious and extroverted as though the wildness of the animal were an analogy for the wearer's own unpredictable temperament. But animals are not only wild – they are utterly strange, unknowable from within even if we adopt their style from without.

'Nothing, as a matter of fact,' wrote Bataille, 'is more closed to us than this animal life from which we are descended.' This is true in the sense that we have never managed to decipher the language of dolphins or exactly replicated the flight of a bee. Animals are a mystery to us, yet we are so often dressed in their skin. We are *under* their skin when we wear leather shoes and woollen jumpers, carry snakeskin bags and suede gloves. When we tuck a feather into the band of a felt hat we are signalling our kinship, some understanding that they and we belong together. We consume animals, we absorb them into our language and our idioms, we treat them as sources of entertainment, even objects of science, but the animal is not simply a thing like a stone or air, and so when we wear animals or imitate their forms, we are presented with an opportunity both to see ourselves as animals and to recognise animal life as capable of consciousness too. And more than this, what we might see in this form of life that is so

'closed' to us, unavailable for our understanding, is a reflection of ourselves as equally wild, unpredictable, utterly extraordinary creatures. Could we be the animals that claim the greatest consciousness and yet the knowledge most hidden from us be the recognition of ourselves as the animals we are?

Like all things that are obscured, animals draw us to them with an allure that is irresistible, intriguing, almost occult. Their consciousness is removed from ours, and yet they can elicit an intimacy, deep, queer and tender, as though some strange magic were at work, binding us together. The animal is unfathomable, full of unplumbed depths that we might sense in ourselves too if only we dared to feel for them. Perhaps animal consciousness is only as closed to us as we are to ourselves – but that rare moment, in which we recognise ourselves as animals too, can be intolerable to us. We recoil from it with the horror that Benjamin describes when he gazes upon the leather gloves.

This animal-object draws us to it though, because this is the glove that fits our hand, that serves our need and secures our sense of self. The animal is fit for purpose – for *our* purpose. We know this in the suffused warmth of fur, the taut, honeyed strength of leather, the velvety softness of suede, the vibrant life of leopard, snake and zebra skins. It is entirely strange and yet serves us exactly right. How could we not seek to bend them to our will, even if we recognise some terrible alliance between them and us? If we make light of animal skins and prints, wearing them with exuberance and irony, it is part of our effort to distance ourselves from the intimate truth of our own animality, the appetites and desires, the monstrosity, the carnality, the supreme violence and savage volition that is also ours. And just like the animal, we do not know ourselves for what we are. This denial is what lies beneath when we dress in the skins of others.

JEAN-PAUL GAULTIER *'Catwoman' evening gown* (Spring/Summer 1997)

WALTER VAN BEIRENDONCK *Elephant crinoline* (Autumn/Winter 2010–11)

In 1792, Mary Wollstonecraft, examining the life of eighteenth-century women, likened their unemancipated condition to that of birds who, it seemed to her, were 'confined' in 'cages like the feathered race'. Descrying their lack of access to education, she lamented the position of women with 'nothing to do but to plume themselves'. These uncritical women-birds, she observed severely, 'stalk with mock majesty from perch to perch'. It's true that the figure of the bird suggests a certain frivolity or flippancy. You can hear it in our idioms: the 'vanity of the peacock', the 'light as a feather' weightlessness cast easily to the winds, the meaningless 'twittering' in the background of a banal day. Birds lack the solidity and seriousness of other creatures, and so their association with women seems similarly to suggest a vacuity or lack of substance, as though in being likened to a bird one might also be in possession of a 'birdbrain'. Such a woman would be guilty of 'preening' and 'parroting'. Of course we would despise her. But the association of women with birds also owes to something more than analogy in this period where feathers were a customary feature of fashion, and particularly important as embellishments in millinery.

If the association of women with birds now seems mystifying, it is only because we have forgotten the long history of hat wearing, the plumes and crests conventionally pinned to our crowns. Think of the Ascot racing scene in the 1964 film of *My Fair Lady*, and Cecil Beaton's elegantly monochrome costume design for Audrey Hepburn's incorrigible enunciator Eliza Doolittle: a white velvet gown with hobble skirt, a thick muff casually dangling from the crook of her arm, and the entire ensemble completed with enormous white ostrich plumes cascading from her hat. Here, the oversized feather is an index of the absurd social mores and exaggerated appearance of civility that the film itself lampoons.

Towards the end of the nineteenth century, the trade in feathers was sizeable enough to be formally recorded in import inventories. A stock ledger from 1884 records the skins of 7,000 birds of paradise, approximately 400,000 birds from West India and Brazil, and 360,000 birds from East India arriving in Britain in the first quarter of the year alone. When the Plumage League, founded by Emily Williamson in Didsbury, Manchester, in 1889, dedicated itself to the task of preserving avian life, the society exhorted members to vigorously 'discourage the wanton destruction of Birds', particularly stipulating that 'Lady-Members shall refrain from wearing the feathers of any bird not killed for purposes of food, the ostrich only excepted'. That same year, Eliza Phillips set up a 'Fur, Fin and Feather Club', meeting at her home in Croydon. In 1891, Williamson and Phillips joined forces to form what would become the Royal Society for the Protection of Birds, or the RSPB. By 1898, they had over 20,000 members and 152 branches.

The RSPB, from the first, was cultivated in Britain by a cohort of nineteenth-century women, conscience-stricken by their implication in the endangerment of birdlife, and devoted to the preservation of species like the greater crested grebe (an elegant waterbird with ornate rust-coloured plumes at the crown) and the kittiwake (a grey-and-white gull with desirably black-tipped feathers at the wing). Female-fronted and, for a time, exclusively ladies-only, the society invoked the tremendous political will of its members. It coincided too with a commitment to the movements of suffrage and abolition. It makes sense that the women sensed the solidarity between wider experiences of subjugation, that there should be fellow feeling between women and birds. There are reasons why birds – with their vulnerable species, subject to predation and their wings literally clipped – might resonate as a cause for women at the turn of the century.

What does it mean, though, to identify with birds, to recognise in them some aspect of ourselves? Harpies, sirens

and metamorphosised nightingales are the mythic, often monstrous, forms of this likeness. For Wollstonecraft, the preening bird is an enraging analogy for the kind of woman encouraged to be concerned only with finery. Writing in 1949, Simone de Beauvoir seized the figure of the bird again in relation to femininity. Here, it is the texture of feathers, she notes, that are expressive of a peculiarly feminine experience. It is true that men are vultures, she concedes contemptuously – in *The Second Sex*, predatory male sexuality 'dives upon his prey like the eagle and the hawk' – but it is the virginal girl who most identifies with the bird. She is naive and narcissistic in her desires, seeking out maternal softness, delighting, de Beauvoir writes, in 'the soft delicacy of eiderdown'. This virgin is unused to rough fabrics, and so the texture of masculinity comes as a shock: 'crude man, with his hard muscles, his rough and often hairy skin, his strong odour, his coarse features, does not appeal to her as desirable; he even seems repulsive'. De Beauvoir describes a girl who is as pliant as feathers and unprepared for the brash force of heterosexual intercourse.

In one of de Beauvoir's earlier works, the thinly disguised autobiographical novel *L'Invitée*, of 1943, a bourgeois couple, Françoise and Pierre, form a disastrous ménage à trois with a young woman named Xavière. De Beauvoir, describing their first meeting with Xavière, notes how when she enters the cafe, she is distinguishable from the crowd by the 'green and blue feathers in her hair'. De Beauvoir observes the uncertainty with which Xavière gazes at Pierre when he places his hand on hers and raises her arm to his lips 'gently blowing the fine down on her skin'. *Down*, she writes, because Xavière is a bird-like creature and Pierre is an entirely different kind of beast. She is unaccustomed to his touch. When Xavière abruptly takes her own life at the end of the novel, the scene is understood as an existential realisation, a wildly unpredictable and deeply philosophical act of angst and freedom.

Yet de Beauvoir surely intends that we intuit something else in the tremulous figure of Xavière too. Something, perhaps, about how fragile birds are in a brutish world, how the forms of male and female desire are different, incommensurable, their encounter like the meeting of abrasive surfaces. Our figurative language aligns women with birdlife, but it does so with contempt; the wives who hen-peck husbands, the writers who churn out chick-lit. De Beauvoir reminds us how serious the stakes are in the figure of the bird, how it analogises the experience of sexual difference. Women are allied with birds, their dresses are printed with swallows and feathers are pinned to their hair, as though the femininity expressed in the avian is always light, innocent or beautiful – but it is not.

'Back in your gilded cage, Melanie Daniels,' is Rod Taylor's smart reply to Tippi Hedren during their opening encounter in Hitchcock's 1963 film, *The Birds*. The scene unfolds in a pet store in San Francisco, Hedren's Melanie and Taylor's Mitch verbally sparring against a cacophony of chirrups, cheeps and squawks. Mitch mistakes her for a store assistant and Melanie's pampered socialite seizes his error as an opportunity for a prank, blithely guiding him around the shop, breezily feigning expertise and smilingly passing off canaries as lovebirds. When Mitch calls her bluff and consents to purchasing a canary, Melanie gamely opens up the golden cage. The bird wriggles free of her uncertain grasp and swoops wildly around the store until Mitch gracefully traps it under his hat. The temporary chaos clearly prefigures the more calamitous drama to come in the film, but the scene also sets up the domestic romance that underpins it. Mitch and Melanie exchange barbs, warily circling and assessing each other, like cautious animals evaluating a mate. Here is that mercurial thing: an *animal* magnetism that shifts uneasily between attraction and animosity.

At first, Melanie is pert and assured, the prankster toying with her mark, but as Mitch begins to test her, she grows suspicious. When he finally reveals his hand, calling her by her

real name, it is to turn the tables, the prey revealed to be predator all along. Melanie, it turns out, is a rare bird unwittingly routed, and when she realises this, she resorts to an impulsive outburst: 'I think you're a louse!' It's a charmingly eloquent period insult, and a reminder too that birds are not the only creatures here. Hedren herself is disarmingly feline-featured, her thickly mascaraed eyelashes are spiders, the lissom limbs belong to a doe. Crucially, when Hedren's character later decides to retaliate by delivering a pair of lovebirds to Mitch's harbour-side home, she arrives in Bodega Bay snugly dressed in a smart mink coat, an alligator-skin frame bag dangling from the crook of an arm and her suede-gloved hands clutching a birdcage that swings with her every step. She is, herself, an exotic animal, glibly dressed in an array of skins. Unsurprisingly, she turns the heads of the local fishermen as she picks her way around the crab traps on the shore. Camille Paglia cleverly reads this as a visual pun, suggesting how in this scene Hitchcock reminds us that Melanie too 'is a fisher of men'.

Hedren's Melanie *is* full of cunning and confidence – until the moment a gull inexplicably attacks her as she rows across the harbour. The bird draws blood from her temple, which she reaches up to feel with a gloved hand. The camera closes in on the taupe suede, a crimson stain on the tip of the index finger. It makes for a remarkably beautiful shot. Paglia describes it as a 'surrealist reversal' of Melanie's red-lacquered fingernails, although it has other associations too – the murderous Lady Macbeth, menstrual blood, a siren's lipstick smear. Suede is derived from the underside of the skin of lambs, goats, calves and deer. Melanie's blood ruins her gloves, but in another way, it reminds us that she already has blood on her hands. Her own blood soaked into the suede returns to it a sign of the life that it once had. And in this scene, as in the bird shop, Hitchcock manages his own deft sleight of hand, turning the predator into the prey and back again: she who carries caged birds is now the object of their attack.

The Birds (1963)

These distinctions between prey and predator, animal and master, dissolve in Hitchcock's film, as the citizens of Bodega Bay are forced to retreat from the chickens they once kept, the gulls they once fed, the birds they once studied. In Melanie's particular case, when the gull attacks, both she and the bird seem to cry out simultaneously, almost as though they were suddenly made one, and its voice an instinctive ventriloquisation of her own pain. As the bird attacks escalate, the suspicious locals turn on Melanie, correlating her arrival to the bay with their violence. The glamorous stranger and the dangerous creature are fused together.

The unhappy identification of women with birds is underlined by Melanie's uneasy truce with local teacher Annie. When they spend the evening together, each smoking and warily sizing the other up, they recognise themselves as the same species, both women having flocked to Bodega Bay in pursuit of their love interest, Mitch, and both thwarted by his mother, Lydia. They are birds of prey, and Melanie, particularly, the cuckoo in the nest, threatening to usurp Lydia's place in the home. As Melanie and Annie confide in each other, they are interrupted by the sound of a seagull forcibly striking the front door, evidently mid-flight and unseeing in the darkness. Annie surmises that the dead bird must have lost its way in the night, but Melanie cries out, 'It isn't dark, Annie, there's a full moon!' There *are* no wolves at the door on this moonlit night, only two young women, mystified by the forces of nature suddenly turned against them. The bird is Hitchcock's symbol of a dangerous female sexuality and the dead gull on the doorstep an augur of its unpropitious future. Melanie is entirely right to be alarmed because what follows is a merciless indictment of her sexuality. Later, she listens in terror as a crackle of wings becomes a roar and hundreds of birds rush through the chimney breast to flood Mitch's comfortable Californian home.

The power of the scene lies in the discordant squaws that drown soft voices, the intrusion of winged things in a domestic

space. Mitch's home is filled with a flurry of feathers and unsheathed claws, creatures that are no longer delicate, but furiously alien. As the crows and gulls relentlessly splinter the door and Mitch battles to secure his home, the film devolves into the familiar scenario of a daughter, mother and wife sheltering under the protection of their male guardian – only Mitch's strength is not itself enough to fend off the monsters at the door. The monsters are not *at* the door. The birds, shrieking and trilling, their wings brushing against each other, generate a tremendous force that seems almost to come from *within* the house.

The birds are the manifestation of something interior to Melanie. In the film, it is not only that she is costumed in mink, suede and alligator skin, that she casually accessorises an outfit with lovebirds in a cage, but that there is *inside* her very being a bird-like quality that makes her utterly alien. There can be a fury to birds, a charge, a vicious unpredictability. Hitchcock forcefully directs us to associate this with Melanie. Yet what threat does a well-dressed woman pose other than the desire she excites in others? Why should the stimulation of desire solicit such a punitive retaliation? Why should Melanie be assaulted by the very creatures with which she is identified?

Hitchcock notoriously released real birds during the film's attack scenes, and so Hedren's terror as they pluck the hair from her chignon and tear at her blouse is visibly authentic. When she climbs up to the attic to investigate the noise, a volley of live gulls, crows and ravens fly at her. The scene is unbearable in the starkness of Hedren's disarray and the relentless frenzy with which she is assaulted. Paglia describes Hitchcock's film as one of his 'perverse odes' to a particular mode of female sexual glamour, the captivating but dangerous woman, whose brittle artifice is rapidly dismantled. The thrusts and parries of the birds crudely reprise the earlier flirtatious exchanges between Mitch and Melanie, and implicitly prefigure the sexual penetration to which their fledgling relationship will reach. But why should

Melanie's exotic bird be bloodied and battered at the end of the film? What does it mean that a woman should be attacked as though she were receiving a terrible retribution for nothing she has said nor done? Only that a woman's sexual desirability is her own fault and that the feathered plumes with which she invites a mate also invite violence.

Hitchcock takes Melanie's outward elegance, her immaculate clothes, gloves, bags and hats, as an insult. He abandons her to creatures that relentlessly tear and nip, unravelling the fabric of her femininity until she is dishevelled, wildly distressed, reduced to the indignity of a wounded animal. She is at once assaulted by them and identified with them. She is an unpredictable and ungovernable force, capable of disrupting the normality of life and dislodging the stability of a home. Women, like birds, are a secret menace, hidden in plain sight, all around, and ready to turn at any moment. They are to be feared and rebuked precisely for their possession of this power.

In the film, the violence dealt to a woman is deferred from the hands of men into the bills of birds, as though in this transposition it might itself be dismissed as a force of nature rather than a force of brutishness. This strategy, whereby birds are deployed to mediate the fraught relationship between men and women, recurs, surfacing as a pattern in literature and culture. It is traceable in the story of Leda, seduced or raped, according to the telling, by a god disguised as a swan. Rubens's *Leda and the Swan* pictures this as the gentlest seduction. The sleeping Leda is creamy, thick, undulating flesh, naked and sprawled with a careless grace, the swan cradled between her legs, its reddened bill at her mouth. The arrangement is romantic even, except for the creature's beady eye, arrestingly non-human. Behind them, stretching into the distance, a sinking sunset enflames the sky while the fauna and foliage in which Leda lies darkens. The painting has a beauty and a menace, but most all, it has the stillness of Leda's unwoken sleep. It hovers

on the brink of a question: how will this woman take to this apparent seduction by subterfuge when she wakes? Will she yell or will she yield?

Rubens never gives us the answer to this, of course, suspending the scene on the cusp of a consummation, as though he were indifferent to whether what happens next is consensual or coerced. But this is a question that we might ask about men as well as swans. Leda's story captures how a man's desire might be as strange to a woman as a swan's. Correggio's earlier rendition is more transparently bucolic; the nymphs and cherubim frolic obliviously, as the slim and softly suffused Leda tends to the swan, ardently pressed against her open legs and reaching up her neck. She smiles lightly, her toes dipping into the clear pool at her feet. Behind her stretches an Italian blue sky, a cluster of leafy oaks, a sense of the most perfect day. But desire is not always as dignified as Correggio imagines. The pursuit of its satisfaction reveals us all as animals. When Yeats rewrites the scene in his sonnet of 1923, he has Leda intuit the crumbling civilisations, the internecine wars and the dynastic dominos that tumble after this tremendous act of interspecies intercourse. When Plath reconfigures the scene again in her 1962 verse play, *Three Women*, it is with an immediate, bitter familiarity. 'There is a snake in swans,' she reminds us darkly. Women are birds, but men are serpents, she insinuates.

Swans conventionally suggest a regal beauty, and in the Petipa and Ivanov ballet scored by Tchaikovsky, Odette is the ultimate woman dressed as a bird. She is also a queen to sixty other dancers of the corps de ballet, each cursed to live as a creature by day and the women they really are by night. At the heart of *Swan Lake*'s classical romance is the eeriness of that troupe of women, their feathered headpieces and uniformly snowy tutus, the *bourrée* steps and the folded arms that signal their hybridity, their part-animal natures and their alienation from civil society. The catastrophe of the ballet is not the craven Siegfried whose

affections, easily led astray by the sorcerer's daughter, consign the swans to their awful fate, but the sorrow of their predicament from the first. Even before the betrayal unfolds, the swans embody the awfulness of being a woman and not free.

But how can it be a curse for a woman to be dressed as a bird when birds are beautiful, diverse, peculiarly capable of moving between the different stratas of life, diving into ponds as well as flying into skies, swooping between trees, clouds and water? McQueen, filling his Autumn/Winter collection of 2001 with ostrich-feathered skirts and taxidermied hawk headpieces, explained, 'Birds in flight fascinate me. I admire eagles and falcons. I'm inspired by a feather but also its colour, its graphics, its weightlessness and its engineering. It's so elaborate. In fact, I try to transpose the beauty of a bird to women.' What he acknowledges here is the difference of womanhood, how its mode of human being might seem like that of another species entirely and how it might be most acutely expressed in the image of a creature like a bird. A woman dressed in a tulle ballroom skirt with a gold three-quarter-length coat of gilded duck feathers, fitted as closely as down, sleeved tightly to the wrist like a skin, stiffened to fan at the neck, is a queen of her own creatureliness. She solicits touch even as she is defiantly untouchable. She enchants you but makes no promise to stay. If women are dressed as birds, isn't it because birds are beautiful and boundlessly free?

These are the qualities that Catherine knows of birds and not women when she is abandoned by Heathcliff in *Wuthering Heights*. She tears her pillow to pieces with her teeth, like a wild animal herself. She pulls out the feathers and arranges them by species – turkey, wild duck, pigeon and moor-cock. The lapwing feather she seizes and declares, 'Bonny bird; wheeling over our heads in the middle of the moor'. Cathy is at home not at home but among these creatures of the sky. The irony of the scene is that in her agony, Cathy buries her face in this pillow, suffocating

her grief among the remains of dead birds, when what she desperately seeks is the freedom of their flight. If women dress in the image of birds, it is with this dream of elevation, the hope of escaping the agony of being human.

ALEXANDER MCQUEEN *Gold-feathered coat*
(Autumn/Winter 2010)

'How can we talk to them?' asks the feminist philosopher Luce Irigaray, writing of animals. Women, she notes, are badly expressed in the stories told by men, and so the alien life of animals offers up an analogy for female experience. 'These familiars of our existence inhabit another world,' she asserts, 'a world that I do not know. Sometimes, I can observe something in it, but I do not inhabit it from the inside – it remains foreign to me.' We share the world but it is differently understood by each of us. And if women, like a species apart, inhabit the world differently to men, then perhaps we make that difference visible in the clothes we wear. When we wear feathers, furs and skins, when we copy the hides of other creatures in our prints and replicate their textures in our fibres, we are seeking to come as close as we can to this different existence. The alterity of the animal world need not be a source of distress: it can be a puzzle and a fascination. To walk through the world as a woman, with swan feathers in our hair and swallow prints on our chest, is to acknowledge a kind of solidarity with the animal that is also other. It is to exercise curiosity, encounter perplexity, take pleasure, find joy, seek refuge, even dream of flight, in a mode of being that is not our own.

'Out there we shall be in the company of swans, storks, and griffins,' writes Hélène Cixous, dreaming of flight. A woman's dream of flight is also the dream of writing, she reminds us hopefully, since in language we might escape what binds us. Writing, she observes, 'is walking on a dizzying silence setting one word after the other on emptiness. Writing is miraculous and terrifying like the flight of a bird who has no wings but flings itself out and only gets wings by flying.' Women are like birds because they seek to leave behind ordinary modes of expression, because no language can contain them, because they hazard a leap into space without wings. So too the woman in the owl-embroidered jumper, the peacock-feathered fascinator, the ostrich-trimmed boa, the woman who wears the bird-shaped

brooch – they long for a freedom beyond ordinary, earthbound things. The bird is the creature that shares our world but which is able to flee from it as we might wish to, whose language is strange and yet sings freely. And if we dress in their feathers, adopting their varied colours and forms, it is as the sign of our own animality and the confidence with which we feel able to display it. As birds, we are innocent and dangerous, soft and strange at once, but always a different species altogether.

THE FEELING OF FUR

Early in Tolstoy's *Anna Karenina*, the title character journeying home from Moscow to St Petersburg, returning to her husband and leaving behind her lover, finds herself overcome by confusion. Her tumult is such that it contorts even her vision. The disarray she feels extends from her emotions and her sense of moral judgement to her ability to apprehend anything altogether. Suddenly, she cannot discern whether the train on which she travels goes forwards or backwards, whether it is her maid or a stranger that sits beside her, and finally, she cannot distinguish what it is that lies on the arm of the chair before her: '... a fur cloak or some beast? And what am I myself? Myself or some other woman?'

The cramped quarters of the train with its darkening compartment neatly captures the intense claustrophobia of Anna's closed horizons, ever narrowing with her return to St Petersburg, and the fleeting instant in which she is no longer able to distinguish between her fur cloak, an imagined beast and herself, suggests an experience close to hallucination, a symptom of her profound psychic agitation. It is a fitting analogy because Anna is a trapped animal, both conscious of her passions and the cage that contains her. Her thoughts move imperceptibly from her fur cloak to the question of her self, because there is no

longer a discernible line between them. She wears the fur cloak but the fur cloaks her too. She is the outward image of a dignified aristocrat and an inward creature of pain.

But isn't there always a deception involved in the wearing of fur? Its thickness and richness, its deep difference, subsumes us, even though we command it, parading the skin of another creature on our own bodies. We wear the dead animal and give it life, verve, sexuality even. Women's fur coats, in particular, seem to bear up that eroticism. Freud bluntly concedes why this might be in his analysis of fur fetishism. 'Fur and velvet,' he asserts confidently, 'are a fixation with the sight of pubic hair.' He offers little further exposition than this, taking the fur coat that flaunts female sexuality, as a self-evident truth. 'Fur coat and no knickers' is only an ugly adage for the woman whose surface elegance thinly disguises baser desires, but furs *do* solicit touch. They promise to insulate the wearer and yet beckon to outsiders, demanding reverence and compelling caresses.

In Titian's *Girl in a Fur* of 1536–38 the partly disrobed girl is only half turned to the viewer and her expression blank, but she petitions your touch in four very specific places: the circle of pearls around her neck, the thick twist of her hair braided at the crown, the pale flesh of her breast with its small puckered nipple, and, finally, the dark, brown fuzz of fur that falls around her shoulder and across her torso. Each texture is distinct and alluring. The portrait is mutely sexualised despite the serenity of the girl's expression and the expense of her dress. This is fur that is soon to be discarded and which is felt against this girl's skin now as her skin might soon be felt under the viewer's touch at any moment. And isn't this the implicit promise of fur? That the silkiness of the down and the softness of the flesh that lies beneath will soon be within our reach?

The figure in El Greco's *Lady in a Fur Wrap* (1577–79) is more securely swaddled in her furs. A plush, long-haired ermine or lynx provides the generous trim to a dark cloak. A veil pinned tightly

around her head lends her modesty but the fur is adamantly luxurious, calling for our touch. And although we cannot, her own fine and pale ringed hand holds the fur in place, her sure fingers finding an imagined entry point for our own. We can feel this fur's texture, depth and warmth, and it takes us as close as we can be to the woman who wears it. The fur signals how this woman possesses means and confidence, asserts how supremely she is kept and how impervious she is to our desire. But this is the trouble with fur: its surface both incites our touch and forbids it too. The woman in a fur wrap is a creature to be caressed *and* a remote goddess, she is kept warm but is always coldly beyond our reach.

EL GRECO *Lady in a Fur Wrap* (1577–79)

By contrast, Helena Fourment, Peter Paul Rubens's second wife, is more exposed and yet much warmer, in the full-length portrait of her dated 1636–38. We have entered her room too soon, catching her ever so slightly off guard. Her skin is creamy, next to the brown, ochre and reddish hues of her setting. She, too, is only partially available to us, turning from the viewer, but her gaze is candid, friendly, evenly returning our own. A long, indistinct coat of dark fur is casually draped over one shoulder and tugged across the lower portion of her hip to cover the pelvis. John Berger observes of the portrait that Fourment's exposed torso is twisted several degrees anticlockwise to the position of her squared hips and that this anatomical error is concealed by the furs she holds in place. If that is so, the painting is not diminished by it. Still, it's puzzling that Rubens should have so grievously miscalculated the angles of this body, since he knew it so well. Is the distortion deliberate? In place of physiological accuracy, Rubens seems to offer up a surer sense of his real experience. He *knows*, intimately, what this woman's body is beneath the fur. It doesn't matter that she is malformed to our view. What matters is that the painting's hidden sexual centre is exclusively his to be understood. And he *does* understand this body. You can tell by the care of the feathered brushwork at the hazy edges of the fur, how true it feels, the sense he imparts of knowing how softly it would meet this skin.

Fourment's fur cloak twists and sweeps, torquing around her form, coalescing with the surrounding darkness. 'She is turning,' writes Berger, 'both around and within the dark which has been made a metaphor for her sex.' Darkness is the right image for sex, because sex is unseeable, both a private act beyond the limits of any form of representation and an experience that is only ever our own each time. What do we do in darkness? *We reach to touch*. Rubens's fur-clad woman intimates this, signalling the mystery of sex and its promise entwined, this urgent part of our animal life that is unseen and yet lingering under the surface.

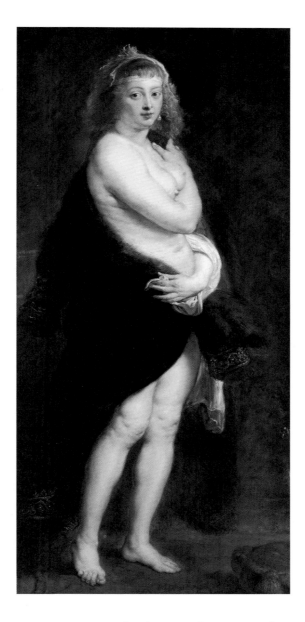

PETER PAUL RUBENS *Helena Fourment in a Fur Wrap* (1636–38)

Where is it that a woman in a fur coat begins and the animal she wears ends? Theirs is an unholy union, the apparent civility of one undone by the carnality of the other. This is what Leopold von Sacher-Masoch imagines in his 1870 novella *Venus in Furs*, where fur and sex entangled fuels the most intractable fantasy. Here, the fur-draped woman is the figure of an insolent European aristocracy, mercurial in temperament and uncurbed in her appetite for every kind of excess. She is impossibly sophisticated and instantly primal in her desires – but she is also a mirror to the man who longs for her. The difficulty that she faces is that her lover, Severin, dreams of her before she materialises. He imagines her as a marble Venus languishing before a great fire, wrapped 'in a great fur', huddled 'like a shivering cat'. And so she is also made to be that uncanny thing: the realisation of a fantasy that precedes the woman forced to live up to it.

This weighs upon her as a burden. Wanda von Dunajew, the 'real' woman charged with the task of fulfilling Severin's fantasy of a Venus in furs, is decked out in a 'dark sable coat'. She elicits from him declarations of devotion and pained laments. 'Wrap yourself in your despotics furs, for they become no one so well as you, cruel goddess of Beauty and Love!' Severin exclaims theatrically, but Wanda's furs really *are* a costume. They act upon her, as though she were channelling their character. Wanda, disbelieving how a squirrel-trimmed blazer could induce in her lover such vehement passion, intuits this uneasy truth. The fur usurps her, seems almost to possess its own personality, capable of overpowering hers. It is imbued with an eroticism that is independent of her body. When she teases Severin, accusing him of being 'truly in love with that jacket', she is only half in jest.

It is strange, perhaps, to attribute character to the skin of dead animals, but isn't it true that furs live? Don't we detect in mink an opulence and an indolence, in sable a density and a seriousness, in leopard audacity, in fox secret viciousness, in wolf a rugged weathering, in rabbit a yielding innocence? When

we wear furs, we co-opt for ourselves the original warmth of the creature it once was, but there are other qualities that we might absorb too. We slip into ermine or marten and feel its suffused warmth and weight, its silky sheen. A spell is cast. Something fugitive, something arcane, overcomes us. We *allow* it to do this, even though deep beneath the fur, we are still there – we, who claim the greater strength of our species, who master wild animals and assume an indifference to the cruelty with which a skin is won. After all, 'To wear the arctic fox', in the elegantly acerbic title of Marianne Moore's poem, 'you have to kill it'.

Furs open up to us different aspects of our character and our nature than we might ordinarily allow. They can reveal our secret venality – because when we are willing to stand in the skin of others we realise how reliant we are on things that are seized in violence, not only the clothes on our back, but the foods we eat and the lands we occupy. Or else they allow us a different understanding again. We wear furs and realise that we are never really equal to them. They suggest the animal they once were, but clothed in them, we are only ever a surrogate, a poor pretender. At the end of Sacher-Masoch's story, Venus, without her furs, is only Wanda. Bared and vulnerable, she finds that Severin's infatuation is literally skin-deep.

The mysterious power that fur confers on the wearer can be rescinded as easily as it is granted. Where, though, does it come from? Fur operates according to its own 'natural law', Severin confidently asserts, speculating as to its peculiar physics, noting how it rises with static and generates heat. The truth is that Severin's attachment to fur comes of a fantasy, sprung from a childhood encounter, violent and erotic, with a stately aristocratic aunt. Her green velvet *kazabaika* (a fur-lined jacket) initiates his pubescent sexuality. Later, Wanda, determined to secure his affections, follows his instruction, deliberately donning a 'red velvet *kazabaika* edged with rich ermine' in abeyance to this fantasy. Fur, he earnestly insists, is an enchanted

object, exercising a supernatural magic. The reality is that this power is the product of his fevered psychosexual imagination.

But is this what animal skins can do? Is this their seduction? They allow us to disown something of ourselves, displacing it instead to the clothes we wear. We defer to fur taboo sexualities, the unrestrained animality of our real desires, perhaps even a remote memory of the violence by which our civilisations have come about. These awful impulses belong to the fur, we say: it does not come from the animals that we ourselves are. Fur is only fur, but it is infused with the imaginative life of those who wear it or reach to touch it. What Wanda reveals at the end of Sacher-Masoch's story is that a woman unshackled from her passion for a man might live up to the furs in which she is gowned. She may be powerful and wilful. When she abandons Severin for a younger lover, she confirms his deepest, darkest fears:

> Every woman, good or bad, is capable at any moment of the most diabolical thoughts, actions or emotions, as well as the most divine; the purest as well as the most sordid. In spite of all the advances of civilization, woman has remained as she was the day Nature's hands shaped her. She is like a wild animal, faithful or faithless, kindly or cruel, depending on the impulse that rules her.

Severin takes this as the bitter lesson learned in the lap of the Venus in furs: distrust women, see them as the unruly creatures they are, ungovernable and intemperate. Tellingly, when Wanda throws off her fur coat, it retains the residual trace of her perfume. It no longer only bears the scent of the animal it once was. It smells, instead, of Wanda herself, and the creature *she* is. Ultimately, the fur coat discloses what Severin cannot account for: how a woman in furs might act as animals do – as he does – under the influence of their own desire. Fur, Sacher-Masoch insists, is the sign of a powerful woman and a cruel animal, the

two fused in the figure of Wanda in her *kazabaika*. But how could he ever know how it really feels to have fur pressed against your skin, to warm your flesh under the hide of another? A woman in furs can have her own love affair with a fur coat. She can also cast it off.

Greta Garbo does precisely this in G. W. Pabst's film of 1925, *Joyless Street*, in which she plays Grete, a young woman forced to decide between poverty and prostitution. Her dilemma is figured in the form of a fur coat. Frau Greifer, the owner of both a fashion boutique and a brothel, coaxes her to wear it. Grete gazes longing at the fur coat in the shop and the store assistant brings it to her, firmly pressing it upon her. Without expositional dialogue, the film relies heavily on these gestures. Here, the wearing of the fur coat functions as shorthand for other moral compromises. What makes the scene so arresting is the dreamy look in Garbo's pellucid eyes, the sudden, almost irresistible seduction of a woman by something she longs to wear.

She feels for the sleeves, unrolling them at the cuffs, running her hand along the smooth grain of the hair. The coat provides her with temporary warmth, its pile deep and luxurious to her thin fingers, even as it tethers her to the brothel owner by means of debt. When she wears the coat, it solicits unwelcome propositions from an employer who assaults her. Later, the laxity the coat signals seems to discourage truer romantic interests. This is a coat that tars the woman who wears it as the 'wrong kind of girl' and so its relinquishment indicates the restoration of a moral order. Yet it also fits the wearer perfectly, immediately bestowing beauty and granting pleasure. This coat makes Garbo's eyes shine. And it poses an unspeakable question. If the things that make us beautiful and give us pleasure are marked by something more sinister, how do we dare to claim them?

It isn't only fur that compels us in this way, although we feel the guilt of it with a peculiar acuity in the case of animal skins.

The most beautiful garments entrance us, commanding our attention, insisting we possess them at any expense, whether moral or financial. Without them, life feels paltry, and yet if we yield to them, won't our pleasure always bear that undercurrent of shame and anxiety? When we long for things we must not or cannot have, how do we allay the desire that grips us? Succumbing to temptation is the danger of Red Riding Hood's cautionary tale, when she strays from the beaten path. 'Watch out for wolves' is the edict easily extracted from the story (although, in truth, they have more cause to fear us when we dress so routinely in their skins). The wolf disguised as grandma is the nightmarish inversion of the fur-wearing woman. And despite being named for the heroine in the scarlet cape, the story hinges on their interchangeability. Wolf and girl are alarmingly indistinguishable, weirdly connected.

In the psychoanalytical accounts of the story, the wolf is the monstrous manifestation of the concerns that trouble a pre-pubertal girl, about to embark upon her own (adult) transformation. Freud reads the tale as a story of sublimated rape and violence, with its dramatic disrobings and desecrated bed. Abandoned by guardians and left to the mercy of cruel wolves and cunning huntsmen, 'Little Red Riding Hood' paraphrases a girl's fear of sex, and the wolf who clothes his beastliness acts as men can too, concealing their intentions. He hides in plain sight, like a wolfish man might.

Yet Red Riding Hood also suggests the unpredictable manifestations of female sexuality. Who is it – *what* is it – that a young woman will desire? When she peers into the mouth of the wolf in grandma's bed, she is acting on a curiosity about male interiority and sexual engagement: what is it that is inside wolves *and* men? Women know what lies beneath the covers and under the skin. Young girls imagine what it would feel like to be inside the animal. The huntsman who slits the wolf's belly performs a kind of Caesarean, and the girl who leaps out from the inside no

longer need labour over the question of where babies come from. She knows from within.

Perrault's original offers up a cloying little rhyming verse reminding us that not all wolves are wolves: some are men. The sexual connotations of this are not lost in the French for whom the sexually initiated girl is she who 'had seen the wolf' (*elle avoit vû le loup*). And there is in the woman who assumes fur, the suggestion of a knowledge acquired, an idea of adult things *understood*, because if we wear the skin of a dead beast, then we must at least have lived in the world, and known something of its brutality, its decadence, its depravity. In Angela Carter's 'The Bloody Chamber' (1979), the murderous husband, a darkly revised Bluebeard, taunts his young wife that she has been bribed with gifts, 'bought' with the 'pelts of dead beasts'. She is, from the first, seduced by the extraordinary skins he lavishes upon her, 'a wrap of white and black, broad stripes of ermine and sable, with a collar from which my head rose like the calyx of a wildflower'. The violence of which her husband is capable comes not as some stunning revelation, but as an invariably unveiled truth. Carter's suggestion here is that the beastliness of husbands is something that wives suspect, desire even as they despise it, holding it close like a stole of sable.

Red Riding Hood intuits the beastly sexuality of men in Carter's revision of the story in 'The Company of Wolves'. The wolf's hunger is an *analogy* for adolescent sexuality, but Red Riding Hood's adamant curiosity is *real* because animal life is real and so is desire. Red Riding Hood tears off her clothes willingly, fully knowing the wolfishness of the wolf. She sleeps in grandma's bed between his 'tender' paws. The ravenous animal is not so far from the sexed girl. The wolf only pretends to be a girl, but girls really are animals, wearing their skins, exuberantly living up to the carnality, the appetite, even the violence that they embody – because the truth is they are wolves in sheep's clothing and the fur coat is the temptation that attests to their most secret nature.

Still, there is something disturbing in this idea that wolves and beasts should be interchangeable with pubescent girls and easily mistaken for sexually rapacious husbands. Fairy tales trade on masquerade and metamorphosis, knowing that the line between horror and happy ever after is dangerously indistinct. Children intuitively understand that these stories are not real, just as they also know that they are not untrue. In furs, we sense the violence of animals and the desire of humans, imbricated and undeniable. These skins are liminal, marking the border between the living and the dead. They warm us with the sacrifice upon which they are predicated. What we choose to forget about fur is not simply that it is culled from a beast, but that the wild creature from which it comes resembles us too, even if we cannot bear to concede it. It reminds us of the savagery on which both sex and civilisation are founded.

THE BARE BONES

The skins in which we live are never really dead. Francis Bacon, reflecting on the images of carcasses recurrent in his work, observed that animal flesh retains 'all the sufferings and assumes all the colours of living flesh. It manifests such convulsive pain and vulnerability, but also such delightful invention, colour and acrobatics.' Why would that not also be the case for fur whose colour is lightened in the sun or the leather marked by old abrasions and injuries? Leather fabrics breathe, goes the conventional wisdom. They allow *us* to breathe, as though they bore a latent memory of an original life. Leather is that paradoxical thing, the still-breathing skin of a slain beast. It absorbs dampness and traps air between its fibres; it is comfortable to wear and never clammy like plastic. We prize it for the very qualities by which it facilitated the good life of the creature it once was. It is rainproof and

windproof, transferring its properties to the wearer like a benediction granted.

Bacon's understanding reveals the secret joy of the animal as well as its tragedy: the part of its life that continues to live even after its death. This is something we know, deep in our *bones*, even, in the whale ribs of a corset and the ivory buttons of a cardigan. The skin and skeleton of animals are the stuff of our dress, and if sometimes this is a cause for grief, the sign of a certain savagery or a history of violence, rearticulated in the things we wear, at other times there can also be ludic pleasure, a glee in the animals we mimic, whose forms generously lend themselves to our dressed lives.

Isn't it strange that they should be dead and yet make us *feel* alive? A misplaced dinosaur bone causes chaos in the Howard Hawks film of 1938, *Bringing up Baby*, but it also inspires fierce love and indefatigable joy. Cary Grant's zoologist works diligently at a skeleton in a natural history museum – he is David Huxley, named, knowingly perhaps, for Thomas Henry Huxley, the nineteenth-century English comparative anatomist, fondly known as 'Darwin's Bulldog' for his advocacy of the theory of evolution. Grant's Huxley, though, is mild-mannered, *tame* even, engaged to marry his assistant, the improbably named Miss Swallow, and devoted to the prehistoric bones in their care. When Katharine Hepburn's madcap heiress, Susan Vance, falls in love with Huxley, she leads him like a headless chicken in hot pursuit of a leopard named Baby. She coaxes Huxley like a trainer with a pet, purring down the phone until he finally agrees to come to her aid. She has the cunning of her own big cat and the same impulse to wreak havoc.

Over the course of the film, Grant is teased and taunted, altogether shaken awake from his sterile academic stupor. Susan steals his suit and so he is compelled to wear her negligee, a silken, bell-sleeved thing trimmed with marabou feathers that quiver impudently with Grant's increasing fury and animation.

Shortly after, she persuades him to borrow her brother's riding habit, oddly appropriate, since Susan and David will soon be on a hunt of sorts, a wild goose chase after a leopard let loose. Driving together to Connecticut in an effort to retrieve the lost dinosaur bone and to restrain Baby, they hit a truck of fowls and end up buying thirty pounds of raw meat.

Bringing Up Baby (1938)

What I mean to suggest here is that this is a film that spills over with an animal madness. It is shot through with the unruly ecstasy of an utterly hare-brained plan. At the climax of the comedy, the placid Baby is mistaken for another leopard escaped from a travelling circus, but it is the film's domestic romance that is the real circus, and Susan, driven wild with love, is filled with the reckless impulses of an untrained animal, gambolling with enthusiasm. Her triumph at the end of the film is that she

succeeds in reminding David of his own joyful animality too and he seizes it with unbridled abandon. Decked in marabou feathers and riding habit, he has followed her in pursuit of a bone, but as Freud explains, the final 'finding of an object is in fact the re-finding of it'. What David discovers is his nature – his true, untamed self.

What is it that we discover in wearing furs, feathers and skins if not our nature, the incorrigible, undeniable family resemblance we bear to other creatures? We share their appetites, their hunger, their desire. We are propelled by the same impulses if we allow ourselves to be unrestrained and we are inspired by their resilience, mining them for our own survival. We live clothed unlike any other creature, but the dignity we claim in being dressed is owed to them, to the diversity of their colour, the versatility of their forms. I think of this now, warmed under a fine-knit woollen sweater, a jewelled swallow pinned to my breast, dreaming of the spring. When we prowl through the world in our fur coats, feather-filled jackets, suede gloves, leather sandals, silk ties and bone-buttoned cardigans, we might remember how tightly our well-being is woven with theirs, and how intimately we know those whose nature we share.

'Hope' is the thing with feathers –
That perches in the soul –
And sings the tune without the words,
And never stops at all.

EMILY DICKINSON '"Hope" is the thing with feathers' (1891)

5.

Pockets, Purses and Suitcases

THE BLACK LEATHER HANDBAG IS QUILTED, *compartmentalised, creased with age. It is embellished with gold clasps and gilt fixtures, sealed with zips and buttons, suspended from an adjustable strap that slots into a particular ridge on your right shoulder. It leaves your hands free to grip the wriggling child on your hip and clamp hold of the other clambering at your knee, but I can walk now, am more independent, privately inquisitive. The compartments of this bag are so numerous that they are the object of infinite enquiry to my small hands which rifle through the spacious interior, fingers plunging into the tightly stitched pouches, sliding into the discreet rear sleeves, discovering, it seems, with every venture, a new slot, a new section, another alcove, another niche. These investigations happen in secret and are conducted with an anxious vigilance, because this bag is the object of sober adulthood, not childish play, its contents too valuable for my prying curiosity. This bag is the kind that is kept close when out in company. You periodically reach for it, dispensing a reassuring pat, which makes me think you have lost bags before, that you were careless once and paid the price, and that the caution you demonstrate now comes from some lesson unhappily learned. The bag cannot be left unguarded, and I intuit its privilege even though I cannot account for it.*

What it contains – household keys on a plastic fob, a slim purse, the delicate thin blue paper of airmailed letters filled to every corner with illegible characters drawn like crawling spiders on a page, a slender, circular tub of some scented unction periodically smeared across your supple hands, napkins hastily snatched from some place in passing, an assortment of safety pins fastened to other safety pins like an unlovely metallic daisy chain, a small vial of Arabian attar hardly used – all of these things are familiar to

me, modest, and so unequal to the conscientiousness with which this bag is secured on your shoulder, never left behind. You are not sentimental – there are no pictures of children, no mawkish mementos – but in one of the hidden recesses, you keep a stash of neatly folded paan leaves encasing finely sliced betel nut, sealed in a plastic bag, meticulously prepared to feed your terrible habit that will turn your teeth red as you age, your fingertips engrained with rust. Maybe this is why, decades later, when you rummage through my bag for change and discover a battered packet of cigarettes, you are unmoved, quietly accepting. Old habits die hard. And yours, strange in a cold English climate, so mortifying to me, ties you to your home. But this isn't why your bag seems to me, still now, to possess some strange mystery, guarded and reified as I remember it.

My bags expose my frailties, my ordinary Englishness: season travel tickets, blunt-edged business cards, a cluster of office keys. I carry powders, brushes, concealers, creams and cotton buds, but you were never so beholden to stupid beauty ideals. Perhaps because your beauty was so natural, so unthought. To this day, you still turn your face to the sun without self-consciousness. I never played with your bag, largely because you were not that kind of mother, the sort that encouraged imagination and pretence, although you were kind in your own way. But somewhere deep inside I think I must have known the folly of pretending to be you when I barely knew you at all, when your character seemed to me so elusive, revealing some carefully concealed compartment as swiftly as it could close itself to me. Or did I only know how inimitable you were, how ultimately irreplaceable you would turn out to be?

This bag is not some surreptitious way to understand you because you were not the sum of the things you owned, you who once travelled so far with two suitcases and four children, who left behind so many things to start from scratch elsewhere. And it's not that you don't belong here, or even that there is this other place that possesses you in a way I never could. It is that our inward

landscapes are so alien, that the things we contain within, the horizons of our desires, the stuff of which we dream, those things could not differ more. It is that place, inside, that we could never share. I never longed to be you because we were always, from the first, so at odds with and unrecognisable to each other. Not that you didn't love me. You carried me, of course, but you were always so closed. Clasped shut.

TRACEY EMIN *My Bed* (1998)

In every installation of *My Bed*, Tracey Emin's notoriously confessional set piece of the late nineties, a pair of suitcases, bound in chains, are positioned quietly adjacent to the rumpled mass of greying sheets. They are silent bystanders amid the detritus and debris of Emin's life that is memorialised in the

bed and the miscellany of discarded condoms, unloved toys and abandoned tissues that surround it. Emin's installation is a living collage, a jumble of underwear crinkled with age and stained with faded menstrual blood, cigarette butts and tampons liberally scattered like dismal stars, a noisy, ugly tangle of scissors and pills, bottles, biros and razor blades. But always at a cool distance to the squalor, sit the two suitcases, melancholy and sober.

The grey Samsonite case is resolutely sensible; the chequered vinyl trunk, bright but battered with age. They lack the open scandal of the bed, the sullied, stark truth of Emin's stuff, and so they suffer instead the ignominy of a certain mundanity, a boxy prosaicism, as though they had fallen upon the scene by awkward accident, a misplaced afterthought, easily overlooked and underwhelming. The bed and the rubble around it – a time capsule, she explained, of four days of incapacitation in 1998 – is Emin's unmediated confession of intoxication, addiction, depression and traumatised stupor. But the suitcases manage something subtler than this too. They are mystifyingly symbolic in this melee of realist disarray: slightly apart from it, they evoke the agony of isolation, and wrapped in chains, they intimate the impossibility of escaping it.

What the suitcases suggest most of all, though, is the sad watchfulness of a thing that is itself forsaken. Our suitcases, briefcases and bags can be pitiful. Forms of luggage, in particular, suffer the injury of only periodic use, the neglect of lying supine under beds and rammed into the backs of cupboards. When an occasion arises, a suitcase is entrusted the menial work of load-bearing, a mere receptacle dedicated to the carting of cargo more precious than itself. Even when suitcases are luxurious and monogrammed, they are also required to be stout and functional, robustly equal to being thoughtlessly bashed, tugged, lugged and jammed. And yet it is the suitcases that redeem Emin's piece, almost by accident. The great paradox of *My Bed* is that the sprawling, open candour of Emin's belongings should reveal so little,

that the plenitude of her littered possessions should ring so empty.

When Emin artfully arranges her bed and presents her stuff, the life she tips out for us to inspect feels paltry and inauthentic despite its sprawling, ardent openness – deliberately so. The suitcases stood quietly to the side remind us that what makes a life feel like a life is not always what we confess. Sometimes it is what we contain instead. It is in the secretive, cavernous privacy of the interior where we really are. We are vessels that store experience. In psychoanalysis, we attribute to consciousness the work of *carrying* memory, language and intention. It is in the collecting, keeping and expending of these phenomena at every waking moment that we are constituted. For this reason, our bags – the workaday holdalls that we haul, the rucksacks that sag from our shoulders, the wallets through which we rummage – all these things, are at once in the service of our lives and a figuration of our very souls.

We isolate our essential items and place them in the special care of our pockets, purses and suitcases. These are the things without which life will stall, we think, evaluating each object before putting it in its place, then zipping up or buttoning down. The spaces themselves can feel intimate. Is it because our secrets are stashed in our pockets that the indignity of being instructed to empty them cuts so deep? The things we carry offer clues to our daily lives: the keys to our homes, offices, cars and bicycles, the pills, powders and prophylactics set aside for our private moments, the jangling coins and gilt-eroded credit cards that amount to all the money we possess in the world. They can disclose, too, our hidden dispositions and underlying disquiets: the receipt that lists the illicit expense, the ticket to travel to the place you must not go but do, the cigarette lighter for the habit you cannot kick.

Then there is the obscure assortment of rubber bands and loosened buttons, the miscellanea of tissues, toggles and safety pins whose presence falls from our remembrance until the instance of their use calls our fumbling hands to dig deep and

recover them triumphantly once more. 'I knew this would come in handy!' we declare. But what *is* it that we need at any given moment and without which we are at a loss? In our bags, we pack the essentials of life, but they so often reveal how inadequately prepared we are for the vagaries of fortune and how little is ever really within our power.

Our carry cases carry worlds. To be incurious about the contents of a bag is to have lost interest in life, its capaciousness and its caprice, made visible in the jumble that we collect along the way. More even than this still: the space of the bag opens up to us a complex sense of ourselves, intimating the ways in which we can possess and are dispossessed by turns, and how these experiences form us. The bag is a metaphor for who we are and the possibilities we contain for feelings of repleteness and emptiness. The activities of amassing, assembling and distributing stuff are an integral part of our experience, and the bag, the purse and the pocket, in all their varied forms, enable this. Hollowed out, it is an inalienably private realm where things can be secreted, held safe and rediscovered by rummaging hands in the dark. It is hidden in plain view, its contents made portable, available to be given away when the moment arises or forcibly seized against our will.

In the bag there are ideas of privacy and barest necessity, plenitude and depletion, dark interiority and public exposure. We fill them with what we deem to need or desire, which we carry with us in order to allow us to be ourselves in different places. It is a trusted repository and yet there is treachery in the moments we find it empty or insufficient. It is an emblem of our own sense of interiority. It reminds us that the capacity to contain is what makes us what we are and loans us mobility so that we might be what we are in different places. It secures our private life even as it opens us up for public inspection. We carry our bags close, as though our life depended on it. Sometimes, it does.

Deep within the amassed pages of the Leonardo da Vinci papers, among the meticulous architectural details, geometric diagrams and animal dissections, is a design for a handbag, dated 1497. Puzzlingly detailed, the sketch sits in the bottom corner of a folio from the *Codex Atlanticus* and resembles nothing else around it – none of the miscellaneous sketches of cogs and gears, a box mechanism, a sliding drawer, a small figure drawn in ink – although it clearly absorbs the artist's attention with the same intensity. Arrestingly modern, Leonardo's bag is a solid trapeze-framed construction, featuring a top clasp and a surprisingly ornate front fascia of curlicues and scrolls. It is such a remarkably modern design that in 2012, an Italian fashion house commissioned an artisanal leather worker to faithfully realise the sketch, producing a limited edition 'Leonardo' handbag in intricately appliquéd dark brown calfskin and ornamented with brass hardware.

At first, the idea that Leonardo should have turned his agile mind to the design of something as inconsequential as a handbag seems faintly absurd, but, tellingly, his papers also include sketches for saddlebags to be carried by camels crossing the Nile, complete with complex pulleys, ropes and meshed nets. Leonardo perceived, even then, just how much would rest upon the efficient transport of goods, how this basic problem of engineering in its various forms would become the enterprises of modernity. Haulage, freight, conveyance and shipment: these are the industries by which the global routes of trade flow. How we solve the problem of carriage is modelled in miniature in the form of the bag. The bag is a feat of design and mechanics. Is it *this* that absorbs Leonardo in that half-thought moment in which he sketches out the shape of a bag in the bottom corner of a notebook? He responds to that simplest of puzzles from which all commerce comes: how best to carry one's possessions.

LEONARDO DA VINCI Handbag sketches

The question of *how* we carry is predicated by our right to possess things at all. In claiming proprietorial rights to stuff that is exclusively *ours*, we mark out the parameters of our particular personhood, distinct from others. Here is the wealthy industrialist with the platinum credit card tucked in a monogrammed wallet. There is the small child on a tender first day of school, anxiously clutching their tiny pencil case. Our bags enable the acts by which we claim possession (holding, keeping, carting, storing) and so they instantiate the fact that we are exclusively ourselves and no one else. This is *mine*, we say. And I am *me*. We own things and we carry them, and it is selfhood itself that we seize as possessions in these acts.

Predictably, the design history of the bag demonstrates how differently the burden of load-bearing has devolved between men and women over the centuries. The term 'purse', originates with the early Latin *bursa* and the Greek *bysra*, cognate to our sternly functional modern terms bursar, bursary and reimbursement, although purses could also be sacred spaces, housing alms, offerings and prayer beads. Its pre-history, though, owes particularly to the more irreverent space of the men's pouch – positioned at the groin. François Rabelais makes a ribald joke of this in his sixteenth-century comedy *Gargantua and Pantagruel*, with the orange that is cheekily stashed in the roguish Panurge's codpiece. He nonchalantly fishes it out in the middle of the most serious debate.

How to reach for your coins, when they are nestled this *closely* to your body is a comic dilemma – made slightly more hazardous with the emergence of the sharp-edged shrapnel of gold and silver currencies. Later, men's pouches would become more purse-like, sensibly moved from their awkward position under breeches to more easily accessed waists. Not that this solved all problems, since the items once stored privately were now exposed and could be susceptible to ruthless 'cutpurses'. Signalling the very wealth it purported to secure, the purse

seems to have invented its own subgenre of criminality. The looser breeches of the seventeenth century permitted more discreetly concealed pockets, while also ceding to cavalier codes of masculinity since the now neatly stowed pouch no longer obstructed a man's access to the weapon at his hip. What I mean to suggest by recounting this history is that even in its earliest forms, there was nothing safe about the purse. The security of its contents is a source of anxiety, watchfully guarded from passing blades and protected by one's own.

For women, the handbag functioned differently. The earliest known example of a portable carry case, specifically for a woman's use, seems to be a small brass box, inlaid with gold and silver, made in fourteenth-century Mosul, Iraq, and likely to have belonged to a noblewoman. The novelty of the piece is recorded in its own strangely self-conscious ornamentation. A narrow strip of the inlay depicts a busy court scene, a man and a woman in feathered hats seated on a dais, surrounded by courtiers, a falconer, a lute player, a parasol carrier and, most unexpectedly, a valet carrying the very same handbag itself. It is, in essence, the first ultra-lux, limited-edition handbag, not liberally monogrammed by its maker in the modern style, but bearing its own exclusive image, as though it were conscious of exactly how remarkable an object a bag itself could be. The engraving depicts the bag slung across the valet's chest, and in his hands, he clutches a mirror and a cloth as though he were readying to attend to his mistress's toilette.

Early purses were associated with personal care, and so they made for especially intimate betrothal gifts, their significance accentuated by the bluntly sexual associations of the bag. What could be clearer than a symbolically hollow interior waiting to be filled? From its beginnings, women's bags have been sexualised objects, not least because they are also the visible sign of a private life, displayed in a public. They solicit speculation. *What* is it that a woman's purse can contain? Who

can access it? And quite how close to her person does a woman keep such a thing?

Early purses, small sacks tied with string, utilised the volume of skirts, were discreetly attached to the waist and tethered under several petticoats. This is what you glimpse at the edge of Pieter Bruegel the Elder's *The Peasant Dance*, painted in around 1567. A small pouch and house key swing into view beneath the flaring skirts of a female dancer. She is being pulled by her enthusiastic partner into the centre of the painting, and the flash of her purse suggests their haste. A crowd of men, seated in the foreground, drink from beer jugs and converse, keeping easy company, while behind them on the left a couple are locked in a comic embrace, lips glued together. Visible in the distant horizon of the painting is a church, its steeple and cross poking into the sky, although the dancers are oblivious to it. It's an exuberant, energetic work, but ambiguous too in its moral judgement. The visibility of the bag seems to pose a question about the character of the woman who carries it.

Mockingly called 'indispensables', later purses made light of the bag, lampooning the idea that a woman could have need of anything essential. Calling cards, decorative fans, handkerchiefs and smelling salts: these were the accoutrements of a graceful, but entirely effervescent social life. When the slimmer dress silhouettes of the nineteenth-century eliminated voluminous skirts and the pouches that could be concealed beneath them, the newly visible 'reticules', hardly more than a pocket gathered with a silk cord, seemed to be named precisely to 'ridicule' the idea that a woman might be entrusted to keep in her possession an item of any significance at all. Despite this contempt as to what women might deem important to carry, these spaces were personal. They could harbour private life itself. The everyday bags in which you might store your needlework, for instance, could be entirely idiosyncratic, a jumble of materials, thimbles, trims, scraps of favoured fabric, coveted threads and offcuts of expensive lace, quietly gathered over time.

Sewing was the small, peaceable work to which many women, so often under-educated and without employment, devoted their time. For the Brontës, domestic life depended upon the daily labour of dressmaking, the hemming of household linen and a constant regimen of repair and repurposing, but their sewing bags were also filled with prized threads and embellishments, the precious materials collected for decorative samplers and more elaborate embroidery projects. And in this private activity of sewing, a woman might find the means for expressing her innermost feelings, otherwise stifled in polite social discourse. In 1830, Elizabeth Parker, a nursery maid in Ashburnham, Sussex, composed in red cross-stitch her thoughts of suicide. 'What will become of my soul ... ' she wrote, her stitches breaking off mid-sentence. What *does* become of a soul? The small tools secured in her sewing purse seemed to permit her the means to pose that most searching of questions – a question which she could not, must not, ask elsewhere.

What do women keep to themselves? The bag is a window into a woman's soul, and it is a metaphor too that suggests what it means to have a private life, to possess the capacity to keep hold of, carry within or give away things that are more intangible than mere stuff. The right to private reflection is not so far from the right to private property, and so the bag is an emblem of the ways in which women's lives can be scrutinised and circumscribed, but also carefully concealed, kept away from view. There are the things that women are expected or allowed to keep in their bags – and then there are the things that they might store in them nonetheless, like a whispered confession made only to oneself.

In the small bag, a woman is permitted only to keep small things or small change, curtailing her abilities to spend, save or gamble. Her purse strings are tightened for her by dint of design. In *The House of Mirth*, Lily Bart's gloved fingers know keenly the lightness of her 'little gold purse' as she mentally reckons what she has, to whom she owes and the risks she may or may not take

in order to repay her debts. These are the enormous questions that burden her when she leaves the card table after a series of devastating losses, returning to her room to discreetly replenish her bare purse. Lily has next to nothing and owes everything. This is her agony. Her delicate purse presents a veneer of gentility and modesty disguising her desperation, the indecent debts she has accrued and what little she has to set against it. Its compactness is an index of class, feminine reticence, the need not to attend to the practicalities of an unleisurely life, and so contrasts to the voluminous bags of labouring women and the capacious aprons of working maids.

The decline of those decorative bags, familiarly dangling from wrists and clutched by gloved hands, and the emergence of the broader shoulder bags of the twentieth century, those generously compartmentalised holdalls, totes and vanities of all shapes and sizes, indicate the changing consumer powers of women, the control they could command over domestic economies and their more frequent excursions away from the home. By the 1900s, dress patterns began to include built-in pockets, alluding to the increasingly pragmatic functions of womenswear, but implicitly acknowledging too the idea that women might engage in the practices of collecting and depositing – that their lives could be altogether more interactive and responsive.

The evolving functionality of women's bags reveals them as no insignificant accessory. It is a technology and, reverse engineered, it discloses at each stage an untold history about the place of women in their worlds. We can trace the popularity of cosmetics in the emergence of dedicated compartments for face powder and inbuilt mirrors, measure the uptake of cycling in the development of shoulder straps, rucksacks and satchels, track the purposefulness of working women during wartime in the profusion of dispatch, cartridge and messenger bags. The backpack, duffel and saddle styles form part of the regular repertoire of women's bags now, but this is a legacy, born of

women's wartime appropriation of men's functional workbags.

Despite these apparently unisex modern styles, the 'shouldering of luggage', complained Germaine Greer, remains 'an ancient female habit, born of servitude'. It is an ancestral legacy of our hunter-gatherer societies in which a woman would trudge along behind her mate, lugging 'their infant, their shelter, their food supplies and her digging stick'. Beneath the elegance of the ubiquitous handbag, there is the indignity of being a woman, this weaker sex, historically burdened with load-bearing. The woman who carries things tacitly agrees that she herself is not the thing worth carrying. She implicitly acquiesces to this relegation, taking up a position of support or supplementation, always the accessory, never the agent. The load-bearing woman is another version of the childbearing mother, a woman reduced to her biological function, and so Greer rails against it – this bag that is only 'an exterior uterus, the outward sign of the unmentionable burden'.

Freud reads the connection between the bag and female biology with an alarming directness in the case of Dora. Brought to his therapeutic care in 1900, 'Dora' is the teenage patient who accuses a family friend of unwanted sexual advances. She presents to Freud as a 'hysteric', her symptoms a persistent cough and a tightness of the throat that result in selective mutism. He notes, too, how anxiously she plays with her handbag, or 'reticule', in their sessions. He reads this habit as a desire to masturbate. His analysis is so confident that it is almost glib, but Dora's traumatic anxiety is real and it seizes up her throat. The 'cervix', in its Latin origins, is the channel to the throat as well as the womb. In Freud's analysis, the bag, the womb and the closed throat are connected, the interchangeable sites of anxiety in which the symptoms of hysterical womanhood make themselves manifest.

If purses are apparently feminised in culture, the pocket is resolutely manly. In those notorious lines apocryphally

attributed to Mae West, the pistol in a pocket is easily mistaken for the arousal of a man 'just pleased to see me'. The object of her joke, though, is masculinity itself, the crude ways in which it makes itself apparent, in sex and violence alike. In either case, Mae West's man is equipped for his situation. Men's clothes have always been designed for function. Their pockets have a purpose and are design-engineered for the life they might expect, from the discreet inner alcove of an overcoat into which a commuter's travel ticket might be slotted to the patch pocket on a military coat that is readied for the large and capable hand that will decisively reach into it and find precisely the right resources for the right moment. The side pocket of a man's pilot's jacket was, in wartime, prepped with an emergency parachute poised to burst open should you find yourself in a spot of bother. To this day, Levi's jeans retain the slim square sleeve, riveted on the right-hand side, the denim pocket a remnant of pioneer days when cowboys could store their fob watches, safe from daily skirmishes with horses and hustlers alike.

The relative lack of pockets in modern womenswear has become a familiar lament, but an important one, since the design functionality of men's pockets so clearly reinforces the characteristic of adventuring pragmatism, seemingly exclusive to their sex. Women's pockets, if they have them at all, are attributed more troubling associations. In the folk rhyme, when Lucy Locket carelessly loses her 'pocket', the song refers to the detachable purses usually tethered to dresses, and Lucy and her rival 'Kitty Fisher' (who finds the pocket with 'not a penny in it') apocryphally take their names from two celebrated courtesans, connected to Charles II. Nancy too, in Dickens's *Oliver Twist*, is the honourable prostitute in a pack of common thieves. Fagin's delinquents pick pockets but Nancy pours out her heart when she confesses her degradation to the genteel Rose Maylie and enables Oliver's rescue. When Rose beseeches her not to return to the 'gang of robbers' and her life of 'wickedness and misery',

she alludes to the prostitution that grimly underlies the novel's surface image of ingenious urchins.

This association of the pocket with prostitution is such an unhappy one because it suggests the vulnerability of the female body too and how easily this personal space could be encroached. Pamela, the eponymous heroine of Samuel Richardson's 1740 novel, is instructed to disclose the contents of her pocket, or bundle, to the predatory 'master' who holds her against her will. The encounter is further evidence of his impropriety, the claim of his right to inspect her without her consent. Pamela's response – fainting, weeping, catatonia, descent into hysteria and melancholia – are the symptoms suffered by a victim of grievous assault. He imprisons her, intercepts her letters, and she has nowhere to turn, not even the privacy of her own pockets.

We hope that our pockets are private enclosures. While they can hold our secrets, we know that they are not inviolable. We entrust to them things that are dear to our heart or vital to life. We hold their contents close to our chest, warmed against our skin. Their power lies in their ability to go where we go, to be our ever-present companion, making their contents known when it is relevant to our requirements and receiving as best they can whatever we command of them. At other times, the pocket only patiently awaits its moment, rising to our demand or falling short of our need. The pocket is unobtrusively there, instantly forgettable and yet always with us. Without it, our hands can be at a loss. The false pocket is an infuriating deception, while the true pocket is the friend that keeps our secrets. Sometimes, a pocket makes a fool of us, abusing our trust, losing things we love or refusing to hold fast at the seams. But at its best, the pocket possesses a certain magic. It supplies the gun, the stolen key, the gold coin, the urgent and indispensable item, the stray object that suddenly rises to an unexpected occasion. It is full of promise.

A 'ham sandwich' is what the cantankerous King in *Alice Through the Looking-Glass* demands when he feels faint. Don't we all? Luckily for him, a sycophantic messenger is on hand and promptly fishes one out from the depths of a bag slung around his neck. Alice is amused and unsurprised by the transaction. Why should she be? Her adventures in Wonderland prepare her for the ludicrous, and purses containing magic beans, sacks crammed with straw spun into gold and pockets filled with breadcrumbs are the familiar stuff of fairy tales. All bags are magic to the degree that magic is the name given to a certain potential for transformation. Think only of the sachet of seeds from which a field of hay springs, the contents of a carrier bag with which you can concoct the most elaborate cuisine, a purse of coins that pays your entry onto a tram and transports you into an entirely different city.

In Yoruba culture, the beaded *apo ifa* bag of the *babalawo*, or tribal oracle, is traditionally filled with the accoutrements of augury – palm nuts, divining rods, carefully carved ivory figurines. Different kinds of bags are capable of different kinds of magic: the doctor's satchel with the instruments that can measure your heartbeat and dilate your eye, the builder's workbox loaded with the pliers, spanners and screws that form solid structures and repair household goods. Even the everyday bags that we fill with umbrellas anticipating rain, bottles of water predicting thirst, aspirins imagining headaches, are prophets of the future. There are other bags, though, that are more mysterious, inviting us to chance our hand. This is the principle of the lucky dip and the lottery, Santa sacks and tombolas alike. These bags leave us to fate, modelling in miniature the unpredictability, the promise and the disappointment of life itself. And what we forget, as we grumble and lug our things from place to place, is how radically the contents of a bag have the power to alter the course of our lives entirely.

It is a smart black Franzen briefcase that derails the characters in Quentin Tarantino's 1994 *Pulp Fiction*. In the film, Ving Rhames's coolly brutish Marsellus is on the trail of a particular attaché case whose combination lock mockingly clicks open to the numbers 666. Delinquents are shot, reprobates tortured, and Marsellus himself brutally raped in pursuit of it, but the film's long tease is that no one ever explicitly discloses the precious cargo it contains. When John Travolta's Vincent Vega and Samuel L. Jackson's Jules Winnfield are appointed its unlikely guardians, their association lends it further grandeur. When the cheerfully violent Vincent opens the case to verify its contents, he is stunned, his face wholly illuminated in a reflected gold. 'We happy?' asks Jules. 'Yeah, we happy,' Vincent exhales, confirming a 'happiness' that is not simply conferred by the safe requisition of the case but granted, like a benediction, from that which lies within.

Later, when Tim Roth's 'Pumpkin', an inexpertly armed hold-up artist, stumbles upon the case while looting customers during a robbery in a diner, he prises it open, against Jules's advice. Its dazzling light suffuses Roth's face and his visibly astonished expression is the viewer's only clue as to what he witnesses. 'Is this what I think it is?' he asks in trembling voice. But *what* is it? There is a Tarantino-ish mischief to the question which tacitly baits an impatient audience. Never granted the view from the

other side, they are left always in the dark, limited only to wildly guessing at what it is that one briefcase can bear.

This is the film's extended joke – because what is it that a briefcase can contain, other than bureaucracy and boredom? A briefcase sails through daily life, largely ignored, indemnified by its innocuous air, gripped businesslike by businesslike people. Its banality is the most perfect disguise for stashed diamonds, wads of cash and Nazi war documents – the loot with which it is customarily entrusted in heist movies. In the complex capers and near-miss plots of these films, the contents of the briefcase matters less than the briefcase itself. Everything narrows instead to the safe transit of this nondescript leather-clad block and the heated pursuit of this thing that is as precious as what it contains. A botched jewel heist provides the plot for Tarantino's debut film of 1992, *Reservoir Dogs*. Perhaps it is the very same jewels that make their way into Marsellus's briefcase in the follow-up film. And although there is a pleasing continuity to this hypothesis, what Tarantino's direction taunts us with is a possibility without limit. The coveted briefcase can contain anything. We need only to long for it, strain at it, throw all caution to the wind in our imaginative quest after it.

Ultimately, the contents of the case do not matter, because Tarantino, steeped in the cinematic historic of heists, knows the power of the device itself, this briefcase loaded (or not) with booty, how it assumes the power of a holy relic, how it absorbs the fervour of those who pursue it so recklessly, and presents back to the viewer only the silhouette of their own unspecified desires. The film attributes the briefcase with a mystical air, taunting us with a secret to which we may never be party. But this is the point: what the case contains is as wild as our imaginations can allow and it can only exist as an object of our imagining as long as it is never revealed. What matters is not *what* is carried within, or even its safe passage, but the container itself, its capacity to house our imaginations, narrowing our fantasies into its

precisely delimited form. This is what bags and briefcases can do: they can receive our unrestrained daydreams. They permit us to speculate about the people who possess them when they swing so innocently from a tightly gripping hand. And they ask us to imagine ourselves too as creatures of mystery, bearing our own secrets in broad daylight.

What we know from our own bags, briefcases and pockets is that in them there can be room for a delightful eclecticism, the madcap conjunction of disparate things, an utterly idiosyncratic assembly: a key ring from Rio de Janeiro, wipes for the grimy face of your child, the button that belongs to your most loved shirt, a leaf whose shape you rather liked one autumn morning, the crumbs of a biscuit unwisely secured in a serviette, the foreign currency you never remember to discard. Sometimes, there is a civility to them, in their discreet keeping of things from view – tampons, condoms, tissues, chewed gum – but they can also be capable of subterfuge. Our pockets are tricksters, toying with our expectations. Is that an engagement ring nestled in the inner alcove of that trench coat? Is there a key for this locked door, lodged deep in that denim jacket? Is there a condom kept in that wallet?

While the things we store in our pockets and purses reveal so many things, sometimes it is those very spaces themselves that are most telling of all. We are, ourselves, containers, the vessels of life. It fills us with its debris, and so we house experience as well as stuff of all kinds. We spill with thoughts, memories, ideas and emotions. The bag resembles us in some uncanny way because it posits the possibility of an interior depth, veiled from view, its contents ever promising to tumble out.

The truth is that we *are* in this capacity to contain, sometimes never to give away. We are made up of half-hidden things stored in ourselves, felt for like the object deep in the darkened pocket or buried in the bottom of the bag, known only to us and not the light of day. The pocket is the place for our secrets. Derrida

observes that 'in order to possess a secret *really*, to have it *really*, I must tell it to myself'. We must keep our secrets as though they were things, carried with and in us, and yet also available to be seen, as though they could be grasped apart from us, held up to our gaze. The paradox of a secret is that it must be yielded, given up or away, even as that very action would destroy it. We may not wish to let the cat out of the bag, but the secret only exists as a secret as long as it also retains that possibility of being made available. The secret is that thing we possess in order to be dispossessed in an act of instant sabotage. And so the self that contains those secrets is a kind of case, a holdall to hold all, if you like, which at any moment can be undone and its contents emptied out.

When we decide to reserve our secrets for ourselves, turning to taciturnity, we hold something back, *keep* it even, as though this ability to store were itself a property of our personhood. The experience of interiority is the inward sensation we each have of our capacity to contain. 'I contain multitudes,' Walt Whitman declares expansively in 'I Sing the Body Electric'. If we're lucky, we too might feel the exuberant kind of largesse that Whitman claims when he extends his humane sympathy to all living creatures in wild, pantheistic abandon. More often though, most of us feel something smaller, a more contained sense of ourselves, carefully delimited by the border of our bodies, the range of our perceptions, the limits of our feelings. This idea that selfhood itself might be *inside* begins with St Augustine's entreaty in *Confessions*: '*Noli foras ire, in teipsum redi, in interiore homine habitat veritas.*' 'Do not go outward; return within yourself. In the inward man dwells truth.' Augustine's exhortation is an *in*vocation; he calls us within because what we seek lies there: '*intus*'. Inside.

Why is it that we locate consciousness 'in' ourselves? Somehow, it makes sense to see ourselves *in* here and not *out* there. 'When a given constellation of self, moral sources, and

localization is *ours*,' writes the philosopher Charles Taylor, in his 1989 *Sources of the Self*, 'that means it is the one from *within*, which we experience and deliberate.' Consciousness is constituted by this idea of possession and the internal coherence that the experience of ownership permits. If we can say this is 'ours', then we have the integrity of a form and a boundary. We are formed by the ways that we keep, retain, retrieve from and root around within a space. We are demarcated by the shape of a body and the imagined parameters of consciousness.

The psyche too is a container. The id, explains Freud, is that primitive and instinctive aspect of personality, a 'cauldron' of excitation, while the unconscious is a 'repository' of experiences not yet fished out by memory. It is the heap of experience that has been rejected or discarded. In it languishes those things that we don't dare to know about ourselves, or which we seek to remove beyond retrieval. They stay there, *inside*, nonetheless. The unconscious is that compartment within the container that we are, long neglected, its locks rusted, its zip snagged, but which we cannot pretend does not exist. At the most inopportune moment something in life tilts us and tips up its contents.

In real life, our real bags carry our neuroses, betraying us easily to those who care to root around. They'll find the pills that signal frailty, the spare tights, tissues and plasters that disclose our anticipated anxieties, the make-up we use to patch up a flaw lest our veneer drop. Sometimes, we hold out hope of a better life in a bag, organising in advance the things we will need, our past resourcefulness smoothing the path of future faultiness. We prepare for every eventuality in the well-stocked bag, following in the fashion of P. L. Travers's insanely competent Mary Poppins. From the depths of her modest carpetbag she plucks aprons, hairpins, a packet of throat lozenges, a bottle of medicine (to be administered with a spoonful of sugar in the Disney film of 1964), seven flannel nightgowns, one pair of boots, a set of dominoes, two bathing caps, one postcard album, one folding camp bed, a

folding armchair, blankets and an eiderdown. Julie Andrews's Mary even manages a coat-stand.

Mary's bag exerts a domestic power that reassures the neglected children left to her care. This bag is the source of a maternal power, presented as magic, unfaltering and unlimited. 'Oh, it's a jolly 'oliday with Ma-ry / Ma-ry makes your 'eart so light!' sings Bert so cheerfully in the film, but Mary is the mother whose real resource is love that pours from a wellspring, boundless and plentiful. Her bottomless bag is the Greek *bythos*, a sea-like depth without end and on which a child can always rely. Hermione, in the last *Harry Potter* novels, carries a bag with a similarly unbounded capacity. She conjures it with magic, but really it is born of the proficiency she already possesses. Instinctively understanding how to supply those around her with what they need, she fills this bag with spell books and cauldrons, rainproofs and pop-up tents. She is the bearer of an infinite capability, an inexhaustible resourcefulness that time and again salvages her boyish companions from the scrapes into which they fall.

The practical magic of these bags seems so unlike that of the precious high-fashion handbag, sometimes small, often extravagantly priced, not always capable of the work to which it might be put. What can you keep in a vintage Dior clutch bag other than a lipstick and a hotel key card? The woman who carries such a bag boasts, instead, of her own, more self-sustaining power. She lives on honey and manna dew, never needing to rely on material forms of sustenance or even a source of money. Hers is a natural beauty that will have no need of the restorative brush of a comb, the spritz of perfume or a change of underclothes. The woman who owns this bag is insouciant, independent, able to survive on air alone, never needing the care of another, let alone a mother. These bags can be small and slim from the outside, safely concealing the chaos within.

Marnie (1964)

The eponymous heroine of Hitchcock's 1964 *Marnie* is the consummately stylish thief, carrying away bags and hearts alike, although the film reveals her as an inwardly anguished, abandoned child. She strides along a train platform in the opening scene, a slim figure with a dark bob and a bright yellow handbag tucked neatly under her arm. A grey suitcase swings lightly from the other hand. 'Robbed!' is the first word of the film, issued by an outraged business owner. 'Cleaned out! Nine thousand nine hundred and sixty-seven dollars! And that girl did it.' The film cuts to the fugitive Marnie's hotel room strewn with two suitcases, an array of saddlebags, wallets, cigarette tins and cardholders, and Marnie packing once more, tipping the contents of the yellow handbag into another, preparing for the next audacious swindle. But it is neither money nor wealth that Marnie really wants, Hitchcock implies, steering us instead into a psychosexual drama of maternal neglect. 'Mama, why don't you love me?' she whines desperately during a visit home, because Marnie is as empty as the bags she fills,

longing for the maternal affection without which she is deficient and delinquent.

The film, littered with surreptitious shots of the interiors of other people's bags, configures Marnie's criminality as an expression of her longing to be as full as she imagines others are. When Sean Connery's wealthy young industrialist catches her in the act, emptying one taupe handbag into another, he pledges to rescue her, endlessly replenishing the money she takes so obsessively and offering up a life without crime or debt. He knows that his material generosity is an attempt to fill another kind of emptiness. He sits at her bedside, assiduously researching female sexual psychosis and the 'undiscovered self', like the psychoanalyst/lover, determined to plug the holes and mend the tears in faulty womanhood. Tippi Hedren's infantilised Marnie is wide-eyed and tormented: 'I'm a cheat, liar and thief – but I am decent,' she cries out theatrically. And yet the film's remorseless thesis is that an unloved daughter is always impossibly broken unless a wealthy man replenishes her. What it never allows for is how universally that feeling of emptiness might extend. We need not be thieves, frauds or hysterics to know what it is to feel unfulfilled, unloved, *wanting* in some vital component. Because isn't there a certain experience of desolation undeniable in all of us?

'What is it that bags have that women most need and do not have?' asks the psychoanalyst Adam Phillips, wondering about their ubiquity. The bag, he hypothesises, is the symbol of the mother, a portable womb. It is the memento we carry with us of the first thing that carried us. It is what we take with us when we leave our mothers behind, when we are left to fend for ourselves far from home. It is true that, at its best, a bag is dependable and capable, and at its worst, it is not equal to the demands we make of it. When we walk away from our mothers, we are compelled to find the inward resources for self-care. The handbag, Phillips observes, allow us to do this. We leave home with the bag that absorbs the functions of the mother. It equips

us so that we might tend to our own needs – wipe our own noses, pay our own way, find our own route home – when they are no longer there to do so. It stores the provisions that might enable us to stand up alone, and so our attachment to it is a sign both of our independent adulthood without the mother and a lingering longing for her nonetheless. If this argument is persuasive, it is because that experience of independence – the feeling of being forsaken, fearful and alone – is so familiar to so many of us.

Mothers know this too. The womb, explains the British psychoanalyst Donald Winnicott, is only a temporary *holding* place, soon to be replaced by maternal arms. The task of holding is the burden of the 'good enough mother' who provides the environment in which a child's development can happen safely. But to be left empty-handed is the object of motherhood, its final, and right, outcome – just as longing for our mothers is the trauma we carry with us from having once been a child and no longer being held in their arms.

The bag is a maternal metaphor, but emptiness is a real experience. Psychoanalysis traces it to the original dispossession of mothers and children, but we are, throughout life, creatures that lose things and who can be at a loss. When Anna Karenina loses the will to live, it is a red velvet handbag that she casts onto the track before laying her own body down. Her suicide is, in its own terrible way, the final act of self-ownership. Tolstoy's novel devotes itself to the fullest delineation of a woman's interiority and its own capaciousness is itself a signal of the dignity and complexity he is willing to grant her. At the end of the novel, when she has expended desire to the point of destitution, it is the discarded bag, small and red like a heart, that marks the dereliction to which she is already abandoned. Finally, she gives up the very last thing she possesses: her own life.

We are, all of us, capable of emptiness, know well that sensation of the hollow interior, the lonely chasm that we sense inside and which nothing will fill, the depleted self that is the

echo chamber of desires spoken only to ourselves and never properly met. In Beckett's *Happy Days*, the desolate Winnie is left with nothing but a bag, and her monologue circles obsessively around:

> There is of course the bag. (*Looking at bag.*) Could I enumerate its contents? (*Pause.*) No. (*Pause.*) Could I, if some kind person were to come along and ask, What all have you got in that big black bag, Winnie? give an exhaustive answer? (*Pause.*) No. (*Pause.*) The depths in particular, who knows what treasures.

What is it that Winnie's bag contains? Is it an elusively existential metaphor or does Beckett mean by it some real material resource that could magically revive or relieve us in crisis? If none of this is made clear to us, what makes sense nonetheless is the idea that in a moment of need we might recourse to something outside of ourselves, seeking the sustenance we cannot find within. This bag promises to sustain Winnie, beckons to her with its possibilities, but the challenge, she knows, is not to come to rely on it and so instead learn to be able to live without it, to live without the need for anything other than the resources she might find inside herself – finally self-sufficient.

Don't we all know this feeling? When we are empty, there are things that we seek out – a mother's kindness, a lover's affection, a book, a drink, a drug, a cigarette – to fill some void. And what we realise in those moments is that we could never have enough or take enough to sate this emptiness. The bag signals our maturity, our ability to prepare for life, how readied we are to support ourselves, but it also confesses our fear that when we are alone we will never be equal to the world we have to face. We stuff our hands in our pockets because we don't know what to do with those hands when they have nothing to grasp

hold of other than themselves. But what if we could learn to be without possessions, to be instead utterly self-possessed, capable of containing only ourselves as we are, carrying nothing but the truth of that alone?

TRAVELLING LIGHT

When Mollie Mathewson, the heroine of Charlotte Perkins Gilman's feminist utopian fantasy of 1914, 'If I Were a Man', awakens one morning to find herself miraculously transformed into the opposite sex, 'walking down the path so erect and square-shouldered, in a hurry for his morning train, as usual', one of the things she notices, alongside the unfamiliar weight of limbs and the swing of a gait, are the pockets. They come as a revelation, easily supplying her with a nickel for the conductor and pennies for the newsboy, alerting her to how unequally the world is tilted to the practical ease of one sex over another:

> Of course she had known they were there, had counted them, made fun of them, mended them, even envied them; but she never had dreamed of how it felt to *have* pockets. Behind her newspaper she let her consciousness, that odd mingled consciousness, rove from pocket to pocket, realizing the armoured assurance of having all those things at hand, instantly get-at-able, ready to meet emergencies. The cigar case gave her a warm feeling of comfort – it was full; the firmly held fountain pen, safe unless she stood on her head; the keys, pencils, letters, documents, notebook, checkbook, bill folder – all at once, with a deep rushing sense of power and pride, she felt what she had never felt before in all her life – the possession of money, of her own earned money – hers to give or to withhold, not to beg for, tease for, wheedle for – hers.

What Mollie understands is not simply the basic readiness with which these pockets equip her, but the largesse they permit and the way that access to money opens up to her a world she can navigate unchallenged. The 'checkbook' and the 'bill folder', even the loosest change which she finds at her fingertips, bestow upon her a startling freedom. She hurries to catch the morning train, but the entire world is now her oyster.

This is the peculiar doubleness of money: it both circulates and enables us to circulate. It flows fluently between buyer and supplier in an unhindered economy. It seems to transfer to us, by association, an ability to move faster, further and more freely. Our pockets, purses and bags, then, are not simply the means of storing what we think is ours; they also plug us into a circulating economy that is constantly in motion. Money takes us with it in the flow of capital, when we walk from the bank to the bus, whether we pay bills at home or take holidays abroad. We pack our bags believing we are at liberty to move without restriction wherever we might will, but it is the movement of money that precedes us. It prohibits or permits the freedom we think is ours. We save and store in purses and wallets, as though money could be stilled and kept, but it is meaningful only in that capacity for motion, fluently given and taken, forever eluding our grasp.

Money equips Mollie with a delicious freedom that astonishes her, but in another respect she is also oddly encumbered. Her pockets are too full, stashed with keys, pencils, letters, documents, notebooks, chequebooks and bill folders, the necessary detritus of her life. To a modern reader, perhaps more inclined to travel light, Mollie is laden in a way that might strike us as quaintly old-fashioned. Cigar cases, visiting cards and handkerchiefs long ago yielded to asthma inhalers, email addresses and disposable tissues. The decorative fans of eighteenth-century reticules are redundant in an age of ubiquitous air conditioning. If the contents of our modern pockets and purses have dwindled, it is because the smart

technologies of the twentieth-first century allow us to dispense with what was once our necessary administrative debris. They streamline, telescope and altogether compact the stuff we conventionally carry.

Our bags have quietly anticipated this, already adapting to this brave new world. No more the generous berth reserved for a bulging Filofax when our appointments are, instead, reduced to a date in a calendar on a device as slight as the palm of our hand. Our phones, encompassing and multifarious in their functions, are seated like royalty in dedicated sleeves, occupying the best spot in a handbag or the pocket of a coat, easiest to access, readiest to hand, designed to be fluidly slotted in and out of place with a gesture so repeated that it becomes a reflex. At any given moment, we know which pocket to pat or pouch to probe in order to recover this phone in which our entire lives are reduced to a data allowance. We know that 'all the world' is no longer a play but only a tap on a glossy panel, the pads of two fingers gliding easily across glass, opening up to us the infinite riches of information. And the pocket that contains it is charged with this precious cargo.

Next to the all-purpose phone, house keys and cash seem like endangered animals. They are awkward, angular things that might at any time be replaced by the silent intelligence of smart watches and contactless cards. They are the remnant of our analogue lag. Money that once possessed such a reassuring, truthful weight, feels increasingly heavier in the hand, weighing down our newly lightened pockets. Rifling through a jumble of coins can feel charmingly vintage, as virtual currencies make real the 'baseless fabric', the insubstantial pageant, of Prospero's old fantasy. You pay for your groceries online with scarcely a click and the world is melted into thin air. What, then, will happen to the purse and the wallet when, emptied of their contents, they are left surplus to use? Will we look back, one day, on the pickpockets who prowled in crowded markets, with the nostalgia we reserve

for chimney sweeps and matchstick girls? No self-respecting thief would hazard the old tech of a surreptitious hand in a pocket when you might more safely swindle confidence and credit over email, shielded behind a screen.

The purse was once a place of vulnerability, as well as power, in the circulating economy of consumer society, and its fastenings and clasps emerged as a response to this, providing security. Cybercrime and identity theft operate by such a different kind of sleight of hand that there is a pathos to the zips we tug and the buckles we fasten, our inadequate defence against an assailant now invisible and impossibly stealthy. And yet if there is little left to steal in the pocket and the purse, there still lies in their secret depths a lingering idea of an inviolable privacy. They are a space secured, entirely our own and vigilantly guarded because what they signal is something beyond the basic contents they contain. They mark the border of a bodily integrity, a respectful line of personhood that cannot be crossed without consent.

This is why nothing ameliorates the horror of Raskolnikov's crime when he murders the pawnbroker in Dostoevsky's novel of 1866, *Crime and Punishment*. Raskolnikov's crime is terrible not only for the fatal bodily injuries he inflicts, but for the trespass upon which it is predicated. Dostoevsky is unremitting in detailing the way Raskolnikov rifles through the old woman's pockets, easing his fingers with painstaking care so as to avoid her bloodied flesh when he searches for a key. Desperate, he is forced to sever a string purse from her neck, and the contact with her dead body is, to him, unbearable.

Later, he raids the chest under her bed, his panic escalating as he rakes through her personal possessions. He fills his own pockets with the watches, rings and bracelets he recovers there, but his crime lies in the intrusion as well as the murder and theft. The measure of this violation is so enormous that no value of goods can ever offset his self-loathing. He stuffs the purse under a heavy stone, incapable of emptying its contents, because what

it contains is no longer just the money he so sought but also the entirety of his offence and the guilt it elicits. 'I took a purse off her neck, made of chamois leather ... a purse stuffed full of something ... ' he confesses later to Sonia, 'but I didn't look in it; I suppose I hadn't time ... And the things – chains and trinkets – I buried under a stone with the purse next morning in a yard ... ' Sonia, despite her sympathy, is mystified. 'Then why ... why, you said you did it to rob, but you took nothing?' She struggles to make sense of what Raskolnikov learns instantly in his crime, which is that what is stolen is insignificant to the violation of this woman, her purse and her person at once, and that those acts – the rummaging in the pocket, the searching of the chest – condemn him regardless of what he takes and what he leaves behind.

We think of theft as the unlawful claim to another person's belongings, and when it happens to us, we itemise the goods that have been stolen; but to enter into the pocket's private space is so much more than simply a question of stuff. Robert Bresson's 1959 film *Pickpocket*, loosely based on Dostoevsky's novel, accordingly lingers on the profound intimacy of the act itself. Martin LaSalle plays the pickpocket Michel with a fugitive grace and beauty, his intrusions bordering on the erotic. He lurks uncomfortably close to an elegant woman at the races, his breath on her neck as his hand slides into her bag, manipulating its clasp and discreetly extracting a purse, the line between stealing and seduction made thin. The transaction is undertaken like the slightest stolen kiss. Later, when he falls in with a gang of professional pickpockets, their practised routines and relays are performed like meticulously choreographed ballet, their transactions loaded with a sexual intensity: deft hands caressing in passing gestures, unfaltering fingers loosening buttons and softly sliding into sleeves, prising open every aperture possible that might aid the undetected transmission of the object of their desire.

Destitution drives Michel into a life of crime, but he also falls into subterfuge and stealth as modes of being. The pickpocket

melts into the very crowd he targets, consciously deflecting attention: he learns to disappear, living not in the gregarious whirl of Parisian society, but in the dark depths of the pockets and purses into which he plunges. LaSalle plays Michel with unfocused eyes, heavy brows and breath, a blank expression, an addict, whose world narrows to the small spaces he ransacks. Michel steals because he has so little, and poverty has already dispossessed him of visibility in ordinary social life. He is the dead walking among the living with their full wallets and freedoms. When he is finally captured, the cell is only another manifestation of the narrowed spaces in which he has forged out his meagre life.

The Pickpocket (1959)

Is Bresson's pickpocket a criminal? Or, working by stealth and moving constantly, is he only an illicit participant in an economy from which his poverty otherwise excludes him? He is the cruelly parodic personification of the relentless circulation of money. His fingers replicate the mechanism of capitalist economy, transferring from one pocket to another money that is always on the move, frustratingly elusive.

For Bresson's haunted pickpocket, this is tragedy, but it could just as easily be farce. *The Immigrant*, a silent, romantic short of 1917 also known as *Broke*, stars Charlie Chaplin as the titular lead who finds a dollar on the pavement and delightedly pops it into his pocket, unaware of the hole through which it drops straight back onto the pavement where it was found. When the immigrant visits a restaurant and watches another customer collared for failing to pay his bill, he surreptitiously rummages in his own pocket for reassurance and is appalled to find it empty. Chaplin captures the horror of this situation, which is at once comedic and an everyday nightmare. Any of one of us might be caught short, leaving home without a wallet, temporarily without a penny to our name. Chaplin's stricken silent film face is perfectly expressive here, playing up both the jeopardy and the joke. By a stroke of luck, a beggar arrives and pays for a coffee with the lost coin, which serendipitously drops once more, this time through the pocket of the burly head waiter. After a series of contortions and ruses, Chaplin's tenacious immigrant finally manages to retrieve the original coin and, with palpable relief, pays the waiter – who, eyeing it suspiciously, discovers it to be a counterfeit after all.

The worthlessness of the coin is Chaplin's brilliant pay-off of the extended caper. The film plays for laughs the mounting ludicrousness of the pursuit of money, but it also quietly notes the hand-to-mouth existence of the immigrant for whom a coin is hard to secure and yet the means of the barest subsistence. The film mimics the infuriating absurdity of a depressed economy,

the fraught circulation of money, the exhausting tricks and subterfuges by which we are compelled to pursue it and how easily it is lost. Money moves with a mercurial quickness, it is barely tangible and hardly enough to survive on. Even when we think we have secured it, it slips through our fingers, literally through the holes in our pockets, leaving us scrambling in the gutter once more.

This is the farce and the tragedy of our pockets and purses, those temporary repositories for something that we cannot keep hold of, whose contents must be counted, are constantly in demand. Our full wallets tell us the reassuring lie that our debts will be reimbursed, that we might move on freely from one transaction to another without sparing a second thought, that we will never be excluded from a world that insists we pay our way. We rummage in our coin purses and cardholders when we are required to, confident that we'll find in them the proof that we are upstanding actors in social life. In truth, they only dignify the relentless ransom to which we are held by money itself.

The Immigrant (1917)

Ultimately, what saves Chaplin's accident-prone immigrant is not money but a romantic resilience, his determination to capture the coin and spend it kindly on others. He knows the value of kindness because he is an immigrant who, having packed up his life and wagered on the possibility of starting afresh elsewhere, is reliant on the generosity of strangers. He understands the conditions by which you might be compelled to travel light, with holes in your pockets and little in your purse. Some travellers cheerfully gather together their slight belongings, seeking new horizons. For others, the possibility of being suddenly uprooted is an ever-present danger, hovering on the horizon, and so you sleep with a suitcase pre-packed, stocked with warm clothes and stowed under your bed, lest you hear the dreaded knock at the door at dawn. The readied suitcase is an attempt to face off that terrible fear.

And yet, we are never really readied for life, even those of us who pack carefully, anticipating every eventuality. The immigrant and the refugee know what most travellers only learn en route, which is that we pack our bags for a life so unpredictable we can hardly account for the next day. Most of us travel and find that our bags are an encumbrance, an embarrassment of our riches: we trip irritably over other people's trunks and wheelies in our hurry through airport lounges and train stations. We long to get to places, swiftly and lightly, silently judging those laden travellers who accumulate stuff, tourists who have overspent, their baggage bulging with goods. We roll our eyes at under-washed wayfarers with towering backpacks and sleeping mats rolled under their arms. But the stories of how and why we travel are told in our luggage. And it can be the sum of all we have, all we are, in strange places.

In Katherine Mansfield's 1920 short story 'The Escape', a woman bickers with her taciturn husband while travelling in a foreign country. She is a horrified stranger in a strange land. Mansfield describes how her 'little bag, with its shiny, silvery

jaws open, lay on her lap', revealing familiar things, private possessions, 'her powder-puff, her rouge stick, a bundle of letters, a phial of tiny black pills like seeds, a broken cigarette, a mirror, white ivory tablets with lists on them that had been heavily scored through', carried like a talisman, the apotropaic objects that could ward off the indignities suffered in a foreign country. But they are trifling things, *only* things, and her husband gazing on them reflects quietly to himself: 'In Egypt she would be buried with those things.'

She carries the bag unthinkingly but he perceives in its miscellany the paltriness of their marriage altogether. Much richer, fuller and more precious to him is this journey itself, fleeting as it is, full of passing impression, nothing *real* or solid that he could physically retain, but full of *something* that he strives to keep nonetheless: the sound of a woman's song floating in the air, an immense tree with a copper arc of leaves, the night air in the corridor of a rumbling train, the 'heavenly happiness' of being somewhere else and leaving his wife far behind. This is only a fantasy of freedom, since he is burdened by baggage, literal and symbolic. He slips away but his 'escape' is momentary, and her voice trailing out to him, leashes him to the life he cannot leave. There are bags we take with us in order to be free, but there are some things that will never let us go.

The intrepid voyager who journeys out unencumbered has an air of romance. Their experience is so far from that of those who flee from necessity. Some of us pack carefully, anticipating the places we plan to visit; others of us take only what we can, compelled to choose from the little we have left and unsure of where we may end up. If we resent having to drag our luggage, we might also acknowledge that it is this, so often prosaic and unwieldy, which also makes us portable, grants some of us this one freedom when we might feel we have no others. When Jules Verne's Phileas Fogg plans to circumnavigate the globe in eighty days, with his neatly named French valet, Passepartout, he

takes with him just a carpetbag containing 'two woollen shirts, three pairs of stockings'. 'The same for you,' he airily decrees for Passepartout. 'We'll buy along the way.'

There is a charm to his spontaneity, his confidence that one might be able to live from the provisions of the earth from moment to moment and place to place, and that a yearning traveller could need so little, other than ambition and resourcefulness. But this is the privilege of his class, his sex, his race, the purchasing power and cultural capital that is his. For him, the world is as open as a book. Fogg needs to carry so little because he already has what matters. Who would deny that there isn't something exhilarating in the wilful relinquishment of material goods? If we travelled light, leaving behind the weight of our stuff and the responsibilities too, owing no due care to any others except ourselves, would we, finally, be free?

'You are undone,' wrote Rousseau, 'if you once forget that the fruits of the earth belong to us all, and the earth itself to nobody.' Modern travel, no longer the reserve of soldiers, aristocratic youth and colonial administrators, allows us to claim our rightful ownership of the earth. Baggage seems to us so ordinary and irksome, but it attests too to the democratic extension of commercial travel, the emergence of airline flights, rail routes and ferry fleets. They invite the invention of boxes for hats, trunks for hooped dresses, rucksacks and beach bags alike. The bag marks the increasing portability of life, the possibility available to us at any moment to up sticks, transplant all our accessories and accoutrements overseas, so that we might live there as we do at home.

There are limits, though, to this freedom, not least the inspections of border control. Most of us know the irritation of an airline luggage limitation and the ritualistic decanting of cosmetics, liquids and laptops at check-ins, the paradox by which we long for our destinations and find ourselves annoyingly tugged back by regulatory inspection. Some of us know more keenly

than others how unequally that scrutiny can be distributed, the greater suspicion with which we are regarded, the magnitude of the deception of our breezily checked-in luggage, the frailty of the apparent 'freedom' of movement we claim. The right to be wherever we are whenever we like, comes with caveats. We 'check in' our bags because we are beholden to the safety of others and subject to surveillance, and so our private spaces are compelled to be available to that cause, our bags are screened, our luggage tipped out, our pockets and purses emptied. At the centre of this practice is an idea that when our possessions are rifled through, when we make visible all the things that we own and have, only then will we be understood, assessed and accounted for. We are, in that inspected instant, the sum total of the things we carry, no more and no less. And what this confirms, finally, is that there is no entirely inviolable space, that privacy is permitted to take no shape outside our internal life.

Still, somehow, the traveller's bag remains the object of our imagination and whimsy. When the Browns discover a bear standing forlornly at Paddington Station, stout in red wellies and felt hat, a blue duffel coat securely toggled and a battered brown case in hand, they know to extend to him their kindness. *'Please look after this bear. Thank you'* reads the tag that dangles from his sleeve, echoing the images of child evacuees shuttled from wartime London with labels around their necks and worldly possessions packed in small cases. The sympathetic Browns take him home to 32 Windsor Gardens, off Harrow Road, between Notting Hill and Maida Vale, this friendly bear from deepest, darkest Peru who comes to them clutching only a scuffed suitcase. They read his need and offer up their resources. He is the traveller who possesses little and so elicits benevolence. Later, the suitcase reveals itself full of mischief, more capacious than it would outwardly seem, complete with a secret compartment for storing marmalade, and Paddington too, with his aptitude for adventure and incorrigible curiosity, proves

himself a natural explorer, the stranger who can make his home wherever he stops with his suitcase.

His modern counterpart is Dora the Explorer, the fearless, bilingual Latina who moves as fluently between English and Spanish as she does from desert to rainforest. I watch my small nieces follow her on the screen, their large eyes, unblinking, transfixed and hopeful. They have faith in Dora, who is always equipped with her purple backpack, her fingers curled around the straps fastened firmly over her shoulders. They see different countries – entire continents – through her questioning eyes, and every new place is safe, accessible, full of friends yet to be made. Dora capably navigates the globe, collecting objects and allies, solving puzzles and fending off Swiper, the thieving fox. Unlike Swiper, she easily discerns the difference between that which is hers and that which belongs to others, and this understanding imbues her with a moral clarity. When she sets out on her quest, she winningly invites the viewer to join her. But Dora already has everything she needs to get to her destination: she has wisdom and unfaltering confidence. She has the fearlessness of the curious child whom she herself is designed to address.

Paddington and Dora are light travellers, beloved by children too small to own much stuff and yet young enough to store deep internal, imaginative worlds, not worldly enough to worry about money and yet prone to prize their few possessions. Their rummaging fingers are barely capable of steady grasp and are connected to a faculty of memory too underdeveloped to recall most acts of storage, and so they might remind us that what we place in pockets and store away in suitcases matters nothing really, that all things we own are easily lost, outgrown, abandoned, discarded along the way. What counts is not that we keep such things at all, but that we come to learn that the world will make demands of us, that we might need to dig deep and call upon our inward resources, be readied for when that moment arises knowing that we will not be found wanting.

Mr Brown was right. It was sitting on
an old leather suitcase marked
WANTED ON VOYAGE,
and as they drew near it stood up
and politely raised its hat.

'Good afternoon,' it said. 'May I help you?'
'It's very kind of you,' said Mr Brown,
'but as a matter of fact we were wondering
if we could help *you*?'

'You're a very small bear,' said Mrs Brown.
'Where are you from?'

The bear looked around carefully before replying.

'Darkest Peru. I'm not really supposed to
be here at all. I'm a stowaway ... '

MICHAEL BOND *A Bear Called Paddington* (1958)

EPILOGUE

FUTURE CLOTHES

THE FIRST CLOTHES I BUY AT THE START OF THE
SPRING are two infant-sized dresses in the palest shade of yellow,
pale cotton the colour of buttercream, starred with flowers.
They catch my distracted eye as I hurry through a French
supermarket, their beauty so clear and small that I cannot bear
to leave without them. The collars are gently rounded and the
cap sleeves minutely gathered at each cuff. A scallop edge loops
effusively around the hem and tiny untouched pockets quietly
wait to store secret things. These details are attentive and so
also charmingly misplaced in garments that are doomed to be
recklessly grass-stained and felt-tip-pen-blotted. I buy them
with a kind of sun-blind hope.

These are dresses designed for lightness, fitted for small,
unrestrained limbs, meant to endure tug and tear, even though
they are destined to be left behind, like childhoods should be.
Disposability is built into infant clothing, the garments at peace
with their transience – cardigans made to be caught on brambles,
small gloves fated to be absently abandoned on park benches.

I imagine the girls in them – see their reaching limbs, a joint
of the wrist startlingly like mine, an expression passing across
a face that has momentarily become a mirror, a flash of temper
guiltily recognised as my own – but the future I hope for them is
predicated on a capacity to be unburdened by the past, unhindered
by others. I buy dresses for them that only I will remember. And
what I wish for them most of all is that constant forgetting, so that

they might be free of the regret and reproach born of our adult
facility for retrospection, so that they might step forward, again
and again, into time that is like a seam that never stops.

What will we wear in a hundred years' time? When Candide
and his manservant Cacambo arrive in the utopian El Dorado in
Voltaire's novel of 1759, twenty beautiful damsels glide forward
to receive them, welcoming the astonished travellers and
gowning them in the customary costumes of the kingdom: robes
woven from the down of hummingbirds. This fabric is a fantasy
of the future, luxurious and light, so fine and weightless, that to
wear it would be to be encased in air.

The real fabrics of our own future seem clunky and prosaic
by comparison, comprising synthetic advancements that boast
practical wipe-clean, waterproof and crease-resistant properties.
Wearable technologies, at present, only clumsily integrate
digital advancements, although 'smart' clothes promise to be
presumptuously auto-responsive, intelligently adapting to our
environments before we've even registered our own need. They
will imperceptibly upload information and download live updates.

In some ways, though, this vision remains as fanciful as
Voltaire's hummingbird-down gown. How, after all, could we
dare to have faith in the future when even now dye-houses
regularly bleed into local rivers, when the polluted waters of
remote villages anticipate the colour of next season's catwalk,
when the apparent 'naturalness' of cotton is won only by
chemical bleaching, and when our 'store new' garments are
passed through innumerable overworked and underpaid hands?

There is a stitch that runs between us. The sweatshop is
shorthand for the conditions of cheap and unsafe labour in a
globalised economy of limited resources and high demand. We
know, with a dim and sometimes reluctant consciousness, the

scale and danger of the industrial and unregulated textile work, the violence and the poverty that subtends its workers. It is the kind of grievous, weary and heavy truth that makes us put our heads in our hands. We know that our clothes are the indictment of our age of disposable consumption and overproduction. Many of us are troubled by this relentlessly throwaway culture, pained by a pang of guilt with every purchase. We might valiantly heed the edicts to buy less frequently and more responsibly, repairing and recycling, supporting fairer pay and protesting poor working conditions. We might invest ethically in a sustainable future.

Challenging these inequalities and injustices can also begin closer to home, close to the skin. We recalibrate our relationship with clothes when we attend to the idea of dress with the due respect it demands, refusing to relegate it to superficiality. We can allow it a place in our understanding. It deserves this. If we buy compulsively, we might ask what inner emptiness is it that dress seeks to fill and for which it is never full enough. If we have some sense of how deeply life is lived in clothes, we should ask how we provide better for those tasked with the work of manufacturing them. We know that the world is in our clothes: it follows that we should care about who makes them and how.

At some point in a day, you will open a wardrobe, pull out a drawer or rifle through a laundry basket. You will button up a jacket or tug off your trainers. You will snatch up your wallet or rummage in a pocket. You will see someone in the street wearing a shirt the colour of a July sky, a coat woven in the perfectly interlocked pattern of herringbone, a skirt in a silk made iridescent by the glance of a certain light. You will find a tie in the exact hue that brings out the unseen inflections of your eye colour, the suit that imparts to you a seriousness you never knew you had, the dress that draws you a different silhouette. Our clothes are ordinary and exhilarating. We wear them to make ourselves understood even though there is no promise of

understanding. They envelop us as though we were, each of us, apart, and entangle us because we are always connected.

The truth is that in clothes we know so many things. We know how one garment can tilt the day, how dresses contain us and how folds hide our depths. We know the grave heaviness of overcoats and the effervescent lightness of jackets, how laughing youth can seize hold of coat-tails and never let go. We reach for the shoes in which we resist gravity and leap into space, that permit us to walk freely or flee unpursued, that right us when we threaten to tumble down and steadily carry us home. In clothes, we sense the mastery of animals that remind us of our own savagery, the wild abandon beneath our dressed civilisation. We plunge into our pockets and purses and find how unprepared we are for the world, how hard it is to protect what we take to be our unalienable privacy, how what we carry with us are our secrets, our burdens, our infinite promise. How then could we ever deny their place in our collective experience? We are clothed creatures moving towards and against each other at any given moment, cotton brushing against leather, silk against wool. Our clothes are the stuff of our material life and the expression of an immaterial one too, this most powerful metaphor of how we ruin each other, how we repair each other, how finely our inner lives are inwoven. We are only mortal bodies, clothed to meet the world: the thinnest membrane between us, an unbreakable thread that binds us.

In the end, these are the things I remember: a tall man who, every morning, rolls the cuff of a trouser up and then back down again, head cocked in evaluation, offering up an exposed ankle for my inspection; a small child in a brilliant turquoise cotton dress, who peels off jumpers and wrestles with hair ties, determined to master a bicycle too big for her one summer afternoon; a stranger with an unbuttoned collar and a loosened tie, laughing, quick and sure, who fatefully catches my wrist as I trip down a stair; a sister whose expert hand runs knowingly over every kind

of silk, whose lips know the name of every kind of print, whose eye unerringly joins the right tone to the right shade every time; a friend who absently fishes out a pair of fingerless gloves from a pocket on an icy day, keeping one for themselves and handing me the other. And then, my own reflection, caught passingly in the mirrored window glass of a department store, glinting in the wintry sun: a woman with dark hair whirling in the wind, wrapped in an oxblood-red coat, clothed for this life for which there are no dress rehearsals.

Sources

PROLOGUE

PAGE

2 *In the Mood for Love*, dir. Wong Kar-wai (2000).

4 On Claribel Cone's Van Gogh: Michael Glover, 'Great Works: A Pair of Boots (Les Souliers), 1887', *Independent* (27 January 2012).

4 Martin Heidegger, 'The Origin of the Work of Art' (1950).

5 Vincent Van Gogh, letter to his brother Theo from The Hague (10 December 1882), in Leo Jansen, Hans Luijen and Nienke Bakker, eds, *Vincent van Gogh – The Letters: The Complete Illustrated and Annotated Edition* (2009).

5 Nick Levine, 'Into the New York Groove: How Madonna's punky early years fuelled her rise to superstardom', *i-D* (9 August 2018).

5 Madonna, 'Borderline' (1983).

6 *Desperately Seeking Susan*, dir. Susan Seidelman (1985).

6 Madonna, *Confessions on a Dance Floor* (2005).

7 Madonna, 'Ray of Light', dir. Jonas Åkerlund (1998).

INTRODUCTION

10 For thoughtful work in dress studies in recent years: Alison Matthews David, *Fashion Victims: The Dangers of Dress Past and Present* (2015); Frances Corner, *Why Fashion Matters* (2014); John Harvey, *Clothes* (2008); Lars Svendsen, *Fashion: A Philosophy* (2004); Andrew Bolton, *Wild: Fashion Untamed* (2004); Caroline Evans, *Fashion at the Edge: Spectacle, Modernity, and Deathliness* (2003).

10 For an informed discussion of dress and gender, see

Jo B. Paoletti, *Sex and Unisex: Fashion, Feminism, and the Sexual Revolution* (2015). On the veil: Reina Lewis, *Muslim Fashion: Contemporary Style Cultures* (2015); Leila Ahmed, *A Quiet Revolution* (2011); Joan Wallach Scott, *The Politics of the Veil* (2007). On dress, rape blame and street harassment: Dean Burnett, 'How "provocative clothes" affect the brain – and why it's no excuse for assault', *Guardian* (25 January 2018). On globalisation, fast fashion and activism: Sarah Corbett, *How to be a Craftivist: The Art of Gentle Protest* (2017); Tansy E. Hoskins, *Stitched Up: The Anti-Capitalist Book of Fashion* (2014); Lucy Siegle, *To Die For: Is Fashion Wearing Out the World?* (2011).

13 E. M. Forster, *A Room with a View* (1908).

14 Edith Wharton, *The House of Mirth* (1905).

15 Karl Marx, *Capital*, Vol. 1 (1867).

15 Peter Stallybrass, 'Marx's Coat', in Patricia Speyer, ed., *Border Fetishisms: Material Objects in Unstable Spaces* (1998).

16 Plato, *Republic*, especially 514a–517a (c.380 BC).

16 Immanuel Kant, *Critique of Pure Reason* (1781).

17 Friedrich Nietzsche, *On Truth and Lies in a Nonmoral Sense* (1873).

17 Susan Sontag, 'On Style', *Against Interpretation* (1966).

18 Sigmund Freud, *On Narcissism* (1914).

18 Simon Blackburn, *Mirror, Mirror: The Uses and Abuses of Self-Love* (2014) for a philosophical discussion of narcissism.

19 Michel Foucault, *Technologies of the Self: A Seminar with Michel Foucault* (1988).

19 Audre Lorde, *A Burst of Light: Essays* (1988).

21 Roland Barthes, *Camera Lucida: Reflections on Photography* (1980).

22 Roland Barthes, *Mourning Diary: October 26, 1977 –*

September 15, 1979 (trans. 2009).

23 *Roland Barthes, A Lover's Discourse: Fragments* (1977).

1. DRESSES

29 Sylvia Plath, 'Lady Lazarus', *Ariel* (1965).

30 Virginia Woolf, *Orlando: A Biography* (1928).

30 Virginia Woolf, *To the Lighthouse* (1927).

30 Joan Didion, *Blue Nights* (2011).

31 Sylvia Plath, *The Journals of Sylvia Plath* (1982).

32 Sylvia Plath, *The Bell Jar* (1963).

36 Gilles Deleuze, *The Fold* (1988).

38 Sigmund Freud, Letter to Martha Freud (24 September 1907) in Ernst L. Freud, ed., *Letters of Sigmund Freud* (1960).

38 Wilhelm Jensen, *Gradiva: A Pompeiian Fantasy* (1903).

40 Euripides, *Medea* (*c.*431 BC).

41 Herodotus, *Histories*, Book V, §87–88 (*c.*440 BC).

42 Homer, *Iliad*, Book XIV (*c.*762 BC).

44 Novalis, Fragment 857, *Pollen and Fragments* (1798).

45 *Ma Vie en Rose*, dir. Alain Berliner (1997).

48 See discussion of Tenniel's *The Haunted Lady, Or 'The Ghost' in the Looking-Glass* in Alison Matthews David, *Fashion Victims* (2015).

48 Karl Marx, *Capital*, Vol. 1, chapter 10, for details of Mary Ann Walkley (1867).

48 Charlotte Perkins Gilman, *The Dress of Women* (1915).

49 John Berger, *Ways of Seeing* (1972).

51 Søren Kierkegaard, 'The Seducer's Diary', *Either/Or: A Fragment of Life* (1843).

52 Laura Mulvey, 'Visual Pleasure and Narrative Cinema', *Screen*, Vol. 16, Issue 3 (1 October 1975).

52 Zoe Moss, 'It Hurts to be Alive and Obsolete: The

Ageing Woman' in Robin Morgan, ed., *Sisterhood is Powerful: An Anthology of Writing from the Women's Liberation Movement* (1970).

52 Simone de Beauvoir, *The Second Sex* (1949).

55 Vladimir Nabokov, *Lolita* (1955).

55 Michel Faber, *Under the Skin* (2000).

58 Roland Barthes, *The Pleasure of the Text* (1973).

59 Deborah Davis, *Strapless: John Singer Sargant and the Fall of Madame X* (July 2003) for context.

60 Robert Browning, 'Porphyria's Lover' (1836).

62 Andrew Bolton, ed., *Alexander McQueen: Savage Beauty*, exhibition catalogue (2011). All quotations from McQueen are taken from this source.

69 Friedrich Nietzsche, *Thus Spake Zarathusta*, chapter 18 (1883–91).

69 Henry James, *The Portrait of a Lady* (1881).

72 Henry James, 'The Romance of Certain Old Clothes' (1868, revised 1885).

75 Virginia Woolf, 'The New Dress' (1927).

76 Hélène Cixous, 'Sonia Rykiel in Translation', in Shari Benstock and Suzanne Ferriss, eds, *On Fashion* (1994).

2. SUITS, COATS AND JACKETS

83 *North by Northwest*, dir. Alfred Hitchcock (1959).

84 For a detailed account of the suit in *North by Northwest*, see blogpost by fashion historian Christopher Laverty (13 May 2009): https://clothesonfilm.com/cary-grant-grey-kilgour-suit-in-north-by-northwest-1959/

85 For discussion of Cary Grant's life and style: Richard Torregrossa, *Cary Grant: A Celebration of Style* (2006); Graham McCann, *Cary Grant: A Class Apart* (1997); Pauline Kael, 'The Man from Dream City', *The New*

Yorker (14 July 1975). Todd McEwen, 'Cary Grant's Suit', *Granta 94: On the Road Again* (2006).

85 Cary Grant, 'Cary Grant on Style', *GQ Magazine* (Winter 1967/68).

89 *The Count*, dir. Charlie Chaplin (1916).

89 *The Adventurer*, dir. Charlie Chaplin (1917).

89 *The Idle Class*, dir. Charlie Chaplin (1921).

89 *The Gold Rush*, dir. Charlie Chaplin (1925).

90 'A Comedian Sees the World', interview with Charlie Chaplin, *Woman's Home Companion* (November 1933).

91 Nikolai Gogol, *The Overcoat* (1842).

97 P. G. Wodehouse, *Right Ho, Jeeves* (1934).

99 For the history of the mess jacket: Diana de Marly, *Working Dress: A History of Occupational Clothing* (1986), and Suzi Love, *Young Lady's Day* (2015).

100 P. G. Wodehouse, 'The Aunt and the Sluggard', *Carry On, Jeeves* (1925).

102 Brian Halford, 'The Real Jeeves: Tragic Warwickshire hero immortalised by a comic genius', *Coventry Telegraph* (20 June 2013).

104 Eugène Ionesco, *Rhinoceros* (1959).

105 Sigmund Freud, *Civilization and its Discontents* (1930).

105 Michel Foucault, *Discipline and Punish* (1975).

108 Joseph Beuys, *Felt Suit* (1970). See Tate catalogue description online for Beuys's comments.

109 Hannah Arendt, *Eichmann in Jerusalem: A Report on the Banality of Evil* (1963).

111 Anne Hollander, *Sex and Suits* (1994).

111 *Frenzy*, dir. Alfred Hitchcock (1972).

112 Bret Easton Ellis, *American Psycho* (1991).

116 G. Bruce Boyer, *Elegance: A Guide to Quality in Menswear* (1985).

117 T. S. Eliot, 'The Love Song of J. Alfred Prufrock', *Prufrock and Other Observations* (1915).

118 Percy Wyndham Lewis, *T. S. Eliot*, Durban Municipal Art Gallery, Durban (1938).

119 Paul Theroux, 'The Male Myth', *New York Times* (27 November 1983).

120 *A Single Man*, dir. Tom Ford (2009), based on Christopher Isherwood, *A Single Man* (1964).

121 'Le Smoking' tuxedo, Yves Saint-Laurent (1966), photographed by Helmut Newton for *Vogue Paris* (1975).

122 Janelle Monáe, 'Make Me Feel' (2018).

123 Michael Lewis, 'Obama's Way', *Vanity Fair* (October 2012).

124 Christopher Breward, *The Suit: Form, Function and Style* (2016) for a comprehensive history of the suit.

124 *Notebooks on Cities and Clothes*, dir. Wim Wenders (1989).

126 Martin Heidegger, *Being and Time* (1927).

127 Karl Ove Knausgård, *A Death in the Family – My Struggle: Book 1* (2009).

128 *Stop Making Sense*, dir. Jonathan Demme (1984).

129 Leonard Cohen, 'Famous Blue Raincoat' (1971).

129 Leonard Cohen, *The Lyrics of Leonard Cohen* (2008).

129 *Rebel Without a Cause*, dir. Nicholas Ray (1955).

131 The Who, 'Don't Let Go the Coat' (1981).

3. SHOES

137 Marie-Josèphe Bossan, *The Art of the Shoe* (2002) for discussion of Goethe's attachment to shoes.

138 Nicolas-Edme Rétif, *L'Anti-Justine* (1798).

140 Ted Hughes, 'The Jaguar', *The Hawk in the Rain* (1957).

141 Vybarr Cregan-Reid, *Footnotes: How running makes us human* (2016), for neurology of feet.

143 Suetonius, 'Life of Nero', *The Twelve Caesars* (AD 121).

143 Daniel Defoe, *The Life and Strange Surprizing Adventures of Robinson Crusoe* (1719).

144 Rainer Maria Rilke, 'You Who Never Arrived' (1913–18).

144 Tim Murray, *Milestones in Archaeology: A Chronological Encyclopedia* (2007).

145 Georges Bataille, 'The Big Toe', *Visions of Excess: Selected Writings, 1927–1939* (1985).

146 Sophocles, *Oedipus Rex* (429 BC).

148 Tom Bishop, 'How to do Things with Shoes', in Patricia Lennox and Bella Mirabella, eds, *Shakespeare and Costume* (2015).

148 Primo Levi, *The Truce* (1963).

149 Primo Levi, *If This is a Man* (1947).

149 Virginia Woolf, *Jacob's Room* (1922).

150 Samuel Beckett, *Waiting for Godot* (1953).

153 Nicholson Baker, *The Mezzanine* (1988).

154 Vladimir Nabokov, *Lectures on Russian Literature* (1980).

154 Nikolai Gogol, *Dead Souls* (1842).

157 Juvenal, 'Satire VI: The Decay of Feminine Virtue', *The Satires* (AD 2).

157 Giambattista Basile, 'Cenerentola', *Pentamerone* (1634).

157 Charles Perrault, 'Cendrillon', *Histoires ou contes du temps passé avec des moralités* (1697).

158 Honoré de Balzac, *Catherine de Medici* (1841).

159 *Cinderella*, dir. Beeban Kidron (2000).

160 Hans Christian Andersen, 'The Red Shoes', *New Fairy Tales, Vol. 1* (1845).

161 *The Red Shoes*, dir. Michael Powell and Emeric Pressburger (1948).

162 Sigmund Freud, 'What does woman want?', Letter to Marie Bonaparte, in Ernest Jones, ed., *Sigmund Freud: Life and Work*, Vol. 2, Part 3 (1953).

163 Anaïs Nin, *A Spy in the House of Love* (1954).

163 Vladimir Nabokov, *Lolita* (1955).

163 Aleksandr Pushkin, *Eugene Onegin: A Novel in Verse* (1833), trans. Nabokov (1964).

165 Sigmund Freud, 'Three Essays on Sexuality' (1905).

166 Elena Ferrante, *My Brilliant Friend* (2012).

168 Elena Ferrante, *The Story of the Lost Child* (2015).

169 *Top Hat*, dir. Mark Sandrich (1935).

172 *Shall We Dance*, dir. Mark Sandrich (1937).

173 *Singin' in the Rain*, dir. Gene Kelly and Stanley Donen (1952).

175 *Black Swan*, dir. Darren Aronofsky (2010).

176 Susan Leigh Foster, 'The Ballerina's Pointe', in her edited collection, *Corporealities: Dancing Knowledge, Culture and Power* (1995).

182 Gilles Deleuze, *A Thousand Plateaus*, (1980).

182 *Zidane: A 21st Century Portrait*, dir. Douglas Gordon and Philippe Parreno (2006).

184 Rainer Karlsch, Christian Kleinschmidt, Jörg Lesczenski and Anne Sudrow, *Playing the Game: The History of Adidas* (2018).

185 Barbara Smit, *Sneaker Wars: The Enemy Brothers Who Founded Adidas and Puma and the Family Feud that Forever Changed the Business of Sports* (2008).

185 Luo Lv and Zhang Huiguang, *Sneakers* (2007).

186 Jacobus 'Co' Rentmeester, photograph of Michael Jordan, *LIFE* magazine (Summer 1984).

187 Mathieu Le Maux, *1000 Sneakers: A Guide to the World's Greatest Kicks, from Sport to Street* (2016).

188 For further resources on ethical sportswear, see https://www.ethicalconsumer.org/ and https://cleanclothes.org/

189 Haruki Murakami, *What I Talk About When I Talk About Running* (2009).

190 Alan Sillitoe, 'The Loneliness of the Long-Distance

Runner' (1959).

192 Jean-Jacques Rousseau, *Reveries of a Solitary Walker* (1782).

4. FURS, FEATHERS AND SKINS

198 Kate Bush, 'Hounds of Love' (1985).

198 *Night of the Demon*, dir. Jacques Tourneur (1957).

200 Sonia Ashmore, *Muslin* (2012).

202 Walter Benjamin, *One-way Street* (1928).

204 Martin Buber, *Between Man and Man* (1947).

206 Giorgio Agamben, *The Open: Man and Animal* (2003).

207 Jacques Derrida, *The Animal Therefore that I Am* (2002).

207 Michel Montaigne, *Essais* (1595).

211 Mary Wollstonecraft, *A Vindication of the Rights of Woman* (1792).

211 *My Fair Lady*, dir. George Cukor (1964).

212 William Mark Adams, *Against Extinction: The Story of Conservation* (2004).

212 For a history of the Plumage League, see https://www.thehistorypress.co.uk/articles/birds-of-a-feather-the-female-founders-of-the-rspb/, and Philippa Bassett, 'A List of the Historical Records of the Royal Society for the Protection of Birds' (1980).

213 Simone de Beauvoir, *The Second Sex* (1949).

213 Simone de Beauvoir, *L'Invitee* (1943).

214 *The Birds*, dir. Alfred Hitchcock (1963).

215 Camille Paglia, *The Birds (BFI Classics)* (1998).

219 W. B. Yeats, 'Leda and the Swan' (1923).

220 Sylvia Plath, *Three Women*, (1962).

220 For a deeper discussion of swans and women's fashion, Andrew Bolton, *Wild: Fashion Untamed* (2004).

221 *Emily Brontë, Wuthering Heights* (1847).

223 Luce Irigaray, 'Animal Compassion', in Peter Atterton and Matthew Calarco, eds, *Animal Philosophy: Essential Readings in Continental Thought* (2004).

223 Hélène Cixous, 'Birds, Women and Writing', in Peter Atterton and Matthew Calarco, eds, *Animal Philosophy: Essential Readings in Continental Thought* (2004).

224 Leo Tolstoy, *Anna Karenina*, (1878).

226 Sigmund Freud, 'Fetishism' (1927).

228 John Berger, *Ways of Seeing* (1972).

230 Leopold von Sacher-Masoch, *Venus in Furs* (1870).

231 Marianne Moore, 'The Arctic Ox' (1958).

233 *Joyless Street*, dir. G. W. Pabst (1925).

235 Angela Carter, 'The Bloody Chamber' in *The Bloody Chamber and Other Stories* (1979).

235 Angela Carter, 'The Company of Wolves' in *The Bloody Chamber and Other Stories* (1979).

236 Gilles Deleuze, *Francis Bacon: The Logic of Sensation* (1981).

237 *Bringing Up Baby*, dir. Howard Hawks (1938).

237 See discussion of Bringing Up Baby in Stanley Cavell, *Pursuits of Happiness* (1981).

5. POCKETS, PURSES AND SUITCASES

245 Barbara Berman and Seth Denbo, *Pockets of History* (2007) for a full account of the development of purses and pockets.

249 François Rabelais, *Gargantua and Pantagruel* (c.1532–64).

251 Pieter Bruegel the Elder, *The Peasant Dance*, Kunsthistorisches Museum, Vienna (c.1567).

252 Elizabeth Parker's sampler in the Victoria and Albert Museum, discussed in Deborah Lutz, *The Brontë*

Cabinet (2015).

252 Edith Wharton, *The House of Mirth* (1905).

253 Judith Clark, ed., *Handbags: The Making of a Museum* (2012) for an excellent cultural history of the handbag.

254 Germaine Greer, *The Whole Woman* (1999).

254 Sigmund Freud, *Fragments of an Analysis of a Case of Hysteria* (1905).

255 Charles Dickens, *Oliver Twist* (1839).

256 Samuel Richardson, *Pamela* (1740).

257 Lewis Carroll, *Alice Through the Looking-Glass* (1871).

258 *Pulp Fiction*, dir. Quentin Tarantino (1994).

259 *Reservoir Dogs*, dir. Quentin Tarantino (1992).

260 Jacques Derrida, 'How to avoid speaking: denials', in Sanford Budick and Wolfgang Iser, eds, *Languages of the Unsayable* (1989).

261 Walt Whitman, 'I Sing the Body Electric' (1885).

261 St Augustine, *Confessions* (AD 397–400).

262 Charles Taylor, *Sources of the Self: The Making of the Modern Identity* (1989).

262 Sigmund Freud, *New Introductory Lectures on Psychoanalysis* (1933).

262 *Mary Poppins*, dir. Robert Stevenson (1964).

263 J. K. Rowling, *Harry Potter and the Deathly Hallows* (2007).

264 *Marnie*, dir. Alfred Hitchcock (1964).

265 Adam Phillips in Judith Clark, ed., *Handbags: The Making of a Museum* (2012).

266 Donald Winnicott, *Playing and Reality* (1971).

266 Leo Tolstoy, *Anna Karenina* (1877).

267 Samuel Beckett, *Happy Days* (1961).

268 Charlotte Perkins Gilman, 'If I Were a Man' (1914).

271 Fyodor Dostoevsky, *Crime and Punishment* (1866).

272 *Pickpocket*, dir. Robert Bresson (1959).

274 *The Immigrant*, dir. Charlie Chaplin (1917).

276 Katherine Mansfield, 'The Escape', *Bliss and Other Stories* (1920).

277 Jules Verne, *Around the World in Eighty Days* (1873).

278 Jean-Jacques Rousseau, *Discourse on the Origin and Basis of Inequality Among Men* (1755).

279 Michael Bond, *A Bear Called Paddington* (1958).

280 *Dora the Explorer*, created by Chris Gifford, Valerie Walsh Valdes and Eric Weiner (broadcast 2000–14).

EPILOGUE: FUTURE CLOTHES

283 Voltaire, *Candide, or The Optimist* (1759).

If you are interested in investigating ethical fashion options, you might find the following organisations and sites useful:

https://waronwant.org/love-fashion-hate-sweatshops
https://cleanclothes.org/
https://www.fashionrevolution.org/
https://www.ethicalconsumer.org/
https://goodonyou.eco/

List of illustrations

PAGE

2 Still from *In the Mood for Love*, 2000 / Kobal / Shutterstock

4 *Shoes* by Vincent Van Gogh, 1886, Van Gogh Museum, Amsterdam / Bridgeman Images

7 Madonna, pictured in concert / Getty Images

35 *Bacchus and Ariadne* by Titian, 1520–23, National Gallery, London / Bridgeman Images

37 *The Three Fates or The Triumph of Death* by unknown artist, early 16th century © Victoria and Albert Museum, London

38 Plaster cast of *Gradiva* or 'The Woman Who Walks' by unknown artist, 1st century BC, Freud Museum, London / Bridgeman Images

47 *The Haunted Lady, Or 'The Ghost' in the Looking-Glass* by John Tenniel, 1863 / Getty Images

57 *Untitled* by Guy Bourdin, undated © The Guy Bourdin Estate, 2019

61 *Portrait of Madame X* (Madame Pierre Gautreau) by John Singer Sargent, 1883–84, Metropolitan Museum of Art, New York / Bridgeman Images

66 Green and bronze torn dress by Alexander McQueen, *Highland Rape Collection*, Autumn/Winter 1995–96, Sølve Sundsbø / Art + Commerce

84 Still from *North by Northwest*, 1959 / Bridgeman Images

108 *Felt Suit* by Joseph Beuys, 1970 © DACS 2018 / Bridgeman Images

113 Still from *American Psycho*, 2000 / Shutterstock

118 T. S. Eliot, 1955 / Shutterstock

122 Janelle Monáe, pictured onstage at the NBC Universal's 69th Annual Golden Globes, 2012 / Getty Images

125 Yohji Yamamoto, pictured during the Yohji Yamamoto Menswear Spring/Summer 2019 show, Paris Fashion Week 2018 / Getty Images

130 Film poster: *Rebel Without a Cause*, 1955, Kobal / Shutterstock

137 *Olympia* by Édouard Manet, 1863, Musée d'Orsay, Paris / Bridgeman Images

171 Stills from *Top Hat*, 1935 / Getty Images

174 Still from *Singin' in the Rain*, 1952 © Metro-Goldwyn-Mayer Pictures / Bridgeman Images

178 'Armadillo' shoes by Alexander McQueen, Spring/Summer 2010, pictured during Paris Fashion Week / Shutterstock

178 'Turquoise Parakeet' bespoke shoes by Caroline Groves © Dan Lowe, used by kind permission of Caroline Groves

180 Cantilevered shoes by Zaha Hadid, Spring/Summer 2014 / Getty Images

181 Nike 'Magista 2' shoes, author's own / Justin Charles

187 Adidas 'Wings 3.0' shoes by Jeremy Scott, author's own / Justin Charles

199 Vinyl album cover: *Hounds of Love* by Kate Bush, MPVCVRART / Alamy

205 Lilac horsehair dress by Alexander McQueen, Spring/Summer 2005, pictured during Paris Fashion Week / Getty Images

210 'Catwoman' evening gown by Jean-Paul Gaultier, Russian Collection, 1997, pictured in the *Fashioned from Nature* exhibition at the Victoria and Albert Museum, London, 2018 / Shutterstock

210 Elephant crinoline by Walter Van Beirendonck, Autumn/Winter 2010–11, pictured during Paris Fashion Week / Getty Images

216 Still from *The Birds*, 1963, Kobal / Shutterstock

222 Gold-feathered coat from the final collection by Alexander McQueen, Autumn/Winter 2010, pictured during McQueen's posthumous presentation at Paris Fashion Week / Shutterstock

225 *Girl in A Fur* by Titian, 1535–38, Kunsthistorisches Museum, Vienna / Bridgeman Images

227 *Lady in a Fur Wrap* by El Greco, 1577–79, Stirling Maxwell Collection, Pollok House, Glasgow © CSG CIC Glasgow Museums Collection / Bridgeman Images

229 *Helena Fourment in a Fur Wrap* by Peter Paul Rubens, 1636–38, Kunsthistorisches Museum, Vienna / Bridgeman Images

238 Still from *Bringing Up Baby*, 1938 / Bridgeman Images

243 *My Bed* by Tracey Emin, 1998 / Getty Images

248 Sketches of handbags from the notebooks of Leonardo da Vinci, 1452–1519 / Shutterstock

258 Franzen briefcase, author's own / Justin Charles

264 Still from *Marnie*, 1964 / Bridgeman Images

273 Still from *The Pickpocket*, 1959, Kobal / Shutterstock

275 Still from *The Immigrant*, 1917 / Bridgeman Images

Acknowledgements

My thanks to Alba Ziegler-Bailey, who saw the shape of this book long before I did, and who has been with me, ready with the right word, at every turn. Thank you also to Sarah Chalfant, for having faith in this project since that first conversation in the sunlit courtyard at Bedford Square.

I am indebted to Bea Hemming, who understood this book immediately and then steered it with such thoughtfulness, sharpening every blunt idea. Thank you for giving it a home. Thank you also to the team at Cape who have put it together so beautifully.

I am grateful to my colleagues at QMUL, the Forum for Philosophy at the LSE, and BBC Radio 3 and 4. My particular thanks to John Barrell, Marina Benjamin, Frances Corner, Matthew Dodd, Paul Hamilton, Alison Matthews David, Tony Phillips, Robyn Read, Jacqueline Rose and Barbara Taylor.

Thank you to my friends, especially Tamara Atkin (pockets on a denim dress), Justin Coombes (navy jumpers), Nemonie Craven Roderick (turquoise salwar kameez), Rob Lederer (jaunty cap), Fiona Mackenzie-Jenkin (wellies at a festival), Elaine Moore (blazer at summer parties), Danielle Sands (buttons on a wedding dress), Laurence Scott (brown leather bomber jacket) and Emma Townshend (black and gold Adidas stripes).

Love and thanks to the Bengali Baris and the Scottish Smiths. And to Craig, who has a snood for every season and who suits me best of all.

Index

Abboud, Joseph, 115
Adidas, 139, 183–4, 185, 186–7, *187*
Adventurer, The, 89
Afghan coats, 96
Agamben, Giorgio, 206
AIDS, 19, 120
Ali, Muhammad, 185
Alice Through the Looking-Glass
 (Carroll), 257
alligator skin, 201, 215, 218
American Psycho (Ellis), 112–16
Andersen, Hans Christian,
 160–62, 168, 177
Andrews, Julie, 263
angora, 206
Anna Karenina (Tolstoy), 201,
 224–6, 266
Annie Hall, 121
anoraks, 96
L'Anti-Justine (Rétif), 138
Antony and Cleopatra
 (Shakespeare), 79
apartheid, 19
Aphrodite, 42
apo ifa bags, 257
Arendt, Hannah, 109
Ariadne, 34–5
Armani, 112
Aronofsky, Darren, 175
arsenic, 48
Ascot Racecourse, Berkshire, 211
Astaire, Fred, 169–73, *171*
Athena, 42
Atropos, 36
Augustine, Saint, 261
Auschwitz concentration camp,
 109, 148
authoritarianism, 90, 91, 104

babalawo, 257

Bacchus and Ariadne (Titian),
 34–5, *35*
backpacks, 280
Bacon, Francis, 236–7
bags, 241–54, 257–70, 276–81
Baker, Nicholson, 153
ball gowns, 41, 47, 208
ballet, 175–9, 220
de Balzac, Honoré, 158
'banality of evil', 109
bandage dresses, 49
Barthes, Roland, 21–3, 58–9
Basile, Giambattista, 157
basketball, 186
Basquiat, Jean-Michel, 5, 6
Bataille, Georges, 145, 208
Battle of San Pietro (1943), 184
Battle of the Somme (1916), 103
Bear Called Paddington, A
 (Bond), 279–80, 281
Beastie Boys, 5
Beaton, Cecil, 211
de Beauvoir, Simone, 52, 78,
 213–14
Beckett, Samuel, 150–51, 267
Bell Jar, The (Plath), 32–3
Benjamin, Walter, 202–3, 209
Berger, John, 49, 228
Berlin Olympics (1936), 184
Berliner, Alain, 45
Between Man and Man (Buber),
 204–6, 207
Beuys, Joseph, 107–9, 128
Bible, 132, 141, 142–3
birds, 211–24
Birds, The, 214–19
Birkin, Jane, 159
bisexuality, 121
Black Swan, 175–6
Blass, Bill, 115

blazers, 13, 65, 67, 84, 88, 96, 105, 133, 230
 boating, 97
 Byrne's, 128
 cricket, 103
 Daltrey's, 131
 Eichmann's, 110
 Keaton's, 121
'Bloody Chamber, The' (Carter), 235
Blue Nights (Didion), 30
Bluebeard, 235
boalee, 201
boating jackets, 88, 97
Boaz, 143
bodycon dresses, 68
boleros, 96
Bolt, Usain, 185
Bond, Michael, 279–80, 281
boots, 3–5
'Borderline' (Madonna), 5–7
Bourdin, Guy, 57
boxing, 185
Boyer, Bruce, 116
Brando, Marlon, 104
bras, 48–9, 58
Bresson, Robert, 272–4
briefcases, 258–9, *258*
Bringing up Baby, 237–9, *238*
British Museum, London, 15
Broke, 274–6, *275*
Brontë sisters, 221–2, 252
Brooks Brothers, 112, 115
Browning, Robert, 60–62
Bruegel, Pieter, 251
Buber, Martin, 204–6, 207
Burberry, 129
Burst of Light, A (Lorde), 19
Bush, Kate, 198–200, *199*
bustles, 48, 59
Byrne, David, 128–9
bythos, 263

Camera Lucida (Barthes), 21–3
Canali Milano, 115

Candide (Voltaire), 28, 283
Capital (Marx), 15, 48
capitalism, 15, 16, 48, 90, 188, 283
carpetbags, 278
Carroll, Lewis, 257
Carter, Angela, 235
catcalling, 51
catfish, 201
centaurs, 204
cervix, 254
Chanel, 31
Chaplin, Charlie, 89–91, 147, 274–6
Charles II, King of England, Scotland and Ireland, 255
Chastity, 37
cheongsams, 1–2
Cheung, Maggie, 1–2, *2*
chiffon, 24, 50
chiton, 35, 41
Choo, Jimmy, 139
chopines, 155–6
Christianity, 132, 141, 142–3, 194
Cinderella, 40, 45–7, 48, 157–60
Civilization and its Discontents (Freud), 105
Cixous, Hélène, 76–7, 223
Claudine and Annie (Colette), 25
Cleopatra, 198
clogs, 152, 155
Clotho, 36
coats, 91–7, 103, 119, 126–8, 206
cocktail dresses, 43
Code of the Woosters, The (Wodehouse), 133
Codex Atlanticus (Leonardo da Vinci), 247, *248*
Cohen, Leonard, 129
Colette, Sidonie-Gabrielle, 25
Company of Wolves, The' (Carter), 235
Cone, Claribel, *3*
Confessions on a Dance Floor (Madonna), 6
Connery, Sean, 265

Coriolanus (Shakespeare), 152
Correggio, Antonio, 220
corsets, 10, 33, 48, 58, 237
Count, The, 89
Creon, King of Corinth, 40
cricket, 102–3
Crime and Punishment
 (Dostoevsky), 271–2
crinolines, 48
Cronus, 42
cuchia, 201

Daltrey, Roger, 131
Dassler, Adi, 183–4, 185
Dassler, Rudi, 184
Davidson, Carolyn, 186
De-Nur, Yehiel, 109–110
Dead Souls (Gogol), 154
Dean, James, 104, 129, *130*
death, 126–8
Degas, Edgar, 176
Deleuze, Gilles, 36, 181
denim jackets, 5–7, 96
Derrida, Jacques, 207, 260–61
Desperately Seeking Susan, 6
Dickens, Charles, 255
Dickinson, Emily, 239
Didion, Joan, 30
Dietrich, Marlene, 121
Dior, 31, 263
Discipline and Punish (Foucault),
 105–6
docile body, 105
domestic abuse, 63
'Don't Let Go the Coat' (The
 Who), 131–3
Dora the Explorer, 280
Dostoevsky, Fyodor, 93, 271–2
dress reform movement, 10, 33, 48
dresses, 26–78
 ball gowns, 41, 47, 208
 bandage, 49
 bodycon, 68
 bustles, 48, 59
 cheongsams, 1–2

chiton, 35, 41
cocktail dresses, 43
crinolines, 48
folds, 33–42
hobbled, 48, 63
Ionic gowns, 41
jersey dresses, 53
magic, 42–7
maxi, 68
necklines, 58–62
'off the peg', 53
pencil, 58
peplos, 35
'right dress', 76
saris, 33, 36, 41, 58
seamstresses, 47–8
shift, 64, 68
shirtdresses, 68
stola, 33, 35, 38–40
sun dresses, 43
trans women and, 45
wedding dresses, 43

Egypt, ancient, 142
Eichmann, Adolf, 109–10
electrical theory, 145
Elegance (Boyer), 116
Eliot, Thomas Stearns, 117–19, *118*,
 127–8
Ellis, Bret Easton, 112–16
embroidery, 252
Emin, Tracey, 243–5, *243*
Engelman, Edmund, 39
Ennis, Jessica, 185
ermine, 231
'Escape, The' (Mansfield), 276–7
Eton College, Berkshire, 99
Eugene Onegin (Pushkin), 163–4,
 168
Eurydice, 49

Faber, Michel, 55–6
'Famous Blue Raincoat' (Cohen),
 129
Fascism, 104, 109

Fates, 36–7, *37*
Fawcett, Farrah, 6
feathers, 201, 203, 207, 208, 211–14, 219–24, 228, 237, 239, 250
Felt Suit (Beuys), 107–9, *108*, 128
feminism, 19, 52, 166, 223, 254, 268
Ferrante, Elena, 166–8
fetishism, 16
 feet, 138, 163–5
 fur, 226
fibulae, 41
FIFA, 180, 185, 186
50 Words for Snow (Bush), 200
Figaro, Le, 59
Filofaxes, 270
Firth, Colin, 120
folds, 33–42
foot binding, 166
foot fetishes, 138, 163–5
football, 180–83, 185
footnotes, 153
footprints, 143–5
Ford, Tom, 120
Forster, Edward Morgan, 13
Foster, Susan Leigh, 176
Foucault, Michel, 19, 105–6
Fourment, Helena, 228, *229*
fox fur, 200, 201, 231
Fragonard, Jean-Honoré, 55
Franzen briefcases, 258–9
Frazier, Joe, 185
French & Stanbury, 112
Frenzy, 111–12
Freud, Sigmund
 on conformity, 105
 Dora, analysis of, 254
 on fetishism, 165, 226
 on furs, 226
 and Gradiva, 38–40, 164–6, 168
 on handbags, 254
 on id, 262
 on libido, 162
 on narcissism, 18, 151
 on objects, finding of, 239
 on unconscious, 39, 126
 on 'what does woman want?', 162, 165, 166
Fur, Fin and Feather Club, 212
furs, 200, 201, 207, 209, 223, 224–36

Galliano, John, 208
Garbo, Greta, 233
Gargantua and Pantagruel (Rabelais), 249
Garrick Anderson, 112, 113
Gaultier, Jean-Paul, 208, *210*
Gautreau, Amélie, 59–60
Gervais, Ricky, 86
Gilman, Charlotte Perkins, 48, 268–9
Girl in a Fur (Titian), *225*, 226
glamour, 42
Glauce, 40
von Goethe, Johann Wolfgang, 23, 137
Gogol, Nikolai, 91–7, 154
Gold Rush, The, 89
Gordon, Douglas, 182
Goring, Marius, 161
gossamer, 24
GQ, 85–6
Gradiva, 38–40, *38*, 164–5
Grant, Cary, 83–9, *84*, 237–9, *238*
Great Depression (1929–39), 91
Greco, El, 226–7, *227*
Greece, ancient, 17, 16, 17, 19, 35, 40–43, 146–7, 157, 219
Greer, Germaine, 254
Groves, Caroline, *178*, 179

Hadid, Zaha, 179, *180*
Hamlet (Shakespeare), 155–7
handbags, 241–54, *248*, 262–3, 264, 267
hangers, 53
Happy Days (Beckett), 267
harpies, 212
Harry Potter (Rowling), 263
Haunted Lady, The (Tenniel),

47–8, *47*
Hawks, Howard, 237
heels, 137–8, 155, 159, 166, 177
Heidegger, Martin, 4, 126
hems, touching of, 132
Hepburn, Audrey, 211
Hepburn, Katharine, 237–9, *238*
Hera, 42
Hermès, 201
Herodotus, 41
herringbone, 200
Highland Rape (McQueen), 64
Hitchcock, Alfred, 83, 87, 111–12,
 214–19, 264–5
HIV, 19, 120
Hobbes, Thomas, 152
hobbled skirts, 48, 63
hockey, 185
Hollander, Anne, 111
Holocaust, 109–10, 148–9, 203
homosexuality, 50, 59, 120
horses, 204–6, 207
Hounds of Love (Bush), 198–9, *199*
houndstooth, 200
House of Mirth, The (Wharton),
 14, 252–3
Hughes, Edward 'Ted', 140
Hugo Boss, 112, 115
Huxley, Thomas Henry, 237

'I Sing the Body Electric'
 (Whitman), 261
id, 262
Idle Class, The, 89
'If I Were a Man' (Gilman), 268–9
If This is a Man (Levi), 149
Ike Behar, 115
Iliad, 42
Immigrant, The, 274–6, *275*
In the Mood for Love, 1–2, *2*
investiture, 124
L'Invitée (de Beauvoir), 213–14
Ionesco, Eugène, 104–5
Ionic gowns, 41
Irigaray, Luce, 223

Isherwood, Christopher, 120
Islam, 10, 142, 200
Ivanov, Lev, 220

Jack the Ripper, 64
jackets, 81, 96, 127–8, 129–33
 boating, 88, 97
 death and, 127–8
 denim, 5–7, 96
 leather, 6, 10
 loss of, 5, 96, 133
 mess, 97–9
 youth and, 129–33
Jackson, Samuel Leroy, 258
Jacob's Room (Woolf), 149
James Bond, 111
James, Henry, 69–74
Jeeves, Percy, 102–3
Jeeves and Wooster, 97–104, 133
Jensen, Wilhelm, 38–9, 164–5
jersey dresses, 53
Jimmy Choo, 139
Jocasta, 146
John Wick, 86
Johnson, Michael, 185
Jordan, Michael, 186
Joyless Street, 233
Judaism, 109–10, 141, 142, 148–9,
 194, 203
Juvenal, 157

Kant, Immanuel, 16
kazabaika, 231–3
Keaton, Diane, 121
Kelly, Gene, 174–5, *174*
Khusrow, Amir, 200
Kidron, Beeban, 159
Kierkegaard, Søren, 51–2
Kilgour, French & Stanbury, 85
King Lear (Shakespeare), 148
Kinsey, Alfred, 138
Knausgård, Karl Ove, 127
Kurdi, Aylan, 149–50

Lachesis, 36

Lady in a Fur Wrap (El Greco), 226–7, *227*
'Lady Lazarus' (Plath), 29
Laetoli, Tanzania, 144–5
Laius, 146
Landau, Martin, 83
LaSalle, Martin, 272–4
Leakey, Mary, 144
leather, 201, 202, 208, 209, 236, 241
leather jackets, 6, 10
Leda, 219–20
Leonardo da Vinci, 186, 247, *248*
leopard print/skin, 201, 208, 209
Leung, Tony, 1, *2*
Levi, Primo, 148–9
Levi's, 255
Lewis, Carl, 185
Lewis, Percy Wyndham, 118–19
LIFE, 186
'Little Red Riding Hood', 234–5
load-bearing woman, 254
Lolita (Nabokov), 55, 163, 165, 168
'Loneliness of the Long Distance Runner, The' (Sillitoe), 189–91
Long, Luz, 184
Lorde, Audre, 19
'Love Song of J. Alfred Prufrock, The' (Eliot), 117–19, 127–8
Lover's Discourse, A (Barthes), 23
Lucy Locket, 255

Ma Vie en Rose (Berliner), 45
Mademoiselle, 31
Madonna, 5–7, *7*
Magista football boots, 180–81, *181*
Magritte, René, 106
Majdanek concentration camp, 149
'Make Me Feel' (Monáe), 121
'Male Myth, The' (Theroux), 119–20
Manet, Édouard, 137–8
Mansfield, Katherine, 276–7

Marnie, 264–5, *264*
Marx, Karl, 15–16, 48, 153
Mary Poppins (Travers), 262–3
masculinity, 52, 65, 87, 88, 119–21, 129, 213, 250
Mason, James, 84
mass production, 107, 188
maxi dresses, 68
McEwen, Todd, 85–6
McQueen, Alexander, 62–7, *66*, 177, *178*, 203–4, *205*, 207, 221, *222*
Medea, 40
Medusa, 198
mess jackets, 97–9
Mezzanine, The (Baker), 153
mink, 218
Mizuno, 193
Monáe, Janelle, 121, *122*
money, 269–70, 274–6
de Montaigne, Michel, 207
Moore, Marianne, 231
Moses, 141
Moss, Zoe, 52
Mosul handbag, 250
Mulvey, Laura, 52
Murakami, Haruki, 189, 193
muslin, 200–201
My Bed (Emin), 243–5, *243*
My Fair Lady, 211
My Struggle (Knausgård), 127

Nabokov, Vladimir, 55, 154, 165, 168
Nahum, Mordo, 148
nakedness, 207
Naomi, 143
narcissism, 17–19, 113
National Basketball Association (NBA), 186
Nazism, 104, 109, 148–9, 184, 203, 259
necklines, 58–62
Nero, Roman Emperor, 143
'New Dress, The' (Woolf), 74–5
New York Times, 119

New Yorker, 109
Newton, Helmut, 121
Nietzsche, Friedrich, 17, 69
Night of the Demon, 198
Nike, 136, 180–81, *181*, 185–8
Nin, Anaïs, 163
Noh theatre, 128
North by Northwest, 83–9, *84*
Notebooks on Cities and Clothes,
 124–6
Novalis, 44

Obama, Barack, 123
Oedipus, 146–7
'off the peg', 53
Office, The, 86
Oliver Twist (Dickens), 255
Olympia (Manet), 137–8, *137*
Olympic Games, 184, 186, 187
organza, 24
Orpheus, 49
'Overcoat, The' (Gogol), 91–7
Owens, Jesse, 184

Pabst, Georg Wilhelm, 233
Paddington Bear, 279–80, *281*
Paglia, Camille, 215
Pamela (Richardson), 256
parkas, 96
Parker, Elizabeth, 252
Parreno, Philippe, 182
pea coats, 96
Peasant Dance, The (Bruegel), 251
pencil skirts, 58
peplos, 35
Perrault, Charles, 157, 235
Perseus 198
Petipa, Marius, 220
Phillips, Adam, 265–6
Phillips, Eliza, 212
phones, 270
pianelle, 157
Pickpocket, 272–4, *273*
pickpockets, 270–71, 272–4, *273*
plaid, 86

Plath, Sylvia, 29, 31–3, 220
Plato, 16, 17
Plato's Atlantis (McQueen), 177,
 178
Plumage League, 212
Plunkett, Marcella, 159
pockets, 254–6, 268–9, 270–76,
 273
pointe shoes, 175–9
Pompeii, Italy, 39
ponytails, 204
Poppaea, Roman Empress
 consort, 143
'Porphyria's Lover' (Browning),
 60–62
Portman, Natalie, 175–6
Portrait of a Lady, The (James),
 69–72
Portrait of Madame X (Sargent),
 59–60, *61*
Postumus, 157
pouches, 249
Powell, Michael, 161–2, 168
Prada, Miuccia, 179
Pressburger, Emeric, 161–2, 168
prostitution, 115, 233, 255–6
Psycho, 112
Pulp Fiction, 258–9
Puma, 184
Punch, 47
punctum, 21–2
purses, 241, 245, 246, 249–55, 257,
 260, 269–73, 275–6, 279, 285
Pushkin, Alexander, 163–4, 168

qabâqiib, 155
Quintino of Beverly Hills, 85
Quran, 142

Rabelais, François, 249
Ramones, 10
rape, 64, 67, 219
'Ray of Light' (Madonna), 7
Real Madrid, 182
Rear Window, 112

Rebel Without a Cause, 129, *130*
Red Riding Hood, 234–5
'Red Shoes, The' (Andersen),
 160–62, 168, 177
Reeves, Keanu, 86
refugees, 149–50
Reservoir Dogs, 259
Rétif, Nicolas-Edme, 138
Reveries of a Solitary Walker
 (Rousseau), 192
Rhames, Ving, 258
Rhinoceros (Ionesco), 104–5
rhizome, 181
Rhodopsis, 157
Richardson, Samuel, 256
'right dress', 76
Right Ho, Jeeves (Wodehouse),
 97–101
Rilke, Rainer Maria, 144
Ritz-Carlton Hotel, Boston, 120
Robinson Crusoe (Defoe), 143–4
Rogers, Ginger, 169–73, *171*
Rolls-Royce, 179
'Romance of Certain Old Clothes,
 The' (James), 72–4
Rome, ancient, 33, 35, 38–40, 143
Ronaldo, Cristiano, 180
Room with a View, A (Forster), 13
Roth, Tim, 258
Rousseau, Jean-Jacques, 192, 278
Royal Society for the Protection
 of Birds (RSPB), 212
Rubens, Peter Paul, 219–20, 228,
 229
Rudy, Frank, 185
running, 185, 189–94
Rykiel, Sonia, 76–7

sabots, 152
von Sacher-Masoch, Leopold,
 230–33
Saint-Laurent, Yves, 31, 121–2
Saint, Eva Marie, 84
Sargent, John Singer, 59–60, *61*
saris, 33, 36, 41, 58

Satires, The (Juvenal), 157
satyrs, 204
Savile Row, London, 62, 85
Schiaparelli, Elsa, 31
Scott, Jeremy, 186, *187*
seamstresses, 47–8, 90
Second Sex, The (de Beauvoir),
 52, 213
Seducer's Diary, The
 (Kierkegaard), 51–2
self-cultivation, 19
sewing, 252
sex, sexuality
 animals and, 203, 213–14, 217–24
 dresses and, 11, 32, 34, 39–40,
 45, 50, 55–6, 59, 60–68, 76–7
 furs and, 226, 228–36
 purses and, 250
 shoes and, 138, 156, 162–5, 169
 suits and, 88, 111–14, 119, 120–23
 violence and, 11, 32, 60–67,
 112–14, 217, 219
Shakespeare, William, 79, 148,
 152, 155–7
Shall We Dance, 172–3
Shearer, Moira, 161
sheepskin coats, 206
shift dresses, 64, 68
shirtdresses, 68
Shoes (Van Gogh), 3–5, *4*, 151
shoes, 3–5, 134–94
 ballet, 175–9
 boxing boots, 185
 chopines, 155–6
 Cinderella stories and, 157–60
 clogs, 152, 155
 engineering of, 179–86
 football boots, 180–83, 185
 freedom and, 140, 166–8, 169
 heels, 137–8, 155, 159, 166, 177
 hockey boots, 185
 Holocaust and, 148–9
 labour and, 3, 151–3
 loss of, 149–50
 mobility and, 144, 165–8

pianelle, 157
pointe, 175–9
qabâqiib, 155
religion and, 142–3
running shoes, 185
sexuality and, 138, 156, 162–5, 169
stiletto heels, 137, 166, 177
trainers, 15, 21, 136, 138, 140, 179, 180–88
Van Gogh's, 3–5, *4*, 151
Sillitoe, Alan, 189–91
Singin' in the Rain, 173–5, *174*
Single Man, A, 120
sirens, 212
skins, 200–209, 215, 223, 224–37
skirts
hobbled, 48, 63
length of, 11
pencil, 58
'Smoking, Le', 121
snakeskins, 201, 208
Sontag, Susan, 17
Sophocles, 146
Soprani and Kilgour, 112
Sources of the Self (Taylor), 262
South Africa, 19
Spencer, George, 99
Sphinx, 146
Spy in the House of Love, A (Nin), 163
stiletto heels, 137, 166, 177
stola, 33, 35, 38–40
Stop Making Sense (Talking Heads) 128–9
suede, 201, 208, 215, 218
Suetonius, 143
suffrage, 48, 212
Sufism, 200
suicide, 252
suitcases, 243–5, 264, 276–7, 278–80
suits, 82–91, 97–101, 104–29
authority and, 90, 106, 111, 117
Beuys', 107–9, *108*, 128

Byrne's, 128–9
courts of law and, 67, 109–10
democratisation and, 107
Eichmann's, 109–10
Eliot's, 118–19
indemnity of, 91
jackets, 81, 82, 84, 86, 88, 97–9
masculinity and, 88, 107, 112, 116, 119–21, 129
mass production and, 107
maturity and, 117
Obama's, 123
restraint and, 105, 111, 116
Savile Row, 62, 85
strength and, 123
tops and tails, 88, 99
trousers, 89
tuxedoes, 31, 121
violence and, 112–16
Wenders on, 124–6
Swan Lake (Tchaikovsky), 177, 220
sweatshops, 188, 283
Swing, The (Fragonard), 55

'Tail Light' (Prada), 179
Talking Heads, 128–9
Tarantino, Quentin, 258–9
Taylor, Charles, 262
Taylor, Rod, 214–18
Tchaikovsky, Pyotr Ilyich, 177, 220
Tenniel, John, 47–8
textile, etymology of, 24
Theroux, Paul, 119–20
Theseus, 34
Thoreau, Henry, 13
Thousand Plateaus, A (Deleuze), 181
Three Fates or The Triumph of Death, 36–7, *37*
Three Women (Plath), 220
ties, 1, 9, 20, 86, 88, 104, 117
Tippi Hedren, 214–19, *216, 264*, 265
Titian, 34–5, *35, 225*, 226

To the Lighthouse (Woolf), 30
Tolstoy, Leo, 93, 201, 224–6, 266
Top Hat, 169–72, *171*
totalitarianism, 104
Town and Country, 116
Townshend, Pete, 131–3
trainers, 15, 21, 136, 138, 140, 179, 180–88
trans people, 10, 45
Travers, Pamela Lyndon, 262–3
Travolta, John, 258
trousers, 89
Truce, The (Levi), 148
Turgenev, Ivan, 93
Turner, Kathleen, 159
tuxedoes, 31, 121
Two Gentlemen of Verona, The (Shakespeare), 148

Under the Skin (Faber), 55–6

Van Beirendonck, Walter, 208, *210*
Van Gogh, Vincent, 3–5, 151
Vanity Fair, 123
Vatican, 38, 39
veiling, 10, 226–7, *227*
Venus in Furs (von Sacher-Masoch), 230–33
Verne, Jules, 277–8
Victoria and Albert Museum, London, 36
Victorian era
 ball gowns, 41, 47
 dress reform movement, 10, 33, 48
Villarreal Club de Fútbol, 182
violence, 11, 33, 41, 58, 60–67, 77, 112–14, 217, 219
Vitruvian Man (Leonardo da Vinci), 186
Vogue, 121
Voltaire, 28, 283

Waiting for Godot (Beckett), 150–51

Walbrook, Anton, 162
Walkley, Mary Ann, 48
War and Peace (Tolstoy), 93
Warhol, Andy, 5
waterproof coats, 96
wedding dresses, 43, 72
Wenders, Wim, 124–6
West, Mae, 255
Wharton, Edith, 14, 252–3
Whitman, Walt, 261
Who, The, 131–3
Williamson, Emily, 212
windbreakers, 96
Winnicott, Donald, 266
Wisden Cricketers' Almanack, 102
Wodehouse, Pelham Grenville, 97–104, 133
Wollstonecraft, Mary, 211, 213
womb, 36, 254, 265, 266
Wong Kar-wai, 1
Woolf, Virginia, 29–30, 74–5, 149
World Cup, 180, 185, 186
World War I (1914–18), 102–3, 184
World War II (1939–45), 109–10, 148–9, 184, 203
Wuthering Heights (Brontë), 221–2

Yamamoto, Yohji, 124–6, *125*
Ye Xian, 157
Yeats, William Butler, 220
Yoruba people, 257
'You Who Never Arrived' (Rilke), 144

zebra print/skin, 6, 209
Zeus, 42
Zidane, Zinedine, 182–3